THE
BLAKE
BOOK

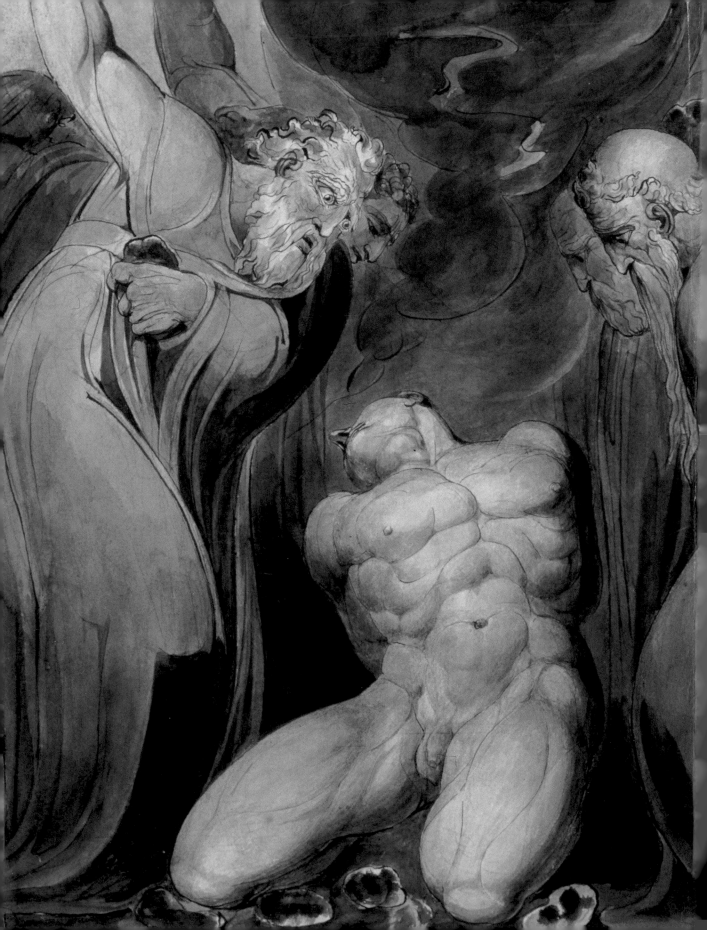

MARTIN MYRONE

THE BLAKE BOOK

TATE PUBLISHING

First published 2007 by order of the Tate Trustees
by Tate Publishing, a division of Tate Enterprises Ltd,
Millbank, London SW1P 4RG
www.tate.org.uk/publishing

British Library Cataloguing in Publication Data
A catalogue record for this book is available from
the British Library

ISBN: 978 1 85437 727 2

Distributed in the United States and Canada by
Harry N. Abrams, Inc., New York
Library of Congress Cataloging in Publication Data
Library of Congress Control Number: 2007920240

Designed by Esterson Associates

Printed in Hong Kong by South Sea International Press Ltd

Front cover: *Newton* 1795/c.1895 (fig.54 detail)
Frontispiece: *Frontispiece to 'Europe a Prophecy'* 1794
(fig.1 detail)

Measurements are given in centimetres, height before width

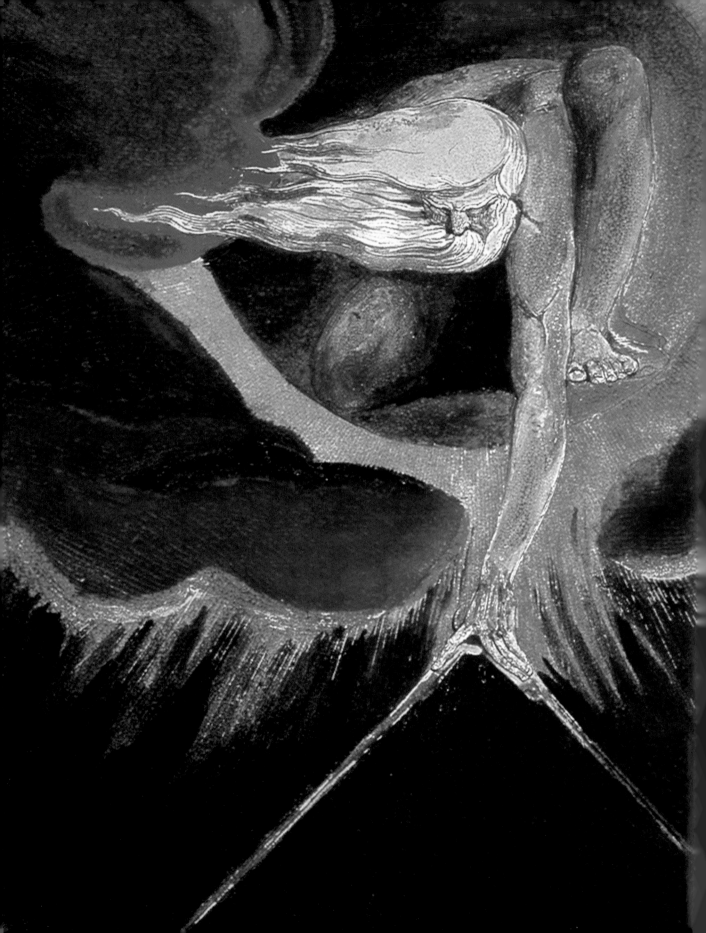

The work of no other artist may be as immediately appealing, yet as forbidding, as that of William Blake (1757–1827). His poems and images have entered the bloodstream of British, indeed world, culture in a unique way. Blake's poem beginning 'And did those feet ', adapted as the hymn 'Jerusalem', is known to vast sporting crowds who may feel little sympathy for the art world, is sung by rock bands, incorporated into film soundtracks and played at political gatherings of all persuasions (see pp.132–3). His coloured prints known as *Albion Rose* (fig.27) and the *Ancient of Days* (fig.1) are reproduced on book covers, album sleeves and posters, pastiched, lampooned and adapted as cartoons. Eduardo Paolozzi's monumental sculpted version of *Newton* (fig.54) has greeted visitors at the British Library in London since 1995. 'The Tyger' (fig.44) is one of the most widely anthologised poem in the English language, recited by schoolchildren around the world. Blake's poetry and art seem to speak to everyone: Left and Right, radical and conservative, old and young.

Yet Blake's art itself can be formidably dense in its imagery, full as it is of massive and bizarre forms, extraordinary dislocations of scale, and contorted and impossibly athletic figures, given weird and original names, often in confusing and ambiguous ways. Those of Blake's contemporaries who bothered to look seriously at his art – and these were in the minority – were equally challenged and often just baffled. While there were a number of collectors and other artists who admired his designs, even his friends considered that Blake's fanciful imagination could become simply eccentric, or even tend towards madness. Although he participated in the public art exhibitions of his day, and held his own private one-man show in 1809, the few documented responses to the works he displayed suggest incomprehension and sometimes outrage.

Blake's poetry, meanwhile, was almost entirely overlooked. His earliest efforts were taken as showing youthful promise, and his *Songs of Innocence and of Experience* 1789–94 (see pp.72–3) were relatively well known and liked. But his visionary and prophetic books, communicated in the form of privately printed 'illuminated books' combining text and images on single pages in a highly original fashion, caused almost universal consternation among the small number of people known to have encountered them.

Blake's reputation as artist and poet was reconsidered in the later nineteenth century, particularly after Alexander Gilchrist's thoroughly researched biography, *The Life of William Blake*, was published, posthumously and under the editorship of the author's widow Anne, in 1863. Still a standard source on the artist, Gilchrist's account was supplemented by a selection of the poems with critical notes by the painter and poet Dante Gabriel Rossetti (1823–82), and a full listing of all Blake's known works by William Michael Rossetti (1829–1919). The vast body of literary commentary and explication that has accumulated since then is forbidding in its own right, for its sheer extent, its variety, and the complexity and technical nature of many of its concerns.

1 Introduction

Blake's personal symbolism has been dealt with in the most extraordinarily wide-ranging terms, as an unruly multitude of religious traditions, literary sources and esoteric ideas have been brought to bear on his iconography. His textual techniques have been explored from the full range of critical perspectives: Blake's writings can appear in this context as an intensive kind of textual criticism in its own right. Blake's poetry, particularly in the form of the illuminated books, has emerged as the subject of highly specialised academic research, and as a sort of test-case for theoretical speculation about the nature of textuality and literary meaning. This involves issues of aesthetics and philosophy, the nature of reading and of looking and the limits of textual criticism to apprehend and investigate them, and questions of literary reputation and cultural value. His life and thought have been examined minutely, and have been placed in the contexts of the eighteenth-century social, religious and political world, and the grand events of history. Blake has been presented as the great exception to almost every rule about the political and sexual prejudices of his time, the artist who tested the limits of poetry as a form of communication, and the restrictions of printed books as a communication technology. The literary study of Blake has been established as a kind of inventive forge, wherein conventional ideas and values are re-made, refreshed, or destroyed entirely.

Meanwhile, Blake remains relatively underexplored by art historians. In his pioneering general study of Blake as a visual artist (1959), Anthony Blunt endeavoured to show that while Blake is 'unusual', 'he is not so unique as is often maintained'. While 'a vast quantity of energy and an excessive amount of ingenuity have gone into the study of Blake little has been written about Blake as a painter and an engraver'. He noted at that time that 'The ordinary methods of art history have never been applied to Blake'.[1] Pursuing similar aims in his magnificent and enduring 1977 study *Blake as an Artist*, David Bindman still needed to validate his focus on the paintings and drawings, on Blake as a visual rather than a textual artist, arguing that the illuminated books are not 'a self-contained aspect of Blake's work' but need to be considered in relation to his art as a whole, and the art of his times.[2] Although there have been full-scale studies of aspects of Blake's art, and several significant exhibitions, the points made by Blunt and Bindman, to a large degree, still hold.

Yet there are historical reasons for approaching Blake as primarily a visual artist, overturning the dominant focus on the small body of 'illuminated books' that preoccupied him in the 1790s. For many of his contemporaries, Blake was a professional printmaker and printer, who only produced his own designs in painting and watercolour as a sideline, and who was merely rumoured to write poetry as well. Even those who bothered to look at the illuminated books seem to have considered them as of mainly visual interest, letting their eyes drift over dense blocks of obscure text. In the diaries of the landscape artist Joseph Farington (1747–1821) he was 'Blake the Engraver', and when the poet William Hayley (1745–1820) took up his cause

1

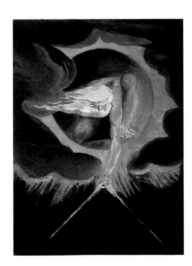

Frontispiece to 'Europe a Prophecy' 1794
Copy B
Relief etching finished with watercolour
37.3 x 26.4
Glasgow University Library

and became his patron in 1800, he referred to him as 'an excellent enthusiastic Creature, by profession an Engraver'.[3] Even later, when Thomas Carlyle recommended Gilchrist's manuscript 'Life of the Painter Blake' to a publisher in 1859, he volunteered a perceived correction, 'Painter, or *Engraver* rather'.[4] It comes as something of a shock to read through the contemporary obituaries of Blake, which describe him as the illustrator of editions of Robert Blair's *The Grave* (published in 1808) and of Edward Young's *Night Thoughts* (in 1797); the maker of drawings and paintings appreciated by only a few informed judges, a visionary and devoted Christian, but someone barely acknowledged to be a poet. The *Gentleman's Magazine* (November 1827) listed some of the illuminated books, but in the context of detailing his published illustrations, rather than for their textual content. The first biographical and anecdotal accounts appeared in writings on art, in J.T. Smith's *Nollekens and his Times* (1828) and Allan Cunningham's *Lives of the Most Eminent English Painters, Sculptors and Architects* (1830).

The present volume is intended as a further, relatively modest, contribution to the efforts pioneered by Blunt and Bindman. Blake is viewed here from the perspective of the wider art history of late eighteenth- and early nineteenth-century Britain, considering his activities as a professional engraver and an original artist in relation to the different domains in which these took place – the world of art training and of public art exhibitions, the studio or workshop, the realm of commercial publishing and the social circles of the new breed of middle-class collectors – rather than working out towards these from the perspective offered by his own symbolism. These domains are not merely the 'context' or 'background' to Blake's life and art; they are where Blake's vision and technique were actually constituted, although often in antagonistic and negative ways.

The conventional ideology of the modern artist – one that holds Blake as in many ways exemplary – would suggest that the creative individual is driven by inner needs and ambitions, without regard to the world around him, viewing art as a higher pursuit. There is much in the way that Blake saw himself, and how he was viewed contemporaneously (both by his supporters and his opponents) that conforms to this view. Without doubting the sincerity of Blake as an artist and an individual, or presenting a mechanistic account of how social conditions 'create' an individual's personality and talents, we should nonetheless consider the historical conditions that made this position possible. Blake's importance in art history might then be enhanced, for we might understand that the public neglect of his work in his lifetime, his personal travails, and the very incomprehensibility of so much of his art, were not the results of an oddball personality, or even of an entirely unique confluence of historical forces around a lone but pristine individual. Rather, they manifest a particular, and highly significant, potential within the cultural world that was being forged during his lifetime by the interaction of individual artists, collectors, entrepreneurs and tastemakers, institutions and political agencies, and the

collective mass of consumers. What may be most significant about Blake, considered art-historically, is the manner in which his art and life make him the representative of a new configuration of these relationships – representative not *despite*, but in fact *because of*, his uniqueness, the way his particular achievements could not be simply reproduced by others, and the manner in which the value and nature of his art was *always* being contested. There is a strong sense in the early commentaries on Blake that this was an artist who could only be appreciated – and even then, barely understood – by a minority. A taste for Blake signified a quite particular, highly individual and eccentric set of personal values. Now, two hundred years later, we may be inclined to consider more highly those collectors and artists who were able to appreciate his art, than those who dismissed it. The turnaround in Blake's reputation over the last two centuries, from neglected outsider to consummate artist, may reveal more than the particularities of shifts in taste over this period: it may indicate the contradictions and paradoxes immanent in the way the artist was beginning to function in the modern world.

Within the wider realm of Blake studies, two strands of inquiry stand out as particularly pertinent to this art-historical contextualisation of his work. The first is the intensive focus on the visuality of Blake's work, though this has still meant, largely, concentrating on a core of works, his 'illuminated books'. The precisely physical nature of these books has been a preoccupation of several influential scholars. This has gone hand-in-hand (and has in part depended on and reacted to) the ever-readier access to Blake's printed designs in reproduction. While once Blake's illuminated books were available only in highly exclusive facsimiles or in reduced reproductions, now anyone with access to the Internet can view every page of the illuminated books in detail, and a number of these in different versions, at the William Blake Archive, a major electronic resource edited by Joseph Viscomi, Morris Eaves and Robert Essick. The William Blake Trust, which produced a series of facsimiles from its foundation in 1949 through to 1987, renewed its efforts in the early 1990s, resulting in a series of facsimile publications of the illuminated books by Tate Publishing that are now available in affordable form.[5] Advances in printing technology and digital imaging mean that we can all now gain the feeling of direct access to Blake's printed works. But we should not forget that this is an illusion; the luminosity of the computer screen and the smooth sheen of the printed page are not precise equivalents to the techniques that Blake used. There is something odd, even vaguely shocking, about the encounter with the originals of these images, smaller, somehow much more modest than we might imagine.

The material study of Blake's art has taken us deeply into both the physical nature of Blake's prints and some of his paintings as objects. As should become clear in the following chapters, there is still much to debate and to understand on these points, which are fundamental to how we might place Blake in relation to the tastes and values of the society in

which he lived. In this regard, a second significant line of inquiry has special relevance. This is the political contextualisation of Blake's art, as initiated by David Erdman's monumental study *Blake: Prophet Against Empire* (1954), which provides a highly elaborate argument relating the symbolism of his poetry and art to the political events and ideas of his time.[6] Erdman's arguments remain a major point of reference when it comes to interpreting Blake's iconography and themes, although his rather starkly literal methodology has been questioned, and the sense of Blake's own political and social positions has shifted considerably.

As Erdman's subtitle suggests, Blake has traditionally been cast as a consistently oppositional figure, hostile to the established political powers, to the nationalistic ideas that developed over these years as a basis for backing costly wars against America and France and their allies. He has been viewed as a man who could not bear prejudice on the grounds of race or rank, who believed in free love and sexual liberation. As such he has been associated with radical plebeian politics and dissenting religious traditions and, in E. P. Thompson's important arguments (elaborated most fully in a posthumous book in 1993), with an emerging working-class consciousness.[7] The sources and qualities of Blake's political ideas have been shown to be ever more complex, in studies that have focused on the multiple and often forgotten or suppressed dimensions of the politics of late eighteenth-century London.

Alongside these efforts, Blake's social position has been more precisely delineated. He has been placed amongst a class of skilled urban artisans, physically and culturally remote from the (still largely rural) working class, but only ambivalently connected with the wealthier middle class. For some commentators, he remains allied even then to the socially marginalised, and fiercely opposed to the economic and social changes that were benefiting most clearly a rapidly developing, literate, professional middle class. But he was also an urban professional himself, who tried in a number of ways to establish himself as a small businessman in his own right, and his most important social relationships were with people from the literate bourgeoisie. His talents were cultivated in the drawing-rooms of educated and liberal civil servants and professionals, well-off scholars and artists, the ancestors of today's 'chattering classes', the well-meaning urban middle class, whom Blake characterised and poked fun at in his early, incomplete satirical play, 'An Island in the Moon' (c.1784–5). For all his idiosyncrasies and his unique powers as an artist, Blake belongs to a distinctly middle-class culture that fostered very particular – although that is not necessarily to say very coherent – ideas about the artistic vocation. And there are indications that we need to be cautious about always insisting on his exceptionalism: his imagery, in however heavily mediated or transmuted a sense, incorporates some of the prejudices and beliefs of his time regarding racial difference, sex and sexuality. However uncomfortable we may be with the idea, Blake may not be as liberal and progressive as we like to think;

more worrying still, his art may indicate how deeply rooted such prejudices are even in the context of a self-consciously liberal and progressive mind.

The very idea of a 'bourgeois Blake' may be disconcerting; it would seem to do an injustice to his memory. Yet what made Blake possible was a loophole within the cultural logic of a specifically bourgeois society that was taking shape around him. The case of Blake helps clarify the paradoxical logic that lies at the heart of the modern cultural system, where the 'pure' love of art, shared by practitioners and consumers, achieved a supreme importance, seeming to stand aside from and even cancel out 'merely' commercial or selfish interests. In this disguised or mystified form, the love of art served as a means of articulating social differences and giving authority to bourgeois values. But this game was not just an entirely cynical affair, where the players always had a clear view of their personal interests. The nature of the game demanded that there was the possibility – and this is what emerges with Blake – of individuals taking it at face value, playing it with a sense of commitment that could bring only material disadvantages in the short term. In this context, the mere promise of future – even posthumous – fame brought a special kind of reward, all the more tempting for individuals who, like Blake, lacked the education, money or inherited status that might otherwise lend them social confidence.

It may be significant that the social circles with which Blake associated and from which he drew patronage incorporated a number of amateur artists, most notably George Cumberland (1754–1848), who could, essentially, ignore the commercial realities of making art. Writing of an acquaintance who had given up professional practice, Blake implies his approval of such a position:

he says that he relinquishd Painting as a Profession. for which I think he is to be applauded. but I conceive that he may be a much better Painter if he practises secretly & for amusement than he could ever be if employd in the drudgery of fashionable dawbing for a poor pittance of money in return for the sacrifice of Art & Genius. he says he never will leave to Practise the Art because he loves it & This Alone will pay its labour by Success if not of money yet of True Art. which is All –[8]

The purest artist, here, might be the one who pays least attention to his practical interests and professional prospects: 'Success', not 'money', is the reigning principle. While the art institutions and theorists of the day were drawing an ever-firmer line between the professional artists and the amateurs, excluding the productions of the latter from public exhibitions and such individuals from membership of art societies, we may suggest that this boundary was only policed so carefully because it was in fact so porous.[9]

These ideas of artistic identity and the artist's relations with the social world are important throughout the present volume. It is organised, though, around a series of thematic and historical issues, which provide a framework for appreciating Blake's imagery and his place in British art. Given the ongoing debates around so many aspects of Blake's art,

the chapters that follow are characterised by a degree of provisionality. With any individual work by Blake there may be fundamental questions about chronology, technique, symbolism and significance, all of which can appear to be rather confidently swept away when his images are published with a title and a date appearing clearly in the caption. When we look at a watercolour called *Los and Orc* c.1792–3 (fig.26), we may immediately reach for our reference books to work out who these two characters are and what their relationship is. Yet that title, along with so many others, has been foisted on to the work, for good reasons, perhaps, but not definitively. The present book is not an effort to dismiss the plurality of meanings and interpretations possible around his art. It does, though, suggest that we need to be critical and historically aware about the social and material conditions for that openness.

The first chapter provides a biographical grounding for Blake's early career. The nature of Blake's training as a reproductive engraver is considered in depth, as too are the market conditions that helped to shape his own career and influence the character of his art. Chapter Two looks at the Royal Academy, the central art institution of the time, where Blake received further training as a draughtsman. Here, also, is discussion of the aspirational idea of 'high art' that was current at the time, and the market realities that re-shaped such ideas. The next chapter considers the theme of 'revolution', both the political revolutions that shaped world history during Blake's lifetime and the revolutionary nature of his technical

and iconographic innovations in the 1790s. Chapter Four takes an overview of Blake's religious art, his ideal of a Christian artist and his treatment of biblical themes and religious subjects taken from the seventeenth-century poet John Milton. Chapter Five concentrates on the various ways in which his art was given public exposure during his lifetime, through the art exhibitions of the Royal Academy and other institutions, and through commercial publications. The way the cultural 'public' was being configured as the 'nation' is also at issue here. The final chapter, 'Blake Among the Ancients', considers the last part of Blake's life and his reputation among collectors and artists, notably the painters who called themselves 'the Ancients', whose identity was cemented in their shared admiration for the elderly painter.

These six chapters provide, I hope, an informative and sometimes provocative overview of Blake's work as a painter, printmaker and draughtsman. Of course, Blake himself provided fascinating and complex statements about art, the artist, and the art world. The selection of his writings presented here focuses on his comments on technique – which go far beyond technical description to encompass a moral and spiritual vision of the world and the place of the artist within it – and his views on individual artists and the nature of art. A further selection of comments on Blake is drawn from the writings and notes of creative artists, painters, writers and musicians. The final section of the book includes a chronology, a bibliography and a guide to collections holding significant bodies of Blake's works.

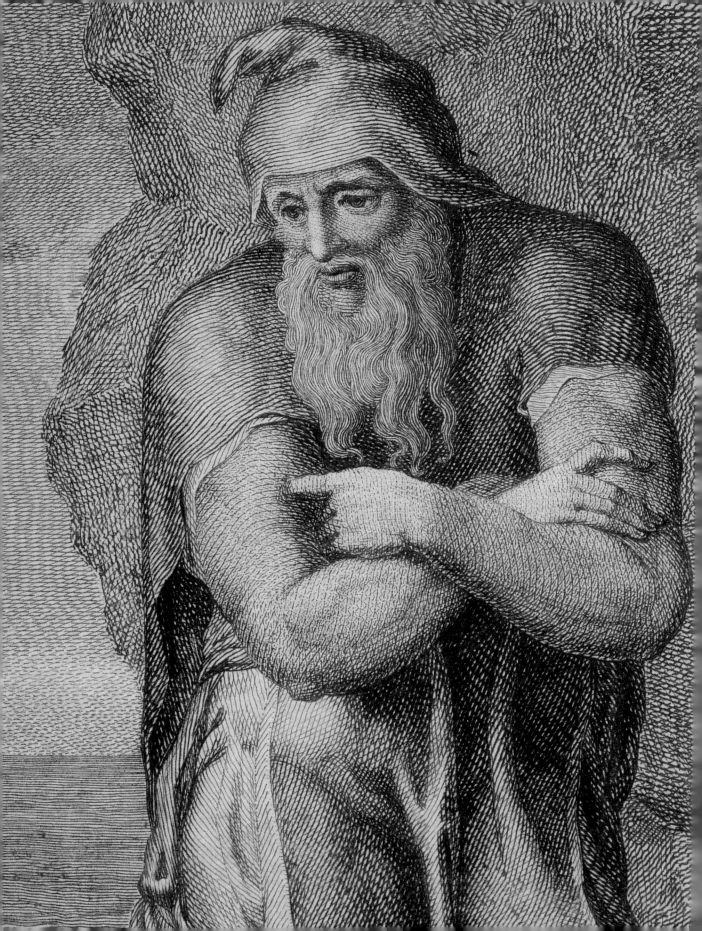

London's Art World

In 1767 a London shopkeeper called James Blake sent his ten-year-old son, William, to study at the drawing school run by the Pars brothers in the Strand. A newspaper advertisement of the time outlines the nature of this establishment:

Drawing and Modelling in all branches taught by Henry and William Pars, successors to Mr Shipley, late Register to the Society for the Encouragement of Arts &c., and other proper masters, at Mr Clarke's Great Room, near Beaufort Buildings in the Strand, where Boys of genius are frequently recommended to masters in such trades and manufactures as require fancy and ornament, for which the knowledge of drawing is absolutely necessary.[1]

As the advertisement indicates, the school had been set up by William Shipley (in 1754), with the intention of equipping youngsters with the skills necessary for employment by the manufacturers of luxury goods – textiles, furniture, ceramics and other domestic wares. These trades had in the past been dominated by foreign businesses, particularly French. Shipley's school, and the Society for the Encouragement of Arts, Manufactures and Commerce (or Society of Arts), which was set up with Shipley as a primer mover at the same time, were part of a patriotic effort to set things right. At the school, boys and girls were instructed in copying details of the human anatomy based on engraved prints, and drawing from plaster casts of antique sculptures, either whole figures or fragments. The Society of Arts, whose membership consisted of gentlemen, businessmen, professionals and a few artists, offered prizes for drawing, painting and sculpture, aimed at both the young students of Shipley's school and other such establishments, as well as more advanced artists. The hope, expectation even, was that within a few years British manufacturing would be so improved in design and technical quality that the flow of trade would be quite reversed: instead of buying imported luxury wares, British families could buy locally and enjoy the profits of a booming national export trade.

To our mind the idea that Britain's economy could be benefited quite so directly by encouraging young people to draw the human body from old plaster casts and engravings may seem quite bizarre. But Shipley and his fellows at the Society were, in eighteenth-century terms, quite conventional in believing that the study of the human body was the absolute foundation of all good design, and that the great masters of the ancient world and Renaissance had absolutely conquered this task, and so were to be copied quite laboriously. Nonetheless, the idea that the young people trained in this fashion would happily head off to work for manufacturers and industrialists did not quite hold. Many of Shipley's original students took up careers in fine-art painting and sculpture, with greater or lesser success. The first-hand accounts of his pupils suggest that the laborious training he provided was rather a

1 The Engraver's World

chore, and that they were keen to move on from dry copying to more adventurous and original activities. If parents thought they were sending their sons off to a training that would equip them with the skills for a sensible career in manufacturing, they were, more than likely, mistaken. This was quite certainly the case with the young William Blake. He was lucky, though, that his father was indulgent. Such was the young student's enthusiasm that his father reputedly bought him his own plaster casts, from which he could study at home, as well as prints reproducing paintings by the acclaimed masters of the past.

William Blake's early studies at Pars's drawing school and at the family home in Golden Square, Soho, are among the few unremarkable facts of Blake's earliest youth derived from early, and mostly reliable, biographical sources. Viewed from the vantage point that would claim Blake to be one of the very greatest British artists, this offers nothing but the most timid and humble beginnings, a proof of an instinctive talent little aided by material circumstances or personal inheritance. But while it may be only commonsensical to consider these facts as the insignificant prelude to a career of startling originality, we might then also lose sight of the historical particularity in the young Blake's vocational choices. Even a casual observer (and there is little in James Blake's professional trade as a hosier to suggest that he was anything more) could recognise that, in the first few years of William Blake's life, London's cultural scene had been swiftly, and thoroughly, reformed.

When William was born in 1757, London's art world consisted of a highly informal network of painters' and sculptors' studios, printsellers, engravers and publishers, picture traders and auctioneers. There was no official art academy, training facility, or exhibition hall. In the City, and further east around the docks, were the shops selling still lifes and marine paintings, purchased from specialist painters and kept in stock. In the City itself there were printshops and publishers, clustered particularly around St Paul's Cathedral, issuing books and magazines and single prints. To the south of the river, there were the potteries and glassworks that employed designers and modellers. In the west, around Covent Garden and Leicester Fields (now Leicester Square), were located the houses of the fashionable artists and architects of the day. Here, near the great houses of the wealthiest, the royal palaces, and the shops and theatres of the West End, were the homes of the great portrait painter Joshua Reynolds (1723–92), the landscapist Richard Wilson (c.1713–82) and the architect William Chambers (1723–96). Each had established their reputations in the previous few years, after travelling in Europe and making their names among the 'Grand Tourists' (wealthy young gentlemen sent to the Continent to finish their education and to live a little before settling down to country life). In Europe they had discovered a class of young gentlemen more committed to high culture than their fathers and grandfathers, more

ready to spend money, not on the dubious Old Masters that had notoriously been the almost exclusive focus of the British aristocracy's timid tastes, but on contemporary, British art.

In London, the artists discovered that there were exciting new possibilities, with a growing market for their productions, not just among the wealthiest of the political elite, but also men and women made newly rich by Britain's thriving economy and imperial and commercial adventures. The flourishing trade in prints (affordable by people of much more modest means) also opened up a further market, spreading the name and reputation of painters far further than could previously have been imagined. After 1760 artists had a further and highly significant outlet for their works: the annual exhibitions organised by the Society of Artists (not to be confused with the gentlemanly Society of Arts) from that year provided, for the first time, a public arena for the display of contemporary British art. To the accompaniment of (sometimes scurrilous) press coverage, itself a novelty, artists obtained fame, and sometimes fortune, on a scale never previously achieved.

These changes were not motivated by any kind of direct state intervention or patronage. In contrast to the situation in many countries in Continental Europe, the Church, monarchy and government were relatively uninvolved in cultural patronage. The backward nature of the visual arts in Britain was a well-established theme in criticism, blamed variously on the retarding effects of the religious and political revolutions of the sixteenth and seventeenth centuries, a philosophical tendency towards empiricism and commonsense rather than the imagination, the national preoccupation with making money, and even the damp climate. There had been those in the culture industries who focused their hopes on the monarchy for patronage, and the arrival on the throne in 1760 of the artistically aware George III inspired some optimism, but large-scale state support never materialised. The rapid transformation of London's art scene was related, instead, to the actions of individual patrons operating in a private capacity, groups of the artists themselves and gentlemen acting collectively, and the public at large, acting as consumers of prints and books, and as paying visitors to the exhibitions. A sense of these combined influences was captured contemporaneously by the term 'encouragement', meaning a sort of mediated form of patronage for the arts. The expectation was that the 'encouragement' offered by the Society of Arts prizes, the individual purchase of a print, subscription to a new publishing scheme, or an isolated purchase of a painting, would kick-start the development of the arts in Britain. By some uncertain process, it was hoped that, once artists had been encouraged by a prize, a one-off commission or a purchase, their material fortunes and personal fame could only grow.

'Encouragement' is a word that crops up quite often in Blake's writings on art, usually with an ironic edge: as he perceived it, the

term might be a mask for the withdrawal of long-term or substantial support for art on the part of the wealthy and powerful, and the introduction of inherently risky free-market principles into the realm of culture. 'Encouragement' was, in that sense, a euphemistic way of describing the *absence* of direct patronage in a capitalist economy. As a critic of the time remarked: 'The present improved state of painting in this country ... is more indebted to the *Engraver* than the encouragement of *the Great*' (*Daily Universal Register*, 22 May 1787).

Blake belonged to a generation that felt badly let down by the cultural establishment. Inspired to innovation, he and many of his peers became frustrated and alienated as their grandiose ideas met with incomprehension or indifference. A crucial perceived division between 'established' taste and a class of pioneering 'outsiders' supported (though barely sufficiently) by self-consciously progressive patrons began to take shape. Blake's visionary commitments may have been uniquely expressed, but they gained meaning in the context of a rapidly transforming, and in large part incoherent and incomplete, modern cultural realm.

During the years of Blake's youth, however, there was a general sense that 'encouragement' was having a material influence on artists' lives. Most prominently, in the earlier 1760s the Society of Arts had run a series of competitions for large-scale canvases representing heroic scenes from British history, and the generous top prize of £100 had encouraged some highly talented artists to compete. John Hamilton Mortimer (1740–79), one of Shipley's pupils and an artist Blake admired enormously, had in 1764 won a top prize with a massive painting showing St Paul preaching to the early Britons (now in the Guildhall, High Wycombe), a picture combining national history, heroic physicality, and primitive Christianity in a way that anticipates important aspects of Blake's art. The Italian artist Andrea Casali (1705–84) and the English painter Robert Edge Pine (1730–88) also scored prominent successes at these competitions, with paintings that treated national themes in a politically suggestive way. The Society's efforts to encourage contemporary British art, and to do so by getting painters to represent scenes from national history, was self-consciously patriotic, but here it is worth remembering that in the eighteenth century 'patriotism' was not necessarily a simply conservative political force. That was to come, and within Blake's lifetime, as discussed in Chapter Four. But in the 1760s, a period of unruly political and cultural change, patriotism was a cluster of ideas that emphasised personal independence from, and even opposition to, the monarchy and established government. 'Patriot' values were to be found among the country's citizens, at least those men whose wealth and social status secured their independence, while royalty and the state were always in danger of becoming corrupted by power and tyrannical in their manner of ruling. The narrative paintings

2
Francis Aliamet after
Robert Edge Pine
*The Surrender of Calais to
Edward III*
1762, republished 1771
Engraving on paper
The British Museum,
London

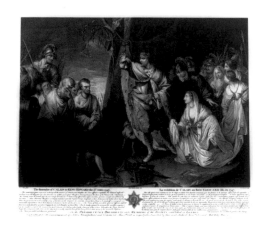

created for the Society's competitions in the 1760s tended to focus on themes that exemplified these ideas.[2] The key example here is Pine's prize-winning picture of 1760; the original painting is lost, but it was engraved more than once during the period of Blake's youth (fig.2). It shows the English King Edward III, who had triumphantly laid siege to the French city of Calais in 1347. To plead clemency, six citizens of the city offered themselves as martyrs. According to 'patriot' versions of history, the king was first inclined to put these men to death. Only the humane intervention of his queen, Philippa of Hainault, stopped him. Pine's picture emphasises the rashness and cruelty of the king, in contrast to the dignity of the men from Calais. Given that a new king, George III, came to the throne the year this painting was exhibited, and that Britain was in the midst of a war with France, this was a daring theme. Blake himself was to take up the subject of Edward III in one of his earliest known writings, a short play printed in 1783 in a little book of *Poetical Sketches* but written while he was still a teenager.[3] His 'King Edward the Third' contains a similarly explicit critique of Britain's monarchy and imperial ambitions. Loyalists claimed that Britain's imperial progress and commercial splendour went hand-in-hand with wise royal command and the extension of humane values around the world. What Pine, and Blake after him, suggested was that Britain's empire, and the men who ruled over it, were capable of cruelty, materialism and destructiveness.

By the time Blake entered Pars's drawing school in 1767, a decade of agitation and activity had established contemporary visual art as a real presence in London's cultural life. The artist appeared for the first time to have an active role to play in metropolitan culture, not merely as a servant to the aristocracy, creating flattering images of themselves and their families, their horses and land, or by working for manufacturers or creating marketable works for picture dealers and publishers, but as creative individuals whose work could incorporate complex, challenging and highly pertinent political ideas.

The Craft of Engraving

To a hopeful young man in London in the 1760s, the world of art must have appeared a realm of opportunity. The example of the older generation suggested that, for the first time in British history, it could reasonably be expected that a talented artist could piece together a decent living, and perhaps even obtain something like a fortune and some fame. There was the clear possibility, too, of producing works that were not merely trivial decorations or pandered to the tastes of individual patrons, but which had, through exhibitions and print publications, a role to play in the world at large.

The reality, however, was quite different, and for someone from a relatively modest background like Blake the idea of embarking upon a career as a creative artist was not easily contemplated. The classes at Pars's school were, as noted, intended to

produce boys ready for apprenticeship with a manufacturer or craftsman rather than artists. Even in the 1760s, a career in art was still both inherently risky, and necessarily expensive. A youth inclined to become a portrait painter should, advised a parents' guide of 1761, 'have money sufficient to enable him to subsist like a gentleman, till he can make his merit known'.[4] According to early accounts, James Blake first investigated sending his son to a painter to study after William had left Pars's school, but found that this was too expensive. He then contacted the successful engraver and publisher William Wynne Ryland (1732–83), but found that the fee for taking a student was still too expensive. In the event, Blake was apprenticed, in 1772, to the engraver James Basire (1730–1802).

Apprenticeship was the standard way in which any young man would learn a trade or profession in the eighteenth century, not just in the manual crafts, but even activities like accounting or surgery. For an initial fee, a boy, usually aged about fourteen, would be sent to live and work with an established master of the trade. The master would provide the boy with his lodgings, clothes and food, and would train him in the various skills and techniques of the trade. He became, in effect, an extra member of the master's family. The boy, meanwhile, worked full time and helped to take care of the business; he would only return to his parents intermittently. After a standard period of seven years, the apprentice, now a young man, could be expected to set up in his own right or work for a wage.

James Blake must have known that his son would get an exceptionally thorough training. Basire was, above all, a craftsman, steeped in the traditions of engraving. He was the son of an engraver, trained by apprenticeship into the profession; his son and grandson, in turn, would become engravers. The skills of the craft were not, in that respect, seen as mysterious: they were biologically predictable, and transferable. Basire was the official engraver to the Society of Antiquaries and to the Royal Society. These venerable associations of gentlemanly scholars provided Basire with a steady supply of work, engraving prints of antique objects and old buildings, scientific instruments and curiosities. This was not exactly an exciting or innovative business, but it must have suggested to James Blake that his son would be trained in a reliable trade and that the boy could expect steady employment in the future. Basire's forte was in traditional line engraving, the most technically difficult, time-consuming and aesthetically severe of printmaking methods. Later in life Blake was proud to proclaim his expertise in this field, learned in the studio of a genuine master who, in his eyes, pursued his craft with dogged sincerity, while the marketable fripperies of commercial rivals like William Woollett and Robert Strange, and indeed Ryland, proliferated (see below, pp.26–7).

Basire was not, however, insulated from innovations in the art world. He had been taken to Italy by Richard Dalton (later George III's librarian) during 1749 and 1750, and had been employed to engrave plates for James

Stuart's and Nicholas Revett's seminal *The Antiquities of Athens, Measured and Delineated* (1762–1816), a cornerstone of the revised vision of the classical world that proved so influential on artists. He was the engraver of a print reproducing *Pylades and Orestes* of 1766 by Benjamin West (fig.4), an early example of a new style of narrative painting evoking classical themes to be seen in London's new art exhibitions, and one of the first of the leading publisher John Boydell's prints to be issued after a work of a contemporary artist working in Britain. Basire was also one of the innovators of the new technique of soft-ground etching for Charles Rogers' *Collection of Prints in Imitation of Drawings* (1778), in which the novel technique was deployed to evoke completely, mimetically, the chalky textures of original drawings.

Blake's master had thus adapted his workshop to accommodate the more diverse printmaking styles of the day. As an apprentice, Blake would have been employed in preparing the tools and materials of printmaking, learning the different techniques of etching and engraving, and the precise business of printing from copperplates. He was also employed in making the drawings on which prints were based. One of Basire's major projects during the period of Blake's apprenticeship was making drawings from monuments in Westminster Abbey for publication as illustrations in antiquarian volumes, issued by the Society of Antiquaries and written by the scholar Richard Gough. A number of the series of drawings that still exist have been tentatively associated with Blake (fig.3). These drawings are initialled by Basire, and the finished prints have his name inscribed on them, but it would be normal for the master of a workshop to claim the work of his students and apprentices as his own. The scholar Joseph Ayloffe states, in the introduction to the Society's *Ancient Monuments in Westminster Abbey* (1780), that the drawings were 'taken under the inspection of Mr Basire'.[5]

These publications were part of a general re-appraisal of the 'Gothic' past during this period, which provides an important context for understanding Blake's art.[6] The earliest biographical account of Blake, published by Benjamin Heath Malkin in 1806 and presumably based on personal conversations with the artist, emphasised the importance of these youthful encounters with the previously neglected medieval monuments in Westminster Abbey:

There he found a treasure, which he knew how to value. He saw the simple and plain road to the style of art at which he aimed, unentangled in the intricate windings of modern practice ... The heads he considered as portraits; and all the ornaments appeared as miracles of art, to his Gothicised imagination.[7]

The taste for the 'Gothic' was a complex phenomenon, and we should be cautious of imagining that there is a straightforward consistency in Blake's attitudes towards medieval art throughout his life. However, the formality and simplicity of medieval sculpture was clearly an important early

3
Studio of James Basire
Side view of the Tomb of Countess Aveline
1775
Pen and sepia wash on paper
37.6 x 27.3
Society of Antiquaries, London

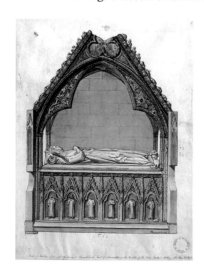

influence on the way he conceived of the human figure and its draperies. More generally, the qualities of stiffness and dry precision conjured by contemporary uses of the 'Gothic' as a stylistic term had particular value for him. 'Gothic' becomes an important word in his later writings on art.

In this respect, Basire's distinctly old-fashioned-looking work as a line engraver manifests its own 'Gothic' qualities, quite aside from the medieval subject matter that so often occupied his workshop. Basire's engraving after Benjamin West's painting *Pylades and Orestes* demonstrates the features of his style of reproductive printmaking, and can be used to illustrate the key features of the process of reproduction. This print was published in 1771, and West's original painting was exhibited at the Society of Artists in 1766 (figs.4, 5). This was one of a series of pictures on classical themes that the American-born West exhibited in London after studying in Rome between 1763 and 1764. They made his name as a painter of classical subject matter, which was drawn from ancient history and literature, and executed in a progressive style. Here, the subject is taken from the play *Iphigenia in Taurus* by the Greek dramatist Euripides. The figures are given heroic physiques and shown in noble postures, disposed carefully across the canvas on the model of ancient sculptural reliefs and, more particularly, the paintings of Nicolas Poussin, which drew on these exemplars. The narrative is communicated by the interchange of glances, and by clear gestures. The hero

Orestes has been taken prisoner with his friend Pylades, and is being presented to the priestess Iphigenia. In a moment, Orestes and Iphigenia will recognise each other as brother and sister. Each figure in this drama is crisply outlined, placed within the composition so that his status and role could be clearly comprehended.

Basire's engraving seeks to represent the overall impression and details of West's canvas accurately, in monochrome. It is important to note, however, that the print is not simply a black-and-white version of West's painting. Most obviously, the composition has been reversed; this means that the design was engraved on to the copperplate with the same orientation as the original painting. When the print was taken from the engraved plate, the design was necessarily reversed. Looking more closely, we can see that, while the forms of the oil painting are constituted through colour and tone, the engraving communicates these same forms through the medium of line. The tonal effects are conveyed by the careful arrangement of lines, which vary in direction, thickness and shape, and which, from a certain distance, blend together so they are read as a fairly solid area of tone. Lines close together will read as darker than lines far apart; lines crossing one another ('cross-hatching') will read as darker and more solid. Thus a sense of shape, volume, texture and tone is built up by the massing and arrangement of hundreds, even thousands, of individual marks.

Much of the professional pride of

4
James Basire after Benjamin West
Pylades and Orestes
1771
Engraving on paper
46.5 x 57
The British Museum, London

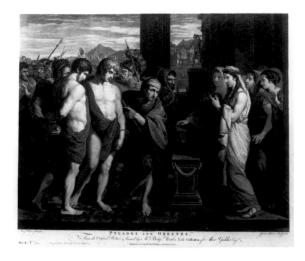

engravers derived from the fact that they were not simply copying, but translating, an image from one medium into another. This print, though, also suggests the way that issuing an image like this was a process that involved several people. Basire has signed his name at the bottom of the image, to the left. West's name is included at the right. Along with the title of the work in the middle is the name of the current owner of the original painting, Alexander Geddes, who would have given permission for this reproduction and may even have lent the work to Basire to be copied. At the very bottom there is the date of publication, and the name and address of the publisher, John Boydell. It would have been Boydell who commissioned Basire to engrave and print this plate, and who would have distributed and profited from the sale of the finished print. His name and the date are included here in order to secure his claim to copyright. The engraving of this lettering would have been entrusted to someone in the workshop, or quite possibly given to an outside specialist.

The transfer of the painted image into engraved form was more than a matter of the engraver sitting down in front of the original canvas and copying. There could be several stages involved. The engraver or publisher would probably have a reduced painted or drawn copy to work from, produced by his own workshop or by someone else for a fee. This further drawn copy would then either be traced through on to the copperplate (so that the design is reversed in the final print), destroying the copy in the process, or a tracing would be made that could be reversed on to the plate (or 'counterproved'). We can see Blake himself doing this for his print based on George Romney's lost canvas, *The Shipwreck* (figs.6, 7). He has made a tonal version of Romney's painting, on squared-up paper to help in the scaling-down of the composition. He would then have traced this drawing, and transferred the tracing on to the prepared copperplate, ensuring in the process that the design would be reversed on to the plate, so it would be printed with the same orientation as the original painting. The precise outline, thus transferred, would provide the bare foundation on which Blake worked, recreating the tonal effects and textures he had captured in his drawing through the highly conventionalised vocabulary of the engraved line.

Clearly, reproductive engraving was a highly skilled, complex and time-consuming matter. A single image would, in fact, be reproduced and changed several times, and the measure of a good engraver would be his ability to achieve in the final engraving a sense of the qualities of the original. Of course, a great deal rested on the quality of the source image, but engravers would, and did, use the reproductive process to change and even improve original designs when these were felt to be wanting. While *Pylades and Orestes* reproduces, precisely, a highly finished painting, often the engravers would have only a slight oil sketch or drawing to work from. Many comic and

5
Benjamin West
Pylades and Orestes Brought as Victims before Iphigenia
1766
Oil on canvas
100.3 x 126.4
Tate

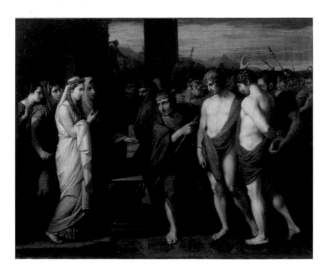

6
William Blake after
George Romney
The Shipwreck 1804
Ink and pencil on paper
16 x 19.8
The British Museum,
London

THE BLAKE BOOK

7
William Blake after
George Romney
The Shipwreck c.1805
published in William
Hayley, *Life of Romney*
(1809)
Engraving on paper
13.2 x 17.8 Tate

satirical prints from the late eighteenth century were based on designs, or even just verbal suggestions, provided by amateur artists, which needed to be actively interpreted by the printmaker. Blake himself had an experience of creating caricature prints only once, in 1784. The illustration designs for books and magazines would be created quickly as drawings, watercolours or small painted sketches, rather than fully realised oils that would be fit for public display in their own right. Blake himself often elaborated and re-organised his source matter. We know that the painter Henry Fuseli (1741–1825) trusted him enough to provide only incomplete drawings to work from, which Blake added to and refined. Blake's engravings for John Gabriel Stedman's *Narrative of a Five Years' Expedition* (1796) were based on watercolours by the author, an amateur (see pp.60–1). Paradoxically, perhaps, the engraved 'reproduction' may be more fully realised than the 'original'.

By its nature, line engraving was an expensive and time-consuming business. It took years to master the technique, and the time it took to create a single engraved plate of any ambition meant that the printmaker required considerable financial backing. Blake could report that the proofs of Romney's *Shipwreck* were completed on 23 October 1804, but even this modestly sized plate remained unfinished at the end of 1805, and was not actually published until 1809. Much to their chagrin, painters were often paid less for their original designs than were the engravers for doing the work of reproducing these images in print. The challenging nature of line engraving could be a frustration for customers as well as producers. Enterprising publishers would often open a subscription for especially ambitious prints or print series, so that customers would put down half of their payment in advance of the print being published, or even begun. The production of the plate might then take many months, even many years. The subscription process could seem like a particular swindle, and it is significant than when Blake advertised his printed works in 1793 he made a point of saying that he was not looking for subscribers (see p.165).

The Business of Print

For sound economic, as well as aesthetic, reasons, printmakers and publishers energetically explored alternatives to line engraving in Blake's time. Pure line engraving was in fact extremely rare; far more common was the 'mixed method', in which an etched line was used to set the basic design of the print, much more quickly and, arguably, more expressively than would be possible with pure engraved line. Mezzotint, aquatint, and stipple engraving were all important alternatives to line engraving, each with their own particular values, strengths and associations (see below, pp.158–9). Stipple engraving in particular emerged as a major alternative to line engraving in the reproduction of literary and historical themes. In the 1770s and 1780s

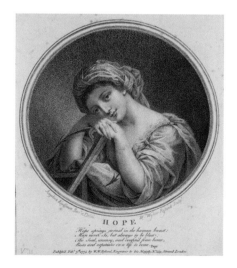

8
William Wynne Ryland after Angelica Kauffman
Hope 1776
Stipple engraving printed in sepia
22.4 x 18.5
The British Museum, London

stipple engravings flooded on to the market, the delicate tonal effects the technique created appearing peculiarly suited to lighter mythological and narrative scenes. The Italian-born printmakers Francesco Bartolozzi and Luigi Schiavonetti specialised in such works, and William Wynne Ryland's prints after the Swiss-Italian painter Angelica Kauffman (1741–1807) had particular commercial currency (fig.8). The delicate tonal and textural effects possible with stipple engraving, the use of appealingly coloured inks, and sentimental or titillating subject matter, were calculated to appeal to contemporary tastes. For high-minded critics and commentators, the market for such productions reflected a debased and effeminate modern appetite. In a scathing, unpublished poem on the art world, the 'Dunciad of Painting', written c.1783–5, about the time he first became acquainted with Blake, Fuseli wrote of the deadened emotions apparent in such prints:

Where London pours her motley Myriads, Trade
With fell Luxuriance the Printshop spread:
There as the wedded elm and tendril'd vine
Angelica and Bartolozzi twine.
Blazoned in Crystal, crowned with sculptured gold,
Imperious Fashion's central seat they hold:
Love without Fire; Smiles without Mirth; bright Tears
To Grief unknown; and without Beauty, Airs;
Celestial Harlots; Graces dressed by France;
Rosy Despair and Passions taught to dance

Irradiate the gay leaf – the charm struck crowd
Devoutly gaze, then burst in raptures loud.[8]

With these issues in mind, it may be telling that one of the very first surviving examples of Blake's art is an engraving created in a contrastingly weighty manner. This is the print later reworked and titled *Joseph of Arimathea* (see p.169). A unique impression of this print in its original state is inscribed 'Engraved when I was a beginner at Basires/ from a drawing by Salviati after Michael Angelo' (fig.9). This shows a solitary, heroically proportioned figure standing on a cliff, looking downcast and chilled. The figure itself is drawn from a detail of Michelangelo's fresco of the *Crucifixion of St Peter* in the Pauline Chapel of the Vatican (1549). Blake never went to Rome, but there were engravings of both the whole composition and of this single figure that he would have known. Though it is sometimes claimed that the present image is based imprecisely on an engraving by Nicolas Beatrizet (1507/15–65), there seems to be no good reason to doubt Blake's stated claim that it was based on a drawing. If, as appears to be the case, the print is a student exercise, it would make most sense if this was a translation into the graphic idiom of engraving of an existing drawing; this was, after all, the fundamental skill of the reproductive engraver, which Blake used repeatedly with his own or others' drawings, as we have seen. His deployment of the engraving technique in this work is starkly descriptive, with a variety of lines evoking

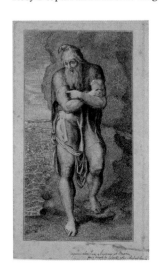

9
Joseph of Arimathea Among the Rocks of Albion
c.1773
Engraving on paper
25.8 x 14
Fitzwilliam Museum, Cambridge

the different textures and materials of the figure's skin, his costume, and the landscape setting. The overall effect is rugged, and the choice of Michelangelo as a model may be telling: he was an artist to be admired, but followed with caution, according to Joshua Reynolds in his contemporary *Discourses* (his lectures delivered to the students of the Royal Academy, 1769–90). His forms were too gigantic, his figures too extravagant, to be a safe example for the young student to follow. Yet for many artists of the time, including James Barry (1741–1806) and Fuseli, both of whom were especially admired by Blake, it was precisely this extravagance that made Michelangelo worth emulating.

If James Blake had intended for his son a solid grounding in a financially viable trade, he succeeded. The succession of homes that he set up with his wife Catherine in London, at addresses in Poland Street (1785–90), Hercules Buildings in Lambeth (1790–1800), South Molton Street (1803–21) and Fountain Court in the Strand (1821–7), with an important interlude staying in a cottage near his patron William Hayley in Felpham on the Sussex coast from 1800 to 1803, were also workshops, where he painted, drew, and engraved and printed his own works and his commercial commissions. Although there were serious reservations about Blake as a designer among his contemporaries, his engraved reproductions were well received, and his reputation as an efficient and exacting printmaker (particularly of linear designs) carried him through life. As his

friend, the sculptor, draughtsman and designer John Flaxman (1755–1826), once remarked, however, he sometimes needed to be reminded to 'condescend to give that attention to his worldly concerns which every one does that prefers living to Starving'.[9]

From the end of his apprenticeship with Basire, presumably in 1779 if he followed the standard course of seven years, Blake received a good number of commissions from publishers for engraved illustrations for books, magazines and separately published plates. Blake's engravings were commissioned on a job-by-job basis, and he was paid an agreed fee to produce a drawn copy of the original, or indeed to provide the original design himself, the engraving of the plate (with the cost of the copperplate being covered), and, if required, printing the finished design. Although from 1784 to 1785 he ran an independent print publishing firm with James Parker, another of Basire's pupils, this faltered, and he returned to working for other publishers. Unusually for an independent engraver, Blake printed as well as engraved: he seems to have kept the printing press from the partnership with Parker.

The full extent of Blake's commercially engraved works sent through this press may never be known: more than four hundred plates are known to have been executed by him during his working lifetime. There must be plates initialled or signed by him secreted away in unexplored publications, or unsigned by him and thus undetected.

At the very end of his life, in searching out proofs of his engravings for Flaxman's *Compositions from the Works, Days and Theogony of Hesiod* (1817), he discovered that several of these were unsuitable to be used: 'What Proofs he has remaining are all printed on both sides of the Paper & so are unfit to make up a set especially as many of the backs of the paper have on them impressions from other Plates for Booksellers which he was employ'd about at the same time'.[10] Given that the only documented commercial prints by Blake from that point is a handful of plates for a single publisher, Longman, these remarks may be taken to suggest that there were further, unrecorded activities even at this time.

The pace at which Blake's engravings were produced was not, though, steady. Certain publishers and individuals became important at different stages in Blake's career. In the early 1780s, his friend the fashionable painter Thomas Stothard (1755–1834) was instrumental in ensuring that so many of his designs were engraved by Blake, for a variety of different publishers. The radical publisher Joseph Johnson (1738–1809) provided Blake with much work over the years, and Fuseli often asked for his services, to the extent that Blake could despair when it seemed 'Even Johnson & Fuseli have discarded my Graver'.[11] Later in life Flaxman put Blake to work on engravings of his own designs and sent commissions from the pottery manufacturer Josiah Wedgwood and the publisher Longman in his direction. Until his very final years, when the personal support of a group of young artists, and most importantly the painter John Linnell (1792–1882), meant that he could commit much more time to his own art, Blake remained a commercially employed printmaker and printer. Whatever we make of his forthright views on art and the art world, and of his radical spiritual, political and sexual ideas, these belong in the context of his life as a craftsman, working in a city of both commercial opportunity and the economic risks characteristic of the open market.

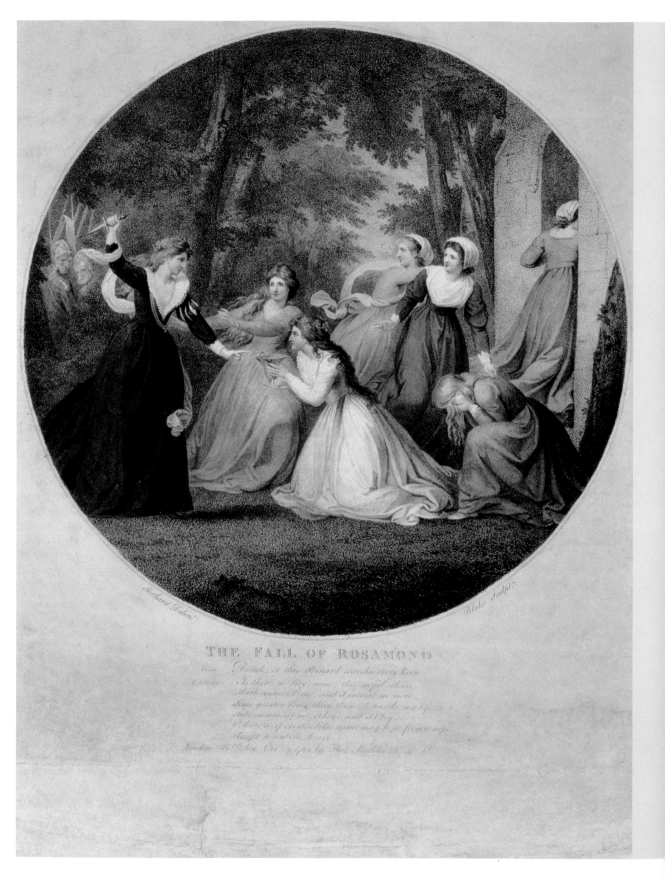

THE FALL OF ROSAMOND

The Fall of Rosamond

The commercial reality of Blake's life as a professional engraver is hard to tally with our more familiar image of him as an inspired poet and painter. But the most conventional of these commercial productions brought him greater material reward, and indeed more critical acclaim, than the illuminated books and visionary watercolours that are so admired now. For his plate of *The Fall of Rosamond*, engraved after Thomas Stothard, Blake received the substantial payment of £80 from the publisher Thomas Macklin, according to an early record. Blake expected only about a pound for individual watercolour designs, and his 'illuminated books' were first priced, in 1793, at all less than a pound each.

The subject is from a contemporary play, Thomas Hull's *Henry the Second, or, The Fall of Rosamond* (1773), based around Rosamond, mistress to King Henry II of England (1133–89), who is forced to commit suicide by Queen Eleanor. Stothard represents the dramatic climactic scene, with Rosamond about to drink the poison while the queen looms over her, dagger in hand. The engraving is executed in stipple technique, and printed in different colours ('*à la poupée*', that is, applied separately with a special leather ball to the different parts of the plate, which was then printed), and further enhanced with watercolour for decorative effect. In these qualities, and in its round format, this was probably intended to be framed and hung as 'furniture', that is, a form of wall decoration within a domestic ensemble, or held in a portfolio to be occasionally drawn out and enjoyed. It was not something to be contemplated seriously or placed in a particularly prestigious position.

For these reasons, such productions were conventionally thought of as belonging to the 'feminine' sphere of the home, in direct contrast to the high-minded and 'masculine' realm of high art. Accordingly, an essay in the magazine the *Repository of Arts* (September 1810) imagined a dialogue between a 'Miss K' and her pupil 'Miss Eve', which focused on this print:

The Fall of Rosamond, a stipple print. William Blake, *sculp*. Published by F. [*sic*] Macklin. Underneath it are these lines:

'*Queen Eleanor*. Drink, ere this poinard searches every vein.
Rosamond. Is there no pity? – None? – This awful silence
Hath answered me, and I entreat no more.
Some greater pow'r than thine demands my life.
Fate summons me – I hear and obey.

O heaven! if crimes like mine may hope forgiveness,
Accept a contrite heart!' –
HULL'S *Fall of Rosamond*, Act 5
'Fair Rosamond, daughter of Lord Clifford and mistress of King Henry II, said to have been concealed in a bower or labyrinth at Woodstock, to protect her from the jealousy of the queen, died about the year 1170. By this lady the king had two children, William Longue-espée, or Long-sword, Earl of Salisbury, and Geoffrey, Archbishop of York.
This print is solid, well drawn, and varied with much taste. How simple is the design, and yet what elegance and feeling it displays!'

As a commodity and as the imagined focus for the exercise of taste and the absorption of a historical lesson, the print is exemplary of the purported 'femininisation' of culture in the late eighteenth century. Lamented by some, applauded by others, it seemed that technological advances and changes in the market were making cultural artefacts more available to an ever wider social base. Accordingly, art and ideas were being packaged in a way that would prove more generally appealing – more decorative, more emotional, more superficial perhaps. History was no longer just a matter for upper-class men, drummed into them in the elite schools: it could be packaged in ways that were orientated to polite society at large. Thus the historical topic of Rosamond's death could be the subject of an overblown, sentimental tragedy, depicted in a pretty print that could be contemplated with pleasure by genteel young women. A sense of cultural entitlement was thus expanded to include a much wider social sector; yet many commentators, Blake included, worried that the intellectual seriousness of art was being compromised by commerce.

10
William Blake
after Thomas Stothard
The Fall of Rosamond 1783
Etching, stipple
engraving and
watercolour on paper
30.6 x 30.6
Tate

The Academy Schools

On 8 October 1779 Blake enrolled as a student at the Royal Academy's drawing schools. The Academy had been founded in 1768–9 by a group of London's leading artists with the backing of George III, following some rather ugly disagreements and secessions within the Society of Artists.[1] While that earlier artists' group had tried to be democratic in its organisation, the Academy was strictly hierarchical. There was a president (Joshua Reynolds, swiftly given a knighthood fitting such a royal position), professors, and a limited number of Academicians. The Academy held annual exhibitions of contemporary art (in which the works of the Academicians featured heavily), ran closely regulated drawing schools, and maintained a full institutional life with awards and committee meetings. The institution was set up, effectively, as a bureaucratically closed realm, which claimed authority over the art world as a whole.

When Blake joined the Academy as a student he was designated as an 'engraver'. He was among the eldest of seven young men enrolled at the schools on that day, aged between fourteen and twenty-two. Four of these were enrolled as 'painters', one as an 'architect'. It is not entirely clear what these designations meant; they presumably referred to what the student had been, and what he could be expected to be, doing during the day (drawing classes were held in the evening). It certainly did not mean that engraving was studied as a practical art within the walls of the Academy. Nor, for that matter,

was painting or sculpture, or decorative design. The absence of practical training in these arts was part of the concerted effort made by the Academy to focus on the conventional skills of 'high art', limited to drawing from the human figure. On first entry, students were admitted to the Antique Academy, where the Keeper of the Royal Academy (during Blake's time, the Swiss-born painter and enamellist George Michael Moser) would direct them in copying plaster versions of ancient Greek and Roman figures and fragments. Students were expected to look at these models in order to master an understanding of human anatomy and to gain an appreciation of how this had been idealised and put to use by artists in the past. There are several rather slight drawings by Blake that are candidates for being student exercises of this sort. Once considered properly qualified (after months or even years of study), the Keeper could agree to let the student progress to the Life Academy. Here, male and female models were posed in evening classes, supervised, more or less effectively, by a rota of Academicians. There are no records of student attendance for the period that Blake was enrolled at the Academy, conventionally a period of seven years, but we might assume that he attended the schools for at least a year or two, and perhaps up to the period he tried to establish an independent publishing business in 1784.

Two drawings identified as being by Blake appear to be products of this time, and represent posed male nudes. It is not clear whether these were produced within the

2 The Royal Academy and High Art

11
*Academy Study: A Naked
Youth Seen from the Side*
c.1779–80
Black chalk on paper
47.9 × 37
The British Museum,
London

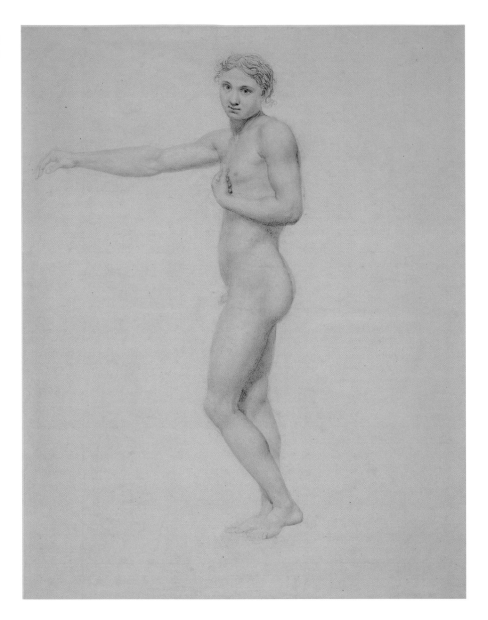

school, or during private study, and one, shown here (fig.11), has been identified as either a portrait of Blake's much-loved younger brother Robert, or as a self-portrait. Certainly, the young Blake has been more attentive to the facial features of his model than would conventionally be the case; otherwise this is a typical product of an academic training. The use of black chalk is wholly characteristic of the tradition, allowing the soft modulation of tone to create a sense of volume. The harsher, more linear forms of draughtsmanship that Blake adopted from John Hamilton Mortimer (fig.14), Henry Fuseli and James Barry, deploying pen-and-ink and watercolour washes, had no place in the Academy schools at this time.

The Grand Manner

The prolonged study of the human body at the Academy, in the idealised form of sculpture and in the flesh, was not intended to be an end in itself. While the drawing activities at Pars' school were understood to refine the young students' sense of design, in a fashion that would equip them for work in the trades, the rhetoric surrounding the Academy was focused on a self-consciously 'high' idea of art, detached from, and supposedly above, the machinations of the market. These academic exercises were meant to equip the young artist with the fundamental tools needed to execute high-minded narrative art: works in the 'Grand Manner' or 'Grand Style', as this had been defined by the theorists and pedagogues

associated with the academies of France and Italy in the previous century. These would be large-scale oil paintings based on important themes from history, the Bible or literature, in which a great idea or moral point would be communicated through the qualities and actions of human figures. The logic was that the nobler the subject and sentiments of a work of art, the more it grew in importance. The painter of still lifes, animals, landscapes, or even unidealised individual human figures, was necessarily to be ranked below the artist who painted heroic and ideal forms. That was the principle, at least: in Britain, the market supported few productions of this sort, and the prime spokesman of the Academy, Reynolds, had to acknowledge this after a fashion. In his *Discourses* he adapted traditional ideas about high art to suggest that the painter of 'lower' genres (portraiture, or even landscape) could achieve a high status if the work was endowed with a sense of dignity and grandeur.[2]

Our sense of Blake's view of the Royal Academy has been tainted by his later, scathing remarks about Reynolds scribbled into the margins of his copy of the President's *Discourses*. Here, he famously lambasted Reynolds as cynical and exploitative, and gave full vent to his frustrations with the art market. By the time he wrote these notes (thought to be some time around 1798 to 1809), there had been a long tradition of complaints about the Academy and its influence, from without and indeed within the institution. From the outset, the Academy was associated with the purportedly

12
P.A. Martini after Johann Heinrich Ramberg
The Exhibition of the Royal Academy 1787
1788
Etching and engraving on paper
36 x 48
Courtauld Institute of Art Gallery, London

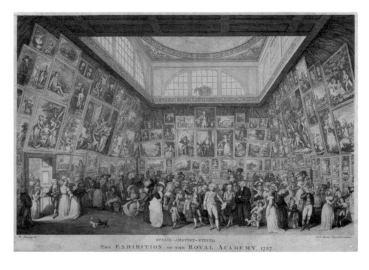

tyrannical tendencies of the King and his court. The institution's lack of pragmatism and its political bias came under attack in print, by critics and artists. The annual art exhibitions held by the Academy, at first in rather improvised settings and then, from 1780, in splendid purpose-built rooms in the newly finished Somerset House designed by William Chambers, were a focal point in the cultural calendar, drawing unprecedentedly large audiences for visual art and creating a level of critical debate that had never been seen before (fig.12). But the exhibitions were also criticised for being like commercial showrooms, and a place where artists showed off rather than aspiring to real artistic achievements; where Royal Academicians kept all the best display spaces for themselves and for their friends, and where the failings of the state to support grand art, and of the public to acquire a taste for it, were exposed in full.[3] Watercolour painters and engravers felt particularly aggrieved. While the Great Room, the main display space at Somerset House, was preserved for oil paintings (with miniatures clustered around the fireplace), works on paper were huddled away in a lower room. Traditionally, watercolour and drawing were just used as a means of preparing finished compositions, and were at that time associated particularly with amateur art activities (a burgeoning field of activity). In this age of commerce and compromise, the illusion of the integrity of 'high art' had somehow to be maintained, and persecuting engravers and watercolour painters and amateurs in this way seemed to help.

Yet Blake did exhibit repeatedly at the Academy, showing works that engaged, although not necessarily very lucidly or effectively, with the proclaimed focus of the institution on grand, narrative art. In the years following his Academic studies, we find drawings and watercolours in varying degrees of completeness showing an artist searching around for subject matter. They reflect a range of interests comparable to that exhibited in his first poetic efforts, collected together and printed in 1783 as *Poetical Sketches*, which includes poems and songs, play fragments and prose on seasonal themes, historical and biblical subjects, and allegorical and melancholic pieces. These were printed at the expense of a well-meaning patron, the Revd A.S. Mathew (1733–1824). He and his wife had been host to literary and artistic gatherings, which also included the artist John Flaxman and his wife, and which provided a platform for Blake's poetry. The art biographer J.T. Smith recalled being at Mathew's house around this time, where 'I have often heard [Blake] read and sing several of his poems', which interestingly suggests that these early poems were meant for oral presentation.[4] Although Smith also remarks that 'He was listened to by the company with profound silence, and allowed by most of the visitors to possess original and extraordinary merit', we should remember the class distinctions that divided the young Blake from his patrons. The introductory note to the *Poetical Sketches*, probably written by Mathew, apologises for its faults, on the basis that 'his talents have been wholly directed to the attainment of

13
Lear and Cordelia in Prison
c.1779
Pen and ink and
watercolour on paper
12.3 x 17.5
Tate

excellence in his profession' (that is, engraving). Blake's poems were being viewed, then, as the leisure-time activity, or hobby, of a working man. Referring to the publication in a letter to Blake's future patron the poet William Hayley (1745–1820), Flaxman added that 'his education will plead sufficient excuse to your Liberal mind for the defects of his work'.[5]

In 1780 Blake had shown a drawing of a subject from medieval British history, *The Death of Earl Goodwin*, at the Academy (lost, but known from a preparatory drawing), and the surviving watercolour of *Lear and Cordelia in Prison* dates from around the same time (fig.13). This tiny, rather awkward design shows a scene taken not from William Shakespeare's play but from Nahum Tate's more sentimental version of the text (1681), which was the only form in which the play was performed in eighteenth-century theatres. Blake has followed the stage directions quite closely: the ancient British king lies sleeping in prison, while his rejected daughter Cordelia laments his fate and the terrible errors he has made. Compared to the contemporary work of some of the older artists Blake admired, this is a singularly timid treatment of the subject. Lear was a key subject in art of the time, painted by Barry, Fuseli, Benjamin West and Mortimer, among others: their paintings and designs treated Shakespeare's play as a form of read literature, rather than theatre, depicting the landscapes and characters that could be imagined in the mind's eye rather than conceived on the relatively placid form of the eighteenth-century stage. Mortimer's depiction of Lear as a primal, white-bearded heroic figure among a series of Shakespearean heads published as etchings in 1775–6 was particularly influential (fig.14). This conception was elaborated by James Barry in paintings exhibited in 1776 (at the Academy) and in 1789 (at John Boydell's commercial Shakespeare Gallery, fig.22), and variations on this character figured repeatedly in Blake's own art, informing his own original conception of the bearded patriarchal figure of Urizen (see figs.1, 50). These treatments of Shakespeare's characters were tailored to the taste for the new aesthetic of the 'Sublime', the idea that awesome, terrifying or wild scenes could be a source of pleasure, crystallised by Edmund Burke's influential *A Philosophical Enquiry into the Origins of Our Ideas of the Sublime and Beautiful* (1757).

The composition for *The Penance of Jane Shore* (fig.15) was originally conceived around this time in sketch form. The more finished watercolour shown here is presumed, on stylistic grounds, to date from much later, around 1793, the time that Blake either planned or executed a series of engravings of British historical subjects that he listed as being for sale in that year. But when Blake exhibited this watercolour as part of his one-man exhibition in 1809, he stated that 'This Drawing was done above Thirty Years ago, and proves to the Author, and he thinks will prove to any discerning eye, that the productions of our youth and of our maturer age are equal in all essential points'.[6] The painting shows a clear debt to the sorts of

14
John Hamilton Mortimer
Lear
1776
Etching on paper
40.4 x 32.6
The British Museum,
London

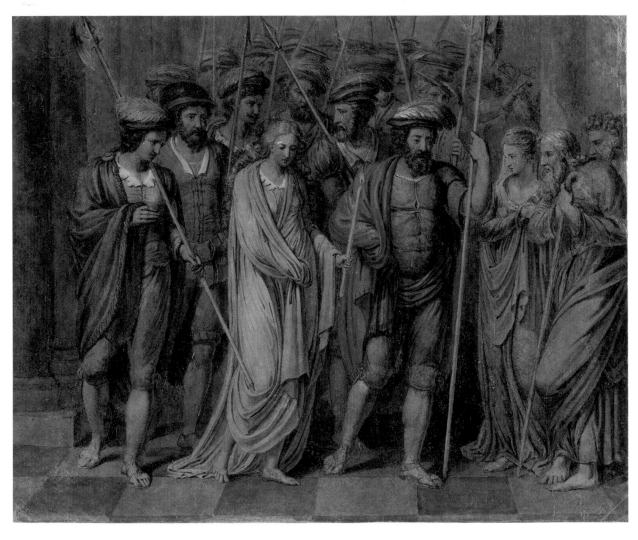

15
The Penance of Jane Shore
c.1793?
Pen and watercolour on
paper
24.5 x 29.5
Tate

restrained narrative scenes produced by the prominent painters of the 1760s and 1770s, Robert Edge Pine, Mortimer and West. Like the works of the first two artists, the subject has a political edge. Jane Shore was the mistress of Edward IV, who, after the King's death, was cruelly thrown into prison and accused of immorality by his successor (later Richard III). Blake shows her being paraded through St Paul's Cathedral in London, wrapped in a white sheet. The political message about the potential cruelty of the Establishment is clear, and connects to the 'patriot' criticisms of monarchy that circulated in the 1760s and 1770s.

Blake's Academy exhibits for 1784 and 1785 show him moving in new directions, and away from the direct illustration of historical or literary themes. In 1784 he showed two watercolours at the Academy, titled *A breach in a city, the morning after battle* and *War unchained by an angel, Fire, Pestilence, and Famine following*. Blake returned to these subjects several times over a period of at least three decades, each time changing details and style; the dating and sequence of these works has exercised a number of Blake scholars. The design of *Pestilence* illustrated here probably dates from around the mid-1780s (fig.16). Although such subjects have been related to the political travails of the period – the violent anti-Catholic Gordon Riots that rocked London in the summer of 1780 and the terrible, widely regretted and drawn-out war with revolutionary America (1775–83) – Blake has not endeavoured to create a sense of a concrete place. The costumes are generically 'historical', and the architecture is evidently classical, although whether the setting is meant to be ancient Greece or Rome, some biblical city, or, indeed, seventeenth-century London (thus evoking the Great Plague of London of 1665), cannot be ascertained.

In a much gentler mode, the subject of *Age Teaching Youth* (fig.17) is similarly uncertain in its significance. As is often the case with Blake's watercolours and individual designs, the modern title is derived from the list of Blake's works drawn up by William Michael Rossetti (brother of Dante Gabriel Rossetti) and included as an appendix to Alexander Gilchrist's biography (1863, republished 1880). Though the title has stuck, it was not Blake's, nor can we be certain that it conveys Blake's intentions. The dating of c.1785–90 has been asserted on stylistic grounds, on the basis of comparison with other works by Blake. An old man in white sits and presents an open book to a small child, either a girl or a feminine boy, who points up to the sky. Another, apparently slightly older and more certainly male, child sits before them, engrossed in his own book. We are left to wonder at the significance of the scene and, armed with knowledge of Blake's later poetic and visual conceptions, we may be tempted to elaborate from it an intricate narrative about the authority of the text and of bookish learning, the impulsive preference of nature over scholasticism. Blake certainly expressed a dislike of bookish learning in his poem 'The Schoolboy', included in his *Songs of Innocence* (1789) ('Nor in my book can I take delight'). If such designs were by another (perhaps any other) hand, we would be

unlikely to expend such efforts on elaborating a meaning for this image.

In 1785 Blake exhibited at the Academy a series of three highly finished watercolours of scenes relating to the life of Joseph, as described in the Book of Genesis. These are still clearly related to the Grand Manner style that dated back to the 1760s, but tend towards a more artificially arranged composition and a daring use of odd figural treatments and narrative effects. Where West or Mortimer had presented their figures with naturalistic proportions, and artfully arranged their compositions to suggest a degree of naturalness, avoiding a too-stark sense of symmetry or artificial repetition, Blake's designs actually emphasise these qualities. In *Joseph's Brethren Bowing Before Him* (fig.18), Joseph turns away, holding up his cloak to mask his face from his brothers, who are arranged to the left. Joseph's heavily cloaked right arm takes the shape of a crescent that evokes only inexactly the anatomy beneath; the cloak that falls from his left shoulder takes the form of a corresponding crescent again with less regard to naturalism than to the abstract principle of design. The brethren are neatly aligned. In the space between them we see the naked back of a servant girl, holding a barely described platter above her head, her arms neatly arranged. Her form, taking the shape of a stunted trident, fits neatly between Joseph and his brothers. The 'intervals' (the shapes created in the spaces between forms) either side of this figure are nearly symmetrical.

The prompts for these developments in Blake's art can be found in two slightly older artists whose reputations were made in the years of Blake's apprenticeship and time at the Academy. The first of these was James Barry.[7] In the 1770s he had made a name for himself as a painter of the most challenging and serious classical themes, quite without regard for market conditions. Accordingly, he had been made one of the very first new members of the Royal Academy, and in 1782 (when Blake would still have been entitled to attend the Schools and the lectures) he was made Professor of Painting. This came at the time he completed work on a series of grand murals for the Great Room in the new offices of the Society of Arts, in the Adelphi complex off the Strand. These were meant to encompass the whole history of human civilisation in the form of allegorical scenes. Although very widely admired, there was also a great deal of confusion about the meaning of these paintings; Barry felt obliged to publish a densely written and lengthy pamphlet trying to explain his symbolism.

Barry was a highly significant figure for the generation of young artists who came to maturity in the 1770s and 1780s. He was outspoken and forthright in his dedication to the cause of high art, to the point that he appeared ridiculous and was even rumoured to be mad. The murals for the Society of Arts were undertaken on the basis that the Society would provide him with materials and no other finance. He apparently lived in poverty while he undertook the scheme, living, according to Blake's own notes, on a diet of bread and apples. The style of his pictures was

16
Pestilence
c.1780–4
Pen and ink and
watercolour on paper
18.5 x 27.5
Collection of Robert
N. Essick, Altadena,
California

17
Age Teaching Youth
c.1785–90
Pen and ink and
watercolour on paper
10.8 x 8
Tate

unremittingly high-minded; his heroic figures have huge barrel chests, and his female figures are fleshy and improbably perfect in their roundness. They are arranged in shallow spaces, composed for abstract impact rather than to create a sense either of simple naturalism, or of conventional theatricality. The space of Barry's painting is emphatically idealised, in which superhuman characters interact, and where conventional iconography seems too limited, the artist claims the right to invent for himself. Barry notoriously improvised the iconography of the scene celebrating Britain's naval achievements. In this scene, a massive Father Thames reclines on a shell pushed through the waters by rubbery limbed water nymphs, who are accompanied, bizarrely, by recognisable figures from British history, including, most obscurely, the musicologist Charles Burney (fig.19). Importantly, Barry undertook to rework and revise the imagery of his murals through self-published prints, issued in the 1780s and reworked several times over the next years. These prints, created using a highly original combination of printing techniques (Barry was untrained in engraving), were an important precedent and model for Blake's adventures in original printmaking. The rugged physicality of these productions, the unpredictable way they were reworked and revised (meaning there was no single, standard impression), their daring and strange imagery and compositions, and the bold and abstracted physicality of the designs, informed and provided a context for Blake's innovations of the later 1780s and 1790s.

Barry's character was important too. He came from an undistinguished family and, as an Irishman and a Catholic, faced a great deal of prejudice among critics and commentators. He had a reputation as a republican, and repeatedly criticised the cultural establishment until, in 1799, he was expelled from the Royal Academy. For all these reasons, Barry was, for Blake and for many others who made claims to idealistic hopes for British culture, an exemplary figure: the artist who, in dedicating himself to the cause of high art and pursuing his highly individual aims, was forced into martyrdom.

However, the fact that Barry was acclaimed by and prospered within the Academy until his expulsion in 1799 demonstrates that we should be careful of assuming that Blake's later, bitter views were held throughout his career. While Blake was being formed as an artist, the Academy still promised to be a reforming, even pioneering, institution. The same point could be made with reference to the career of the second pivotal influence on Blake, the Swiss-born painter Henry Fuseli.[8] Their friendship and the intimate relationship between their art was the subject of early anecdotes. According to the painter George Richmond, 'Fuseli admired Blake very much. The former when Blake showed him a design, said – "Blake, I shall invent that myself", while Fuseli supposedly declared that 'Blake is d…d good to steal from.'[9] It is now generally appreciated that the pictorial debt was largely the other way round, with Blake borrowing and adapting from the older artist; as the chronology and nature

18
Joseph's Brethren Bowing Down Before Him
c.1784–5
Indian ink and watercolour over pencil on paper
40.3 x 56.2
Fitzwilliam Museum, Cambridge

of Fuseli's art continues to be refined, the evidence for this will doubtless increase. Although the association between these artists is widely recognised as significant, the depth of Blake's debt to Fuseli is probably still underestimated.

Fuseli established a reputation in the 1780s as the most challenging painter of literary and imaginative themes, with a particular strength in the representation of supernatural and horrible subjects. He painted the most brutal and terrible subjects drawn from ancient literature, Shakespeare and John Milton, in an attempt to visualise primal physical dramas and wild imaginings that would be associated, not necessarily in a philosophical way, with the aesthetic category of the Sublime (fig.20). The dramatic physical forms of Fuseli's figures, derived from Michelangelo and Mannerist artists, with their skintight costumes – so often, anachronistically, evoking the visual effects of cycling shorts! – hugely exaggerated gestures and wild expressions, are the model of Blake's own figural style when it achieves maturity. When Samuel Taylor Coleridge later viewed Blake's designs and complained of the 'ambiguity of Drapery. Is it a garment – or the body incised and scored out?', he was making a complaint against the ambiguity inherent in the 'Fuselian' manner of designing.[10]

Further aspects of Fuseli's art in the 1780s deserve particular attention for their influence on Blake's work. In the early 1780s he exhibited and published prints of medieval subjects that he had invented himself. As Fuseli later acknowledged, these images represented 'philosophical Ideas made intuitive, or Sentiment personified'.[11] The idea that the artist could abandon existing literary sources and invent his own universe of characters in order to represent essential values or ideas, was highly significant to Blake when he came to develop his own poetic world. As Christopher Heppner has noted in an important commentary on this point, Fuseli elaborated this strategy into a whole theory of art via his Academy lectures, but did not follow the possibility through fully in his art, fearing that it could become simply incomprehensible. After the experiments of the early 1780s, he stuck to painting characters from existing literary sources, although these were often so obscure that they might as well have been invented.[12]

Fuseli did, however, create a number of pictures that do not directly illustrate the action of the literary source material, but which embody a fleeting metaphor or simile within a poetic text. The key example here is *The Shepherd's Dream* (fig.21) exhibited as early as 1786, which is based on Milton's *Paradise Lost* (1667). It does not represent anything that actually happens within the poem, but rather the image the poet evokes when describing the swarms of demonic figures in Pandemonium. Milton compares this 'aerie crowd' to the 'Fairie Elves,/ Whose midnight Revels, by a Forrest side/ Or Fountain some belated Peasant sees'. In this, Blake anticipates the 'literalization of figuration', a phrase that the Blake scholar Robert N. Essick has coined to describe the key strategy in Blake's later works, wherein he 'grants substantial being to

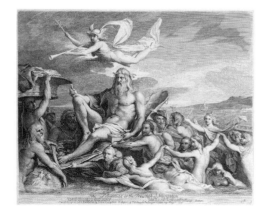

19
James Barry
The Thames, or the Triumph of Navigation
first published 1792
Intaglio print on paper
45.7 x 56.2
Tate

what we would usually take to be only a figure of speech'; metaphors are taken as literal events, confounding 'Our usual distinctions between literal and figural, the substantial and the conceptual'.[13]

But if some key starting points for Blake's art and poetry can be found in Fuseli's work from the 1780s, there is a world of difference between these two men. A sceptical, widely read intellectual with a university education and prolific skills in ancient and modern languages, Fuseli ingratiated himself into the advanced literary circles associated with the publisher Joseph Johnson in London. He was, significantly, a frequent contributor of essays and reviews to Johnson's periodical *The Analytical Review* (first published 1788), a journal which, as the title suggests, pursued forms of philosophical rationalism and argument, views that were entirely alien to the lower middle-class, deeply Christian Blake. If Fuseli and Blake adopted comparable strategies in their art, there were fundamental differences in their social status, material resources and personal profile, which meant that their fortunes were quite different.

The Artist and the Market

In other circumstances, Fuseli and Barry might have given up art or turned to some more rewarding genre, had they the skills to do so. But market conditions and critical opinion conspired to validate their eccentricities. The print market provided new opportunities for money-making. The official print after Fuseli's famous painting *The Nightmare* (exh. RA 1782; Detroit Institute of

20
Henry Fuseli
Oedipus Cursing his Son, Polynices
1786
Oil on canvas
149.8 x 165.4
National Gallery of Art, Washington, Paul Mellon Collection

Arts) reputably earned the publisher £500, and the painter was careful in future to keep a closer hold on the publication of his images so he could benefit more directly. Despite his protested poverty, Barry was just about able to survive on the income he received from his post as Professor of Painting at the Academy, and through sales of his prints. The public art exhibitions provided an unprecedented opportunity for artists to make their names with the larger public who, even if they had neither the means nor the will to purchase original oils, might pay out occasionally for an engraving. Meanwhile, these artists obtained friends, and thus emotional and (more rarely) material support among a new breed of collectors drawn from the educated middle classes. A self-consciously liberal cultural elite was taking shape in London's drawing-rooms, coffee shops and bookstores, which was able to sustain a few artists who temperamentally and aesthetically seemed quite at odds with the wider marketplace.

The changing nature of the market for art was exploited in a particularly notable way in the later 1780s and 1790s by enterprising print entrepreneurs. During these years, a succession of gallery projects was set up by print publishers and artists, each promising to present a series of specially commissioned paintings based on established sources, including Shakespeare (in the first of these schemes, initiated by John Boydell, and in a later project set up in Dublin and moved to London by James Woodmason), David Hume's *History of England* (1754–62), the Bible, English poets and John Milton (an ill-fated one-man

show from Fuseli).[14] The plan with each of these was to exhibit the paintings for a number of years, thus stirring up critical interest and attracting subscriptions for the series of prints and luxury printed editions that would form the climax of the scheme. These projects promised to initiate a patriotic revival in the arts, contributing the patronage that had been missing in the absence of strong state or church support for the visual arts. For the painters and printmakers of the time, these schemes offered lucrative sources of income. Painters jockeyed for the attention of these patrons, seeking to outdo each other in their productions. Even the most high-minded and apparently exclusive of painters, including Barry, received commissions (fig.22).

Blake must have hoped that he would have been among the beneficiaries of these schemes. It may be no coincidence that he undertook several Shakespearean watercolours around this time (fig.23). In the event Blake was not employed as a designer by Boydell or the other print publishers, and he contributed only one small reproductive plate to Boydell's Shakespeare scheme; he did, though, receive an important commission from Boydell around this time, to engrave on a large scale William Hogarth's painting *The Beggar's Opera* (1729). This, Blake's largest and most ambitious reproductive plate, appears to have been commissioned as a separate project by 1788, although the finished plate was printed and bound with Boydell's new edition of Hogarth's works in 1790 (fig.24). It is not known how much he received for this work, but it could be assumed to have been a three-figure sum (this

21
Henry Fuseli
The Shepherd's Dream
1785–6
Oil on canvas
154.3 x 215.3
Tate

was the sort of figure Boydell paid to engravers working on comparably sized plates for his Shakespeare Gallery).

Blake was conscious that, even as the publishers flourished, his own prospects did not look good. His highly original innovations in printmaking appear, in this context, as an attempt to find a way of capitalising on the burgeoning market for art, while maintaining his intellectual and material independence. As early as around 1784 or 1785, when he wrote his fragmentary satirical play known as 'An Island in the Moon', he was able to present a comically overblown idea for self-publication (see p.160), most probably a scheme conceived by George Cumberland. It seems likely that Blake himself was venturing to produce some kind of original illustrated poem only shortly afterwards. From this date we have a manuscript poem, 'Tiriel', which was unpublished in Blake's lifetime, and a record of a set of twelve wash drawings to accompany it, nine of which are known to survive (fig.25). The format and scale of these drawings match up; their relatively detailed treatment, and the fact that they are monochrome, make them eminently suitable as models for engraving (to be traced and counterproved like Blake's monochrome sketch of George Romney's *The Shipwreck*, fig.6). This uniformity in Blake's designs, and the fact that the poem exists separately in manuscript, suggest that he planned to have the poem set in conventional type, and print the illustrations separately; the designs would have fitted quite neatly into a landscape-format folio page. As with the published plates of commercial schemes like Boydell's Shakespeare Gallery, we might assume that they would have been engraved as single sheets, and also incorporated into a large-format, luxury edition of Blake's poem. Although we know that Blake had his own printing press, and so would have been able to print the plates separately, he did not have the facilities to print the text of the poem in the conventional manner.[15] He would presumably have needed to go into partnership with, or sold the copyright to, a publisher, to achieve this.

Although some of Blake's designs, such as that of *Tiriel Supporting the Dying Myratana and Cursing his Sons* (fig.25), can be related very closely to specific lines in the poem, others seem to represent scenes not literally represented in the text, or to add to or elaborate on suggestions contained therein. From this opening, dramatic scene, where Tiriel calls his three sons to the palace to witness the death of their mother and his queen, Myratana, Blake's poem elaborates a series of wild incidents. In a bleak and blasted fantasy landscape, Tiriel undergoes a series of travails and confusing encounters. The overall style and character of the poem have been related to the poetry and prose-poems associated with the supposed ancient Gaelic Bard Ossian. They had begun to be published in the early 1760s by the Scottish teacher and poet James Macpherson, who claimed that they were translations of ancient Gaelic originals.[16] The poems were acclaimed for their primitive aesthetic qualities, which conformed to the most stringent ideals of the Sublime. They conjured scenes of bleak wildernesses, heightened emotions and epic violence

22
James Barry
King Lear Weeping over the Dead Body of Cordelia
1786–8
Oil on canvas
269.2 x 367
Tate

23
Oberon, Titania and Puck
with Fairies Dancing
c.1786
Pencil and watercolour on
paper
47.5 x 67.5
Tate

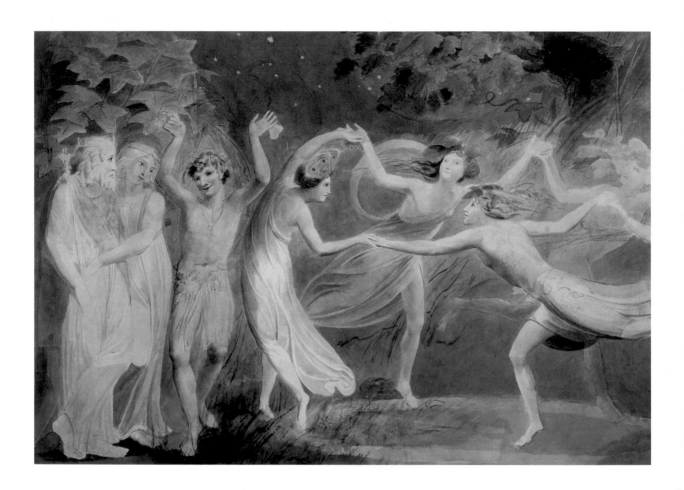

through an abrupt, fragmented and imagistic, rather than descriptive, use of language. Although hugely popular, suspicions were raised early on that they were frauds. In notes written in the margin of his copy of William Wordsworth's *Poems* (1815) where that poet dismissed Ossian as 'spurious', Blake stated, 'I believe both Macpherson & Chatterton, that what they say is Ancient, is so', thereby joining the Scottish author to the youthful Bristol poet Thomas Chatterton (1752–70), who had created popular forgeries of early English poetry.[17] By this time Macpherson's fraud had been revealed to the satisfaction of most observers. What Blake suggests is that, in grasping elemental poetic truths, Macpherson had created a work of art that cannot be judged by the standard measures of credulity or historical authenticity. This was a claim that is vital to our appreciation of his own works.

The illustrated poem 'Tiriel' is not, though, a simple exercise in pastiche. It has also been called 'a full-fledged Greek tragedy', closest to Sophocles's *Oedipus at Colonus*, a relatively obscure text which had been illustrated by Fuseli (fig.20). David Erdman argued that 'Tiriel' needs to be interpreted as an allegory of current historical events. The themes of monarchical madness, tyranny and rebellion in the poem appear to connect it with the recent American Revolution and George III's mental illness, which became a major public crisis in 1788–9. This latter event has led to the poem being dated to that point. 'Tiriel' is, however, based on literary and visual precedents that had currency before

these events, and the drawings could also be dated somewhat earlier on stylistic grounds.

Blake's 'Tiriel' has not received the same level of intensive scholarly interest as his other poems, and the illustrations – 'something of an exception to Blake's usual fine craftsmanship'[18] – have not been considered in depth. But they suggest both where Blake was coming from, and where he was going. They lay claim to the sort of imaginative inventing that Barry and Fuseli had undertaken in the preceding years in the visual arts, and the literary liberties claimed by Macpherson: the right of the artist to draw freely on existing literary resources, but to interpret, extend and add to this repertoire of themes and ideas – and indeed, names – if he so wished. Their format indicates that Blake was by the late 1780s ambitious to become a self-publishing artist, as Mortimer had been with his *Shakespearean Heads* and Barry had been with his strange prints (figs.14, 19). The revolutions that took place in the next few years, both global and highly personal in Blake's case, ensured that this was to be the case, but in a form that perhaps no one could have easily predicted.

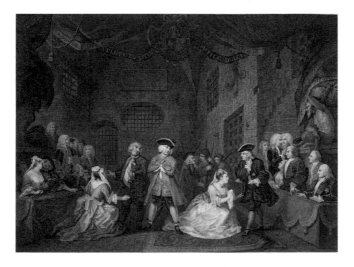

24
William Blake after
William Hogarth
The Beggar's Opera, Act III
c.1788, published 1790
Engraving on paper
40.1 x 53.7
Tate

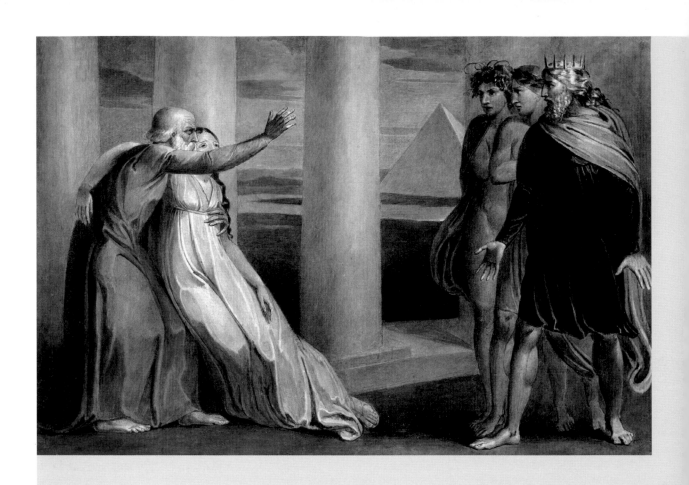

Tiriel Supporting the Dying Myratana and Cursing his Sons

Blake's poem 'Tiriel' concerns the elderly, mad former ruler of an unspecified ancient kingdom and his sons. The poem opens abruptly, with Tiriel displaying his dying wife to his sons, and cursing them for their ingratitude. They had deposed him in the past, and he now faces a lonely and impotent future. For their part, they assert that his rule was cruel, and they have had to win their freedom by rebelling against him.

This is the scene illustrated by Blake. The costumes might suggest a medieval and northern setting, but the columns appear starkly classical and a pyramid features prominently in the background. Blake's design can be related in some detail to the action of the poem. The three sons have just arrived at the gates of the palace, brought there by Tiriel's summons. The eldest, bearded son speaks (his mouth is open and his right hand is shown palm out, to indicate this); Tiriel responds, holding his right hand up and supporting his dying wife with his left.

As so often with Blake's designs, the imagery of this drawing has been related closely to the highly personal symbolism that he developed in his later poetry, on the assumption that there is a career-long, systematic consistency in his thought. In this case, the fact that the eldest son wears a crown means that he is interpreted as an allegorical representation of 'material power'. The bay or laurel leaves that dress the second figure's hair are taken as symbolising poetry; the curling forms in the hair of the figure on our left are interpreted as vine leaves, associating him with wine and thus physical pleasures. Given Blake's later statements regarding the allegorical interpretation of his images (notably in his text on the lost painting of the *Ancient Britons*, see pp.174–6) such speculation can be justified, although whether we should further claim that the series forms a systematic symbolic representation relating to the theme of tyranny that becomes a later poetic preoccupation in the figure of Urizen is open to dispute.

From William Blake, 'Tiriel' c.1785–9
And Aged Tiriel. stood before the Gates of his beautiful
 palace
With Myratana. once the Queen of all the western plains
But now his eyes were darkened. & his wife fading
 in death
They stood before their once delightful palace. & thus
 the Voice
Of aged Tiriel. Arose. that his sons might hear in
 their gates.

Accursed race of Tiriel. behold your father
Come forth & look on her that bore you. come you
accursed sons.
In my weak arms. I here have borne your dying mother
Come forth sons of the Curse come forth. see the
 death of Myratana.

His sons ran from their gates. & saw their aged parents
 stand
And thus the eldest son of Tiriel raisd his mighty voice

Old man unworthy to be calld. the father of Tiriels race
For evry one of those thy wrinkles. each of those grey
 hairs
Are cruel as death. & as obdurate as the devouring pit
Why should thy sons care for thy curses thou accursed
 man
Were we not slaves till we rebeld. Who cares for Tiriels
 curse
His blessing was a cruel curse. His curse may be
 a blessing

He ceast the aged man raisd up his right hand to
 the heavens
His left supported Myratana shrinking in pangs
 of death
The orbs of his large eyes he opend. & thus his voice
 went forth

Serpents not sons. wreathing around the bones
 of Tiriel
Ye worms of death feasting upon your aged parents
 flesh
Listen & hear your mothers groans. No more accursed
 Sons
She bears. she groans not at the birth of Heuxos
 or Yuva
These are the groans of death ye serpents These
 are the groans of death

Nourishd with milk ye serpents. nourishd with
 mothers tears & cares
Look at my eyes blind as the orbless scull among
 the stones
Look at my bald head. Hark listen ye serpents
 listen ...

25
*Tiriel Supporting the
Dying Myratana and
Cursing his Sons*
c.1785–90
Pen and grey wash on
paper
18.6 x 27.2
Yale Center for British Art,
New Haven

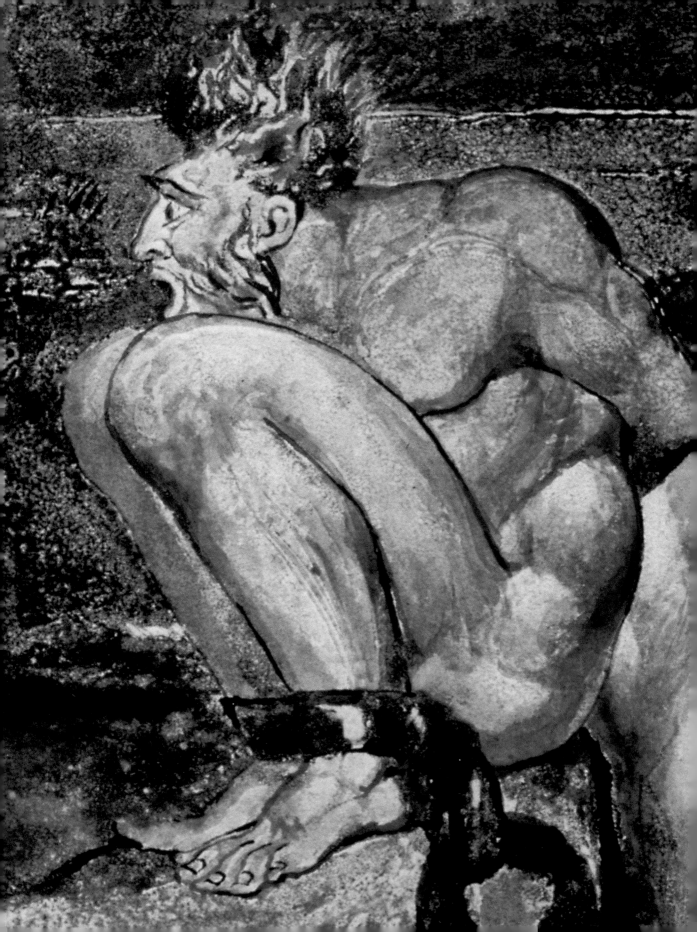

The Age of Revolution

Britain was involved in international wars for half of the seventy years of Blake's life. The Seven Years War (1756–63) pitched Britain against France and Spain in a vast, truly international conflict. While this established British naval power around the world and helped consolidate a powerful sense of unified national identity, the expensive and bloody American wars (1775–83) created an enormous national trauma. While previous wars had been conducted against the traditional enemies of France and Spain, who, in their Catholicism, political systems, language and, at least reputedly, morality, could be safely viewed as alien and despicable and therefore deserving everything they got, here was a war against people who were in their race, language, Protestant faith and moral values so like the British themselves. The vital influence of this conflict on Britain's culture and identity, and the material repercussions of this long and unhappy war, are still be actively explored by historians. The even longer and greater wars with Revolutionary and Napoleonic France (1793–1815) were a vast strain on Britain's economy, and led to fearful political oppression within the kingdom and a more definite, restrictive sense of 'patriotism', which was deeply conservative, loyal to the king, and nostalgic. A kind of enforced consensus about Britain and its identity emerged in these years, which exerted a powerful influence over the arts.

Blake was still a small boy when the Seven Years' War ended, but its impact on the culture he grew up in was momentous. The triumphant progress of Britain's forces (at least in the latter part of the war, after 1759) created a general sense of optimism about Britain's future, and led to calls that this success should be matched by equally forceful endeavours in the realm of culture. It is no accident that the great efforts of the Society of Arts, and the formation of the Society of Artists in 1760, and various public exhibitions, belonged to these years. Yet the hopes that the new king would lead Britain to a golden era of cultural enlightenment soon turned sour. There was widespread criticism of the new regime, with claims that George III was becoming tyrannical. By the time Blake became a pupil at Pars' school in 1767 there were major rifts in British political life, which became focused on the controversial political figure John Wilkes, who declaimed against corruption in public life. The Royal Academy was founded in the midst of open opposition to the king, coming not least from an increasingly articulate commercial middle class, who feared that their interests were not well represented by the state.

By the time Blake enrolled at the Academy schools in 1779, Britain was embroiled in war again, now with the American colonies, who were, arguably, asserting the sort of political independence from the king and his government that Britons themselves had enjoyed in former times. When the Spanish and French joined America as allies, Britain's fate was sealed. The war limped on miserably until an embarrassing admission of defeat in 1783. These years had divided Britons.

3 Blake's Revolution

Loyalists saw the conflict as an unjust rebellion; many more thought that it was an ugly civil war, or even righteous opposition to a tyrannical government. There was poverty and strife at home, which could be blamed on a thoroughly misguided war effort. In order to bring in the support of Catholic Canadians against the Americans, a parliamentary act was passed in 1778 giving Catholics a few more rights than they had historically been allowed by the British state. The response was a mass campaign, culminating in riots in the summer of 1780. The Gordon Riots – so-called after the leader of the Anti-Catholic movement Lord George Gordon – shook London for six days in June of that year. Blake himself appears to have been a witness, being swept up in the crowd and seeing the most shocking event of the riots, the breaking open of Newgate Prison. Although a sign of ugly bigotry, these disturbances could also be interpreted as a citizenry asserting its liberties against a decadent and unprincipled establishment. For a generation or more, the Gordon Riots provided the archetypal images of revolution. The themes of conflagration, mob rule, chaos and violence that Blake had seen in person in the summer of 1780 hung over his work from this point. The origins of Blake's image known as *Albion Rose* (fig.27) have been traced to his experience of this moment, and the uncoloured impression of the image is signed by him with that date.

Initially, news of a revolution against the king and state in France in 1789 was greeted enthusiastically in Britain. Many saw it as a popular uprising, a righteous assertion of liberty against tyranny, similar to the peaceful political revolution in England in 1688. But news of atrocities, terrible economic suffering and virulent political radicalism that went beyond traditional ideas of personal liberty to insist on the equality of all people, raised greater fears, crystallised by Edmund Burke in his *Reflections on the Revolution in France* (1791). Sensationalist and powerful, Burke's book conjured the spectre of an uncontrollably bloody revolution that threatened to overturn the established order in all of Europe and destroy all distinctions of social class, rank and gender. With the execution of France's king, Louis XVI, and the declaration of war against revolutionary France in 1793, British supporters of the Revolution were thrown under ever-greater suspicion. The Prime Minister, William Pitt the Younger, introduced stringent anti-terror laws, leading to arrests and a prevailing sense of paranoia.

Blake's personal sympathy for the American and French revolutions is beyond doubt, insofar as these represented the overturning of the old powers and the potential for an apocalyptic global rebirth. The theme of actual, political revolution was treated most directly in his poem 'The French Revolution', which was, after the *Poetical Sketches* of 1783, the only one of his poetic works to be printed in a conventional way in his lifetime. It was not, though, published (that is, distributed and sold), and only the first book (the title page of which promises the poem will comprise 'Seven Books') survives in a unique proof printed with the date of 1791 (Huntington Library, San Marino,

26
Los and Orc
c.1792–3?
Pen and ink and watercolour on paper
21.7 x 29.5
Tate

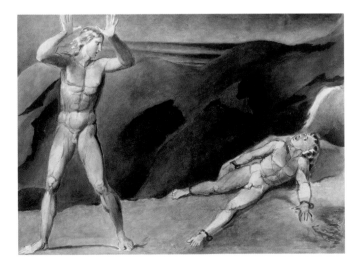

California). It is not clear whether further books were drafted by Blake. The poem includes clear references to contemporary events and French political figures, although these feature in the context of a densely allegorical text thick with weird and morbid imagery. Nonetheless, it is assumed that the publisher, Joseph Johnson, took fright of publishing such a work in the ever-more heated political atmosphere.

The 'prophetic books' Blake created in the 1790s address the theme of global revolution in still less direct ways. The 'Continental Prophecies' of *America a Prophecy* (1793; figs.37–9), *Europe a Prophecy* (1794; figs.1, 40), and *The Song of Los* (1795) push the allegorical representation of historical events to the point of incomprehensibility, as his own invented characters take the place of recognisable names from political life and the themes of spiritual and sexual revolution come to the fore and take over from historical events. However, scholars have pointed out that the use of allegory was well established among political dissenters. E. P. Thompson, in a highly significant book of 1993, explored the detailed connections between Blake's poetic language and the established language of political dissent, a tradition of spiritual and constitutional oppositionality rooted in the English Civil War and revolution of the seventeenth century.[1] Targeting those who would see Blake as an abstractedly profound mystic, a deep reader of esoteric texts, Thompson wanted to place him firmly within a political tradition. John Mee extends this view in seeing him as a '*bricoleur*', making use of a variety of political and poetic languages in a fashion characteristic of radical writers and poets of the time.[2] The results may be complex to our eyes, but they were not as outlandish as has often been assumed.

In purely visual terms, the themes of slavery, revolution and liberty underpin what Blake developed in the late 1780s and 1790s as a highly idiosyncratic iconography, developed through the words and images of his prophetic books, his drawings and watercolours. Scholars have been able to trace individual motifs as they circulate between these different forms, and gain and change meaning in the process, although, as the chronology of so many individual prints or designs is still in question, the precise order of priority and the significance of this is open to discussion. So, we have the small watercolour showing two nude figures in a bleakly empty landscape, usually dated to around 1793 but possibly as early as 1790, called *Los and Orc* (fig.26). One, the older of the two, holds up his hands in the conventional gesture of despair, and looks down on the other, a stockier figure, perhaps a muscular boy, who is chained by the hands and feet to a rock and strains upwards, his mouth open in a pained cry. The basic design appears in the large marginal illustrations to the opening plate of text from Blake's illuminated book, *America a Prophecy*, dated 1793. There, the older male figure is accompanied by a woman, who covers her head in fear or sorrow. The text describes the fourteen-year-old 'red Orc' who has been chained by Urthona and is being tended by his 'shadowy daughter' before suddenly breaking

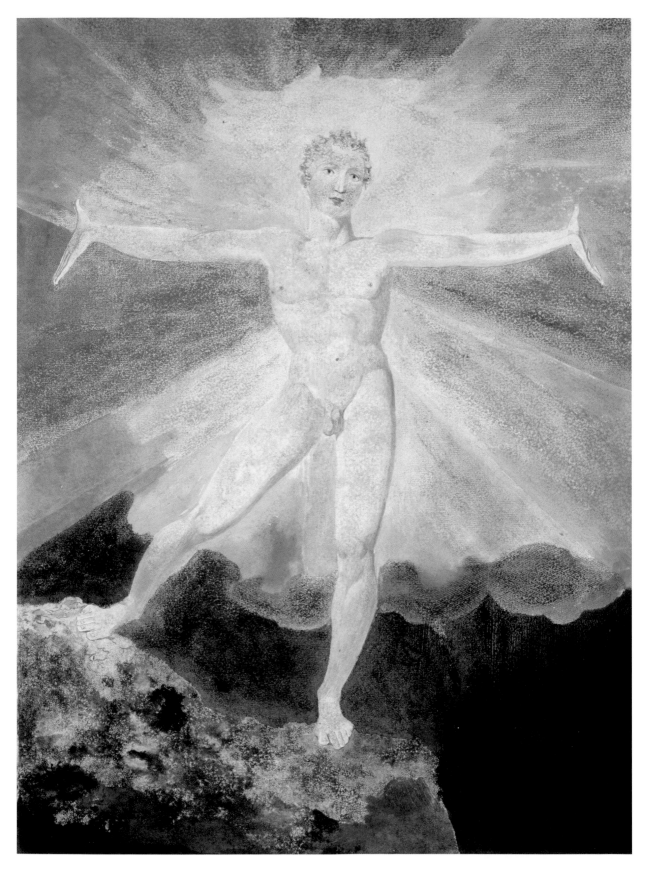

THE BLAKE BOOK

27
Albion Rose
c.1795
Colour-printed engraving
with pen and watercolour
27.2 x 19.9
Huntington Library and Art
Gallery, San Marino

free, and forcibly having sex with her ('Round the terrific loins he seiz'd the panting struggling womb'). Thus, we can derive from this and from the poem as a whole, Orc sets loose the powers of revolution. In the later manuscript 'Vala' (c.1795–7), renamed and reworked as the 'Four Zoas', the chaining of Orc is described again, in terms that more clearly evoke the present image:

But when returned to Golgonooza Los &
 Enitharmon
Felt all the sorrow Parents feel. they wept toward
 one another
And Los repented that he had chaind Orc upon the
 mountain
And Enitharmons tears prevailed parental love
 returnd
Tho terrible his dread of that infernal chain. They
 rose
At midnight hasting to their much beloved care
Nine days they traveld thro the Gloom of
 Entuthon Benithon
Los taking Enitharmon by the hand led her along
The dismal vales & up the iron mountain top
 where Orc
Howld in furious wind he thought to give up
 Enitharmon
Her son in tenfold joy & to compensate for her
 tears
Even if his own death resulted so much pity him
 paind.[3]

Thus, retrospectively, we can follow this poem and label Blake's watercolour *Los and Orc*, overlooking the fact that Orc's other parent, Enitharmon, is absent, and that Los as a character was not yet clearly conceived (at least in written form) when he executed the design. We can argue, of course, that Blake had the iconography exhibited in the poem worked out fully in his imagination by 1790; it would seem more realistic to suggest that both the drawings and the poetic texts see an evolving myth, elements of which are contingent, transient and provisional, and which will be, therefore, always somewhat illegible. What coherence we find may be at least in part imposed by us, as readers, rather than inherent to the designs and texts in question. We could, equally, relate the subject to the succession of designs by Henry Fuseli and George Romney from the previous two decades representing Prometheus, the heroic giant from Greek mythology, who rebelled against the gods and was chained to a rock as his punishment. The chained figure might then be considered as the embodiment of an idea of creative rebellion, either Prometheus or Orc, following the lessons Blake could have learned from Fuseli about the irrelevance of proper names in the representation of 'philosophical Ideas made intuitive, or Sentiment personified' (see p.45).

The 'philosophical Idea' of revolution was embodied in a lastingly persuasive way in the coloured print known as *Albion Rose* (fig.27). The conventional title for this composition is derived from the engraving of the same design dated 1780 – but which probably dates from at least a decade later – captioned 'Albion rose from where he laboured at the Mill with Slaves/ Giving himself For the Nations he danc'd the dance of Eternal Death'. Albion is

the traditional, mythical name for Britain, and a central character in Blake's later poetry, in which he is conceived as a giant personification of the nation as well as a geographical entity. The heroic character in figure 27 has, though, also been associated with the figure of Orc, the embodiment of rebellion. It has in addition been linked with an image of physical heroism evoked in Blake's early prose work 'King Edward the Third', printed in his *Poetical Sketches*:

> ... the bright morn
> Smiles on our army, and the gallant sun
> Springs from the hills like a young hero
> Into the battle, shaking his golden locks
> Exultingly; this is a promising day. [4]

Still, the present image is not easily reduced to being a literary illustration. As a purely visual icon, *Albion Rose* sets in motion ideas of physical perfection, intellectual and sexual liberty, physical fortitude and nationalistic pride. The man's physique evokes classical sculpture, the nudity and physical perfection of which embodies an ideal of liberty and beauty in conventional eighteenth-century aesthetics. The pose relates to the picture of the 'Vitruvian' man, famously depicted by Leonardo da Vinci in 1492, the nude figure posed diagrammatically within a circle and a square to exemplify perfect human proportions, associated with the Roman architect Vitruvius (c.80/70 BC–c.25 BC). Within Blake's visual works this figure's pose, with arms outstretched, recurs in representations of characters in ecstasy.

In one of his 'Aphorisms on Art' (a manuscript started around 1788), Fuseli had written: 'The forms of virtue are erect, the forms of pleasure undulate.'[5] Thus Fuseli suggested that the ideas of physical heroism, pictorial form and political (and perhaps sexual) revolution could all be intimately connected. 'Virtue' had, in such thinking, a purely visual dimension – it could, potentially, be represented by heavily gendered bodily forms, colours and shapes that in themselves conveyed ideas, without needing the aid of allegorical or literary reference. Blake knew and appreciated Fuseli's thinking, and had opportunities to translate that artist's efforts at expressing such abstract qualities into engraved form. He had, for instance, engraved the plate showing the medieval blacksmith and anti-establishment hero Wat Tyler looming over the vile tax collector he had attacked, for publication in Charles Allen's *History of England* of 1798 (fig.28). A leader of the Peasants' Revolt (1381), Tyler represented the spirit of righteous rebellion for the radical set of the later eighteenth century. Allen's book was published by Joseph Johnson, who would have seen in such historical narratives a justification for present-day political change. Fuseli's depiction of Tyler makes much of his sheer physicality – his swelling muscles and elongated limbs are 'forms of virtue', which the artist would later claim convey the idea of the narrative even if we do not know the original story. Fuseli, relatively cynical and worldly, did not pursue the full implications of this possibility. Blake, the sincere, visionary

28
William Blake after Henry Fuseli
Wat Tyler and the Tax-Gatherer
1797, published in Charles Allen, *History of England* (1798)
Etching and engraving on paper
14.7 x 8.2
Tate

artist, encouraged in his eccentricities by a few more socially secure men and women who (sometimes) proclaimed their dedication to the cause of liberty, and by a changing cultural scene that still promised so much, went much further with figures such as *Albion Rose*. Unchained entirely from the task of historical or literary illustration, or straightforward allegory, Blake's imagery participates in a potentially revolutionary effort to embody feelings and ideas without the apparatus of conventional narrative art, and thus, like political revolution itself, risked bringing into play unmanageable forces and descending into chaotic incomprehensibility.

Liberty and Slavery

The revolutionary events in France provided a focus and stimulus both for working men and women and for the self-consciously liberal and progressive elements within the educated middle classes. Blake's position in relation to these different social groups can be actively debated. On the one hand there was the urban artisan class from which the artist drew his social origins, and amongst which revolutionary sentiments had a particular currency in the 1790s. We know that many printers, engravers and publishers were actively involved in discussions of parliamentary reform, democracy and even revolution against the king. Within such groups, these radical ideas often combined with religious fervour, leading to a wild sense of apocalyptic revelation and millenarian anxieties. There can be no doubt that Blake knew of the arrests and persecution of such

radicals and self-proclaimed prophets, and felt oppressed by the sense of fearfulness and secrecy that prevailed. His own 'prophetic' writing, Blake's own term, used to evoke a sense not only of predicting, but of bringing into being, a revolutionary future, was in this setting dangerous stuff. In an age in which the slightest deviation from a loyalist vision of the future, with king and government securely in control and every Briton kept firmly in his place, might be interpreted as treasonable, Blake may, arguably, have been vulnerable to prosecution. He is not, though, known to have associated actively with any of the radical political groupings that emerged in that decade. The very obscurity of Blake's visionary writings from the 1790s – both in terms of their imagery and the highly rarefied way they were produced and circulated – kept him out of harm's way. We do know, however, that Blake felt the sharp end of the political paranoia of the era on one, slightly later occasion. In 1803 he was arrested for reputedly uttering treasonable statements after he got into a scuffle with a soldier, John Scolfield, in the garden of his cottage in Felpham, near his patron William Hayley. With the support of Hayley, who provided a lawyer for his defence, Blake was eventually let off after a trial early in 1804, but the whole experience was traumatic, and can be understood as motivating the still-more arcane nature of his later long poems, *Milton* and *Jerusalem*.

If Blake's personal background may have orientated him towards the artisan radicalism of the period, his professional activities and social affiliations brought him in contact with

the urbane circle of writers and intellectuals focused on the radical publisher Joseph Johnson. Here, enthusiasm for the political revolution in France was combined with wide-ranging philosophical reflection about gender roles and sexuality, race and individual liberty. The ethos of this group, exemplified in the very title of the literary magazine published by Johnson through these years, *The Analytical Review*, was rationalist, reflective and, generally, secularised. Blake, as a working man and a committed Christian, could not be expected to ingratiate himself with such people in a social sense, nor were his personal ideas easily married to their vision of the world. As Edward Larrissy noted, in an important formulation of the social basis of Blake's art, he related in a complex way to both the religious and political traditions of the artisan class, and the articulate radicalism of the middle classes, who provided him with work and encouragement.[6] Differences were bound to arise. The designs he produced for the pioneering feminist writer Mary Wollstonecraft's *Original Stories from Real Life* (published by Johnson in 1791) have been interpreted as expressing hostility for that writer's progressive ideas about the rational education of women and the intellectual equality of the sexes.[7] Despite our tendency to imagine Blake as a free-wheeling advocate of free love, his poetry often uses highly conventionalised notions of femininity. His images, meanwhile, can make use of exaggerated contrasts between virile male and limp female bodies.

More complex and disputable still are the illustrations Blake was commissioned to execute by Johnson in 1791 for John Gabriel Stedman's *Narrative of a Five Years Expedition Against the Revolted Negroes of Surinam* (1796). This was an account of the author's rollicking adventures as a mercenary sent to the Dutch colony of Surinam to put down a slave revolt in 1772. Stedman's substantial manuscript provided fulsome details of the author's military and sexual adventures, as much as the local flora and fauna, and disturbing accounts of the brutalities of slavery, and was accompanied by at least eighty watercolour designs produced by the author, an amateur artist. The publishing project proved to be a prolonged affair, as Stedman was unhappy with the way his text was being edited and changed, expunging the more explicit materials so that the narrative would conform better to conventional liberal tastes.[8] Although Stedman grew to dislike Johnson, he did become a friend and admirer of Blake at this time.

Blake signed thirteen of the prints that appeared in the published version of Stedman's text (1796) and is thought to have executed three more. These include depictions of figures from colony life, monkeys at play, local fruits, the skinning of an enormous snake and three scenes of black slaves suffering torture. These last are probably the most extensively discussed of Blake's reproductive engravings. In one, a man is being viciously beaten; in another, a woman is shown being strung up by her wrists and whipped. In another, often

29
Frontispiece to 'Visions of the Daughters of Albion' 1793, printed c.1795
Colour print finished in ink and watercolour on paper
17 x 12
Tate

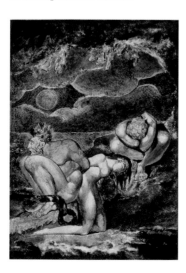

30
William Blake after John Gabriel Stedman
A Negro Hung Alive by the Ribs to a Gallows 1791–2, published in J.G. Stedman, *Narrative of a Five Years' Expedition Against the Revolted Negroes of Surinam* (1796)
Etching and engraving with watercolour
18.3 x 13.2
The British Library, London

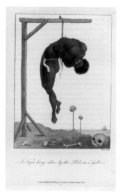

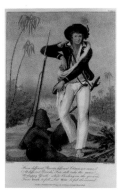

31
Francesco Bartolozzi after
John Gabriel Stedman
Frontispiece 1794
published in
J.G. Stedman's *Narrative of
a Five Years' Expedition
Against the Revolted
Negroes of Surinam* (1796)
Etching and engraving
with watercolour
The British Library, London

considered to be the most powerful, a man is suspended by a hook inserted cruelly between his ribs (fig.30). These compositions have been interpreted as highly personal adaptations of Stedman's originals, connecting with Blake's own poetic interest in the themes of slavery and liberty.

Blake's contact with Stedman and his work on these images have been seen as a key influence on his own illuminated book *Visions of the Daughters of Albion* 1793 (fig.29), in which the theme of slavery is expressed in the form of sexual allegory. Here, on the frontispiece, the female figure of Oothoon and the evil Bromion are chained together; the figure curled up to the right is Theotorman. In David Erdman's influential reading of the *Visions*, Bromion represents the slavers, and Oothoon, whom he rapes, the enslaved; Theotorman stands for the liberal abolitionists, who cry and emote but prove to be ultimately ineffectual. Blake thus appears to offer a radical vision of the damnable nature of slavery in all its dimensions (sexual, political and economic), and of the weakness of sentimental liberalism as a political force.[9]

While the visual and chronological connection between the Stedman illustrations and the Visions are suggestive, the overall validity of Erdman's argument has been called into question.[10] Although Stedman's *Narrative* was published by Johnson on the basis that it provided a documentary account of the appalling cruelties involved in slavery, thereby adding to the arguments of the abolitionists who called for the end of the slave trade, it does not simply conform to the latter's views. Importantly, we should remember that Stedman was categorically not a liberal abolitionist of the type that populated Johnson's social set. He was a professional soldier and did not oppose the institution of slavery, only its abuses. The frontispiece to the published version of the *Narrative*, reproducing Stedman's self-portrait, shows him towering over a mortally wounded rebel, while a village burns in the background (fig.31). The verses (presumably penned by Stedman himself) convey what we may think is a bizarre sentiment: while it is the fate of the rebel to suffer physical injury, it is Stedman's fate to feel the wounds of sentimental pity. That Blake struck up a warm friendship with this man, rather than some of Johnson's other authors whose viewpoints we may now be more comfortable with, could be telling.

Stedman's descriptions of slave beatings have been presented by Marcus Wood, in his important studies on the imaging of slavery, as prime evidence of the pornographic tendency within eighteenth-century treatments of slavery and the slave trade.[11] Blake's engravings are excused from participating in this pornographic culture, at least in part, because of their monumentality, which seems to convey a sense of heroism and humanity. Certainly, they are more restrained than the bowdlerised adaptations that appeared in versions of Stedman's text in succeeding years, in which a great deal more blood is spilt to titillating effect, or, indeed, the grotesque imagery of contemporary caricature, which conveys a deeply ambiguous

view of black Africans and their abusers (fig.32). Yet in his treatment of the subject Blake was also simply conforming to the conventions of the Grand Style in art. Fuseli wrote quite extensively about the way an image of violence would be degraded and made ineffectual by the inclusion of actual gore, at precisely the time Blake was preparing his engravings for the *Visions*.[12] If Blake made his figures heroic, and avoided showing the blood and guts that Stedman evoked in his text, he did so because that is what a visual artist should do. Furthermore, we might say that this sense of heroism in the face of suffering conforms to established stereotypes about the physicality of Africans and their spiritual fortitude. Whether we read Blake's illustrations for Stedman as a heroic re-invention of the designs that demonstrates the profound libertarianism of Blake's imagination, as workaday engravings intended to create visual impact, or as documents illuminating the ambivalence surrounding race and the issue of abolition, depends much on our own point of view.

Recent scholarship on Blake and race has tended to emphasise the complexity of Blake's vision. The other key document in this respect is the short poem 'The Little Black Boy' from the *Songs of Innocence* (1789).[13] Here, a black child narrates a spiritual vision:

My mother bore me in the southern wild,
And I am black, but O! my soul is white;

White as an angel is the English child:
But I am black as if bereav'd of light.

Blake has arguably been unable to escape conventional colour symbolism, which associates blackness (including racial blackness) with ignorance and whiteness with enlightenment and beauty. While this means that the African boy can bear the bright spiritual light of God ('the beams of love'), he does so from a position of blind innocence. Ultimately, even when the white boy finds the spiritual resources to withstand the powerful spiritual light, the black child occupies a servile role and wishes still more to be like the European:

When I from black and he from white cloud free,
And round the tent of God like lambs we joy:

Ill shade him from the heat till he can bear,
To lean in joy upon our fathers knee.
And then I'll stand and stroke his silver hair,
And be like him and he will then love me.

Blake's commitment to a radical vision of humanity, his opposition to the established forms of power and the invidious effects of the modern economy and empire, and the revolutionary nature of his art in its very techniques and languages, is beyond dispute. But whether his art escaped the matrix of racial and sexual prejudices that shaped the culture of his time, and even set the terms on which those prejudices could be criticised, remains an open question.

32
James Gillray
Barbarities in the West Indies
1792
Etching with watercolour on paper
24.7 x 34.8
New College, Oxford

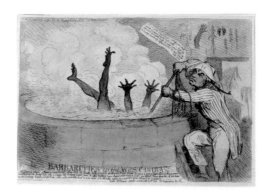

Slavery and Abolition

The London in which Blake lived was visibly transformed during his lifetime. While acutely aware that he did not always benefit personally from these changes, he saw the streets and buildings become grander, the populace became more refined in their tastes, and cultural institutions multiply and become ever more visible. To a degree which remains disputed, the institution of slavery underpinned these transformations. The trade in African slaves was an important commercial venture, and it was slave labour that made possible the vast profits to be drawn from the sugar plantations of the West Indies and America.

Britain's involvement with the international trade in slaves taken from Africa began in the sixteenth century, when John Hawkins sailed to Africa and transported three hundred African men and women to the Caribbean, where they were sold to the Spanish. In the early seventeenth century, Britain established its own colonies in the Caribbean. An official merchant company, the Royal Adventurers, was founded in 1660, later becoming the Royal African Company. The slave trade, and the sugar plantations on which slaves were put to work, proved to be enormously risky, but potentially hugely profitable, ventures. Exact figures are disputed, but, by Blake's time, Britain was the dominant commercial power in the world, with around 500,000 slaves at work in plantations in the West Indies, and with many thousands of slaves being shipped from Africa each year. The great ports involved in the trade – Bristol, London and Liverpool pre-eminently – grew rich and splendid on the profits.

The facts of slavery sat uneasily alongside Britain's proclaimed religious and political ideals, which laid claim to a tradition of humane values and individual liberties. Yet the brutal reality of the slave trade was largely accepted until late in the eighteenth century. While it was once argued that the slave trade was opposed for economic reasons, the general view now is that cultural factors were far more significant. Motivated by liberal political values, religious dissent, and business philosophies that favoured free trade and free labour, a movement for reform coalesced in the 1780s. Societies for the abolition of the slave trade were organised around the country. Petitions of 1788 and 1792 involved hundreds of thousands of signatories, in a highly visible campaign. But the movement became associated with dangerously radical politics in the 1790s, leading some of its prime movers to withdraw their support. The cause for abolition dragged on until finally, in 1807, the slave trade was officially abolished. Slavery itself was still legal in the British Empire until as late as 1833, and still continued in illicit forms after that date.

The campaign for the abolition of the slave trade has been accepted as a triumph for Britain's liberal middle class. More recently, scholars have questioned the nature of the abolition movement. Even while proclaiming basic human rights as universal, the abolition movement may have proffered its own restrictive stereotypes. The black slave was presented as the object of sympathy, as the passive receiver of white European pity, and racial stereotypes persisted and were perhaps strengthened. Meanwhile, pornographic and exploitative elements have been detected in the narratives and images of slavery, even where the motivation was to oppose the trade. The issue of abolition was tackled in ambiguous and sometimes unnerving imagery. James Gillray's *Barbarities in the West Indies* (fig.32), ostensibly a comment about the subhuman cruelty of the plantation owners, renders the theme comically horrible. The experiences of the Africans themselves and the role of slaves and freed slaves in the West Indies and in Britain as writers and political agitators has perhaps been underplayed, in favour of the testimonies of the white abolitionists. The substantial black presence in Britain itself, including, by the 1780s, many impoverished and disgruntled ex-servicemen, was a further, highly significant factor in the way the ideas and images of slavery were shaped. The extent and nature of slavery's visible and invisible influence on British culture has yet to be fully realised.

Some further reading:
J.R. Oldfield, *Popular Politics and British Anti-Slavery: The Mobilization of Public Opinion Against the Slave Trade 1787–1807*, Manchester and New York 1995
Helen Thomas, *Romanticism and Slave Narratives: Transatlantic Testimonies*, Cambridge 2000
Marcus Wood, *Slavery, Empathy and Pornography*, Oxford 2002
Brycchan Carey, Markman Ellis and Sara Smith (eds), *Discourses of Slavery and Abolition: Britain and its Colonies, 1760–1838*, Basingstoke 2004

33
William Blake after
Robert Blake
The Approach of Doom
c.1788?
Relief etching
29.7 x 21
The British Museum,
London

The Illuminated Books

The vehicle of Blake's revolutionary poetic sentiments was what is conventionally referred to as the 'illuminated books', the poems that Blake printed using his own invented technique of 'relief etching' and made into little books, including *The Songs of Innocence and of Experience* (1789–94), *The Marriage of Heaven and Hell* (1790), the 'Continental Prophecies' of 1793–5 (*America a Prophecy, Europe a Prophecy* and the *Song of Los*) and the later, longer works *Milton* (dated 1804) and *Jerusalem* (c.1804–20). These have formed the central focus of literary scholarship on Blake, even at the expense of other aspects of his art. The scholarly literature on these works is vast and difficult, and the poems themselves are challenging, even baffling, whether viewed in the intended 'illuminated' format with the accompanying illustrations, or in conventional typography (which can, perversely, make them harder to appreciate). The symbolism of the poetry, the intricate questions of meaning and method the text raises, and the bibliographical and technical questions surrounding the printed volumes, have occupied many full-scale studies. In the present context, an attempt will be made simply to establish the basic chronology of the illuminated books, and outline the major issues about technique and the relationship of texts to images raised by these productions.

The earliest surviving relief etching appears to be *The Approach of Doom* 1788 based, tellingly, on a design by Blake's much-loved younger brother, Robert (fig.33). He had died, tragically young, in 1787, and Blake's own account of the evolution of relief printing had this tragedy as a pivotal event. According to J.T. Smith, who probably had this from Blake himself, Robert came to Blake in a vision, and 'so decidedly directed him in the way in which he ought to proceed' that he was able immediately to master his innovative technique.[14] *The Approach of Doom* seems to have started as a conventionally executed intaglio print, which Blake enhanced and transformed with relief effects, leading to the strange textural qualities we can see now.

The technique of the relief-etching method that Blake developed around 1788 has long perplexed scholars. Blake himself left no clear statement of his method. There are, instead, the anecdotes of visionary visitations, and obscurely allegorical comments. In the text accompanying plate 14 of *The Marriage of Heaven and Hell*, he imagined the acids and corrosive effects of relief printing in daemonic terms:

But first the notion that man has a body distinct from his soul is to be expunged; this I shall do by printing in the infernal method, by Corrosives, which in Hell are salutary and medicinal, melting apparent surfaces away, and displaying the intimate which was hid.

The very act of creating a design on the copperplate is cast here as a form of revelation, which may be suggestive of Blake's views but helps little in determining how such images were produced. What seems certain is that the technique involved printing from copperplates, as with conventional engraving

or etching. But while these intaglio techniques relied on cutting into the copper, and forcing ink into those cut lines, with relief printing it is the raised surfaces which are coated with ink and printed. Instead of cutting into the copper, Blake drew or painted a specially resistant liquid on to the plate, so that when acid was applied to this surface these areas remained raised and could be printed. Blake used different coloured inks, printing any given book in several contrasting colours, or using different colour effects on a single plate. On some occasions, both the top surface and the etched areas would be printed. With the addition of watercolour and (with *Jerusalem*) even gilding, the pictorial qualities of the different versions of the same book could vary a great deal. Any single plate may be printed in one single colour, several colours, or in several colours with additional watercolours (figs.34, 35).

All this sounds fairly straightforward, but has considerable implications for how we can conceive of these productions. Because Blake etched the texts and images together, and made these plates into little books, they are both like and unlike conventionally printed books. We are meant to pick them up and 'read' them, but they also need to be looked at. Conventional printing techniques for illustrated books involved different people engraving and printing the images, from those setting the individual letters ('type') in blocks from which the text would be printed, mechanically. Blake appears, however, to have conceived, executed and printed the whole himself (with his wife, Catherine). In addition, each book may be quite different each time it was made, with the plates in a different order, and individual sheets or whole sections removed or added. Conventional printing techniques were valued because they created a uniform product; a single image, a single text, could be multiplied hundreds, or thousands, of times. The initial investment put into creating the plates and setting the type is potentially repaid over and over again. Blake's illuminated books spoil this logic; they are at once multiple, and unique.

This bare account of the facts around Blake's use of relief etching should be uncontroversial. But there are many major questions concerning the nature and use of the technique, which remain open to debate. These have been pursued with reference to textual allusions, and by a close examination of the physical evidence of the prints; only one small fragment of one of the original plates survives. Most of the copperplates passed from Catherine Blake to Frederick Tatham, and over the coming decades were either destroyed, lost or stolen. In the absence of physical evidence, artists and scholars have endeavoured to recreate the process through practical experimentation. A highly technical, and sometimes rather bad-tempered, debate around Blake's methods of making and printing the illuminated books has opened up.[15] This has become forbiddingly specialised, and to even enter into the debate would require an enormous level of knowledge and expertise based on seeing multiple copies of the books in their various

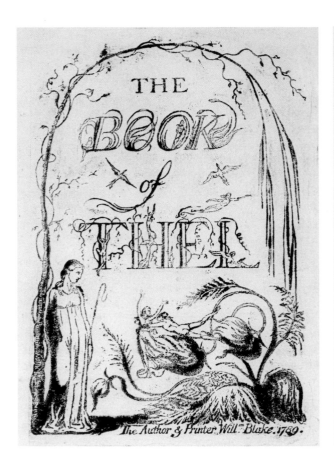

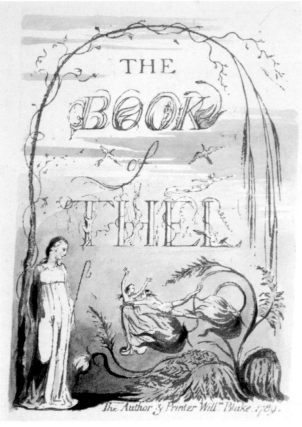

34
Title page from 'The Book of Thel'
1789, proof copy a
Relief etching on paper
15 x 11
Morgan Library &
Museum, New York

35
Title page from 'The Book of Thel'
1789, Copy H
Relief etching with
watercolour on paper
15 x 11
Library of Congress,
Washington

homes in public collections and private hands around the world. At stake is the essential question of whether the relief-printing process successfully achieved the complete union of conception and execution that Blake proclaimed in his theory of art, so that his illuminated books represent a spontaneous expression of his imagination in its poetic and visual dimensions, or whether this was a more laborious process: was making the illuminated books harder, or easier, than conventional engraving? Did they depend on fully realised sketches, or were they wholly, or in part at least, created directly on the plate? Did Blake print these works quickly, all at once, and keep a stock? Or did it take a long time and much effort to print even one set of the plates?

Blake's first attempts to integrate texts and images appear to be the series of tiny prints collected as *All Religions are One* (fig.36) and *There is no Natural Religion*. These are two miscellaneous collections of little emblems and aphorisms that have proved particularly elusive in terms of their bibliographical history. There are no contemporary references to these works, and the relationship between the two series is still unclear; are they parts of a single work, or two distinct books? There is only one complete copy of either book, and further versions have a different organisation of plates. They are assumed to be early experiments with relief etching, as they are so modest in their size and effects. One plate of *There is no Natural Religion* appears with reversed writing, which has been taken to suggest that Blake somehow forgot to reverse the lettering in this case, and the poor quality of the printing throughout has meant that Blake has had to use pen and ink after the printing process to enhance his designs. The invention of these plates is usually dated to 1788, primarily on the grounds that in the relief-printed *The Ghost of Abel* (1822), Blake claimed that the first 'Original Stereotype was 1788'. However, all the impressions of both books date to rather later, with a printing after 1794 and a further printing after 1811, and quite possibly later still. Blake apparently sold none of these during his lifetime.

The first successful and complete printing of an illuminated book of poetry came with the first copies of *Songs of Innocence* (1789), subsequently joined with *Songs of Experience* (1793) and printed together, as a single *Songs of Innocence and of Experience* (from 1794; see pp.72–3). *The Book of Thel* (figs.34, 35) was the first illuminated book to feature Blake's invented characters, followed by *The Marriage of Heaven and Hell*, *Visions of the Daughters of Albion* (fig.29) and the books known as the 'Continental Prophecies': *America a Prophecy* (figs.37–9), *Europe a Prophecy* (figs.1, 40) and *The Song of Los*. These trace the theme of revolution in global terms, through Blake's invented characters and increasingly obscure allegory. In *America* it is still possible to relate these in a fairly direct way to historical events. Urizen, the bearded patriarch who appears in Blake's prophetic works as the embodiment of reaction and oppressive law, is readily interpreted as a version of George III (fig.39). The poem thus extends the themes of madness and tyranny that had already

36
Title page from 'All Religions are One'
Engraved 1788, printed after 1794
Relief etching on paper
13.7 x 10.7
The British Museum, London

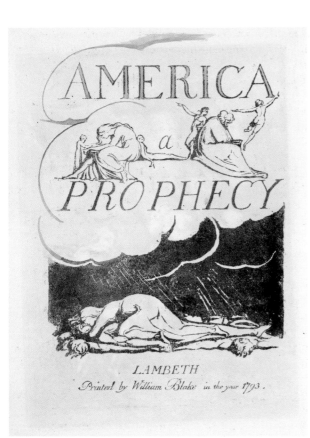

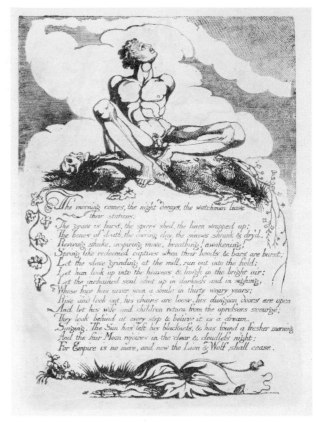

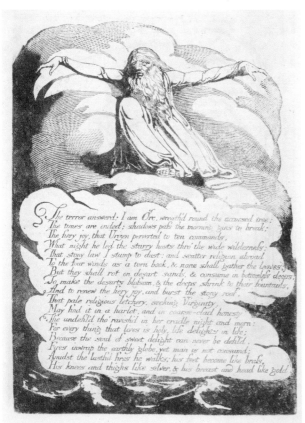

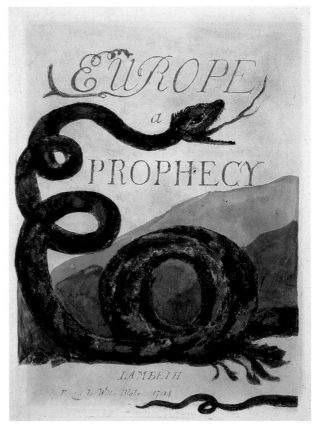

emerged in 'Tiriel' (c.1785–9; pp.50–1), and, indeed, in British art more generally in the 1760s and 1770s. Orc, the athletic youth, is here the emblematic embodiment of the revolutionary colonists (fig.38).

These 'Continental Prophecies' were followed by the 'Urizen books', focusing on Blake's invented mythical character of that name, consisting of *The First Book of Urizen* (figs.49, 50), which incorporates a much more dominant visual element than his earlier work, *The Book of Los* (fig.51) and *The Book of Ahania*, which consist of colour-printed designs, but with the text engraved. Blake appears to have concluded around this time that colour printing was best used for images; thus the creation of the large colour prints in around 1795, prints that were, as Blake later put it, 'unaccompanied by any text' (figs.52–5). In 1794–6 he produced at least three separate books of images, reprinted, without texts, from the existing illuminated books. There are two books called the *Small Book of Designs*, and one surviving copy of the *Large Book of Designs*. His illustration projects following on from those years saw different methods of relating texts and images, with his designs for poems by Edward Young and Thomas Gray (figs.76, 7 7; see also pp.115–17) and his own illuminated poem, left in manuscript, 'Vala' (started around 1795–7). Subsequent printmaking experiments included 'white-line engraving', involving cutting on copperplate but printing the raised surfaces (fig.79), and even the new method of lithography when it was introduced to London artists in the early 1800s. He took up relief etching again in the 1800s, producing the lengthier visionary poems *Milton* (figs.67, 68) and *Jerusalem* (figs.86–8), although they both also incorporate other printmaking techniques.

In all, there are more than 160 documented copies of Blake's various illuminated books, which have been subject to intensive bibliographical analysis and documentation. Different copies of Blake's illuminated books are referred to by letters: copy 'A', 'B', 'C' and so forth. These do not refer to the chronology or importance of individual copies. That is, in itself, an area of debate and active inquiry. While Blake included dates on the title pages of the books, it is not certain whether this was when the book was begun, when the plates were finished, or when the plates were printed. So *Milton* is dated 1804 on the title page, but we know he printed four copies, three around 1810 and a fourth after 1816. The watermarks (the signs and letters imprinted into paper by the manufacturers) are vital evidence in establishing when any individual sheet was printed (although an individual sheet might be used long after it was actually manufactured).

Much also depends on whether we consider that printing relief etchings was a quick and easy process, undertaken in one swift procedure, which meant that Blake could create a stock of books in a short period, or whether it was difficult and time-consuming, with the plates being run through the press more than once to create the full range of colour effects, meaning that he only took the time and effort to produce an

individual copy of a book when someone was willing to buy one. Blake's own claim, made in the 'Prospectus', the printed advertisement for his productions he engraved in 1793 (see p.165), was that the method allowed him to create and circulate his writings far more effectively than even the greatest writers of the past. As such, they can be interpreted as contesting (effectively or not) the dominant modes of production, in which an illustration and text might be commissioned and created quite separately, and printed and bound together by someone else again, to the greater financial benefit of the publisher who organised the whole project than of any of the creative individuals or craftsmen involved. For the proponents of the 'one-pull' theory, Blake achieved an exceptional unity in the relief-printed productions, bringing together the roles of artist, publisher, engraver and printer in a single person, overcoming distinctions between conception and execution, and dissolving the stages by which images were conventionally originated, copied, transferred and reproduced into a single moment of spontaneous creativity.

Blake's own claim was that he was thus able to do away with the middle men of the business of culture and set himself up as a financially independent creative individual. Quite aside from the question of how and why he failed in this regard, there are further dimensions to the radicalism of the illuminated books. The painter Samuel Palmer, one of Blake's most passionate admirers from among the younger generation, called them 'something between a thing and a thought'.[16] This sense of ambiguity is central to any reader's experience of the illuminated books. For a start, we may hardly be justified in called ourselves 'readers', for the texts themselves have a visual quality: we look at, as well as read, the illuminated books. Should we read first, and then look at the pictures, or look first, then read – or is it possible to do both, simultaneously? How do we relate the things we see to the things we read about? We tend to give names to the figures we encounter in the pictures drawn from the texts, but it is not always certain that we are right to. Often enough, the figures appear unrelated to the text, or even to contradict it in tone or sense. Meanwhile, the texts themselves have a profoundly visual quality: they are not merely conventionalised signs, but are animated by the artist's hand and by the decorative configuration of the page. Instead of steady, uniform type, as with conventional printing, where an 'a' always looks like an 'a', a comma is unequivocally shown as ',' rather than '.' or, ' ' ' or even '/', there is not always this certainty with Blake. Is the mark at the end of the third line of text in plate 10 of *America* (fig.39) a comma or a full stop? Is the squiggle that leads from the top of the 'O' in 'Orc' in the first line significant, or merely decorative?

A further major problem in considering these works is the question of audience. Who looked at these works? His *Poetical Sketches* had been conventionally printed and circulated privately, but was not advertised and distributed. *The French Revolution*, the only other of Blake's poetic writings to be set in

type under his command, may have initially been intended for full publication but this was abandoned. And we can assume that Blake hoped that 'Tiriel' would be published, but it never was. Although Blake put Joseph Johnson's name on the title page of his little engraved emblem-book, *For Children: The Gates of Paradise* (1793), neither this nor any of the other illuminated books appear to have been 'published' in the conventional sense of being distributed and sold more widely among booksellers. Blake's invention of relief printing had been an attempt to establish himself as a self-publishing artist. Blake's printed 'Prospectus' addressed 'To the Public' (10 October 1793) announced as for sale a range of illuminated books that were said to be 'now published and on Sale at Mr. Blake's, No. 13, Hercules Buildings, Lambeth'. It is clear though that this did not succeed. In the important letter of 1818 written to Dawson Turner, Blake noted that 'I have never been able to produce a Sufficient number for a general Sale by means of a regular Publisher' (see pp.165–6). Blake goes on to say that 'It is therefore necessary to me that any Person wishing to have any or all of them should send me their Order to Print them', which suggests that he only ever printed them individually, one at a time, once a purchase had been proposed. Whether Blake had ever prepared an extensive stock of the illuminated books in an economically viable way depends on the technical arguments about how long it would have taken him to produce these.

Whatever the case, Blake's illuminated books were not nearly so hidden away as is often assumed. It appears that *For Children* and, quite possibly, other of Blake's books were on display at Johnson's bookshop next to St Paul's Cathedral; the 'Prospectus' of 1793 may, indeed, have served as a flyer that the publisher could have handed out to prospective customers.[17] Plates from the as-yet incomplete *Jerusalem* were included among the exhibits by Blake at the exhibition of the Associated Painters in Water Colour in 1812, and the book itself was once 'puffed' (discretely advertised), albeit in a rather bizarre fashion, in the press when it was completed in 1820 (see p.130). The illuminated books did find purchasers, and the *Songs* in particular sold relatively well. But quite what any of the people who saw, or even bought, the illuminated books thought they were looking at is another issue. All the evidence is that contemporaries were simply baffled by the symbolic content, even if they were impressed by the visual appearance of these works.

Songs of Innocence and of Experience

Songs of Innocence and of Experience were the most widely read and appreciated of Blake's poems. As early as 1806, some of the songs were included in Benjamin Heath Malkin's account of the artist. The original owners of copies of *Songs of Innocence* and *Songs of Innocence and of Experience* included Blake's friends and supporters John Flaxman, George Cumberland, Thomas Butts, Joseph Thomas and Thomas Griffiths Wainewright, as well as poets and noblemen, and writers and artists. Wordsworth and Coleridge knew and admired them. For the great majority of readers in the past, and for most readers today, they remain the most accessible and meaningful of his poetic works.

Songs of Innocence and of Experience originally existed in three forms. *Songs of Innocence* were printed by Blake with the date on the title page of 1789. Some of these poems were being drafted years earlier; several appear in the manuscript of the incomplete play 'An Island in the Moon' (c.1784–5). Blake printed and sold separate copies of *Songs of Innocence* until at least 1818. *Songs of Experience* was printed by 1793, when Blake listed it as a separate publication in his 'Prospectus' of that year. No examples of a separate edition of *Experience* now survive. Some copies were printed separately and bound in with *Songs of Innocence*, and Blake combined and printed the two together and created a new title page covering both series from 1794 (fig.42).

Although Blake was later to call his method 'illuminated printing', a term that evokes medieval marginal illustrations, the format of the *Songs* plates is unlike anything he would have seen in the way of medieval manuscripts. They evoke instead a now largely lost domestic visual world of decoration and design, of printed writing papers, ephemeral religious prints, decorative wares and furniture. One important surviving form that may give a sense of this visual realm is the embroidered sampler, the common and highly prized exercises in needlework undertaken by girls and women, often framed and used as a kind of decoration themselves (fig.41). Blake would undoubtedly have known such works at first hand; any household would have them on display, and the wife of his patron Thomas Butts appears to have embroidered a version of one of his designs. Samplers were an important form of domestic creativity, with hymns or pious poems – from published sources or invented by the individual – placed in the midst of a decorative border. The ornamental twirls and wavy lines that characteristically fill out the spaces left beside or between individual lines of text in these samplers are thoroughly reminiscent of the *Songs*. Here, also, we find the shift between different representational systems that is so characteristic of Blake's designs; particularly where a three-dimensional scene at the bottom of the design gives way, and flows into, planar design, so that a tree rendered as a three-dimensional object in the lowest quarter of the composition transforms into ornamental patterns of leaves and branches intertwining with lettering, at the top.

In keeping with their homely visual profile, the *Songs of Innocence* present relatively straightforward sentiments, at least at face value, without, most commentators agree, being simply sentimental. The sing-song rhymes of 'The Lamb' (fig.43), and the straightforward illustrated element, seem to work together with a coherence and directness that we may struggle to find elsewhere in Blake's works. But, as the title page for the combined *Songs* declares, the two series of songs set out to explore 'Two Contrary States of the Human Soul'. 'The Lamb' in *Songs of Innocence* evokes the reforming Methodist Charles Wesley's hymn 'Gentle Jesus, meek and mild' (precisely the sort of text copied into samplers), but without the moralising overtones. If the infant in 'The Lamb' was certain of the divine love, 'The Tyger' (fig.44), the partner plate in *Songs of Experience*, poses unanswered questions. 'The Lamb' appears in bright daylight, near a homely cottage, where a child can roam naked and in safety. 'The Tyger' takes us to a dark and threatening wood, and into the realm of the unknown and unknowable, conventionally labelled the Sublime. 'London' (fig.45), meanwhile, in *Songs of Innocence and of Experience*, offers an unequivocally bleak vision of a city ruled by materialism and law (the streets 'charter'd', that is, subject to ownership and regulation), where the wars of the privileged elite bring mindless destruction and bloodshed ('the hapless Soldiers sigh/ Runs in blood down Palace walls') and where new life itself is cursed and diseased. Like a number of the poems in the *Songs*, it can be related directly to Blake's experience of the metropolis, and the social suffering that he saw in the streets around him. The accompanying image of a small child leading a bent old man along a cobbled street suggests universal themes of youth and age, hope and despair.

41
Mary Brooks
Bordered sampler 1792
Woollen sampler
embroidered with
polychrome silks and
edged with a pink ribbon
44 × 32.8
Fitzwilliam Museum,
Cambridge

42
*General title page from
'The Songs of Innocence
and of Experience'*
1789–94, Copy C
Relief etching with
watercolour on paper
11.2 x 7
Library of Congress,
Washington

43
*'The Lamb' from 'The
Songs of Innocence and
of Experience'*
1789–94, Copy C
Relief etching with
watercolour on paper
11.2 x 7
Library of Congress,
Washington

44
*'The Tyger' from 'The
Songs of Innocence and
of Experience'*
1789–94, Copy C
Relief etching with
watercolour on paper
11.2 x 7
Library of Congress,
Washington

45
*'London' from 'The Songs
of Innocence and of
Experience'*
1789–94, Copy C
Relief etching with
watercolour on paper
11.2 x 7
Library of Congress,
Washington

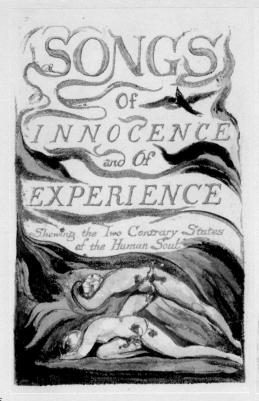

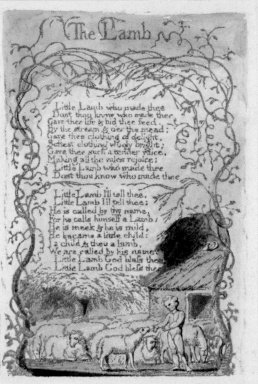

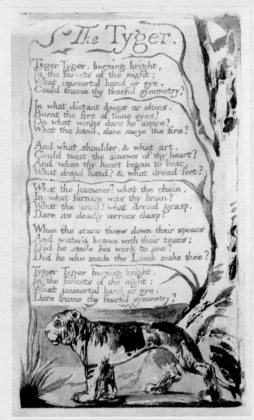

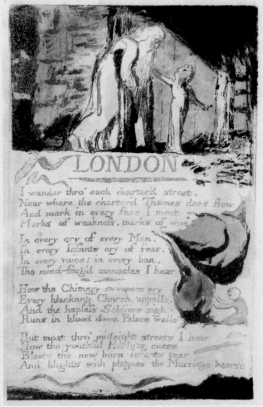

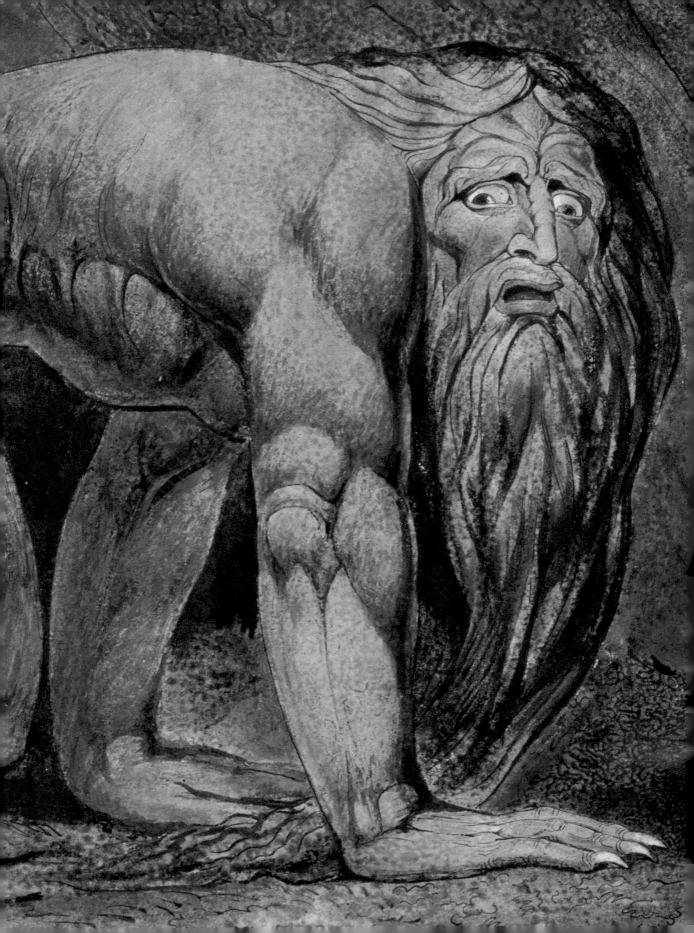

The Christian Artist

Blake was a Christian artist. His writings contain explicit statements of this, and go further to say that art itself is a form of Christian worship, and even that true art is impossible unless infused with belief. Contemporaries and memorialists were uniform in testifying to the deep sincerity of his faith. Yet the nature of Blake's spiritual upbringing and affiliations remain disputed. He was baptised in the Church of England, at St James's Church, Piccadilly, but it has always been assumed that his parents were radical dissenters of some sort. The Church of England was, as it is now, the official or 'established' religion of England, with the monarch at its head. Although Anglicans claim the origins of their church in the era of the Roman empire, the political character of the Church of England was defined in the break with the Roman Catholic church in the sixteenth century and through the civil wars of the next century. The constitutional character of the Church was established in the late seventeenth century, when adherence to Anglicanism became a requirement for holding civic office, having a university education, and being an officer in the army. Ancient prejudice against Jews and the longstanding distrust of Roman Catholics were thus backed up by law, and even the moderate relaxation of these laws in the late 1770s stirred up fierce violence in the populace, with the infamous Gordon Riots of 1780.

One of his earliest biographers, J.T. Smith, said that Blake 'did not for the last forty years attend any place of Divine worship', while also asserting that 'he was not a Freethinker, as some invidious detractors have thought proper to assert, nor was he ever in any degree irreligious. Through life, his Bible was every thing with him'.[1] He gives this rather intriguing account of Blake's final days:

Some short time before his death, Mrs Blake asked him where he should like to be buried, and whether he would have the Dissenting Minister, or the Clergyman of the Church of England, to read the service: his answers were, that as far as his own feelings were concerned, they might bury him where she pleased, adding, that as his father, mother, aunt, and brother, were buried in Bunhill-row, perhaps it would be better to lie there, but as to service, he should wish for that of the Church of England.[2]

There has been much discussion and debate about the religious beliefs of Blake's parents, this seeming to offer a key to understanding Blake's spiritual upbringing. Blake's father, James, has been identified as a Baptist, but with no certainty. Important new evidence has recently been uncovered about Blake's mother, however. She had been born Catherine Wright in London and had been christened, in an Anglican church, in 1723. She first married a hosier called Thomas Armitage in 1746. He died in 1751, and she married James Blake in 1752. Both marriages took place at St George's Chapel, Hanover Square, which, besides being local, had a reputation for informality in its conduct of the marriage ceremony, which had previously been taken as

4 Blake and the Bible

evidence that these marriages were between dissenters. E. P. Thompson argued that Blake's mother was connected with the Muggletonians, a tiny Protestant sect, but this suggestion has been overruled. Keri Davies and Marsha Keith Schuchard have provided documentation that points to Blake's mother and her first husband being members of the Moravians, a rather more prominent sect of dissenters. This is most intriguing, as Moravians were recognised by the Anglican Church. Blake's dissenting views could therefore sit with having an Anglican baptism and burial. Whether the liberated sexual attitudes associated with the Moravians can be related to Blake's own vision as closely as Schuchard proposes has yet to be generally agreed.[3]

Although Thompson's arguments about the origins of Blake's beliefs have been cast aside purely on the basis that he misinterpreted Blake's family background, there is clearly still much of value in his opinions. Thompson's claims did not simply rest on the identity of Blake's mother, but rather on relating his ideas to broader traditions of thought than was generally allowed, by scholars who wanted to connect his art with a dazzling array of esoteric texts, and to cast their subject as at once a deeply read philosopher, profound mystic and theologian. Thompson argued that Blake's ideas needed to be related to the traditions of antinomianism, which he could have absorbed quite informally, given the currency of these ideas among the urban artisan class from which he came. These traditions dictated that man is born incapable of sin, and that the laws ('nomos') imposed by religious leaders and the state are wrong-headed and can thus be rejected.[4] Many of Blake's texts can be productively considered as expressions of antinomian beliefs, sometimes stated quite bluntly. This example of one of the angry notes he added in the margin of his copy of the conservative Anglican Bishop Richard Watson's *Apology for the Bible* (1797) reveals a stark confrontation between Blake and an upholder of the conventional Church:

The laws of the Jews were (both ceremonial & free) the basest & most oppressive of human codes. & being like all other codes given under pretence of divine command were what Christ pronounced them The Abomination that maketh desolate. ie. State Religion which is the Source of all Cruelty.[5]

To the native traditions of antinomian thought, Blake certainly added visionary and poetic influences that affected his reading of the Bible in profound ways.[6] When Blake wrote to Flaxman that 'Paracelsus & Behmen appear'd to me' in his youth, he was evoking the names of mystic writers of an earlier age, whom he had read in translation. Paracelsus (1493–1541) was a medical scientist who produced mysterious alchemical and philosophical works, and the alchemical themes in Blake's writings (not least in his imaginative treatment of the processes of relief etching) have been traced to this source. More importantly still, according to the German Christian mystic Jacob Boehme or Behmen (1575–1624), the poetic and visual

imagination was a privileged means of entering the spiritual world. His detailed spatial configuration of the different aspects of the mind, body and spirit were a key influence on Blake's own (geographical and bodily) sense of space, developed in his later poetic works. To these historical influences must be added the name of Emanuel Swedenborg (1688–1772), the Swedish mystic who had visited, and died in, London, and produced a large body of spiritual writings. Although a successful and innovative scientist and engineer, he had abandoned his career to pursue the radical spiritual visions he experienced in dreams, in which it was revealed to him that the physical world simply represents the spiritual, in the form of 'correspondences' or resemblances between them. Although the Swedish mystic had not established any kind of formal church, one was set up in Blake's time, known as the Swedenborgian New Church, and there is documented evidence that Blake and his wife attended their first meeting in 1789, the only time that we can connect the artist with a specific sect. Blake's friend John Flaxman was a Swedenborgian, and his own sculptural designs, in which angels hover and float not in conventional winged form but as a real presence, are derived from that influence, and share much with Blake's visions (fig.46), to the extent that Blake, after falling out with his friend, accused him of plagiarism (see p.181). But while Flaxman and some other artists of the day known to Blake adhered to Swedenborgian principles, the evidence is that Blake broke from the sect quite

dramatically and, even while admiring the creative potential of the Swede's influence, was wary of what he considered his errors regarding the nature of sin and evil.

To these esoteric influences, we might add the realm of formal Bible scholarship. The rehabilitation of the Bible as an inspirational literary source has been posited as one of the key shifts in taste in the eighteenth century. Robert Lowth's *Lectures on the Sacred Poetry of the Hebrews*, published in Latin in 1741 and in English in 1787, had an important role to play. According to Lowth, the Old Testament was a form of primitive prophetic poetry, and could be admired for its aesthetic powers. Blake appears to have known this text, perhaps as early as 1788, and its influence can be traced in *The Marriage of Heaven and Hell* 1790: 'We of Israel taught that the Poetic Genius (as you now call it) was the first principle and all the others merely derivative'.[7] Through his association with Joseph Johnson and his circle, he could also have known of Continental 'higher criticism', which was asking searching questions about the historical nature and poetic powers of the Bible. The French writer C. F. Volney's *Ruins of Empire* (1791), published in English by Joseph Johnson in 1796, had proposed a universal basis for all religions, which derived from a single symbolic system developed among the sun cults of ancient Egypt. Blake, like the proponents of 'higher criticism', saw the Bible as a historical record of individual poetic voices, which therefore had to be treated with scepticism or actively rejected. The Bible was not a source of moral authority, if morality

46
John Flaxman
Model for the monument to Isaac Hawkins Browne
1806
Plaster
25.4 x 38.1
University College, London

could be a matter of cold philosophising ('If Morality were Christianity, Socrates was the Saviour').[8] It was a work of interpretative art, of inspiration, which could be rewritten and re-imagined accordingly. Blake's efforts as a poet, painter and maker of illuminated books can be interpreted as his attempt to rework and recover what he found genuinely inspired in the Bible, rescuing its real lessons from the abuses and misinterpretation of the state and organised religion.[9]

Blake's religious vision, and his specific break with Swedenborg, who in his view had begun as a genuine visionary but whose writings have become doctrinaire, was marked in his illuminated book *The Marriage of Heaven and Hell* (figs.47, 48, 104). It opens with a free-verse 'Argument', and includes 'Memorable Fancies' that parody Swedenborg's 'Memorable relations', perhaps the most quotable and quoted of Blake's writings, which confront conventional morality with a series of shocking paradoxes and inversions. Here, it is proposed that man should attend to 'Energy' rather than moral laws handed down by philosophers and theologians: 'Without contraries no progression. Attraction and Repulsion, Reason and Energy, Love and Hate, are necessary to Human existence.' The imagery appearing in the book makes it evidently clear that 'Energy' is a sexual, as well as an intellectual and spiritual, force (fig.48). The 'Song of Liberty', which appears at the end of the book, alludes to the American Revolution, and has been thought to have been originally planned as a separate work. In fact the

arrangement of the book as a whole presents an extremely complex bibliographical conundrum that can not easily be summarised. Blake produced no two copies of *The Marriage* that present an identical sequence of plates. If *The Marriage* proposes that organised religion and doctrinal thought need to be rejected, then the very ordering of the book extends such a revolutionary sentiment.

In *The Marriage*, Blake declares that he has already created 'The Bible of Hell: which the world shall have whether they will or no'. The books he produced in the coming years, including the 'Continental Prophecies' and the Urizen books (*The First Book of Urizen*, *The Book of Los* (fig.51) and *The Book of Ahania*) have been identified as contributions to this 'Bible of Hell', representing a subversive rewriting of biblical narratives, as corrosive and unconventional as the relief-etching process itself, as this is figured within *The Marriage* (fig.104). While the contemporary 'Continental Prophecies' use historical events to illustrate universal themes, the three Urizen books under consideration here use a yet more arcane, and more heavily visual, symbolism, which re-envisages Christian creation myths in a simultaneously cosmic and biological framework. The format of the written elements of *The First Book of Urizen* (figs.49, 50), with its double columns of text and plates, recall scriptural texts as these would appear painted on boards in church decorations and in standard printed Bibles. Blake's intention is satirical: to damn the oppressive nature of written laws. The title

47
*Title page from 'The
Marriage of Heaven and
Hell'* 1790, Copy H
Relief etching with ink and
watercolour on paper
15.2 x 10.5
Fitzwilliam Museum,
Cambridge

48
*Plate 3 from 'The Marriage
of Heaven and Hell'*
1790, Copy H
Relief etching with ink and
watercolour on paper
15.3 x 11.1
Fitzwilliam Museum,
Cambridge

page has the familiar figure of Urizen, the judging, oppressive god-figure who appears so frequently in Blake's imagery, writing out his laws. The two stone tablets behind him suggest the oppressive laws handed down to Moses in the Old Testament. The creation of the material world is, in these books, an act of cruelty, damning man to take up a physical form, painfully divided from the realm of the spirit.

The Large Colour Prints

In 1795 Blake created a group of large prints on a uniform format, using a sort of 'monotype' technique (printing from a wet or tacky painted surface) that extended the possibilities of colour printing from the experimental prophetic books and separately printed images of the previous years. In 1818, when he offered these for sale to Dawson Turner, he described them as '12 Large Prints Size of Each about 2 feet & 1 & ½ Historical & Poetical Printed in Colours ... unaccompanied by any writing' (see pp.165–6). At that point, Blake was offering them at 5 guineas each. Although he lists them as a group, it is clear that he would have been prepared to sell them individually or in small groups if needs be. Eight of them had been sold to Thomas Butts (1757–1845) in 1805–6 for a guinea each, and a group of seven were being proffered by Blake's widow in 1829.

In their scale and format, the 'large colour prints' recall a tradition of publishing portfolios or series of prints. This tradition can be traced back to William Hogarth, whose 'modern moral series' of narrative prints

helped forge a new commercial identity for British art in the earlier eighteenth century. More recently there were the influential series of prints engraved by Domenici Cunego after the series of grandly heroic Homeric scenes created by Gavin Hamilton, the self-published portfolios of John Hamilton Mortimer and James Barry, and Henry Fuseli's contemporary scheme for a series of prints reproducing pictures in his Milton Gallery (which did not, in the event, materialise). Print series provided an opportunity for artists to explore a pictorial scheme or idea more extensively than was usually the case with large-scale painting, and in a fashion that could reap financial rewards when distributed through the open market. The scale and high finish of Blake's prints, and the considerable innovation that went into their technical conception, indicate the importance these prints must have had to him. But they have neither the obvious conceptual coherence nor the commercial viability of any of these earlier projects by other artists.

Blake's technique was described by Frederick Tatham, and the details of his account have been checked by several practical experiments and technical examinations, most fully with the research undertaken by Noa Cahaner McManus and Joyce Townsend.[10] According to Tatham:

Blake, when he wanted to make his prints in oil ... took common thick millboard, and drew in some strong ink or colour his design upon it strong and thick. He then painted upon that in such oil colours and in such a state of fusion that they

49
Title page from 'The First Book of Urizen'
1794, Copy D
Relief etching with pen and ink and watercolour on paper
15 x 10.5
The British Museum, London

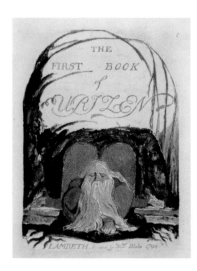

50
Plate 7 from 'The First Book of Urizen'
1794, Copy D
Relief etching with pen and ink and watercolour on paper
15 x 10.5
The British Museum, London

would blur well. He painted roughly and quickly, so that no colour would have time to dry. He then took a print of that on paper, and this impression he coloured up in water-colours, re-painting the outline on the millboard when he wanted to take another print.[11]

Tatham was not even born until 1805, however, so he could not have witnessed the production of these prints. The technical evidence is that millboard (that is, a sort of pasteboard made from sacking or paper, 'milled' or pressed into sheets) could have been used as the 'plate' for these prints, painted with specially prepared colours and printed. However, Tatham's suggestion that Blake repainted the millboard between printings has been rejected, as this would be impractical, and would presumably lead to different impressions varying far more than is the case. It appears that Blake drew (with ink) on the board, worked up the design with thick, tacky gum or glue-based paints, printed, allowed the print to dry, and then enhanced it with ink lines and watercolours. The resulting prints are densely textured, and incorporate, as Tatham also noted, 'a sort of accidental look' (most spectacularly with *Newton*, fig.54). The printed elements of the prints are heavily 'reticulated', that is, they display a dense network of tiny ridges. Blake inscribed a number of the prints with the word 'Fresco', evoking thereby the dry surfaces and textures of Renaissance wall-painting.

By the nature of the technique, which rested upon the painted design remaining tacky itself or being reactivated when it came into contact with the dampened paper, it would have been impossible to produce very many versions of each composition. Twenty-eight impressions of the twelve designs survive, with no single image appearing in more than three impressions. Those of the prints that are dated are marked '1795'. Yet two (figs.54, 55) are printed on paper bearing watermarks (the manufacturer's imprints) of 1804 while also bearing that earlier year in Blake's hand, and the first documentary evidence relating to these productions are the payments made by Thomas Butts to Blake in 1805. The generally accepted theory is that the designs were conceived by Blake at that earlier date, but may have been actually printed and finished at the later time, although the only firm evidence is that the group as a whole was not printed and available to be purchased until 1805.

Scholars have attempted to impose a thematic coherence and systematic organisation to these twelve plates, either as a series in its entirety, or in smaller groups or pairs. While there are obvious visual and iconographic parallels between individual pairs of works, Blake clearly conceived of them being available singly to individual patrons (he gave an individual price per print to Dawson Turner in 1818), and the question mark that remains over the discrepancy between the dating of these works by Blake and the date at which at least some of them were printed, should caution us against elaborating a too-comprehensive symbolic scheme for these works. Blake's 'Historical &

51
Title page from 'The Book of Los' 1795
Etching with some colour printing on paper
13.3 x 9.9
The British Museum, London

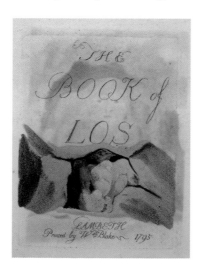

Poetical' subjects were drawn from a range of sources, including the Bible (six subjects), Shakespeare and Milton, and from his own imagination. If we are to view these prints as a single sequence, we are obliged to shift our interpretative perspective abruptly several times, from viewing a visual presentation of action from Scripture or Milton, involving human agents or gigantic spiritual forces, to engaging with the 'literalization of figuration' (see p.45) that sees Shakespeare's lines, 'And pity like a newborn babe', given direct visual form; to pondering images that seem to depend in some way on our knowledge of Blake's own poetry but only inexactly and dubiously.

The print traditionally known as *Hecate* (fig.52) may relate to elements of Blake's mythology found in the prophetic books. It has been proposed that the image illustrates Blake's female character Enitharmon setting out her false ideas of religion and creating guilt and division (represented in the male and female figures who hide their faces in shame behind her back). Yet the image is replete with traditional witchcraft motifs, and has been equally associated with themes from Greek tragedy, Dante's story of Ugolino and his sons, as well as with the 'Cave of Despair' in Edmund Spenser's *Faerie Queene* (1590), and the idea of melancholy, all of which would have been grasped immediately by any contemporary of Blake's.[12]

Even when the source matter is ostensibly obvious, there is the possibility of detecting further layers of meaning. *Elohim Creating Adam* 1795/c.1805 (fig.53) refers to the lines,

'And the Lord God formed man of the dust of the ground, and breathed into his nostrils the breath of life, and man became a living soul' (Genesis 7:2). In that sense it is a straightforward representation of the subject of 'God creating Adam', under which title Blake referred to this print when he sold it to Thomas Butts in 1805. It is inscribed with the title given here, and, as Elohim is a Hebrew name for God, which also means 'judge', this may adjust our interpretation of the print. Blake's visual conception of God here can thus be connected with his poetic allusions to the Old Testament deity as a potentially cruel and oppressive lawmaker. Significantly, a snake or worm is wrapped around Adam's lower limbs, and this has been elaborated as a multiple symbol in Blake's art, as an emblem of nature (in the title page to *Europe*, fig.40), of materialism, and of sin. Here, it is suggestive of themes of sinfulness, mortality and imprisonment, of man in the moment of his creation being tied down to the material world.

These negative aspects of man's existence are also suggested by two further prints, *Nebuchadnezzar* (fig.55) and the famous *Newton* (fig.54), the former representing the Old Testament king who was driven to animalistic madness by his pride (Daniel 4:31–3), the other the scientist Isaac Newton (1643–1727), preoccupied with reason and thus condemned to exist in darkness, looking down on his geometric calculations and away from the joyful multiplicity and even chaos of the world (evoked, we might suggest, in the glittering 'accidental look' of the rocks he is seated upon). These two prints can be persuasively paired, as

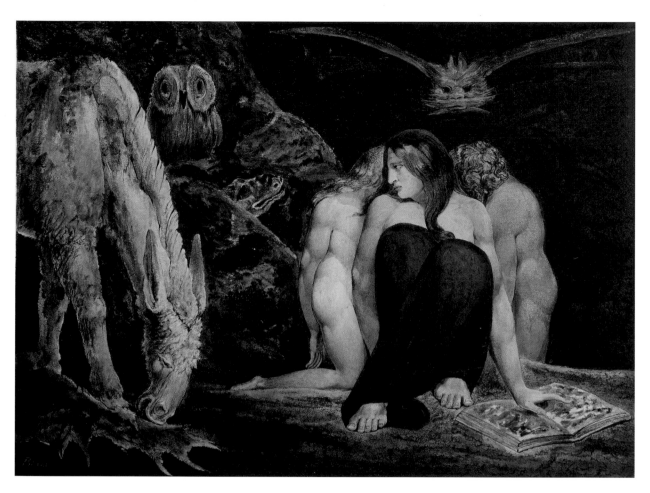

52
*Hecate (or 'The Night of
Enitharmon's Joy')*
c.1795
Colour print finished in ink
and watercolour on paper
43.9 x 58.1
Tate

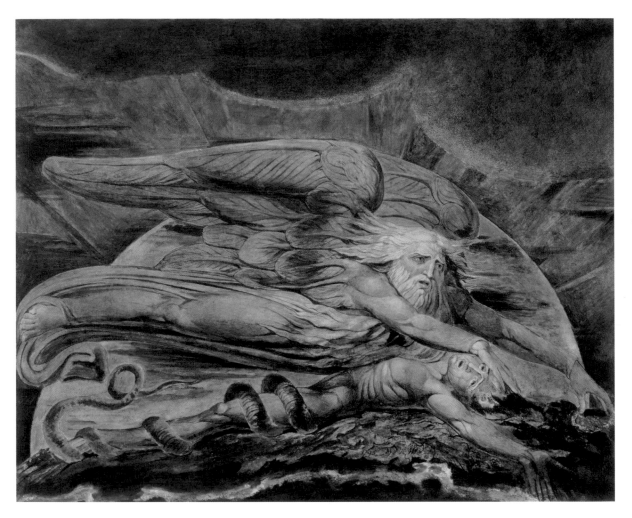

53
Elohim Creating Adam
1795/c.1805
Colour print finished in ink
and watercolour on paper
43.1 x 53.6
Tate

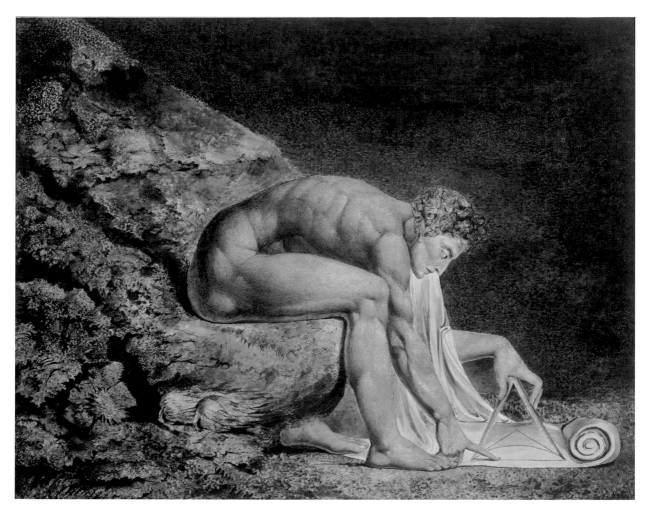

54
Newton
1795/c.1805
Colour print finished in ink
and watercolour on paper
46 x 60
Tate

55
Nebuchadnezzar
1795/c.1805
Colour print finished in ink
and watercolour on paper
54.3 × 72.5
Tate

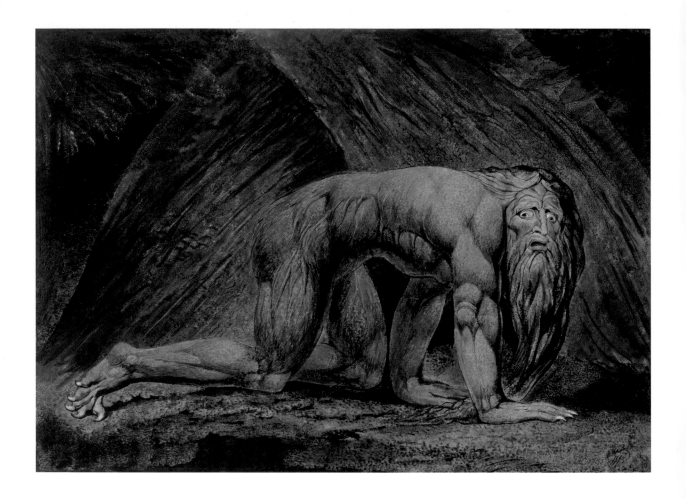

illuminating aspects of man's error in pursuing materialism or blunt rationalism; the oddness of such a pairing of a character from biblical history and a monumental representation of a recent historical figure in the form of a spiritual allegory, is reduced if we consider that what is being shown in both cases is a personification of an idea, a way of making a philosophical viewpoint 'intuitive' (that is, understood through the senses). Whether the idea takes the form of a historical figure who is described in character, of a kind of portrait (and Blake's representation of Nebuchadnezzar matches the description in the Bible: 'His body was wet with the dew of heaven, till his hairs were grown like eagles' feathers and his nails like birds' claws'), or an abstracted and idealised spiritual embodiment of a figure that appears entirely detached from any descriptive source material, is almost beside the point. Blake's Bible is one source for the twelve prints, alongside Milton and Shakespeare, traditional imagery and Greek tragedy, his own imagination and history, because all that each of these does is embody spiritual realities under different garbs. That, at least, is what we can claim as Blake's principle, derived variously from the traditions of religious dissent and mystical thought, and the more immediate sources of idealistic art theory (notably Fuseli's) and scholarship on language and symbolism.

The Painter's Bible

The first documented owner of the twelve large colour prints was Blake's leading sponsor Thomas Butts, who is recorded as buying eight in 1805–6, and must have bought more, perhaps a complete set. Butts's largest commission from Blake was to extend the artist's exploration of Christian subject matter, in the form of a long series of biblical illustrations. Blake and Butts may have met in the earlier 1790s, and were corresponding warmly by 1799. At that time, Blake noted that 'I am Painting small Pictures from the Bible', and claimed he had an order for 'Fifty small Pictures at One Guinea each'. About thirty of these temperas are known to survive today. Around 1800 Blake began another series of Bible illustrations, this time in watercolour, for Butts. Blake had started the watercolour series before moving to Felpham to work for William Hayley in September 1800. He did not work on the series much while he was there. He did, though, work intensively when he returned to London in 1803, and it appears that he produced the bulk of the series in the next two or three years. He continued work on them through to 1806, though he may have added to the series after this date. One is dated 1809. Between 1805 and 1806 he also produced a distinct series of watercolour designs from the Book of Job for Butts. So, over a period of a decade Blake produced a very considerable body of biblical images for Butts, perhaps one hundred and fifty in all. Although these works are individually small in format, they add up to a large-scale pictorial endeavour. They had a certain public profile, too, for Blake exhibited examples of the tempera paintings at the Royal Academy in 1799 and 1800, and two of the watercolours there in

1808 and in his own exhibition in 1809.

Evidently, in terms of technique and chronology, but also thematic focus, we are not talking here of a single, linear sequence of images that had been conceived in its entirety in 1799, or even, we suspect, later. Instead, the intended purposes of the series as a whole may have shifted over time. The initial sequence of small tempera paintings – pictures in 'fresco' according to Blake's own terminology – were perhaps intended for a specific architectural setting as a form of 'furniture' (pictorial decoration). Certainly, it would seem unlikely that Butts would commission such an extended series without first considering where and how they would have been displayed. *Christ Blessing the Little Children* (fig.56) comes from this initial sequence of paintings, and is dated by the artist 1799. The picture is presumed to allude to Mark 10:13–16:

And they brought young children to him, that he should touch them: and his disciples rebuked those that brought them. But when Jesus saw it, he was much displeased, and said unto them, Suffer the little children and forbid them not: for of such is the kingdom of God. Verily I say unto you, Whosoever shall not receive the kingdom of God as a little child, he shall not enter therein.
And he took them up in his arms, put his hands upon them, and blessed them.

Cast into the context of dissenting religion and Blake's own poetry, the image may take on further resonances, as an allegory of the radical Church, and as an expression of the theme of 'innocence' explored in *The Songs of Innocence*. It is, above all, an image of almost disarming directness, with its warm tonalities (albeit adjusted and mauled by damage and restorations), the doll-like proportions of the figures and the pastoral setting.

Whether due to the technical problems with the tempera medium, or because of a change of mind in Butts or his artist, the 'fresco' series was largely left off in 1800, although Blake may have added a few further works in the coming years. From that date, the new watercolour series took precedence. David Bindman has suggested that Butts considered using these watercolours to 'extra-illustrate' a printed Bible, at least at first.[13] Extra-illustration was the practice of adding in drawings or prints between the pages of a published volume. Between 1800 and 1803 Blake produced single illustrations for most of the Old Testament books, which could have been fairly neatly arranged in a large-format copy of the Bible. The watercolour known as *The Blasphemer* (fig.57) dates from this first sequence, and shows either Achan being punished for his greed by Joshua (from Joshua 7:18–25) or the blasphemous son of an Israelite woman being stoned to death on the orders of Moses (Leviticus 24:10–25). The subject is not certain, and although a textual reference to the latter subject appeared on the mount, the authority of such inscriptions in this series is disputable. In either case, the extravagant physicality of the scene, with the bizarrely distorted central figure and the starkly repeated forms of his accusers, are visually arresting, and evoke the imagery of

56
Christ Blessing the Little Children
1799
Tempera on canvas
26 x 37.5
Tate

THE BLAKE BOOK

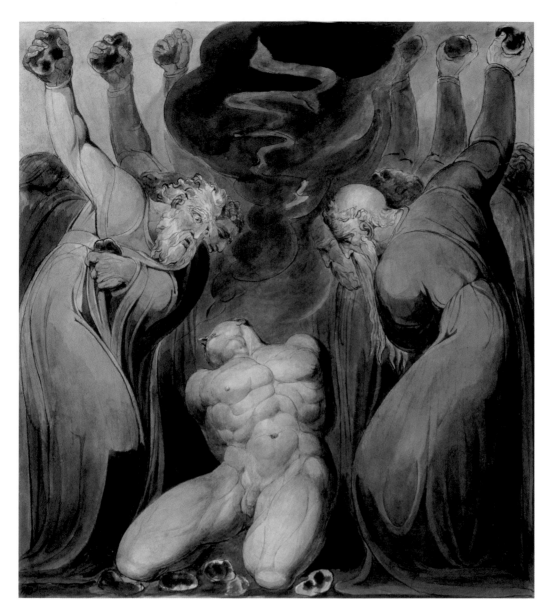

57
The Blasphemer
c.1800
Pen and watercolour on
paper
38.4 x 34
Tate

Promethean heroes explored by artists in the previous decades, and Blake's own revision of the myth with his figure Orc.[14] In the context of an Old Testament scene, the contrast between the central, heroically proportioned figure and the fiercely blank expressions and mechanical actions of the old bearded men implies a condemnation of the iron laws handed down by Moses, giving visual form to Blake's views on 'State Religion which is the source of all cruelty'.

A further subset, unified in their tonality and format, represent the Crucifixion and Resurrection. In *The Crucifixion* (fig.58), Christ commends his mother to the care of John his disciple: 'Then saith He to the Disciple, "Behold thy Mother!" and from that hour that Disciple took her unto his own House' (John 19:27). The sombre tone continues with *The Entombment* (fig.59), which seems to bring together references from Luke and John to represent both the presence of the 'three Maries' (Mary Magdalene, Mary the mother of Christ, and a third women variously identified by tradition) and his disciples Joseph of Arimathea and Nicodemus (the two bearded figures to the left). The spectacular watercolour of *The Death of the Virgin* (fig.60) was apparently originally inscribed with the same lines as those alluded to in *The Crucifixion*, and offers a profound contrast in its heightened colour effects, while also extending the tendency to rather stark symmetry apparent in the other painting. Both works evoke the attenuated forms and repetitively arranged draperies of medieval sculpture.

It is in part the formality of Blake's Bible watercolours that helped him realise the most outrageous and abstract of imagery in a persuasive visual form. As Bindman notes, Blake was 'arguably the first major artist since Dürer to attempt a comprehensive picturing of the fantastic imagery of the Book of Revelation and the biblical books of prophecy, rather than representing them by figures of the prophets themselves *writing* the visions'.[15] The figural language of revelation is embodied by Blake in the most strident terms, sometimes delineating biblical imagery in rich detail, sometimes elaborating and layering meaning on the basis of much slighter allusions. *Satan in his Original Glory* (fig.61) and *The Whirlwind: Ezekiel's Vision of the Cherubim and Eyed Wheels* (fig.62) elaborate visionary scenes from the Old Testament book of Ezekiel. In *The Whirlwind* the prophet himself appears as the diminutive figure reclining at the bottom of the composition, while above him God delivers in a whirlwind an intricate vision of 'the likeness of four living creatures … they had the likeness of a man', each with four faces, and each with four wings. *Satan in his Original Glory* takes a much slighter reference from later in Ezekiel, to the 'king of Tyrus', Satan, before his fall, on the 'mountain of God' and 'covered' with precious jewels and highly worked musical instruments. These are presumably personified in the fairy-like figures that dance and play around Satan.

As prophecy, the Book of Ezekiel was among the Old Testament texts that Blake appears to have considered highly,

58
The Crucifixion: 'Behold Thy Mother'
c.1805
Pen and ink and watercolour on paper
41.3 x 30
Tate

59
The Entombment
c.1805
Pen and ink and watercolour on paper
41.7 x 31
Tate

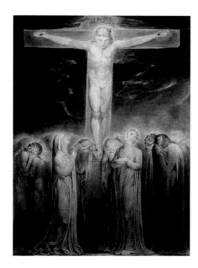

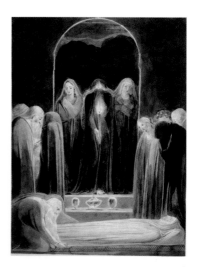

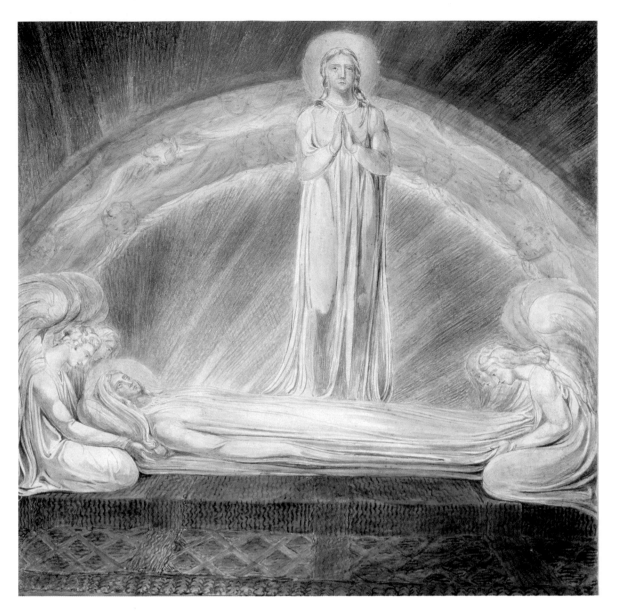

60
The Death of the Virgin
1803
Watercolour on paper
37.8 x 37.1
Tate

61
Satan in his Original Glory
c.1805
Pen and ink and
watercolour on paper
42.9 × 339
Tate

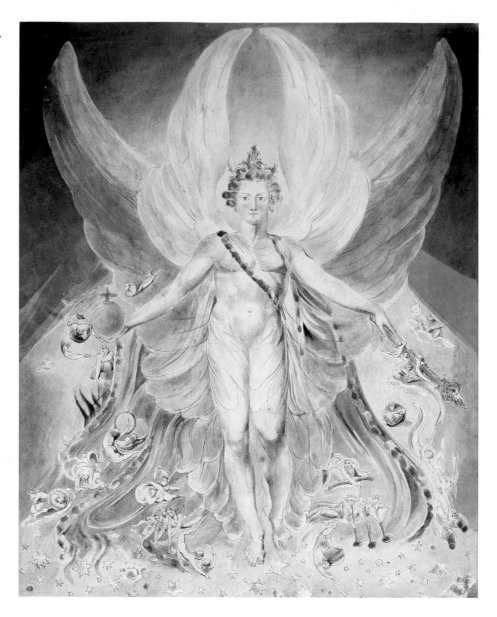

62

The Whirlwind: Ezekiel's Vision of the Cherubim and Eyed Wheels
c.1803–5
Pen and ink and watercolour over pencil on paper
39.4 x 29.5
Museum of Fine Arts, Boston

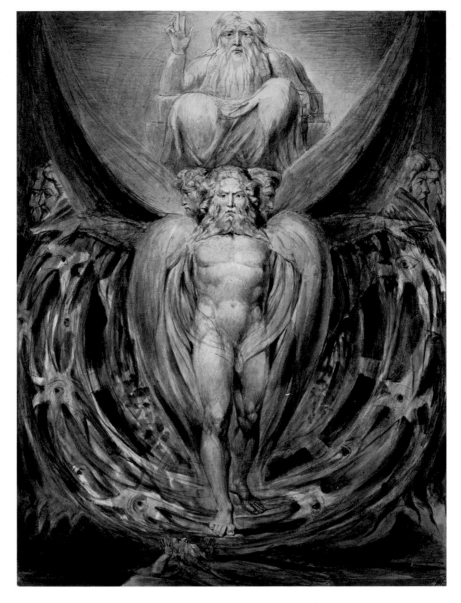

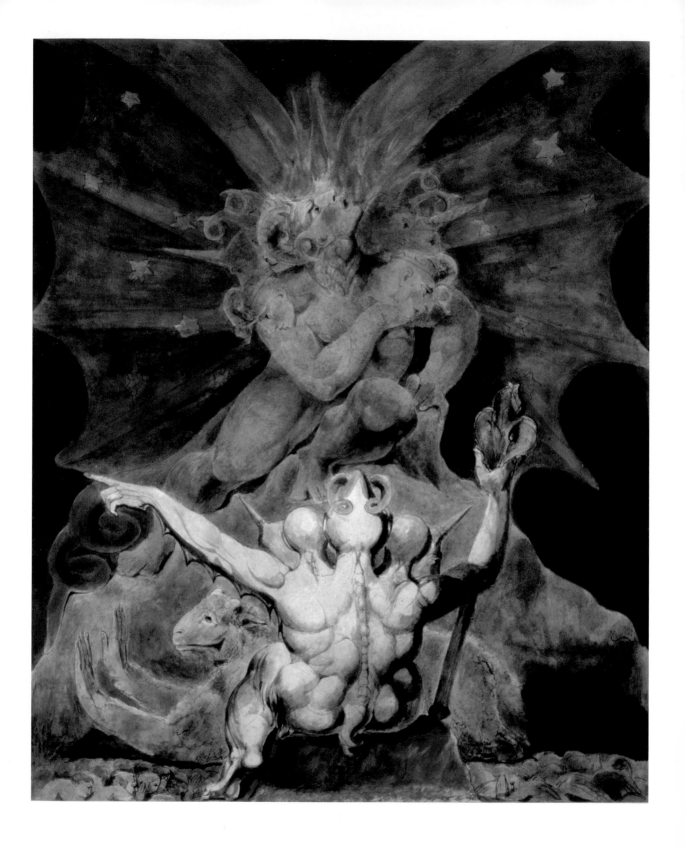

63
The Number of the Beast is 666
c.1805
Pen and ink and
watercolour on paper
41.2 x 33.5
Rosenbach Museum and
Library, Philadelphia

representing as it did vision and inspiration rather than the damnable moral laws issued by Moses and condemned in *The Blasphemer* (fig.57). The Book of Revelation itself was the subject of at least eleven watercolours, encompassing the dazzling spectacle of St John's vision of the throne of God, detailed precisely by the artist (fig.74), a concentrated group focusing on the apocalyptic climax of 'The Red Dragon', the 'Beast' and another horned figure who 'spake like a dragon', 'his number is Six hundred threescore and six' (fig.63), and the monstrous woman of Babylon 'upon a scarlet coloured beast, full of names and blasphemy, having seven heads and ten horns' (fig.64). These images have fascinated scholars who would wish to relate Blake to the most obscure esoteric traditions, alchemical and numerological ideas, world religions and philosophies, so each gesture, or colour, every multiplication of forms or symbols might be subjected to analysis. But the languages of revelation and apocalypse were more immediately available to Blake, in the form of the dissenting ideas of religious and political radicals, a tradition of apocalyptic imagery that was becoming obscure by the 1790s and treated, among a polite bourgeois society that defined itself through its rationalism and liberal viewpoint, as outlandish, even dangerously so. For many living through the unprecedented historical traumas of the revolutionary 1790s and 1800s, it seemed that the biblical apocalypse, so often in the past treated coolly as a form of distant allegory, was becoming a reality. As Christopher Burdon, a historian of

apocalyptic ideas, states: 'The mythical and the monstrous have now become a matter of contemporary public experience; they cannot so easily be bound in patterns of regular chronology or in a detached world of Gothic fantasy.'[16] Perversely, it is precisely this outlandishness that made such imagery appealing to later bourgeois tastes, both among the cliques of Blake's supporters at the end of his life, and, even more so, for the artists and writers drawn to his work in the later part of the nineteenth century. However much this imagery might have been anchored in a tradition of radical religious dissent, it is these extravagances that later helped transform Blake into 'a wild pet for the supercultivated' (to use T.S. Eliot's phrase, see p.188).

The largest and most coherent subset of biblical watercolours created for Butts was the series treating the Book of Job.[17] This biblical text was used repeatedly by Blake; it was here that the idea of moral law and the nature of God's justice were tested out in the most obscure way. Blake first took subjects from Job in the mid-1780s; an engraving and several drawings based on this theme are dated to that period. A further engraving of *Job* is dated 1793. The subject of Job appears twice in the initial series of biblical temperas and watercolours that Blake executed for Butts, and, in around 1804 or 1805, presumably as an extension of that commission, Butts had Blake create a whole series of designs based on the biblical book. The final result was a series of twenty-one watercolours, mainly executed between 1804 and 1810, and perhaps more

64
The Whore of Babylon
1809
Pen and ink and
watercolour on paper
26.6 x 23.3
The British Museum,
London

65

*Job and His Family
Restored to Posterity*
c.1805–6
Pen and ink and
watercolour on paper
23.4 x 27.6
Morgan Library &
Museum, New York

specifically around 1805–6, although two of the series appear to have been executed and added at a much later date. Like the other Bible illustrations, they tend to a strong sense of symmetry in their compositions, and the first design of *Job and His Family* recalls quite directly the earlier tempera of Christ and the children (fig.56).

The Book of Job appears in the Old Testament. Job is a wealthy and pious citizen of Uz, 'the greatest of all the men of the east' (Job 1:3), who lives a righteous life and who should thus, according to conventional wisdom, be rewarded by God. However, he suffers a succession of appalling misfortunes. These are sent to him as a test by Satan, who has been given power over Job by God. Job's cattle, sheep and camels are stolen or destroyed, his children are killed, and Job himself is struck down with plague. Though three of his friends argue with him that his sufferings must be a punishment sent by God, Job insists that he is innocent. He experiences visions and is visited by God. He laments his fate and complains about the extent of his sufferings, comes to bleak and challenging conclusions, but is eventually allowed to live happily with greater wealth than before, and in the joyous company of a new family (fig.65).

A provocative combination of poetic vision and philosophical dialogue, the Book of Job conveys an ambiguous message. It does not dictate a moral, but offers a debate that remains unresolved. According to medieval tradition, and more recently and pertinently, Swedenborg, the story of Job foreshadows

that of Christian salvation. Blake's designs allude to this parallel. Christ himself appears to Job in a vision in the design illustrating Job 42:5: 'I have heard of thee by the hearing of the ear: but now mine eye seeth thee.' In the opening design of the series, *Job and His Family*, a Gothic church appears in the background to the left, and behind that is a setting sun with part of the beginning of the Lord's Prayer drawn within it: 'Our father which art in Heavn Hallowed be thy Name thy will be.' His further designs show Satan's challenge to God, the awful fate suffered by Job's sons and daughters, the prophet himself struck down with the plague, and his terrific visions and dreams. In *Behemoth and Leviathan* (fig.66), Job appears with his wife and friends, while God leans down from the clouds and points out to them the monsters Behemoth and Leviathan, the first a terrible land animal, incorporating elements of an elephant or rhino and a bear, and the last a scaly sea-creature breathing fire:

Behold now behemoth, which I made with thee; he eateth the grass as an ox. Lo now, his strength is in his loins, and his force is in the navel of his belly. He moveth his tail like a cedar: the sinews of his stones are wrapped together. His bones are as strong pieces of brass; his bones are like bars of iron.

As for Leviathan:

His scales are his pride, shut up together as with a close seal. One is so near to another, that no air can come between them. They are joined one to

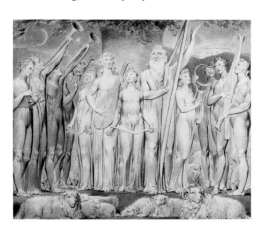

another, they stick together, that they cannot be sundered. By his neesings a light doth shine, and his eyes are like the eyelids of the morning. Out of his mouth go burning lamps, and sparks of fire leap out. Out of his nostrils goeth smoke, as out of a seething pot or cauldron.

Job's story, of a man awakened spiritually into a state of creativity by way of terrible sufferings and gigantic, elemental visions, is echoed through Blake's later work. Blake explicitly refers to Behemoth and Leviathan in his epic illuminated poem *Jerusalem* (c.1804–20) as representatives of war on land and in the seas respectively, and attaches them to his allegorical representations of the Prime Minister William Pitt (fig.84) and the naval hero Nelson in his tempera paintings of their 'spiritual forms' (fig.83). What Blake the Christian artist proposed with such designs was that the impending apocalypse – individual and global – could herald a new spiritual dawn such as that experienced by Job in the conclusion to the narrative.

Milton

The poetry of John Milton (1608–74) was of central importance to Blake's work as a poet and a painter.[18] In his ironic *Marriage of Heaven and Hell* 1790, Blake wrote that 'The reason Milton wrote in fetters when he wrote of Angels & God, and at liberty when of Devils & Hell, is because he was a true Poet and of the Devils party without knowing it'. In those heady times, Milton appeared the exemplar of the artist who was full of revolutionary energy, called, by the oppressive reasoning of

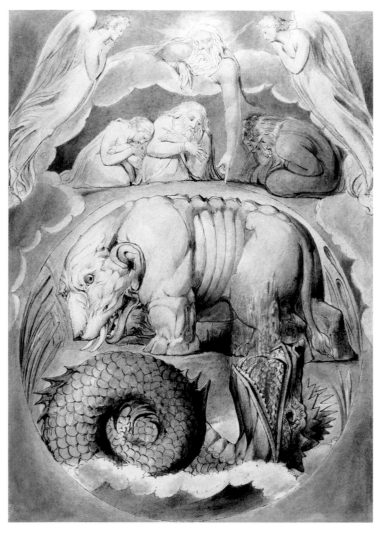

66
Behemoth and Leviathan
c.1805–6
Pen and ink and
watercolour on paper
27.3 x 19.6
Morgan Library &
Museum, New York

John Milton (1608–74)

The poet and political writer John Milton was one of the most widely admired writers in English during Blake's lifetime. He was thoroughly educated in the classics, and his first substantial poem, 'On the Morning of Christ's Nativity' was written while he was still at Cambridge (1629). 'L'Allegro' and 'Il Penseroso' (1632) related the themes of joy and melancholy, evoking appropriate landscape settings. Destined for a career in the Anglican Church, Milton remained independent and critical of the religious establishment. The English Civil War (1642–51) radicalised his religious and political vision, and helped generate an ambitious, fiercely reforming sense of national pride. Frustrated by the political and religious compromises that followed, and the return of monarchy, Milton retreated from public life. His later poems, written when he was blind, present an epic vision of spiritual conflict, full of contradictions and paradoxes. *Paradise Lost* (1667; revised 1674) re-envisages biblical narrative, conjuring vast images of Satan's rebellion against God, the Garden of Eden, and the corruption of Adam and Eve. *Paradise Regained* (1671) traced the themes of salvation by elaborating on Satan's temptations of Christ.

Although *Paradise Lost* sold slowly in Milton's lifetime, by the time of his death its literary reputation was being made, with new editions, translations and adaptations. His fame escalated in the eighteenth century, as scholarly and critical commentaries proliferated. Joseph Addison dedicated a series of essays to him in the journal *The Spectator* (1711–12), which was aimed at a wide literary public. By the middle of the eighteenth century *Paradise Lost* was compared to the greatest ancient epics; only Shakespeare stood before Milton as a writer in the English language. It has been estimated that there were more than a hundred editions of *Paradise Lost* alone during the eighteenth century.

By Blake's time Milton was common property among the literate classes. We can expect that any educated (or self-educated) person would be familiar with *Paradise Lost* (along with the Bible and John Bunyan's *Pilgrim's Progress*) to a degree that may be hard to imagine. But Samuel Johnson claimed that nobody would read Milton for pleasure: '*Paradise Lost* is one of those books which the reader admire and lays down, and forgets to take up again. (None ever wished it longer than it is). Its perusal is a duty rather than a pleasure.' John Wesley complained that *Paradise Lost*, powerful and sometimes beautiful as it may be, 'is unintelligible to abundance of readers'. Yet this very potency, the crowding and extravagance of Milton's imagery, made the text all the more appealing for readers of Blake's generation. Successive writers on the Sublime – the aesthetics of grandeur and extravagance – claimed from Milton the most pertinent examples of the power and grandeur that was possible with poetry.

Samuel Johnson called Milton a 'surly and acrimonious republican', but this was simply downplayed or overlooked by most of his admirers in the eighteenth century. Milton stood instead for a particular kind of political fortitude and integrity that could be folded into a rather generic notion of English 'liberty', without calling into question the institutions of the monarchy and the state. In 1737 a monument to Milton was erected in Westminster Abbey, setting, quite literally, the poet's reputation in stone in the context of a national literary heritage. Even in the era of the French Revolution and wars, Milton could be openly heralded as a bastion of political liberty and integrity, as well as the poet of revolution.

Some further reading:
John T. Shawcross (ed.), *Milton, 1732–1801: The Critical Heritage*, London 1972
Dustin Griffin, *Regaining Paradise: Milton and the Eighteenth Century*, Cambridge 1986
Lucy Newlyn, *Paradise Lost and the Romantic Reader*, Oxford 1993
Kay Gilliland Stevenson, 'Reading Milton, 1674–1800', in Thomas N. Corns (ed.), *A Companion to Milton*, Oxford 2001

the state and reactionary spiritual forces, demonic. In the spiritual autobiography he wrote to Flaxman in 1800 (see p.181), it was Milton who 'lovd me in childhood' and first inspired him to poetry, suggesting the gentler vision that was to come. Along with Shakespeare and Chaucer, Milton appears in the apocalyptic vision at the end of *Jerusalem* (c.1804–20). For Blake, the poetry and, importantly, the biography of Milton provided a source of grand imagery, but also a lesson. Blake interpreted Milton's imagery in order to trace his own narratives, seeing in the poet the potential for genuine inspiration initially frustrated by Puritan doctrine and an inhibiting sense of morality.

Although the deeply personal aspects of Blake's interpretation of Milton can be stressed, his direct illustrations of the poet were the result of a series of commissions. Blake was commissioned to produce illustrations to Milton's masque *Comus* (1634) in 1801, by the Revd Joseph Thomas. Another set of illustrations to the same poem were commissioned by Butts in around 1815. Milton's epic poem *Paradise Lost* (1667) was illustrated by Blake in a series of twelve illustrations commissioned by Thomas in 1807; a further set of twelve was commissioned by Butts in 1808 and three more by John Linnell in 1822. *Paradise Regained* (1671) was painted for Linnell in around 1816–20. Milton's 'On the Morning of Christ's Nativity' (1629) was the subject of a set of six watercolours commissioned by Thomas in 1809; Butts followed with his commission of further versions of the same designs (executed perhaps around 1815). Then, of course, Milton

was a character in Blake's own poetry, with the epic *Milton* (dated 1804–10) named after him. Thus Blake returned to Milton and to Miltonic subjects repeatedly over a period of about twenty years.

In a letter to Butts dated 25 April 1803, Blake wrote:

I have in these three years composed an immense number of verses on One Grand Theme Similar to Homers Iliad or Miltons Paradise Lost the Person & Machinery intirely new to the Inhabitants of Earth (some of the Persons Excepted) I have written this Poem from immediate Dictation twelve or sometimes twenty or thirty lines at a time without Premeditation & even against my Will. the Time it has taken in writing was thus renderd Non Existent. & an immense Poem Exists which seems to be the Labour of a long Life all produced without Labour or Study. I mention this to shew you what I think the Grand Reason of my being brought down here.[19]

The 'three years' Blake refers to here were his time staying near William Hayley in Felpham, Sussex, and the lengthy, inspired poem he refers is sometimes thought to be *Milton*. This was written in Felpham and London; the title page is dated 1804 (fig.67), but the work appears not to have been completed until around 1810 when it was first printed and put together. The illuminated book was etched on fifty-one plates, twenty-six of which comprise only dense, and barely legible, text. Between forty and forty-five of these plates were included in each of the four known copies of the book. As Blake described it, the poem was written under the spiritual dictation of Milton,

who in this context provides a spiritual guide or revelation about the true nature of poetry. In coded fashion, Blake refers back to his time in Felpham. This had started out optimistically, when it appeared that Hayley's support, in combination with the healthy rural air, would prove a powerful source of inspiration. In the event, Blake became frustrated with the trivial nature of the undertakings provided by Hayley, painting portrait miniatures and producing engraved illustrations for the poet's various publications. His well-meaning advice was taken as an attempt to shape and restrain the artist, to his growing irritation. *Milton* was part of Blake's poetic endeavour to deal with this traumatic period of his life, setting out to liberate Milton from his erroneously restrictive vision, and thus to set out his own obscure vision of the true nature of poetic inspiration.

Milton is divided into two books, which track the return of Milton and then his female counterpart, Ololon, to earth, leading to a cosmic apocalypse, which is also a moment of poetic self-discovery for Milton, Blake and perhaps the reader. The text includes references both to Blake's invented figures, biblical personages, and to historical characters, but connects and conflates them, so that our grasp on these, and on any sense of time or place, or of the biological orientation the text evokes, is repeatedly baffled. In place of narrative, we are invited to enter a vision, a infinite movement through time and space, a dizzying passage through a 'Vortex':

The nature of infinity is this! That every thing, has its
Own Vortex; and when once a traveller thro Eternity,
Has passd that Vortex, he percieves [*sic*] it roll backward behind
His path, into a globe itself infolding: like a sun:
Or like a moon, or like a universe of starry majesty.
While he keeps onwards his wondrous journey on the earth
Or like a human form, a friend with whom he livd benevolent.
As the eye of man views both north & south & west encompassing
Its vortex; and the north & south, with all their starry host;
Also the rising sun & setting moon he views surrounding
His corn-fields and his valleys of five hundred acres square.
Thus is the earth one infinite plane, and not as apparent
To the weak traveller confin'd beneath the moony shade.
Thus is the heaven a vortex passd already, and the earth
A vortex not yet pass'd by the traveller thro' Eternity.[20]

Blake elaborated and named these spatial elements as 'Urthona' (north), 'Urizen' (south), 'Luvah' (east) and 'Tharmas' (west), which are, of course, also names for Blake characters. Extending the figurative method that Blake had drawn from Fuseli in the late 1780s, the text exhibits a visionary literalism: figures of speech and historical figures can

67
Title page from 'Milton: A Poem'
c.1804–11, Copy B, printed 1810–11
Relief etching with watercolour
16 x 11.5
Huntington Library and Art Gallery, San Marino

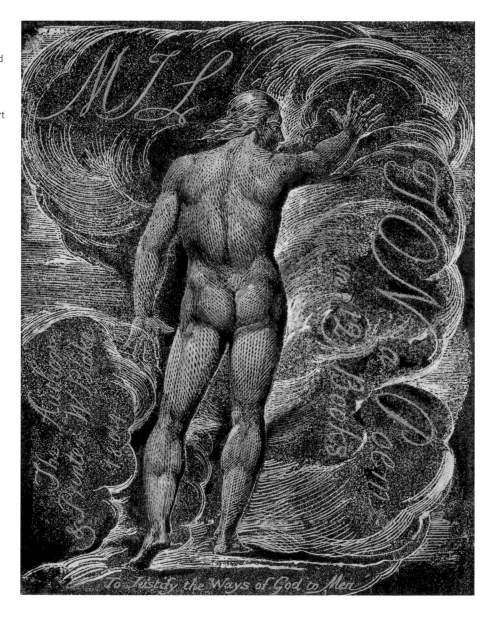

interact, baffling our intellectual division of 'real' and 'invented'.

The idea of the book as a form of travel is suggested in the opening plate, which is dominated by a nude figure seen from behind, thrusting his right hand forward into a plume of swirling smoke. We have a sense here of a heroic protagonist, presumably Milton, but also Blake himself, for the key event of Book One is when the spirit of that epic poet enters our author, by way of his foot (fig.68):

Then first I saw him in the Zenith as a falling star.
Descending perpendicular, swift as the swallow or swift;
And on my left foot falling on the tarsus, enterd there;
But from my left foot a black cloud redounding spread over Europe.[21]

The cosmic vision of *Milton* has entranced generations of readers since the first efforts to really come to grips with Blake's symbolism in the late nineteenth century. Its complexity as a text and as an object has continued to fascinate scholars. But there is interest, too, in the very fact that Blake as an artist has achieved such a degree of obscurity in his vision that it is impossible by any objective measure to assess whether his art has intellectual coherence or is simply unintelligible – or even fraudulent. We have either to accept its terms and go along for the ride, or reject it. In that sense, Blake had, in the early nineteenth century, achieved what was to become the characteristic

position of the modern artist.

The free-wheeling symbolism of *Milton* provides a complex and difficult matrix involving space, time and the human body in radical configurations. There have been repeated efforts to unpack the imagery of this and Blake's other later poems, reforming them into a coherent system that can be traced throughout his own written works and invented images and, much less certainly, through his illustrations to other writers. Blake's own recurring treatment of directly Miltonic themes have tended to be seen in this light, with every symbol and gesture related intimately to our poet's conceptions rather than to his source material. His *Satan Arousing the Rebel Angels* (*Paradise Lost*, Book I, 300–34; fig.69) puts the fallen angel centre-stage, his heroic physique matching the dominant interpretation of the fallen angel as the hero of Milton's epic. As the embodiment of rebellious energy, Milton's Satan represents a potential source of creative inspiration. Meanwhile, the sensual potential of Milton's text is fully explored by Blake, to a degree that goes beyond what the Puritan poet might have approved himself. *Satan Watching the Endearments of Adam and Eve* (*Paradise Lost*, Book IV, 325–35; fig.70) has the original couple engaged in an intimate embrace, Eve's nudity announced rather than hidden. As Stephen Behrendt has explored, in his full-length discussion of these designs, Blake's illustrations do not simply follow the narrative but set up chains of associations and interconnections that emphasise, above all, not the heroic misadventures of Satan, but the

68
Plate 29 from 'Milton: A Poem' c.1804–11, Copy B, printed c.1810–11
Relief etching with watercolour
16 x 11.5
Huntington Library and Art Gallery, San Marino

69
Satan Arousing the Rebel Angels 1808
Pen and ink and watercolour on paper
51.8 x 39.3
The Victoria and Albert Museum, London

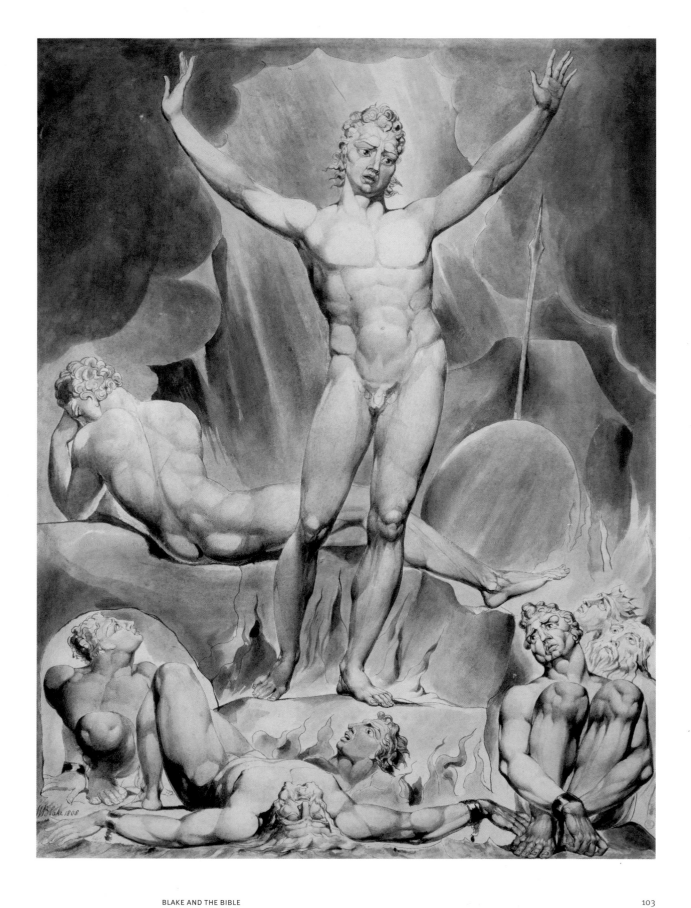

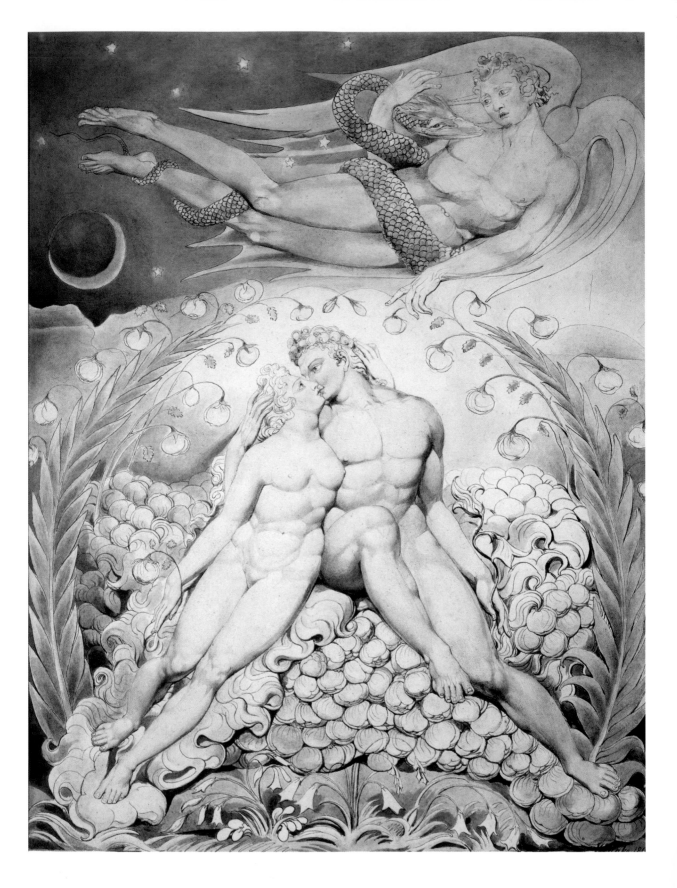

THE BLAKE BOOK

70
Satan Watching the Caresses of Adam and Eve
1808
Pen and ink and watercolour on paper
50.5 x 38
Museum of Fine Arts, Boston

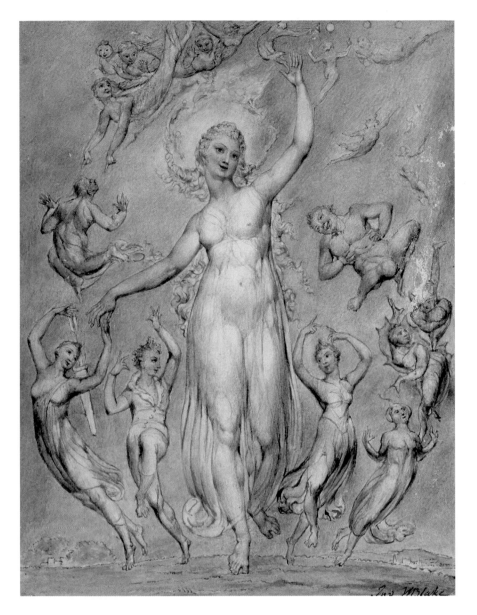

71
Mirth
c.1816–20
Pen and brush, black and grey ink and watercolour on paper
16.1 x 12.1
Morgan Library & Museum, New York

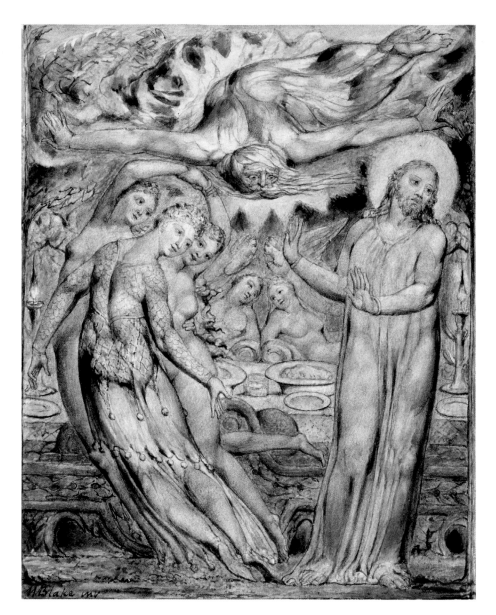

72
*Christ Refusing the
Banquet*
c.1816–20
Pen and ink, grey wash
and watercolour on paper
17.1 x 13.5
Fitzwilliam Museum,
Cambridge

73
Milton in his Old Age
c.1816–20
Pen and ink and
watercolour on paper
15.9 x 12.5
Morgan Library &
Museum, New York

process of salvation through Christ's sacrifice.[22] For the first time among illustrators of the poem, Blake commits a whole design to the Crucifixion, and it is this that provides the pivot around which Blake's reinterpretation of *Paradise Lost* moves.

The cycle of temptation and salvation, and the process of self-discovery, that Blake draws out of *Paradise Lost*, is further manifested in his illustrations of *Paradise Regained*, wherein the whole biblical narrative is encompassed by Milton in the scenes of Christ's temptation (fig.72), and reflected back on to Milton's own poetic life in the illustrations Blake created for the shorter poems 'L'Allegro' and 'Il Penseroso' (1816–20). While the illustrations for *Paradise Lost* lack inscriptions or even numbering that would assert their order and relationship to the source text, making them vulnerable to readings that would connect Blake's iconography from design to design rather than in relation to the narrative, Blake clearly numbered these later designs, transcribed the textual sources and added annotations that indicate that the two poems were used to trace the poet's spiritual development, from joyful innocence to maturity. The former state is embodied in the design of *Mirth*, in which personifications of Laughter flit around the figure of Mirth herself (fig.71). *Milton in his Old Age* shows the poet 'sitting in his Mossy Cell Contemplating the Constellations. Surrounded by the Spirits of the Herbs & Flowers. bursts forth into a rapturous Prophetic Strain.' (fig.73).[23] The poet is here

in a state of spiritual revelation, discovering a true poetic vision not in stern laws of morality but in joy, music and inspiration, as Job had in Blake's earlier design (fig.65).

Both directly, and through the example of Milton, Blake claimed the right to re-invent biblical narratives, introducing an increasingly open and extravagant sexuality into his imagery. As visual spectacles, his religious illustrations convey a sense of heterosexual and sometimes homosexual erotic liberty, which may go beyond his express views about the proper (unequal) relations between men and women, but which have accordingly proved to be alluring and challenging for generations of critics and viewers of all persuasions.

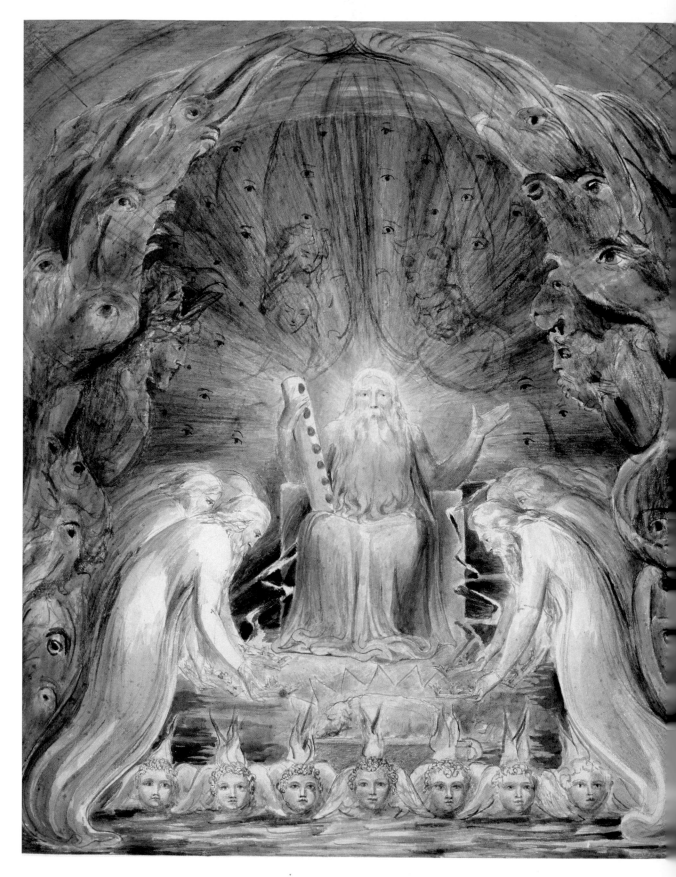

THE BLAKE BOOK

The Four and Twenty Elders

This is among the last of the biblical watercolours that Blake produced for Thomas Butts, as part of a substantial commission begun in around 1800. The intense colour effects are considered characteristic of the watercolours produced around 1805, when Blake returned to the series in a sustained way for the last time. But because of the use of pencil rather than pen and ink, it is thought the drawing may have been started around 1803. The composition is listed in Blake's accounts as among a group of twelve drawings delivered to Butts in May 1805.

The design represents the visionary scene of the throne of God presented to St John in Revelation, Chapter 4, though imagery from Chapters 5 and 6 are also incorporated. The biblical text is taken up with the visionary evocation of the different elements of the scene, and Blake has organised these into a strictly symmetrical order. The basic format of the composition was worked out in a pencil drawing (Tate), in which the central position of the throne and the sheltering pointed Gothic arch formed by the angelic wings are already clearly indicated. In the finished watercolour we can trace each element evoked by the biblical text:

After this I look, and behold, a door was opened in heaven: and the first voice which I heard was as it were of a trumpet talking with me; which said, Come up hither, and I will shew thee things which must be hereafter.

And immediately I was in the spirit: and, behold, a throne was set in heaven, and one sat on the throne.

And he that saw was to look upon like a jasper and sardine stone: and there was a rainbow round about the throne, in sight like unto an emerald.

And round about the throne were four and twenty seats: and upon the seats I saw four and twenty elders sitting, clothed in white raiment; and they had on their heads crowns of gold.

And out of the throne proceeded lightnings and thunderings and voices and there were seven lamps of fire burning before the throne, which are the seven Spirits of God.

And before the throne there was a sea of glass like unto crystal: and in the midst of the throne, and round about the throne, were four beasts full of eyes before and behind.

And the first beast was like a lion, and the second beast like a calf, and the third beast had a face as a man, and the fourth beast was like a flying eagle.

And the four beasts had each of them six wings about him; and they were full of eyes within: and they rest not day and night, saying, Holy, holy, Lord God Almighty, which was, and is, and is to come.

And when those beasts give glory and honour and thanks to him that sat on the throne, who liveth for ever and ever.

The four and twenty elders fall down before him that sat on the throne, and worship him that lived for ever and ever, and cast their crowns before the throne, saying,

Thou art worthy, O Lord, to receive glory and honour and power: for thou have created all things, and for thy pleasure they are and were created.

Blake's deity, enthroned, holds in his right hand 'a book written within and on the backside, sealed with seven seals' (Revelation 5:1). The opening of these seals in Revelation 6 brings forth the apocalypse. Before the throne is 'a Lamb, as it had been slain, having seven horns and seven eyes, which are the seven Spirits of God sent forth into all the earth' (Revelation 5:6). The seven spikes rising from the back of this creature might be taken as alluding to these 'horns', and the seven cherubic faces with flames rising from them in the foreground as representing the 'Spirits of God', and the 'seven lamps of fire' of Revelation 4.5.

The number symbolism apparent in this scene, and the way, as with *Ezekiel's Wheels* (fig.62), that multiples and unities meld into one another, underpinned Blake's own poetic conceptions. In the 'Four Zoas' c.1795–1807, Blake incorporated St John's vision of the throne into his own vast symbolic scheme:

The Cloud is Blood dazling upon the heavens, & in the cloud,

Above upon its volumes is beheld a throne & a pavement

Of precious stones. surrounded by twenty four venerable patriarchs

And these again surrounded by four Wonders of the Almighty

Incomprehensible. pervading all, amidst & round about,

Fourfold, each in the other reflected they are named Life's in Eternity

Four Starry Universes going forward from Eternity to Eternity.[24]

74
The Four and Twenty Elders Casting their Crowns before the Divine Throne
c.1803–5
Pencil and watercolour on paper
35.4 × 29.3
Tate

The Problem of the Public

Blake repeatedly invoked the 'public' as an important entity in relation to his own work as an original artist and independent printmaker. The 'Prospectus', advertising his stock of original prints and illuminated books in 1793, was addressed 'To The Public', and sought to bring to their attention the artist's new printmaking methods, which now made possible a level of artistic independence and visibility that had never been known, not even to Shakespeare or Milton. Here, Blake claimed that his 'powers of invention' were such that 'he has been regularly enabled to bring before the Public works (he is not afraid to say) of equal magnitude and consequence with the productions of any age or country' (see p.165).

Writing to Thomas Butts in 1803, he claimed: 'If it was fit for me I doubt not that I should be Employd in Greater things & when it is proper my Talents shall be properly exercised in Public. as I hope they are now in private. for till then. I leave no stone unturnd & no path unexplord that tends to improvement in my beloved Arts.'[1] To his brother James Blake, he wrote in the same year: 'I know that the Public are my friends & love my works & will embrace them whenever they see them My only Difficulty is to produce fast enough.'[2] It is hard to know quite what to make of this statement. Blake had exhibited infrequently, had no regular showcase for his art, and the original designs that went out under his name in publications or in the annual shows had not been generally well received. By this time he had a certain reputation with some leading artists, notably Thomas Stothard, John Flaxman and Henry Fuseli, all of whom had brought him work, and with the publisher Joseph Johnson in particular. Clearly, he did not exist in complete obscurity; neither could we say that he had a great public reputation. Yet Blake persisted in addressing the 'Public'. Around 1809–10 he wrote a 'Public Address', in which he laid out his rather abrasive theories of art. His commentary on his engraving of Geoffrey Chaucer's Canterbury pilgrims extended these themes, now addressed to a public misled about his reputation and ideas; the first section of his *Jerusalem* opened with a plate addressed 'To the Public'. Plates from *Jerusalem* were exhibited with the Associated Society of Painters in Water Colour in 1812, but other than that brief moment of exposure, and the sideways piece of puffery given by Thomas Griffiths Wainewright in the *London Magazine* in 1820, this poem existed only as a rumour among London's literary and artistic circles, and then as rumour of a insanely epic rant rather than a work of 'magnitude and consequence', as he might claim it to be in his Prospectus.

The problem of conceiving of, and energising, a public for art was a central theme in British art writing of the later eighteenth century.[3] In the more abstract and high-minded kinds of art theory, art mattered and needed to matter only to a tiny elite. Wealthy property-owners (therefore purportedly independent in their views and tastes) and exclusively male (and thus, according to the prevailing sexual stereotypes, coolly intellectual), this elite led the nation in politics

5 Blake and the Public

and could represent its values and qualities in their persons and their tastes. This was the idea, at least. The reality was quite different. While theories of this sort took their model from the societies of the ancient world and Renaissance Italy, modern Britain was quite different. The religious and political upheavals of the seventeenth century meant that Britain's court was a relatively weak entity; there were no great princes to hand out patronage in the arts. The Protestant Reformation meant that the Church was a very limited patron of the figurative arts (though there was a huge amount of church-building in the eighteenth century, and rather more work for painters and sculptors than has traditionally been imagined). Instead there was a wealthy and various – and increasingly so, in both respects – middle rank of society, including landowners, but also professionals, businessmen and skilled craftsmen and traders. How was such a diverse group to be imagined as a 'public'? And how did this match any notion of the 'nation'? What, if any, material investments were they prepared to put into art, traditionally associated with the sorts of ostentatious cultural displays that were considered intrinsically foreign to Britons?

It was obvious to artists and entrepreneurs that there was money out there to be taken, particularly after the imperial wars of the mid-century established Britain's vast international trade. Wealthy landowners and aristocrats were stirred, by patriotism and by the social challenge of the new middle classes, to invest in culture, but the beneficiaries of this patronage were limited in number. There appeared to be greater potential in somehow managing the aggregated resources of the middle classes, the 'public' – or indeed, the 'nation' – as it could now be conceived. The efforts of 'encouragement' societies at mid-century had been directed at somehow improving this 'public' taste, on the assumption that if the populace as a whole were equipped with sufficient critical faculties, then artists would, again by some rather weakly conceived mechanism, acquire material support. The Royal Academy, set up by a self-elected clique of mainly London-based artists, could nonetheless claim a national status and the right to address the public. Yet the opponents of this institution – increasingly vocal during Blake's lifetime – could claim the same. These terms were slippery enough that they could accommodate a variety of vested interests and conflicting values.

It is entirely possible, and really quite productive, to think of the various cultural enterprises of the later eighteenth and early nineteenth centuries as primarily efforts to capitalise on the perceived potential of this new mass-market for art. Which is not to say that many, or indeed any, were really that successful. The idea of a public for art, and the means by which their tastes and values could be reformed in the interests of the nation and of artists individually, was a problem that never went away. It was the source of much personal suffering – as Blake knew all too well – and helped create the paradoxically unreasonable logic that underpins the modern cultural system.

Book Illustrations

The period of Blake's career as a professional engraver has some claim to be considered as a kind of 'golden age' of book illustration in Britain. The number, quality and ambition of illustrated books being published multiplied enormously during his lifetime. Book illustration was a primary source of income for many printmakers; providing designs for these illustrations was virtually institutionalised as a sure, if relatively undistinguished, source of income for painters. Publishing illustrated books was a complex and costly business, and the production and dissemination of such publications involved a range of skilled professionals and a level of investment far beyond the means of most individual artists. It was, therefore, the publishers who held power over book production. They had the capital, the contacts, and the means to disseminate their products; they took the risks, but could also expect the greatest rewards. Even then, the level of capital needed to put an illustrated book into production (to pay the authors, typesetters, designers, engravers, printers and so on) was such that it might be necessary to raise a subscription; individual customers would put down a set sum (perhaps half the final price of the publication) long before the expected publication date, and pay the remainder on receipt of the volumes.

The print shop established, albeit briefly, by Blake with James Parker in 1784 appears to have issued only a handful of separate plates. They could not conceivably have become involved in independent book publication. The wash drawings for 'Tiriel' that Blake produced after this date might be taken as signs of wishful thinking. The publication of a typeset volume incorporating these twelve relatively large designs would have been quite beyond Blake at this time, in financial or technical terms. Could he have offered the manuscript and the illustrations to a publisher, hoping to score a success as James Macpherson and Thomas Chatterton had before with their imaginative, archaistic poems? Perhaps he did, and was rejected. Blake himself accounted for his invention of 'illuminated printing' as a solution to the problem of a poet distributing and profiting from his own works.

Blake failed to set himself up as a print publisher in 1784–5, and again as an self-publishing entrepreneur in 1793. But over these years he was able to establish himself as a fairly successful designer and engraver working for other publishers. Blake would be provided with a drawing or painted sketch, or an opportunity to take a sketch himself of the image in question, and commissioned to translate that design into engraved form. Blake did not, however, enjoy a firm reputation as an original designer of illustrations. His design for the frontispiece of a new translation of Gottfried Augustus Bürger's poem *Leonora* (1796) (fig.75), produced for unknown reasons by an engraver called Perry, was viciously reviewed in the press; a writer in

75
Perry after William Blake
Frontispiece to Gottfried Augustus Bürger,
'Leonora'
1796
Stipple engraving
20 x 16.5
The British Library, London

76

*'Night the Third: Narcissa',
from illustrations to
Edward Young's 'Night
Thoughts'*
c.1795–7
Pen and ink and
watercolour with
letterpress text (printed
1742) on paper
42 × 32.5
The British Museum,
London

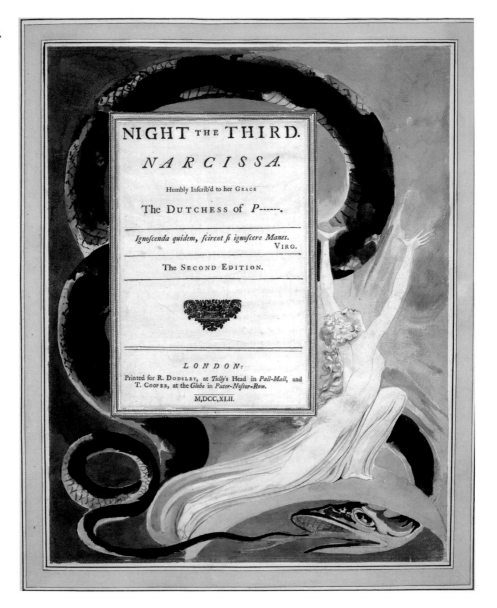

The British Critic complained about 'the distorted, absurd, and impossible monsters' that populated Blake's design, based on 'that detestable taste, founded on the depraved fancy of one man, which substitutes deformity and extravagance for force and expression, and draws men and women without skins, with their joints all dislocated; or imaginary beings, which neither can nor ought to exist'.[4] The 'one man' in question was, of course, Fuseli; these were stock criticisms levelled against his work, and what was being perceived by some by this date as his baleful and extensive influence over contemporary British art. Yet even Fuseli is recorded as expressing his concerns over the extravagance of Blake's imagination, fearing that 'fancy is the end, and not a means in his designs' (see p.183). As J.T. Smith summarised, in his biography of the artist: 'It is most uncertain, that the uninitiated eye was incapable of selecting the beauties of Blake; his effusions were not generally felt … It would, therefore, be unreasonable to expect the booksellers to embark in publications not likely to meet remuneration.'[5]

Yet there were publishers willing to venture on Blake's designs, on quite an ambitious scale. In 1796, the essentially rather conservative and only modestly successful London publisher Richard Edwards took the rather surprising decision to commission a series of illustrations from Blake for a new edition of Edward Young's *Night Thoughts* (1742). The landscape painter and diarist Joseph Farington reported:

Blake has undertaken to make designs to encircle the letter press of each page of 'Youngs night thoughts'. Edwards the Bookseller, of Bond Str. employs him, and has had the letter press of each page laid down on a large half sheet of paper. There are abt. 900 pages. – Blake asked 100 guineas for the whole. Edwards said He could not afford to give more than 20 guineas for which Blake agreed. – Fuseli understands that Edwards proposes to select abt. 200 from the whole and to have that number engraved as decorations for a new edition.[6]

As Farington succinctly describes, the nature of these illustrations was really very odd. Blake's designs were drawn around the sheets of the typeset text, filling the wide margins that were left around the printed paper, and playing around, and 'behind' the page (fig.76). In the end, Blake executed a remarkably long series of designs, more than 530.

Advertising the publication of the first (and in the event, only) part of this new luxury edition, Edwards claimed that the designs were 'in a perfectly new style of decoration, surrounding the text which they are designed to elucidate'. In the 'Advertisement' (really a kind of short explanatory preface) of the published work, Edwards elaborated that these designs 'form not only the ornament of the page, but, in many instances, the illustration of the poem'. Edwards suggests that he understood that Blake has gone beyond decoration; that they also provide 'illustration' (in the more strongly interpretative sense of 'Explanation; elucidation; exposition', as Samuel Johnson's

77

'The Bard', from illustrations to Thomas Gray's 'Poems'

c.1797–8

Pen and ink and watercolour on paper with letterpress text (printed 1790) on paper

42 x 32.5

Yale Center for British Art, New Haven

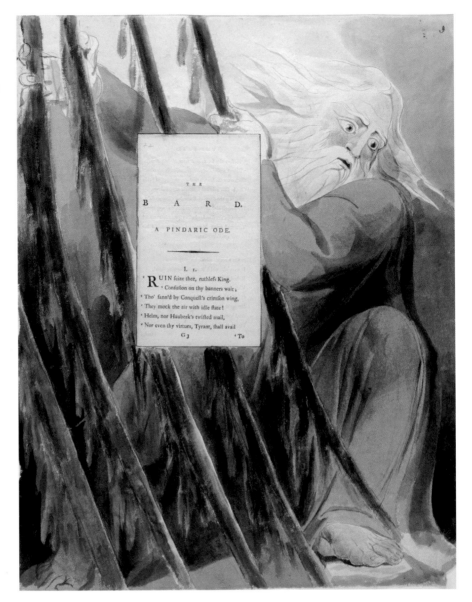

Dictionary of the English Language of 1755 defined it). The means by which this is achieved is the method Blake learned from Fuseli in the 1780s; to literalise and embody metaphors and allusions. As Edward Bulwer Lytton wrote in 1830, referring to Blake's illustrations of Young's poem: 'He seems almost the only poet who has had his mere metaphors illustrated and made corporeal'.[7] Although there is evidence that Blake's designs were quite widely appreciated, the literalism of his approach to the poem is readily open to ridicule. Stothard complained that: 'They were like the conceits of a drunken fellow or a madman. "Represent a man sitting on the moon, and Pissing the Sun out – that would be a whim of as much merit"' (see below, p.183).

Although only the first volume of Young's *Night Thoughts* was published by Edwards, this was among the very best-known, and generally admired, of Blake's works in the coming decades. It also led directly to a second, comparable commission in 1797–8, for illustrations on the same format for Thomas Gray's *Poems*, executed for John and Nancy Flaxman. Again, the watercolour designs occupy the wide margins left around the printed pages (fig.77). There is no evidence that these were intended to be published, though we should not discount the possibility that they had in mind a commercial project given the popularity of Gray's poems, and John Flaxman's business acumen. In the event, they survive as a particularly well-crafted kind of 'extra-illustration'. This was the practice of inserting additional illustrations between the pages of a published volume in order to enhance and illustrate the narrative. Blake was commissioned in 1806 to create such illustrations for the 1632 folio edition of Shakespeare's works owned by the Revd Thomas, who specified the format and size of the designs so that they would match in with the images being created by other artists. As already discussed, it is also possible that the series of watercolour illustrations to the Bible created by Blake for Thomas Butts from around 1800 were intended, at least during the first stages of the project, to be introduced into volumes in this way (see pp.88–90).

The aborted publication of Young's *Night Thoughts* must have been a frustration, but a greater disappointment still was to come with a further great series of illustrations commissioned from Blake, this time by the engraver and publisher Robert Hartley Cromek for illustrations to Robert Blair's famous melancholic poem, *The Grave* (1743). In November 1805 Blake reported that

Mr Cromek the Engraver came to me desiring to have some of my Designs, he namd his Price & wishd me to Produce him Illustrations of The Grave A Poem by Robert Blair, in consequence of this I produced about twenty Designs which pleasd so well that he with the same liberality with which he set me about the drawings, has now set me to Engrave them. He means to Publish them by Subscription with the Poem.[8]

By this time Blake had already executed several of the designs, including *The Gambols of Ghosts According to their Affections Previous to the Final*

78
The Gambols of Ghosts
According to their
Affections Previous to the
Final Judgement
1805
Pen and ink and
watercolour on paper
26.9 x 20.7
Private collection

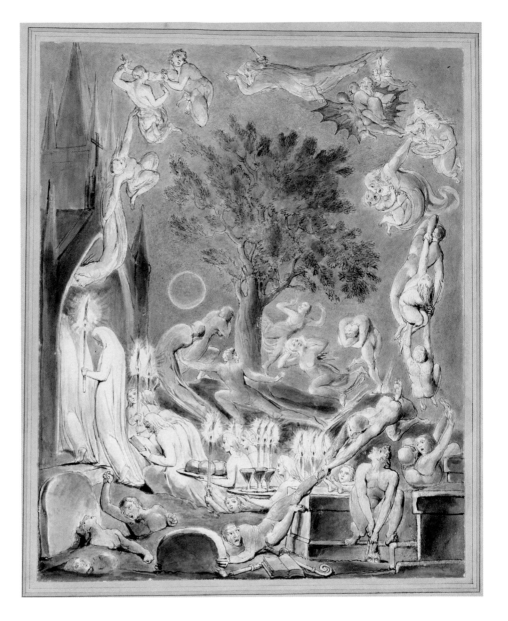

Judgement (fig.78), which Flaxman records as among 'the most Striking'.[9] Writing his letter in November, Blake was able to enclose Cromek's 'Prospectus', advertising the project and trying to drum up interest, and listing fifteen plates to be designed and engraved by Blake. But at this point something went wrong. Robert Stothard (son of the artist, Thomas) says that Blake had 'etched' one of the designs, but Cromek thought so 'indifferently and carelessly' that he turned to the Italian-born printmaker Luigi Schiavonetti to execute the finished plates.[10] It is likely that the design in question is Blake's own relief-etched version of his design *Death's Door* (fig.79). When compared to the subtle tonal effects and gentle visual qualities of Schiavonetti's conventional reproductive engraving (fig.80), qualities that Blake was perfectly capable of producing when needs be, the primitive nature of this print is obvious.

Blake remained committed to the project, even if he was clearly frustrated to have the engraving of his designs taken out of his hands. By 1807 relations between Blake and Cromek were severely strained. Blake had sent a vignette to Queen Charlotte, which had apparently met with royal approval, and had clearly brought this up with Cromek. He replied furiously, stressing the chance he had taken in having 'to create and establish a reputation' for the artist, a great struggle because 'I had not only the public to contend with, but I had to battle with a man who had predetermined not to be served. What public reputation you have, the reputation of eccentricity excepted, I have acquired for

you'.[11] Naturally, leaping to Blake's defence, scholars have tended to see Cromek as short-sighted and even outright cruel. The other side of the story would be to stress the risk he was taking in commissioning designs from an engraver whose reputation as a designer was extremely uneven, and it does seem that Blake went back to Cromek to demand further payments once the original account had been settled.

Blake's approach to these designs was elaborated by Fuseli, whose 'Observations' were printed by Cromek in the 'Prospectus' and again in the published edition of the book. In an age of luxury and corrupted taste, Fuseli writes, the task of exciting and educating the public was an enormous challenge: modern readers expected, demanded, to be surprised by original and incisive imagery. So:

The Author of the Moral Series before us, has endeavoured to wake Sensibility by touching our Sympathies with nearer, less ambiguous, and less ludicrous Imagery, than what Mythology, Gothic Superstition, or Symbols as far-fetched as inadequate could supply. His Invention has been chiefly employed to spread a familiar and domestic Atmosphere round the most Important of all Subjects, to connect the visible and invisible World, without provoking Probability, and to lead the Eye from the milder Light of Time to the Radiations of Eternity.[12]

Yet the literalism of the designs came under attack from other quarters. The radical, middle-class journal *The Examiner* complained

79
Death's Door
1805
White-line etching on paper
16 x 11.4
Collection of Robert N.Essick, Pasadena

80
Luigi Schiavonetti after William Blake
Death's Door
Published in Robert Blair, *The Grave* (1808)
Engraving on paper
24.3 x 13.9
Tate

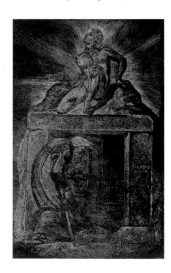

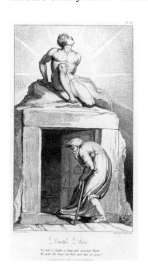

in 31 July 1808: 'Thus, when Mr BLAKE describes "the soul exploring the recesses of a grave, by a figure clad in drapery, holding a candle, and looking into a tomb" no other idea is suggested but simply of a human being examining a tomb.'[13] On 17 September the following year, *The Examiner* returned to the theme, and complained of 'a futile endeavour by bad drawings to represent immaterially by body personifications of the soul, while it's [*sic*] partner the body was depicted in company with it, so that the soul was confounded with the body, as the personifying figure had none of the distinguishing characteristics of allegory, presenting only substantial flesh and bones'.[14] Blake's designs were lampooned in the conservative magazine *The Anti-Jacobin* as well, although the critic admitted that 'the defect of giving strong corporeal semblance to spiritual forms was much less glaring' in the original drawings, as compared to the more solidly descriptive prints.[15]

Distressing as the whole affair may have been for Blake, the prints for Blair's *The Grave* were probably his most widely circulated and admired images for decades to come. Cromek's 'Prospectus' of November 1805 had given the names of the 'Gentlemen' who have already offered 'Subscriptions and Patronage'; it includes the names of thirteen Royal Academicians, not only Blake's old friends Flaxman and Fuseli, but also the President and former royal favourite, Benjamin West (who, politically and artistically, might be considered his complete antithesis), together with Thomas Hope, the pioneering patron of 'Greek' taste, and William Locke, a wealthy amateur artist. As Flaxman noted at the time, it was 'a formidable list'.[16] Blake's portrait by Thomas Phillips, commissioned by Cromek and engraved as the frontispiece of *The Grave*, was exhibited at the Academy in 1807 (fig.81). This was the public face (even literally so) of Blake for generations, and the original painting (National Portrait Gallery, London) may even now be the most frequently reproduced likeness of the artist.

When Blake's wood-engraving illustrations for Dr Robert John Thornton's *The Pastorals of Virgil, With a Course of English Reading, Adapted for Schools* (1821) were published, they were prefaced by a note that sums up Blake's reputation as a book illustrator. Underneath Blake's *Thenot and Colinet* (fig.93), Thornton could proudly note that: 'The Illustrations of this English Pastoral are by the famous BLAKE, the illustrator of *Young's* Night Thoughts, and *Blair's* Grave.' But he also remarked that they 'display less of art than genius' and, damning with a sort of faint praise, 'are much admired by some eminent painters'. Blake's original designs might, then, be appreciated for their 'genius' among artists, but hardly as art by the public at large. His art, at the point it was most widely disseminated among that public, served as a particularly rarefied marker of exclusive or sophisticated tastes. Although he did not benefit materially, once the initial commission was completed, his name and reputation were thus spread, and his art participated in the new patterns of aesthetic discrimination and consumer choice that the expansion of the market for print and the continuing growth of literate society made possible.

81
Luigi Schiavonetti after
Thomas Phillips
William Blake
1807
Published in Robert Blair,
The Grave (1808)
Engraving on paper
37.5 x 26.3
Tate

Nationalism

The long international wars that sprawled across the decades of Blake's life transformed Britain's fate. The Seven Years' War (1756–63) had forged an empire, but the American War of Independence (1775–83) ensured that the idea of creating a coherent international empire of English-speaking Anglo-Saxons was frustrated. From that point, imperial policy focused on the economic exploitation of subjected peoples around the world, from the West Indies to the East Indies (the Indian subcontinent) and, in a preliminary fashion, Africa. The French wars created a fierce sense of pride in Britain's imperial achievements, and created a new sense of a coherent national identity, a Great Britain and a United Kingdom encompassing English, Scottish, Welsh and, only ever problematically, Irish identities.

This was the period in which many of the familiar markers of national identity were put in place. James Thomson's poem 'Rule, Britannia' was set to music in 1740; the Union Flag (or 'Union Jack') itself was first designed in 1801 following the controversial union of Great Britain and Ireland. The deaths of General James Wolfe in 1759, and of Admiral Nelson in 1805, and the rise of the Duke of Wellington as a national leader, provided heroes fit for this new era. Technological changes in printmaking and manufactures meant that their images were spreader wider than ever before, appearing in prints and paintings, on ceramics and glassware, textiles, buckles and buttons. British culture became saturated with images suggesting pride in the national endeavour, provided by painters and sculptors working at every level of society. The portrait painters of the elite created epic paintings of generals shown at the Academy; sculptors were commissioned to create monuments for Westminster Abbey, St Paul's Cathedral, and cathedrals and churches around the country; engravers and designers multiplied their designs and made their own contributions to the iconography of nation. More subtly, as war in Europe made foreign travel impossible, the national landscape became the focus of poets and visual artists. Britain's countryside, its flora and fauna and old ruins and churches, were charged with a new significance.

Patriotism had hitherto been a radical force, rooted in republican traditions of resisting tyranny and the civic independence of the propertied gentleman. A sense of national pride was grounded in Britain's purported traditions of personal liberty and free speech, the strict limitations of state powers and the authority of the king. While this could be bluntly xenophobic, it could also be combined with a sense of cosmopolitanism, an appreciation of the international nature of republican independence and admiration for the cultures and traditions of other nations. The wars of the 1790s and 1800s were accompanied by political paranoia, and Prime Minister William Pitt's war on terror blunted the traditionally radical dimensions of national pride. To be patriotic now tended to mean supporting – not criticising – the king, and opposing, even hating, foreigners as inferior species. Political abstractions like personal liberty and democracy, proclaimed by the revolutionaries of America and France, might now be denounced as alien intrusions upon a more organically formed national political tradition.

Some further reading:
Gerald Newman, *The Rise of English Nationalism: A Cultural History*, London 1987
Linda Colley, *Britons: Forging the Nation 1707–1837*, London 1992
David Simpson, *Romanticism, Nationalism, and the Revolt against Theory*, Chicago and London 1993

The Bard, from Gray
?1809
Tempera heightened with
gold on canvas
60 x 44.1
Tate

Blake at the Exhibitions

If Blake drew his income and status from his association with the commercial realm of engraved illustration, his engagement with the public did not stop there. There is now evidence that Blake's books were sold and shown more widely than has previously been understood, although they only ever had a very limited audience, and an even smaller number of people appreciated them; of them, perhaps none actually pretended to understand what they were reading and looking at. But Blake's original art was exposed to potentially many thousands of people, by being included in the annual exhibitions of contemporary British art organised by the Royal Academy. Blake exhibited watercolours and tempera paintings there in 1780, 1784, 1785, 1799, 1800 and 1808. This may not be a prolific record of exhibition, but any one of these paintings could have been seen by tens of thousands of people during the run of the exhibitions held in the spring of those years, albeit in the midst of many hundreds of other works of art.

The annual exhibitions were the most visible forum for contemporary art, and the growth in visitor numbers over the decades of Blake's career was phenomenal. As a showcase for contemporary art, the exhibitions had a troubled history. The very first exhibitions in the 1760s were riven with discord over entrance charges; as the press coverage accompanying the annual shows grew louder and more combative, and as the walls of the shows themselves became ever more crowded, the stakes were raised and the disagreements and contestations became more vocal. Critics complained that artists were producing works that grabbed public attention with sensational themes or visual effects, rather than creating studious works of academic value. Portraits of celebrities seemed to prevail over pictures of noble literary and historical themes. The Academy itself was aware that artists produced pictures that were big, or had glaring frames, in order to grab attention on the walls. In his first academic lectures, Joshua Reynolds had warned his students against creating facile effects that would too easily please the market; in the form of the annual exhibitions, however, the Academy had itself created the forum in which precisely this superficial facility appeared to gain the greatest impact.

Meanwhile, artists themselves became dissatisfied with the Academy exhibitions. The Academicians and their friends seemed to reserve all the best spots in the display rooms; the workings of the Hanging Committee, which directed the installation each year, was a politically fraught business. The crowds that were rammed into the gallery each year meant that the exhibition grew hot and stinky, and was full of people more interested in being seen than in looking. Certain groups of artists had more serious complaints. If your picture was hung too low it might never be seen: too high, and it might disappear from sight. The Great Room, the largest and grandest space at the exhibition, was given over entirely to oil paintings with miniatures clustered around the fireplace. Watercolour paintings and drawings were generally crowded together in

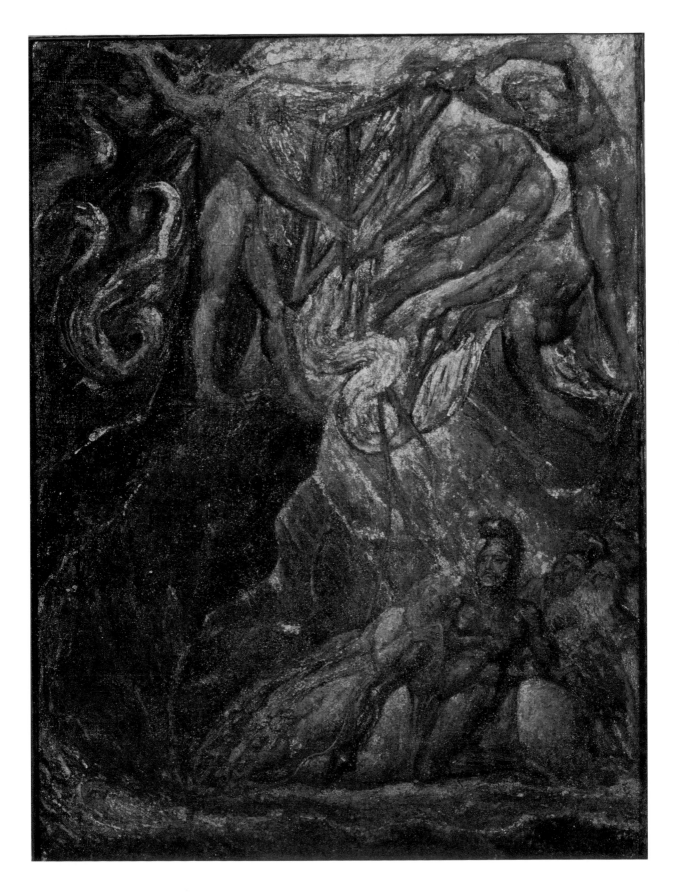

the downstairs room, used for the rest of the year as the Antique Academy.

An alternative was to set up an independent exhibition, which a number of artists attempted with varying levels of success. Withdrawing from the Academy exhibitions permanently in 1784, the leading portrait and landscape painter Thomas Gainsborough held annual shows in his own house. Joseph Wright of Derby, who had a troubled relationship with the institution, held his own show in 1785. John Singleton Copley showed his mammoth contemporary history paintings of *The Death of Peirson* 1781 (Tate) and *The Death of Chatham* 1784 (Tate) in private rooms, to enormous critical and public acclaim. Fuseli had spent the best part of a decade preparing his one-man Milton Gallery, modelled on the efforts of John Boydell and others, but this had flopped terribly when it opened in 1799.

In 1809 Blake joined their ranks with an exhibition held in the family hosier's shop in Golden Square in Soho. These were not, perhaps, ideal surroundings for an art exhibition, nor was Golden Square on the natural route of the cultural tourist: the Royal Academy show was in the Strand, and the further independent exhibitions were in Pall Mall and Green Park, all on or near the conventional tourist route that went from the Tower to Westminster Palace.

The exhibition included sixteen paintings in tempera and watercolour, and was accompanied by a substantial printed catalogue that provided Blake's fullest published statement about art, titled *A Descriptive Catalogue*.[17] For all the esoteric qualities of Blake's imagery, this was an attempt to gain public attention and, more than that, engage the public's interest and reform their tastes. Patriotic and national themes had a significant role to play in this endeavour, as they had done with the earlier one-man shows by more conventional artists. Blake's important painting of Chaucer's Canterbury pilgrims was a prominent exhibit (fig.90). *The Bard, from Gray* (fig.82) draws from that popular poet, in a subject that had been treated by other artists before (and by Blake himself in illustrations for the Flaxmans, fig.77). Blake shows the last of the Welsh bards standing on a cliff top, facing the armies of Edward I. The Welsh were taken among patriotic writers to be the representative native people of the British Isles – the original Britons – who stood out against a tyrannical monarch until their ultimate destruction. In this respect, Blake's painting continues in a tradition of radical history painting, which goes back to Robert Edge Pine and John Hamilton Mortimer in the 1760s.

These paintings are relatively straightforward literary illustrations. *The Spiritual Form of Nelson* (fig.83) and *The Spiritual Form of Pitt* (fig.84) are quite another matter. These mind-bogglingly dense images represent the national heroes as, respectively, a classical athlete and a Christ-like figure, each directing a gigantic monster of war. Nelson directs the actions of Leviathan, the massive serpent, Pitt Behemoth, the monster who represents war on land. But, eccentric as they may seem, these two paintings represent

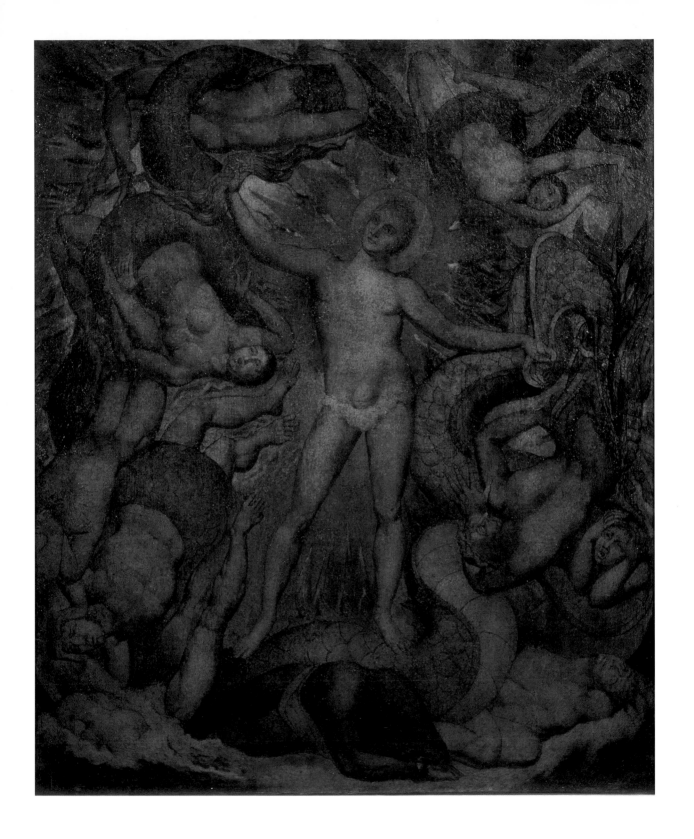

84
The Spiritual Form of Pitt Guiding Behemoth
?1805
Tempera heightened with gold on canvas
74 x 62.7
Tate

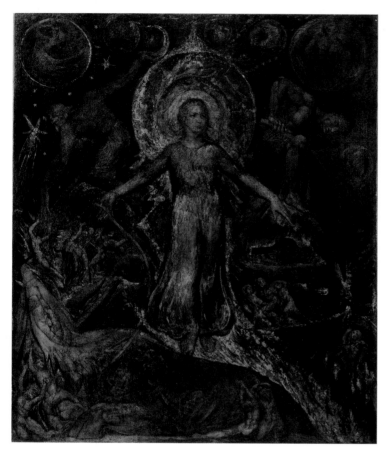

contributions to the contemporary, competitive efforts to apotheosise Nelson and Pitt as national heroes. West had painted a large narrative treatment of Nelson's death and shown this in his studio in 1806. Responding to the competition initiated in 1807 by the government-sponsored Committee of Taste to find the best way to memorialise the hero, West had also exhibited his painted proposal for an altar-like architectural assemblage featuring an allegorical *Apotheosis of Nelson* at his house (Yale Center for British Art, New Haven), and a sketch of the *Apotheosis* itself (National Maritime Museum, London) at the Academy in 1807. Flaxman began the large monument to Nelson for Westminster Abbey, proposed by the Committee, in 1808, and would continue to work on it until 1818. This features Nelson standing on a plinth while Britannia leads two young apprentice sailors to admire him, with a fierce lion standing guard.

A further ambitious monument to Nelson by James Smith was erected in the Guildhall, London, between 1806 and 1811, simultaneously with a monument to Pitt by James Bubb, commissioned in 1806 and unveiled in 1813. Both feature a range of allegorical and mythical figures. Richard Westmacott's allegorical monument to Pitt for Westminster Abbey was begun in 1807 and completed in 1815. The closest parallel to Blake's dense allegories of contemporary political and moral life might in fact be found in the later prints of James Gillray, in which characters from contemporary public life play out parts in cosmic dramas (fig.85).

In the context of these various efforts, Blake's allegorical language may look a little less eccentric or wilful. But the patriotic intent of these efforts in sculpture and public paintings are not in question. Blake's paintings are, by contrast, deeply ambivalent (a characteristic shared only with Gillray from among the artists noted here). A significant feature of Blake's treatment of these heroes in this respect is, at Nelson's feet, a collapsed African slave (the cruel shackle on his wrist is clearly visible). The idea of the racial 'other' being inspired to admiration of or voluntary submission to Britain's imperial heroes was a key theme of nationalist ideology, rationalising the nation's commercial and military expansion as a means of spreading enlightened Christian values. Such characters would feature in conventional sculptural iconography, displaying their gratitude or admiration of dead political or martial heroes; a Native American Indian featured prominently in West's *Death of General Wolfe* (exh. RA 1771; National Gallery of Canada, Ottawa), moved by the death of the hero to admiration, despite what would be assumed about his native savagery by contemporaries. Blake's painting instead represents war as frankly destructive. The role of the subjected race, in that case, could be seen as a herald of apocalypse, and the rebirth of the world. A third picture, of Napoleon, was known in the nineteenth century but is now lost. This was not exhibited in 1809 or at Blake's last contribution to a public show in 1812, and may have been painted only after Napoleon's death in 1821. If this had survived, the patriotic or apocalyptic viewpoint represented in the two temperas might be clarified.

The most important picture in the exhibition is now lost. This was the picture of *Ancient Britons*, painted on a huge scale – with figures larger than life and the overall dimensions of the canvas more than 3 by 4 metres (9ft 10in x 13ft). It was thus a painting on a similar scale to James Barry's *Lear and Cordelia* (fig.22) and Fuseli's *The Shepherd's Dream* (fig.21). The long note that Blake produced about this picture is one of the clearest statements from the artist about how his images should be interpreted (see pp.174–6), but the sheer visual impact of the canvas can only be guessed at. In 1866 Seymour Kirkup recalled having seen the picture in the exhibition, and described it as 'too Greek', with the heads of the figures resembling 'the Hercules & Apollo' (that is, the classical sculptures of the Hercules Farnese and the Apollo Belvedere) too greatly. But he was full of admiration for the picture as a whole, noting: 'There is a great propriety in its academic character, for the Britons went naked – I am not sure if he gave them a sort of bathing-drawer, to make them decent'.[18] The picture appears to have been commissioned, by the Welsh scholar Owen Pughe, and represents a subject taken from his own published studies of ancient British life.[19] Thus we have, exceptionally, a privately commissioned painting on a serious historical subject, painted in a severely classical style, full of patriot feeling,

85
James Gillray
Phaeton Alarm'd!
1808
Etching and aquatint with watercolour on paper
34.2 x 37.8
New College, Oxford

and completed on a very large scale. Such was the ambition of so many painters trained and inspired by the Academy. That Blake was among the very few to achieve such a heroic aim is exceptionally important. If the picture had survived, our image of Blake might be quite radically different: he would be placed even more readily in the company of Barry and Fuseli than he is now.

Blake's way of characterising his efforts in heroic art were, though, quite idiosyncratic. As the *Descriptive Catalogue* elaborated, his ambition was to use this exhibition as the launch-pad for vast public pictorial schemes, which would recover the original spiritual power of art, lost at the far horizons of history and represented only faintly in the surviving sculptures of the ancient world. There are certainly sources for such ideas in the theological scholarship and antiquarian studies of the time, but his configuration of these themes was seen as entirely eccentric. Only a handful of visitors to the exhibition are documented, and even Blake's friends were confused. George Cumberland noted, with interest, that 'Blakes Cat. is truly original', but that it consisted of 'part vanity part madness – part very good sense'.[20] The journalist Henry Crabb Robinson noted in his diary:

I was deeply interested in the Catalogue as well as the pictures. I took four – telling the brother I hoped he would let me come in again – He said – 'Oh! as often as you please' – I dare say such a thing had never happened before or did afterwards.[21]

There was a single published review, and this has gone down in history as the most outrageously vicious single attack on the artist. The art critic Robert Hunt wrote a lengthy tirade in *The Examiner* (17 September 1809), which flatly accused Blake of madness:

If beside the stupid and mad-brained projects of their rulers, the sane part of the people of England required fresh proofs of the alarming increase of the efforts of insanity, they will be too well convinced from its having been spread into the hitherto sober regions of Art ... the poor man fancies himself a great master, and has painted a few wretched pictures, some of which are unintelligible allegory, others an attempt at sober character by caricature representation, and the whole 'blotted and blurred' and very badly drawn. These he calls an Exhibition, of which he has published a Catalogue, or rather a farrago of nonsense, unintelligibleness, and egregious vanity, the wild effusions of a distempered brain.[22]

This was not, though, an attack from the establishment or from the reactionary right-wing. The journal, run by Robert's brother Leigh Hunt, was radical in its political orientation, but Blake's art was simply too outlandish. *The Examiner* represented a sort of militant middle class that prided itself on its common sense and lucidity, its ability to do business and make a difference – not to indulge in wild fantasies.

It was in the context of these terrible disappointments that Blake wrote his most venomous statements about the condition of

the art world, scribbling his wild accusations in the margins of his copy of Reynolds's *Discourses* and fuming in his 'Public Address' of c.1809–10. After the 1809 exhibition, Blake exhibited in a public show only once more, when, in 1812, he included works with the Associated Society of Painters in Water Colour exhibition. This society was one of the groups that were formed as an alternative forum from the Academy, in this case by watercolourists who felt particularly aggrieved by the way their works were represented at the Academy. Their exhibitions form an important element in the establishment of watercolour as a viable artistic medium in the art world, and, as Greg Smith has detailed, the activities of such groups provides an important context for Blake's experiments with watercolour and tempera.[23] The 1812 show included the Nelson and Pitt (figs.83, 84), the painting of Chaucer's pilgrims, and 'Detached specimens of an original illuminated Poem, entitled "*Jerusalem the Emanation of the Giant Albion*"'.[24] At that time, the Chaucer painting was praised for its accuracy, but Stothard's oil version, which had already become famous, was preferred; the Nelson and Pitt 'are also too sublime for our comprehension; we must therefore deprecate the mercy of the lovers of the Fuselian and the Angelesque'.[25] Blake's art had, once more, met with incomprehension, and was, once more, considered as a difficult, acquired taste.

The Lost Years
In 1810 an unknown essayist in the art magazine *The Repository of Arts* imagined a dialogue between two women of taste, which included discussion of two of Blake's reproductive prints (*The Fall of Rosamond*, fig.10, and his engraving of Hogarth's *The Beggar's Opera*, fig.24). The apparently well-informed author noted that:

This artist seems to have relinquished engraving, and to have cultivated the higher departments of designing and painting with great success. His works shew he must have studied the antique with considerable attention.[26]

Coming the year after the exhibition in Golden Square, this is a startling statement. Who this author was, and how he or she was informed of Blake's situation, is not known. But if we can only dismiss his claim that Blake had taken up painting with 'great success', it is the case that commercial engraving work was not greatly forthcoming.

It was around this time, for a period of at least sixteen years, that Blake wrote and designed his final, extended poetical work, *Jerusalem*, consisting of one hundred plates – more than twice as many than *Milton* and on a larger format. The production of this poem is shadowy. By 1807, George Cumberland reported that Blake had engraved '60 Plates of a new Prophecy', which are presumed to be from *Jerusalem*.[27] In his diary, Henry Crabb Robinson reported (24 July 1811) that Robert Southey had met Blake recently, and had been shown 'a perfectly mad poem called Jerusalem – Oxford Street is in Jerusalem'.[28] And 'detached' plates were included in the Associated Society of Painters in Water Colour show in 1812. There are few further

86
Frontispiece to 'Jerusalem'
c.1804–20, Copy E,
printed c.1821
Relief etching with pen
and ink and watercolour
on paper
21.9 x 15.9
Yale Center for British Art,
New Haven

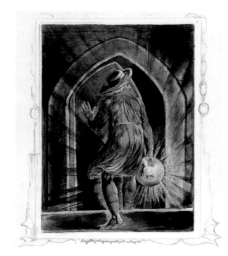

contemporary traces of this poem. However, it was, remarkably, the subject of a published 'puff' (a covert advertisement) by the artist and writer Thomas Griffiths Wainewright in 1820. Wainewright's account gives a fascinating insight into how Blake's works might have been perceived by his contemporaries. He jokingly refers to a forthcoming scholarly study by 'Dr Tobias Ruddicombe, MD':

An account of an ancient, newly discovered, illuminated manuscript, which has to name 'Jerusalem the Emanation of the Giant Albion!!!'. It contains a great deal anent one '*Los,*' who, it appears, is now, and hath been from the creation, the sole and fourfold dominator of the celebrated city of *Golgonooza*! The doctor assures me that the redemption of mankind hangs on the universal diffusion of the doctrines broached in his MS. – But, however, this isn't the subject of the *scinium*, scroll, or scrawl, or whatever you may call it.[29]

We know that Wainewright admired Blake, and owned works by him, so we may suspect that the poet would have appreciated this joke. His knowing references to Blake's character 'Los' and to 'Golgonooza', the intricately symbolic city Los builds, shows that he had, exceptionally, bothered to read the texts, in at least a cursory fashion. The text is unveiled by him as a kind of knowing fraud, a playful piece of antiquarian forgery, thrilling because of its very obscurity and outlandishness, as Macpherson's *Works of Ossian* (1765) had been years before, and as so many thrilling Gothic and fantastic literary

productions were in more recent years. The very jokiness of Wainewright's tone might be dismissed, were we to insist on interpreting Blake as a profound and unearthly mystic. But it may represent a rather more historically appropriate way of reading his work.

The first complete printing of the poem took place in 1820. There is a total of just six copies, five of them complete. Four of these were uncoloured, and were actually sold by Blake in his lifetime; hardly a bad 'strike rate' for what is one of his most difficult texts, if we assume that the printed production of such a lengthy and visually intricate work was a time-consuming affair, meaning that he may not easily have been able to produce many more. The fifth complete copy was richly coloured by Blake, with the addition of gold and silver, and is widely considered to be his masterwork in the medium (figs.86, 87, 88). The poem's theme, anticipated in the famous lines of 'And did those feet' from *Milton*, is the rebuilding of Jerusalem in Britain – the recovery, that is, of spiritual plenitude in the form of apocalypse and redemption. Blake himself succinctly, if only vaguely, stated the theme of his poem in his commentary on the *Ancient Britons*, Blake's lost work from 1809 (see also p.174):

They were originally one man, who was fourfold; he was self-divided, and his real humanity slain on the stems of generation, and the form of the fourth was like the Son of God.

87
Title page to 'Jerusalem'
c.1804–20, Copy E, printed c.1821
Relief etching with pen and ink and watercolour on paper
21.9 x 15.9
Yale Center for British Art, New Haven

How he became divided is a subject of great sublimity and pathos. The Artist has written it under inspiration, and will if God please, publish it; it is voluminous, and contains the ancient history of Britain, and the world of Satan and of Adam.[30]

The text is divided into four chapters, each addressed to a different party: 'the Public', 'the Jews' (fig.88), 'the Deists' and 'the Christians'. Although full of complex imagery and shifts in time and space, there is a basic historical progression through the text. As with *Milton*, the first image (fig.86) suggests the theme of a journey and of spiritual discovery, with a night watchman, identified with Blake's character Los (partly the poet himself), stepping through a doorway. The fairies on the elaborate title page (fig.87) mourn the female figure of Jerusalem, the female counterpart to ('emanation' of) Albion. At the opening of the poem, Albion – a giant personification of Britain as well as the island itself – is divided, but battles on through time to redemption and the rediscovery of a sense of wholeness through Jerusalem, the spirit of liberty and creative freedom. Amidst the cosmic phantasmagoria, London's topography is evoked in unsettling specificity (as Crabb Robinson detected):

The fields from Islington to Marybone,
To Primrose Hill and Saint Johns Wood:
Were builded over with pillars of gold,
And there Jerusalems pillars stood.[31]

Epic and obscure, *Jerusalem* has proved elusive to those scholars who see Blake's poetry as translating into allegorical form contemporary events and radical political values. There are numerous encrypted autobiographical references (Robert Hunt appears as the evil figure of 'Hand' for instance), but, far from representing a simple retreat from current affairs into personal mysticism, its great themes of national redemption and apocalypse had strong historical resonances during a period of war, political reform and religious anxiety. Scholarly work on *Jerusalem* and, particularly, the famous lines from the 'Preface' to *Milton* (see p.132) has established a more critical view of the nationalistic political content of these works. Blake's prejudiced criticism of Catholic imagery and ritual, and his imperialistic assumption that Jerusalem will be built in Protestant Britain as a matter of destiny, relate in complex ways to the dominant political themes of the moment, and have proved to have had a powerful influence over nationalistic thought in later ages.[32]

88
'To the Jews', plate 27 of 'Jerusalem'
c.1804–20, Copy E, printed c.1821
Relief etching with pen and ink and watercolour on paper
21.9 x 15.9
Yale Center for British Art, New Haven

PREFACE.

The Stolen and Perverted Writings of Homer &
Ovid: of Plato & Cicero. which all Men ought to
contemn: are set up by artifice against the Sublime
of the Bible. but when the New Age is at leisure
to Pronounce; all will be set right & those Grand
Works of the more ancient & consciously & profes-
sedly Inspired Men, will hold their proper rank. &
the Daughters of Memory shall become the Daugh-
ters of Inspiration. Shakspeare & Milton were
both curbd by the general malady & infection from
the silly Greek & Latin slaves of the Sword—
Rouze up O Young Men of the New Age! set your
foreheads against the ignorant Hirelings! For
we have Hirelings in the Camp, the Court, & the Uni-
versity: who would if they could, for ever depress Ment-
al & prolong Corporeal War. Painters! on you I call!
Sculptors! Architects! Suffer not the fashionable Fools
to depress your powers by the prices they pretend to
give for contemptible works or the expensive advert-
izing boasts that they make of such works; believe
Christ & his Apostles that there is a Class of Men
whose whole delight is in Destroying. We do not
want either Greek or Roman Models if we are but
just & true to our own Imaginations. those Worlds
of Eternity in which we shall live for ever; in
Jesus our Lord.

 And did those feet in ancient time.
 Walk upon Englands mountains green:
 And was the holy Lamb of God.
 On Englands pleasant pastures seen!

 And did the Countenance Divine.
 Shine forth upon our clouded hills?
 And was Jerusalem builded here.
 Among these dark Satanic Mills?

 Bring me my Bow of burning gold:
 Bring me my Arrows of desire:
 Bring me my Spear: O clouds unfold!
 Bring me my Chariot of fire!

 I will not cease from Mental Fight.
 Nor shall my Sword sleep in my hand:
 Till we have built Jerusalem.
 In Englands green & pleasant Land

 Would to God that all the Lords people
 were Prophets Numbers XI. ch 29 v

'And did those feet ...'

Only rivalled by *The Tyger*, the text known as 'Jerusalem' is Blake's best-known poem. Confusingly, the poem does not appear in *Jerusalem* itself, but as the preface to only the first two out of the four surviving versions of *Milton*. In its historical context, in the midst of the wars against Napoleonic France, Blake's 'And did those feet ...' was probably meant originally as a pacificistic statement. The text appears to warn Blake's readers against the militarism represented by the classical tradition and its heirs: Shakespeare and Milton have been 'curbd by the general malady & infection from the silly Greek & Latin slaves of the Sword'. Instead, we are invited to turn towards the Bible, and 'mental' as opposed to actual war. The question 'And did those feet ...' alludes to the legend of Jesus himself visiting the British isles, in the company of Joseph of Arimathea. The famous line referring to the 'dark Satanic Mills' may, indeed, refer to the factories that were undermining traditional work patterns and living standards; Blake scholars have tended to see the allusion as more abstract, referring to the 'Mills' of materialism that suppress spiritual life.

The pacifistic and spiritual sentiments of Blake's poem are rather hard to tally with our modern knowledge of the text. There is an ambivalence in the text itself, of course, and the call to take up arms, even if they are intellectual rather than physical, are expressed with reference to a sense of physicality that may be easily misunderstood. Perhaps Blake himself realised this, hence his removal of the text from the later versions of *Milton*. But our understanding of Blake's poem has been forever marked because 'Jerusalem' is now most familiar as a rousing hymn. Is it possible to read these lines now without orchestral sounds rising to our ears? It was set to music by Charles Hubert Parry (1848–1918), for the 'Fight for Right' movement of a British officer, Sir Francis Younghusband (1863–1942), and the song was re-used for a Women's Demonstration meeting at the Albert Hall in 1917. It was re-scored by Edward Elgar in 1922. The Women's Institute took it up as their unofficial anthem in 1924, and it was sung by workers during the General Strike of 1926. Since 1953 it has been sung at the last night of the annual BBC Proms at the Albert Hall in London.

In its reformulation as a hymn, 'Jerusalem' has had a vigorous and sometimes downright weird existence. It has endured as a blunt statement of patriotic pride, in the context of the banal middle-class rituals of the last night of the Proms, and at political gatherings. In the 1980s it was played at the Tory party press conferences; in 1990 it appeared at the end of the Labour conference, marking, as the literary scholar Susan Matthews noted presciently in an academic article of the time, 'an innovation which might signal alternatively a change in Labour or in the politics of nationalism'. Blake's words had provided the title of the 1981 movie *Chariots of Fire*, a film that for many epitomises the retrogressive cultural conservatism of the Thatcher years.

More awkward and imaginative treatments of the poem are possible. Mark E. Smith's experimental rock band The Fall recorded a version in 1988 in which Blake's words are punctuated by a paranoid rant ('It was the government's fault/ It was the fault/ Of the government') that undermines any pretence to blandly spiritual uplift or patriotic abstraction. A commercially successful version was released in 2000, to coincide with the European football championship, by Fat Les, an ad-hoc group headed by the actor Keith Allen and Alex James of Blur, both celebrating and grotesquely caricaturing the aggressive patriotism associated with football fans. Fat Les was briefly the most visible attempt to reclaim 'Jerusalem' as a new national anthem, one that could supersede 'God Save the Queen'. The very mutability of meaning apparent in the performance history of the hymn 'Jerusalem', and the ambiguity inherent in its imagery, combined with its musical power (both in Blake's lines and that embodied in Parry's music) has made it peculiarly available as an ambivalent expression of 'nationhood' in an era when the meaning, and even the possibility, of such a concept remains moot.

89
Preface to 'Milton a Poem'
c.1804–11
Copy B
Relief etching with watercolour on paper
16 x 11.5
Huntington Library and Art Gallery, San Marino

Writing to the poet William Hayley on 23 October 1804, Blake commented on his recent deep melancholy (evidence, perhaps, of depression), and of his ensuing spiritual release:

I was a slave bound in a mill among beasts and devils; these beasts and these devils are now, together with myself, become children of light and liberty, and my feet and my wife's feet are free from fetters. O lovely Felpham, parent of Immortal Friendship, to thee I am eternally indebted for my three years' rest from perturbation and the strength I now enjoy. Suddenly, on the day after visiting the Truchsessian Gallery of pictures, I was again enlightened with the light I enjoyed in my youth, and which has for exactly twenty years been closed from me as by a door and by window-shutters.[1]

Blake refers here to the collection of the exiled German aristocrat, Count Joseph Truchsess, notable for the early German and Flemish paintings it contained.[2] It was the latest in a series of major collections of Continental princes and aristocrats brought to London following the French Revolution and wars in Europe, creating an unprecedently rich market for art. Where once these early paintings had been reviled as crude and worthless, they were now beginning to be appreciated for their sincerity, spirituality and precise technique. A major shift in taste, underpinning the Gothic Revival in architecture and design in the coming decades, was taking place. Blake's letter to Hayley has been taken as evidence of his own,

deeply personal and spiritual 'Gothic Revival'. It is from after this point that the term 'Gothic' comes to play a significant role in Blake's theory of art, representing a universal and timeless ideal. And it is from this vantage point that Blake reconstructed his youthful training in Basire's studio as a thorough grounding in antique methods of printmaking, and as the opportunity to see at first hand inspirational medieval monuments (these views being communicated to Benjamin Heath Malkin, in around 1805). Blake's technical experiments with tempera painting and use of watercolour, his stylised treatment of the human body (often expressed as a kind of architectural element in a design), and the more severe use of line-engraving techniques in the original productions of the later part of his career, can be explored in relation to this admiration for the archaic forms and values of the Gothic.

The highly personal nature of Blake's interpretation of medieval antiquity is clear; but he was not unique in this pursuit. The taste for the Gothic (in its broadest sense) emerged rather earlier than is sometimes assumed, and among precisely those social circles that lent Blake the greatest material and moral support. Early paintings and, more affordably, prints, by Italian, German and Flemish artists of the sixteenth century were favoured by several significant figures in Blake's life, including George Cumberland, Francis Douce, Charles and Elizabeth Aders and Lord Egremont, who all owned works by the artist. James Edwards, the brother of Richard, who commissioned the Edward

6　Blake Among the Ancients

Young illustrations from Blake (fig.76), had visited key print collections in Germany and Austria and was closely connected with the pioneering scholars of the early print from those territories. The way these men and women configured a new realm of taste and judgement during the latter part of Blake's life is yet to be fully explored, but Heather MacLennan has established that the field was dominated by enthusiastic professional men and amateur scholars, constituting a distinctly middle-class group 'within the diverse society of art collectors in early nineteenth-century Britain, showing characteristic individuality and eccentricity as they interacted with the possibilities offered to them by a buoyant art market'.[3] It was among these people that Blake's distinctive art – characterised itself by individuality and eccentricity, of course – found a favourable market. In this context his artworks could mean something, not necessarily as an expression of a coherent and legible symbolic system, but as curiosities of technique and imagery. Thus Thomas Griffiths Wainewright's highly significant published 'puff' for *Jerusalem* in 1820 cast this book as an outlandish curiosity (see p.130). Where the wealthy and powerful of earlier ages may have looked to their artists to provide paintings that would manifest their status, embodying ideas and values in lucid ways, here Blake created obscure, intensely visual artefacts, the meanings of which were impossible to grasp, but whose qualities as crafted objects and as the output of an individual imagination were manifest. The very obscurity and archaic look of his art must have had a certain value to them. That it is Blake, rather than the painters of grand historical scenes or flamboyant portraits, who in the present day seems the exemplary artist, may indicate the way that it is such tastes as were apparent among the predominantly middle-class purchasers of his works that have come ultimately to gain mastery over the field of culture.

The key facet of Blake's pursuit of an archaic (and for him universal) ideal in painting was his rejection of oil as a medium, and his exclusive use of drawing, watercolour painting and an invented tempera technique. This last, together with the monotype 'large colour prints', he called 'fresco', a term that had a vital role to play in recent art theory. What might be considered 'true' fresco meant painting with pigments on to a wet plaster surface and completing the painting with water-based paints as the surface dried, but the term was used in Blake's time to refer to all wall-paintings executed in water-based paints. It conjured associations with the heroic endeavours on a grand scale of the painters of the Renaissance, and the values of grandeur, intellectual mastery and technical perfection. As Joshua Reynolds noted in his *Discourses*: 'The principal works of modern art are in *Fresco*, a mode of painting which excludes attention to minute elegancies: yet these works in Fresco, are the productions on which the fame of the greatest masters depends'.[4] The relatively damp and cold climate of Northern Europe meant that true fresco could never be practised successfully, while the absence in contemporary Britain of the kinds of extensive patronage of Church and princes that made

possible the fresco schemes of the sixteenth and seventeenth centuries meant that such endeavours would never be financially viable, anyway. There was, then, an apparent irony: the greatest achievements of art to be recommended to the students of the Academy were in a medium and on a scale that would never be achieved in Britain. Reynolds's solution was to present an idea of the 'Grand Manner', or 'Great Style', as consisting of an ethos, rather than a technique or subject matter. The modern artist in Britain could emulate the great fresco painters by painting broad and ideal forms, but with a disciplined precision in drawing and technique, even if he was painting in oils, and even if he was painting a portrait or a scene from everyday life rather than noble allegory or complex narrative.

This point was elaborated and dramatised by Henry Fuseli, in his lectures as Professor of Painting at the Royal Academy from 1799. In these, the associations of luxuriousness and sensuality that had been attached to oil painting by high-minded art theorists in the past were openly attacked, and a much more stringent definition of the Grand Manner re-imposed in a way that influenced Blake crucially. Fuseli creates a whole symbolic scheme around the material properties of fresco as a medium:

The tones fit for Poetic painting are like its styles of design, generic and characteristic. The former is called negative, or composed of little more than chiaroscuro; the second admits, though not ambitiously, a greater variety and subdivision of tint. The first is the tone of M. Angelo, the second that of Raffaelo. The sovereign instrument of both is undoubtedly the simple, broad, pure, fresh, and limpid vehicle of Fresco. Fresco, which does not admit of that refined variety of tints that are the privilege of oil painting, and from the rapidity with which the earths, its chief materials, are absorbed, requires nearly immediate termination, is for those very reasons the immediate minister and the aptest vehicle of a grand design. Its element is purity and breadth of tint. In no other style of painting could the generic forms of M. Angelo have been divided, like night and day, into that breadth of light and shade which stamps their character.[5]

Opening his succeeding lecture on colour in oil painting, Fuseli acknowledges the irony in recommending the supremacy of fresco, 'a method of painting almost as much out of use as public encouragement, and perhaps better fitted for the serene Italian than the moist air of more northern climates'.[6] But he still sets limits on oil as a medium: it can achieve only 'Historic effects', rather than the 'Poetic', which represents the highest achievements. Or at least, that is the case when oil paint is allowed to behave like oil paint: oil colouring becomes more acceptable when 'reducing colour frequently to little more than chiaroscuro'.[7] The act of painting itself becomes a powerful ethical struggle for the artist, where he may descend into immorality and sensual luxury, or ascend to pureness and nobility of thought. The primary duty of the artist is to work in a true fashion, eschewing cheapness and sensation in pursuit of higher

truths. With public taste deranged, the artist alone and in isolation might heroically transform the materials of his art and, by that means, historical reality. In important ways, Blake worked within this framework, recognising in the struggle to create a painted image the opportunity to transform, indeed reform, himself, and therefore serve the public in an important capacity. Next to aphorism no.521 from J. H. Lavater's *Aphorisms on Man* (1788), 'He, who reforms himself, has done more toward reforming the public than a crowd of noisy, impotent patriots', Blake noted 'Excellent'.[8] And it was not simply ironic that Blake adopted Nelson's famous call to patriotic arms in his *Descriptive Catalogue* (1809): 'The times require that every one should do his duty, in Arts, as well as in Arms, or in the Senate.'[9] Blake's individualism, understood in these terms, was far from mere eccentricity; he was engaging in an attempt to change the course of history. The 'patriot' ambitions of artists like Robert Edge Pine and John Hamilton Mortimer in the 1760s are translated by Blake, via the example of Fuseli, or even Reynolds, into a solipsistic technical struggle to reform the techniques of art.

Fuseli was, in fact, understood by contemporaries to have followed his own theories, adapting oil paint to mimic the effects of fresco. He painted, according to his acolyte William Young Ottley, 'in that solemn tone of colouring which we admire in the works of the greatest fresco-painters, and which Sir Joshua Reynolds observes to be so well adapted to the higher kind of pictorial representation'.[10] But where Fuseli may have tested the limits of the oil medium pragmatically in an effort to emulate earlier, greater phases in art, Blake, exceptionally, actively rejected the medium altogether. In his memoir of the artist, Frederick Tatham recalled:

Oil painting was recommended to him, as the only medium through which breadth, force, & sufficient rapidity could be gained; he made several attempts, & found himself quite unequal to the management of it; his great objections were, that the picture after it was painted, sunk so much that it ceased to retain the brilliancy & luxury that he intended, & also that no definite line, no positive end to the form could even with the greatest of his Ingenuity be obtained, all his lines dwindled & his clearness melted, from these circumstances it harassed him, he grew impatient & rebellious, & flung it aside with ill success & tormented with doubts. He then attacked it with all the Indignation he could collect, & finally relinquished it to men, if not of less minds of less ambition.[11]

A single painted oil study after a figure by Michelangelo (Huntington, San Marino) has been associated with Blake in the past, though this attribution is not now generally accepted. All his paintings are executed in watercolour or in the self-invented techniques using tempera that he called 'fresco'. Blake envisaged that he would paint his designs on a vast scale, on the walls of churches and public buildings. In reality, his 'fresco' paintings were executed on the thickly prepared, white surface of canvas, then later on mahogany panels, and occasionally metal, and the 'large colour prints'

he similarly called 'frescos' were printed on paper.

By virtue of the collections of his friends and patrons, and the outstanding collections that were circulating in London's art market, Blake would certainly have known medieval paintings at first hand. He may have been exposed to the technical descriptions in the medieval goldsmith Cennino Cennini's 'Book of Art' (c.1390). But his painting methods were quite novel. In the catalogue of his 1809 exhibition he referred to some of his exhibits as 'Experiment Pictures'. As experiments, there was a high level of failure; he admitted that he laboured too hard at these first works, and was subject to the 'infernal machine, called Chairo Oscuro', and the resulting pictures became clogged and dark. Blake worked on the pictures over a period of years, returning to them and adding layers of glue in the expectation that this would preserve the colours. Time has not been kind, and the tempera paintings have suffered both from darkening and damage, and have been changed through restoration. The green highlights in the foreground of *Christ Blessing the Little Children* (fig.56), for instance, are painted in a pigment not available during Blake's lifetime. *The Spiritual Form of Pitt* (fig.84) was substantially restored by George Richmond, and the overall orangeness of *The Spiritual Form of Nelson* (fig.83) may be a result of the varnish discolouring.[12] Over the years, Blake tried (apparently in two phases, around 1810 and at the end of his life) using much thinner paint, and experimented with wooden panel supports rather than canvas, with some success. Thus *The Ghost of a Flea* c.1819–20 (fig.102) is painted on a relatively sturdy mahogany panel, though in a dense, textural fashion that recalls the first experiments in tempera.

The tempera paintings, and the heavily textured use of specially mixed printing inks or paints in the 'large colour prints', were an attempt to emulate the characteristic textures and, more importantly, the stringent technical restrictions of fresco. While oil paint could be manipulated and reworked, entirely obscuring or transforming the original drawn design, the rhetoric surrounding Blake's use of 'fresco' was that each colour needed to be laid on in a pure form, precisely following a linear design. Blake's use of watercolours shares some of the same characteristics. Watercolour had traditionally been used primarily for tinting monochrome designs, either drawings, or prints. While the direct and expressive use of watercolour was being explored in significantly new ways by contemporary landscape painters, Blake's use of the medium was fundamentally as a means of giving colour to tonal and linear designs executed in diluted ink or earth colours.[13] Importantly, he tended not to mix these colours on the palette, but applied them pure to the paper, using the whiteness of the paper to lend a sense of intensity and brightness to his transparent colours. Together with his avoidance of blotting or scratching the pigments (characteristic techniques among landscape watercolourists), Blake's method was aimed at ensuring the purity of individual colours and the primacy of the drawn design. Although watercolour painting itself was

90
*Sir Jeffrey Chaucer and the
Nine and Twenty Pilgrims
on their Journey to
Canterbury*
c.1808
Pen and ink and tempera
on canvas
46.7 x 137
Pollok House, Glasgow
Museums

eschewed in high-art theory, because of its associations with lowly productions like coloured prints and topographical landscapes, as well as its use by amateurs and women, used in this way it could be interpreted as conforming much more closely to the esteemed productions of the fresco painters of the Renaissance than to modern oil pictures.

Blake's archaic approach to painting met an archaic subject in his painting and print of Chaucer's Canterbury pilgrims (fig.90). He must have calculated that, with the proper publicity, a single print of a painting based on this highly admired literary source could be financially rewarding. His ambitions were considerable. He claimed that Chaucer had captured a universal vision of mankind: 'Every age is a Canterbury Pilgrimage; we all pass on, each sustaining one or other of those characters; nor can a child be born, who is not of these characters of Chaucer.'[14] Blake appears to have believed that Cromek was prepared to collaborate with him in this enterprise. But his plans were undermined when it emerged that Cromek was due to publish a print by Luigi Schiavonetti of the same subject after a painting by Thomas Stothard (fig.91). Although Blake and Stothard had been friends from the 1780s, this was the occasion of a bad falling out.

Both Stothard and Blake represent the full cast of pilgrims setting out from the Tabard Inn in Southwark. Although the existence of a design by Stothard of the pilgrims setting out in a publication of 1793 has been noted as a means of asserting that painter's primacy, that design has so little resemblance to the later,

long-format painting that it can be disregarded, and in fact both artists were long preceded by an engraving that was included in John Urry's edition of Chaucer, printed in 1721. This follows a long, panoramic format used by both later artists, with the gently undulating rhythm of Stothard's figures and the rearing horse recalling this composition quite closely. There is also the suggestion of even older versions of the scene. A correspondent to the *Gentleman's Magazine* in 1812 identified as 'P' refers to 'A well-painted Sign by Mr Blake' at the Talbot (formerly Tabard) Inn in London that 'represents Chaucer and his merry Company setting out on their journey'. Although it has been supposed, rather imaginatively, that this is somehow a reference to William Blake's painting, the sign in question is clearly visible in an accompanying engraving, and bears no relation to his tempera. It was either painted by a sign-painter called Blake, a common enough name, or the author was making an obscure slight against our artist. The sign remained in place until later in the nineteenth century.[15] There had also been, until shortly before 1812, an old tapestry representing the same scene at the inn. There is no way of knowing how this might have influenced Stothard or indeed Blake in their conceptions.

Cromek called Stothard's painting 'The little Cabinet Picture of Chaucers Pilgrims ... the most extraordinary production of the Age', and congratulated himself upon having happened upon the idea, though even he noted that 'it was sufficiently obvious ... what is obvious is often overlooked'.[16] The published

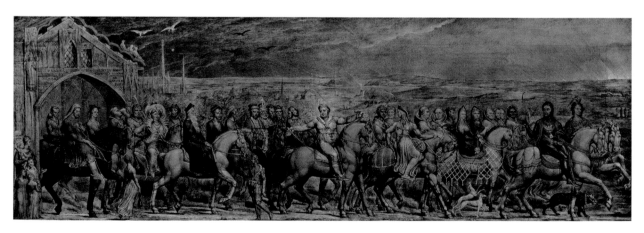

91
Thomas Stothard
The Pilgrimage to Canterbury
1806–7
Oil on oak panel
31.8 x 95.2
Tate

proposals for Stothard's print noted that 'Gentlemen of the first taste in the Antiquarian Society, and particularly those who are celebrated for their knowledge of the ancient costumes of the country, have been consulted', but that this precise historical detail was 'contained within picturesque beauty'. This last phrase encapsulates the elegant arrangement of poses, suggesting, within the limits of a linear procession, a variety of posture. According to conventional artistic theory, such variety was necessary in order to interest the viewer and lead them through the narrative or allegory presented in the picture. Figures that were too stiff, poses that were too repetitive, would bore the viewer and turn them away.

It is precisely these primitive pictorial qualities that Blake plays up in his version of the subject. Stothard's pilgrims are so arranged that our eye is led gently up and down as we scan across their faces: Blake's are all neatly arranged in a single line. Stothard's horses are turned in and out of space, Blake's are all shown flatly from the side in a strict procession. And of course, Stothard's picture is in oil paint, and displays an enticing variety of colours. Blake's is tempera, and the palette is limited. Where the oil colours of Stothard's work have substance in their own right, laid on to and obliterating the drawn or thinly painted grounding for the design, Blake's picture consists largely of lines, drawn with pen and ink and painted with tempera; areas of flesh and costume are tinted with colours. The naturalistic proportions and expressions of Stothard's painting are contrasted, too, with

the doll-like forms and exaggerated features of Blake's. In fact, there have been several attempts to interpret Blake's picture as a whole as an elaborate satire on the theme of corruption in public life, incorporating caricature likenesses of specific historical figures, notably Prime Minster William Pitt in the figure of the Pardoner (the pointy-nosed character to the right of centre, turning back on himself) and George, Prince of Wales, in the corpulent figure of the Host, at the centre.[17]

Blake's painting was included in his one-man exhibition in 1809 and discussed at length in the *Descriptive Catalogue*, and exhibited again with the Associated Society of Painters in Water Colour in 1812. He issued a 'Prospectus', announcing the publication of a print reproducing the picture, and in 1809–10 drafted an essay that he intended to present to a professional society for engravers (the Chalcographic Society) when the print was published. The primitivist aesthetic of the painting was continued in the engraved plate, said by Blake in a published proposal to be in 'the style of Alb Durers Histries & the old Engravers'. These three documents contain Blake's most direct and forthright commentaries on art and the responsibilities of the artist. They contain a barely concealed attack on Stothard, an artist driven, in Blake's eyes, by material desires and, therefore, compared to the worldly and corrupt oil painters like Peter Paul Rubens and Rembrandt rather than the true artists – and painters in fresco – Michelangelo and Raphael.

Following the terms of Blake's theory of art, as this was laid out in 1809–10, his Canterbury

pilgrims work, together with the other 'fresco' paintings exhibited in 1809, represent a concerted effort to establish the technical and iconographic means by which the spiritual wholeness of art, long lost to history but seen through the visionary imagination, could be captured again. Robert Hunt's review in *The Examiner* (p.129) demonstrated one possible response: the artist was a madman, rather than a visionary. Another perspective appears in a review of the Canterbury pilgrims picture in *The Lady's Monthly Museum* in 1812:

A picture of mongrel existence; yet has such a repulsive appearance, that we doubt most of our fair readers will scarcely view it with pleasure, unless they should be well acquainted with *Aunciente* tapystre, to enter into its merits. That it is the work of genius no one will deny; it possesses all the truth, the costume, and manners of the times; and the artist is perhaps worthy of the highest commendation for his industry, research, and correctness; but for our parts, we feel ourselves so perfectly satisfied with the same subject, as treated by Stothard, that we wish not to possess a picture whose greatest merit seems to be an imitation of the arts in their degraded taste.[18]

Thus we find, only roughly sketched out, oppositions between 'genius' and 'taste', intellect and popular feeling, the ugly and the beautiful, that lie at the heart of modern cultural values.

In 1784–5 Blake had tried to establish himself as a publisher. In his 'Prospectus' of 1793, he announced the technical inventions that would make him a self-publishing author the like of which the world had never seen (p.165). The years from 1809 to 1812 saw Blake try once more to establish his artistic independence, this time through exhibition and self-publication. Once more he failed, and effectively disappeared from public view more completely than ever. Continuing commissions from his old supporter Butts and the Revd Thomas brought him some income, but he was thrown back on his skills as a reproductive printmaker to make ends meet. Most of his copy engraving commissioned in these years came through the good auspices of John Flaxman, and the only sustained project was his engravings of that sculptor's illustrations to the Greek mythology of Hesiod (begun in 1814 and published in 1817). While Flaxman's previous efforts to illustrate Homer had been acclaimed for their severe linear purity, these later prints used a kind of stippled line (so that the line is made up of dots rather than being continuous). The effect is softer and gentler than these earlier prints, and we can assume that this was deliberate, matching Flaxman's jokey assertion that 'I am going to publish – not a patent medicine – nor elastic whiskers – nor I was going to say, Youth & Beauty restored, but yet it is something of this latter kind because the Graces, the Muses aye & Venus will come into the compositions'.[19] Yet even these appear substantial as works of art, compared to the bizarrely sentimental stipple engraving, *A Child of Nature* (fig.92), produced after a design by the miniature painter Charles Borckhardt in 1818. Technically and iconographically, this is the antithesis of everything Blake had proclaimed about art.

92
William Blake after
Charles Borckhardt
The Child of Nature
1818
Stipple engraving on
paper
28 x 24.7
Fitzwilliam Museum,
Cambridge

The CHILD of NATURE

The Ancients

After 1818, Blake's fortunes took a distinct turn for the better. It was then that George Cumberland's son, also George, introduced Blake to his drawing tutor, the precocious and materially successful painter John Linnell (1792–1882).[20] Linnell was to become the central, sustaining force in Blake's art for the remainder of his life, buying works from him and forming the most complete collection of his writings, commissioning new projects, and introducing him to artists, friends and patrons. The most important of these was the circle of artists who called themselves the 'Ancients' and referred to Blake as the 'Interpreter': Samuel Palmer (1805–81), George Richmond (1809–96), Edward Calvert (1799–1883) and Frederick Tatham (1805–78). An informal gathering of young, middle-class, idealistic artists, they felt themselves at odds with the contemporary world and, like other groups of younger artists of the nineteenth century, looked to pre-Renaissance ideas of the workshop and artistic brotherhood as a protecting alternative to the machinations of the open market. [21] They regarded Blake as a spiritually wise older man. His poetry appears to have been little read and even less appreciated among them, but, as an artist, the visionary and universalising claims he had made a decade before were accepted with enthusiasm.

The most modest of the commissions secured through Linnell proved to be the most enduring. This was the set of illustrations for Dr Robert John Thornton's Latin primer *The Pastorals of Virgil, With a Course of English Reading, Adapted for Schools* of 1821 (fig.93). Thornton counted among his medical clients Linnell and his family. Blake was commissioned to produce 17 tiny wood engravings, among the 230 designs by a number of artists. Yet the results inspired passionate admiration among the Ancients. Samuel Palmer was most eloquent on this point:

They are visions of little dells, and nooks, and corners of Paradise; models of the exquisitest pitch of intense poetry. I thought of their light and shade, and looking upon them I found no word to describe it. Intense depth, solemnity, and vivid brilliancy only coldly and partially describe them. There is in all such a mystic and dreamy glimmer as penetrates and kindles the innermost soul, and gives complete and unreserved delight, unlike the gaudy daylight of this world.[22]

The influence of these little prints has endured, and inspired a much later generation of painters including Paul Nash and Graham Sutherland in the twentieth century, who imitated them quite directly. For these later generations of artists, the illustrations of the *Pastorals* represented a sense of spiritual vision that was anchored in the experience of nature and the observation of the world.

One of the most significant productions of these later years, and one of the works for which Blake remained known through the nineteenth century, was his set of engraved *Illustrations of the Book of Job* 1826 (figs.94, 95).[23] Blake's original watercolour series of around 1805–6 (see above, pp.95–7) were admired by Linnell, who undertook to start tracings of the designs

93
'Thenot and Colinet'
from Robert John
Thornton, *The Pastorals of Virgil* (1821)
Wood engraving on paper
6.1 x 8.5
Tate

that were finished in ink and watercolour by Blake in 1821. In 1823, Linnell commissioned a series of engravings of these subjects, promising to pay 'five pounds pr. Plate or one hundred Pounds for the set, part before and the remainder when the Plates as finished', as well as 'one hundred pounds more out of the Profits of the work as the receipts will Admit of it'. This was a good deal, and, together with the subsequent commission from Linnell to design and engrave illustrations to Dante, provided a kind of pension for the artist through the last years of his life.

In preparation for the engravings, Blake created a series of small pencil drawings in 1823–4, originally in a sketchbook (although this is now dismantled) and perhaps also as full-size designs that could be transferred to the plates. Blake engraved the plates himself, using, importantly, a pure engraving technique – that is, directly cutting the copperplate without using etching to initially set out the outlines of the design. He must have transferred full-scale drawings by the technique of counterproving (making a second copy or tracing that could be reversed on to the plate), or else drawn directly on to the plate with a pencil or chalk (to achieve this, the surface of the copperplate would have been slightly roughened by exposing it briefly to acid). Although the title page (fig.94) states that the series was 'Invented & Engraved' by Blake in 1825, and gives the date of publication as March 1825, it is thought that Blake completed the twenty-two plates (twenty-one scenes from the narrative plus the title page) and had them printed only early in 1826.

Unlike all of his earlier original printmaking endeavours, which were printed by Blake, he had the plates printed by a commercial printer in Oxford Street, although we can assume that he would have overseen the process. The commissioning and printing of Blake's *Book of Job* is unusually well documented: we know that 215 'proof copies' were printed, to be sold at 5 guineas each, and another 100 'plain' copies were published, to be sold at 3 guineas.

Linnell worked hard at selling these prints. A number of Blake's friends and supporters were signed up as subscribers up to two years before publication, but Linnell struggled to find more buyers. George Cumberland suggested to Catherine Blake in 1827, after Blake's death earlier that year, that a set should be deposited with the British Museum, 'as that will make them best known – better even than their independent author who for his many virtues most deserved to be so – a Man who stocked the english school with fine ideas, – above trick, fraud, or servility'.[24] Another associate of Linnell, H. Dumaresq, showed a set around to his friends, but concluded that 'It will be valued only by artists'.[25] It was not until 1863 that the 'plain' copies were sold out, and there were discussions about reprinting the plates. This took place in 1874, and it is prints from that pull that are represented in figs.94 and 95.

Blake's engravings present scenes from the Job narrative set within sparsely linear decorative borders, incorporating organic motifs and figures. The relevant lines from the Book of Job and texts from elsewhere in the Bible are incorporated in these wide borders.

94
Title page of 'The Book of Job'
1825, reprinted 1874
Line engraving on paper
19.1 x 14.7
Tate

In plate 17, the key scene in which Job achieves salvation through a vision of Christ, only a single line from Job is quoted in the plate. These textual additions and visual interpretations add complex glosses to the original narrative. So, in the first plate, Job and his family sit together under a tree (fig.95). The words at the top of the design are taken from the first lines of the Lord's Prayer (these words had appeared in the background of the earlier work). The first two verses of the Book of Job are arranged to the left and right at the bottom of the plate; between these are phrases taken from Corinthians: 'The Letter Killeth/ The Spirit giveth life/ It is spritually Discerned' (2 Corinthians 3:6 and 1 Corinthians 2:14). Above all of these is larger lettering, reading 'Thus did Job continually' (from Job 1:5: 'Job sent and sanctified them, and rose up early in the morning, and offered burnt offerings according to the number of them all: for Job said, It may be that my sons have sinned, and cursed God in their hearts. Thus did Job continually').

Any single plate of Blake's *Job* is open to interpretation, but there is a general critical consensus about how the series should be understood. Blake presents a narrative in which Job starts out as a conventionally pious man, who pays attention to the rituals and words of the faith. What his spiritual and physical travails reveal to him is a deeper sense of faith, based around love and creativity. In *Job and his Family*, the prophet has dutifully got his family up at first light to read from the holy books, while musical instruments hang unused from the tree. As the additional

inscriptions imply, his worship is constituted in 'burnt offerings', made out of fear of the punishment of sin, and he attends to the deathly 'Letter' rather than the spirit. In the final plate of the series, closely following the watercolour of 1805–6 (fig.65), Job and his family sing and play instruments joyfully: an additional inscription reads 'In burnt Offerings for Sin/ thou has had no Pleasure' (Hebrews 10:6). Job's revelation, presented by Blake as a vision of Christ, is emphatically visual, rather than based in ritual or bookish learning.

In their engraved form, the *Job* illustrations have been considered as one of the most complete and coherent of Blake's productions. Samuel Palmer's inspirational first meeting with Blake came when he was 'midway in the task of engraving his *Job*':

'At my never-to-be-forgotten first interview,' says Mr Palmer, 'the copper of the first plate – 'Thus did Job continually' – was lying where he had been working at it. How lovely it looked by the lamplight, strained through the tissue paper.[26]

A century later, it was the sight of this print in an Oxford bookshop window that inspired the great Blake scholar Geoffrey Keynes to take an interest in his art.[27] Their decidedly archaic style was understood as not calculated, however, to please the generality. George Cumberland tried in vain to sell copies to his friends in Bristol, but found that 'the prices [have] always been a hindrance'. As the contemporary writer Allan Cunningham registered, 'They are in the early fashion of

95
Job and his Family
1828, reprinted 1874
Line engraving on paper
18.4 x 15
Tate

workmanship, and bear no resemblance whatever to the polished and graceful style which now prevails'.[28] The poet Bernard Barton complained to Linnell:

There is a dryness and hardness in Blake's manner of engraving which is very apt to be repulsive to print-collectors in general – to any, indeed, who have not taste enough to appreciate the force and originality of his conceptions, in spite of the manner in which he has embodied them.
I candidly own I am not surprised at this; his style is little calculated to take with admirers of modern engraving. It puts me in mind of some old prints I have seen, and seems to combine somewhat of old Albert Durer with Bolswert. I cannot but wish he could have clothed his imaginative creations in a garb more attractive to ordinary mortals, or else given simple outlines of them. The extreme beauty, elegance, and grace of several of his marginal accompaniments induce me to think they would have pleased more generally in that state.[29]

Linnell's influence over these prints extended beyond the mere fact of his commission. For Linnell was a printmaker as well as a painter, and the first projects handed to Blake had been 'for Laying in the Engraving' for a portrait that the (apparently self-trained) Linnell was to complete. Robert N. Essick has argued that the collaborations between Linnell and Blake were highly influential on Blake's engravings of Job.[30] While Blake had been taught in the standard codes of reproductive engraving, Linnell had a more unconventional and uncompromising approach in practice, and may have directed Blake back to the early engravers.

Mei-Ying Sung has also considered a suggestive context for the *Job* plates, which has a much wider relevance for Blake's work. A full set of the prints appears in a twenty-two-volume extra-illustrated Bible, known as the 'Kitto Bible' (Huntington Library, California), which was put together in the mid-nineteenth century.[31] The existence of such 'extra-illustrated' productions is a reminder that the rather bald opposition between 'normal' publications and Blake's illuminated books is not so clear cut. Publications in regular typography might be produced in many different versions, with plates in different places or different sequences. Moreover, these were subject to being personalised, enlarged and transformed by their owners.

It is conceivable that the same is true of the very final watercolour series that Blake was engaged on: a series of illustrations to Dante's *Divine Comedy*, created in 1824–7, again produced at the behest of Linnell.[32] The plan appears to have been to have these designs engraved, although only seven proof prints were produced before Blake's death in August 1827. When the prospective customer Sir Edward Denny wrote to Linnell in November 1826 to ask if the *Job* engravings he had admired in their unfinished state were now completed, he asked 'whether Mr Blake is engaged in any other work – I think I remember your telling me that he had some notion of illustrating Dante'.[33] More dramatically, Samuel Palmer recalled a visit to Blake in 1824:

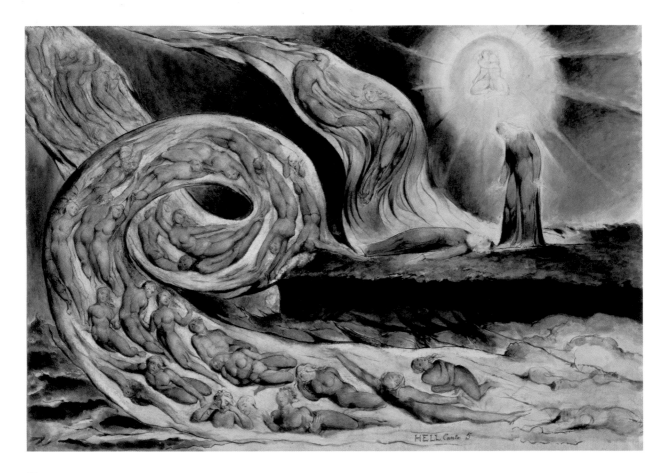

96
The Circle of the Lustful
c.1824–7
Pen and ink and
watercolour on paper
37.5 × 53
Birmingham City Art
Gallery

Mr Linnell called and went with me to Mr Blake. We found him lame in bed, of a scalded foot (or leg). There, not inactive, though sixty-seven years old, but hard-working on a bed covered with books sat he up like one of the Antique patriarchs, or a dying Michael Angelo. Thus and there was he making in the leaves of a great book (folio) the sublimest designs from his (not superior) Dante. He said he began them with fear and trembling. I said 'O! I have enough of fear and trembling'. 'Then,' said he, 'you'll do.' He designed them (100 I think) during a fortnight's illness in bed![34]

There are some 102 surviving watercolours and drawings of the *Divine Comedy*, following the poet's narrative of his spiritual journey, led and protected by the Roman poet Virgil, through Hell, Purgatory and Heaven. Although now widely spread across different collections, they are in a uniform format and so were presumably originally produced in a volume, as Palmer indicates. Some three-quarters of Blake's designs focus on Hell, where Dante and Virgil witness an array of spectacular punishments. The carnally lustful are swept up in a whirlwind (fig.96), a theme that sits uneasily with Blake's open celebration of sexuality (a theme glimpsed in the embracing couple of Paolo and Francesca seen in the sun above Dante), and a pope guilty of simony (selling ecclesiastical offices) is cast upside down into a well full of flames (fig.97), in a punishment that recalls James Gillray's satire on abolition (fig.32). Devils, monsters and physical tortures of the most sensational kind abound. In Purgatory, Dante enters the Garden of Eden and is visited by a new guide,

Beatrice, who arrives in a fantastical chariot (evoking the whirlwind seen by Ezekiel in fig.62), drawn by a Gryphon who embodies Christ, and in the company of personifications of Faith, Hope and Charity, the three young robed women in green, red and white (fig.98). Representing the Church, in its spectacular and ritual aspects, it is Beatrice who guides Dante to Paradise. Here, the poet has a vision of Christ, and is judged by Beatrice to be worthy of achieving redemption. After being questioned by St Peter and St James, who are choreographed by Blake into a startling pink, blue and lemon yellow composition (fig.99), Dante achieves a final vision of spiritual redemption.

Blake's own expressed views on the Italian poet, recorded in conversations with Henry Crabb Robinson and in annotations to his copy of the *Divine Comedy* and on one of these drawings, were sharply negative: as a moralising, conventionally orthodox Catholic who emphasised issues of sin and punishment, Dante's beliefs could hardly have been expected to sit easily with Blake's dissenting, antinomian Protestantism. Dante had criticised the Church for its failings; Blake criticised organised religion for its imposition of a venal sense of sinfulness and its restrictions on spiritual life. Hence, the series as a whole has been interpreted as offering a warning about Dante's central lesson on the importance of attending to doctrine, although it has also emerged as a major test-case regarding the degree to which Blake's own prophetic symbolism is being imposed on Dante's vision. The figure of Beatrice has been

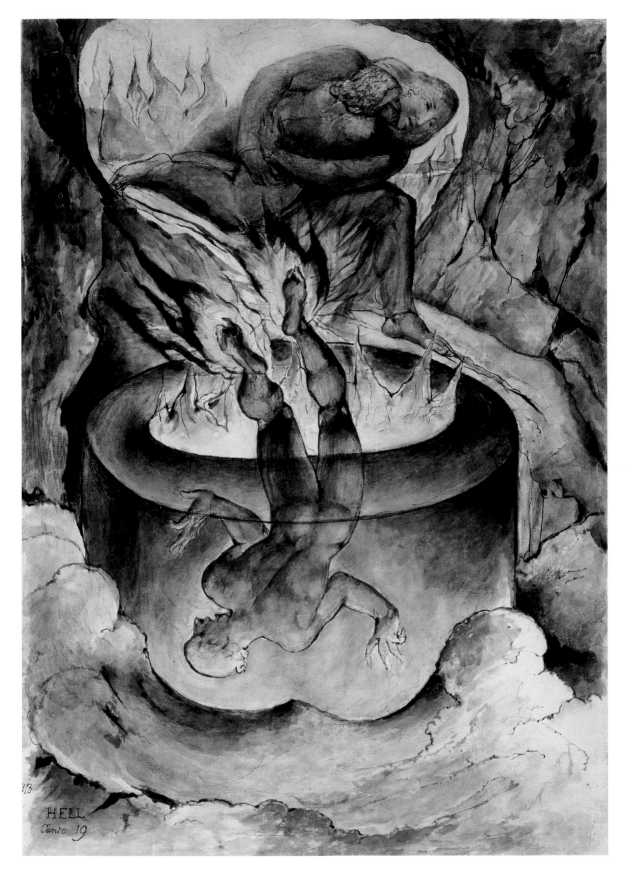

HELL
Canto 19

THE BLAKE BOOK

97
The Simoniac Pope
1824–7
Pen and ink and
watercolour on paper
52.7 x 36.8
Tate

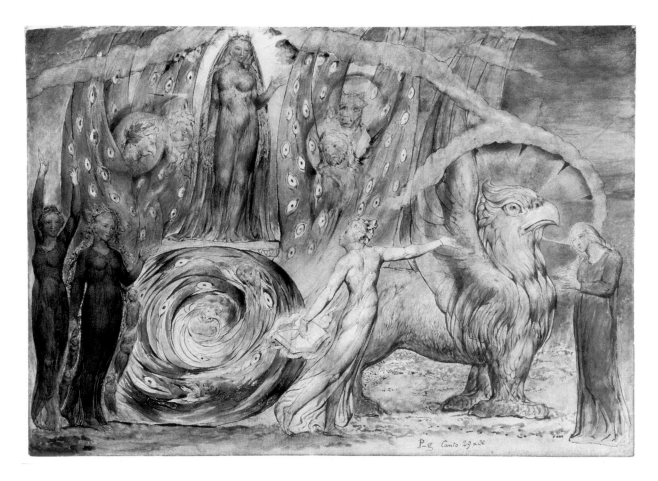

98
*Beatrice Addressing Dante
from the Car*
1824–7
Pen and ink and
watercolour on paper
37.2 x 52.7
Tate

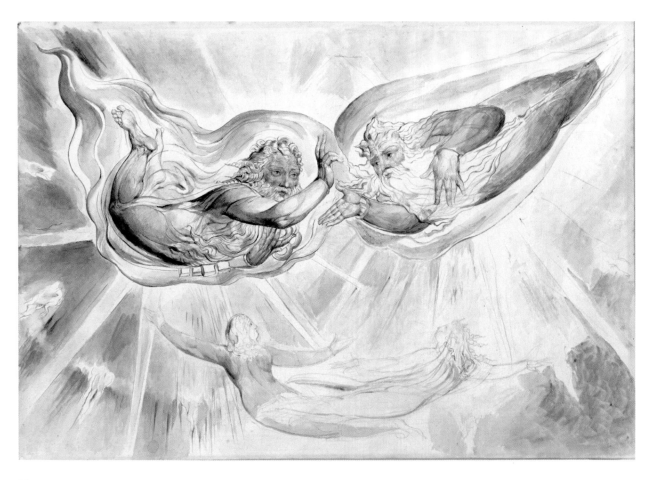

99
St Peter and St James with
Dante and Beatrice
1824–7
Pen and ink and
watercolour on paper
37.1 x 52.7
National Gallery of
Victoria, Melbourne

particularly disputed: the gold crown she wears in Blake's design (fig.98),but not in the poem, may represent material power, for instance, though there may be other reasons for this deviation from Dante's text. In the succeeding design, *The Harlot and the Giant* (National Gallery of Victoria, Melbourne), the chariot is transformed and caricatured into the Beast of Revelation, carrying the Whore of Babylon (compare with fig.64). The role of Beatrice, and the dominant place given by Blake to the female figure of the Virgin Mary, holding a sceptre and mirror in the illustration of Dante's final vision, may suggest Blake's criticism of the vanity and material power of the Church, corrupted by the ruling influence of the venal feminine forces, rather than true spiritual uplift. However, the incomplete nature of the series as a whole, and of many of the individual designs, leaves the narrative more open-ended than these conclusions would suggest.

A very late effort on Blake's part to re-interpret a biblical text through images and words, probably undertaken in last months of his life, was his attempt to illuminate a manuscript version of Genesis (fig.100). This was a further, and in the event final, commission from John Linnell. Blake produced two versions of a title page, and nine further illustrations, arranged above and below transcriptions of the Scripture, executed in a Gothic hand. He provided his own chapter headings, glossing the meanings of the Scriptural text. Blake's intentions for this manuscript are uncertain. It conforms more closely than do his illuminated books to the traditions of medieval illumination, in scale and format, and in the relationship of the texts to the marginal illustrations. If it was to be printed, it would connect with efforts earlier in the eighteenth century to produce luxury editions of the Bible with the lettering engraved, which Blake's friend Cumberland must have had in mind when he publicised his plans to publish engraved writing (see p.160). Rather than extending Blake's efforts in illuminated printing, this work seems to be a response to the developing antiquarianism in the taste of Blake's circle in the later part of his life.

The letters of the title are broken down and arranged in the middle of the composition. To our right is God the Father, holding his right hand into the air; to the left is God the Son, Jesus, handing the scroll of revelation to Adam. At the top a spirit is stretched impossibly in flight; at the bottom, the four living creatures representing the four Evangelists (a serpent, an eagle, a lion and a bull). The visual incidence of the columnar form making up the 'I' of 'GE-NE-SIS' with Adam's genitals may be suggestive. As a statement of faith, incorporating words and pictures, complex allusive ideas and directly sexual imagery, the Genesis title page provides a fitting conclusion to Blake's life as an artist, offering, at the end of his life on earth, a new vision of the beginning of the world.

100
First title page to the illuminated manuscript of Genesis
c.1826–7
Pen and ink, pencil and watercolour
34.2 x 23.9
Huntington Library and Art Gallery, San Marino

Catherine Blake

Catherine Blake (1762–1831), born Catherine Boucher, was a constant and vital presence in Blake's life as an artist. She was the daughter of a market gardener in Battersea, and Blake met her while on a visit to the area in 1781. According to biographical legend, Blake was recovering from a broken heart after being rejected by another young woman. According to J.T. Smith in his *Nollekens and his Times* (1828): "'Do you pity me?" asked Blake of Catherine, "Yes; I do, most sincerely." – "Then," said he, "I love you for that." – "Well," said the honest girl, "and I love you.'"

Blake and Catherine Boucher married in Battersea in August 1782. They remained together until William Blake's death. Anecdotes that Blake intended taking a mistress remain the subject of much fascination and speculation, but though there were certainly trials and tribulations their relationship remained fast. Like William Blake, Catherine appears to have had dissenting religious affiliations, and they attended the meeting of the Swedenborgian New Church in 1789 as a couple, suggesting a shared interest in spiritualism and vision.

Quite aside from the moral support Catherine Blake provided for her husband in a career that encountered more than its fair share of practical and emotional challenges, she also ran the household finances and took an active role in the production of his works, both the commercial engravings and his illuminated books. J.T. Smith reported that Blake 'allowed her, till the last moment of his practice, to take off his proof impressions and print his works, which she did most carefully, and ever delighted in the task'. She had an acknowledged role in colouring at least some of the illuminated books, although the view tends to be that those more clumsily painted must be her work, on the assumption that her skills were inferior. Her role in producing prints by more conventional means is evidenced in William Hayley's remarks in a letter of 1802 that 'He & his excellent Wife (a true Helpmate!) pass the plates thro' a rolling press in their own cottage together; & of course it is a work of some Time to collect a Number of Impressions'. In 1803 Blake wrote to his brother James (who had taken on the family hosier's shop) that 'the whole number of Plates for Cowpers work which She does to admiration & being under my own eye the prints are as fine as the French prints & pleases every one'.

In the aftermath of William Blake's death, Catherine had an important role in preserving and disseminating his works. She moved in with John Linnell, and then Frederick Tatham. The younger George Cumberland wrote to his father in 1828 to report that: 'her late husbands work she intends to print with her own hands and trust to their sal for a livelihood'. She also advised the Earl of Egremont about the varnishing of his Blake paintings, in terms that suggested her own technical comprehension in this matter and implying that she had undertaken varnishings herself.

Catherine Blake was an artist in her own right, although only a handful of works by her are known to survive. They include a portrait of Blake as a young man, executed after his death, which, in the spirit of that artist's own 'Visionary Heads' (see p.157), represents his spiritual form, his hair rising as flames of inspiration from a forehead swollen with imaginative thought (fig.101).

101
Catherine Blake
Portrait of William Blake as a Young Man c.1827–31
Pencil on paper
15.5 x 10.4
Fitzwilliam Museum, Cambridge

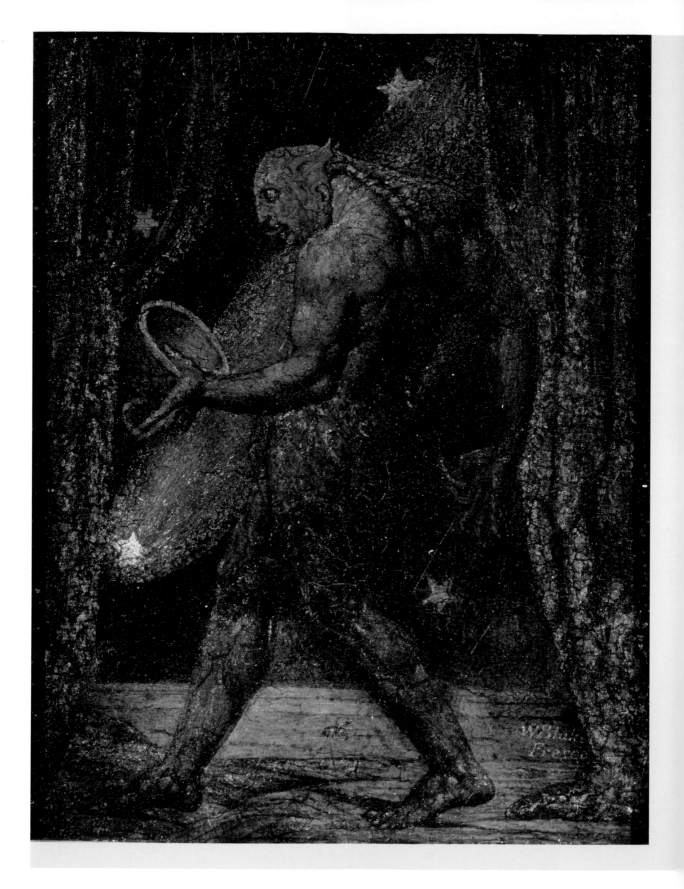

THE BLAKE BOOK

The Ghost of a Flea

The tiny tempera painting of *The Ghost of a Flea* appears to have originated among the drawings of 'Visionary Heads' that Blake was prompted to create by watercolour painter and astrologist John Varley (1788–1842) at his house in around 1819–25. These were claimed to document Blake's visions of figures from the spiritual realm, including historical and legendary figures such as the ancient British chieftain Caractacus, King Alfred, Merlin and Wat Tyler, Muhammad, Voltaire, 'Tom Nixon the Idiot author of the prophecies', devils, biblical characters, figures from literature and mysterious characters like the man who taught Blake painting in his dreams (fig.103), which has been taken as a likeness of Blake himself (and may be alluded to in Catherine Blake's depiction of the artist, fig.101). Whether these drawings were sincere or were created to humour the mystically inclined Varley is a moot question. Some of them were subsequently copied or traced and were engraved for Varley's *Treatise on Zodiacal Physiognomy* (1828), including the design representing the spirit of the flea. Varley's text commented:

I felt convinced by his mode of proceeding, that he had a real image before him, for he left off, and began on another part of the paper, to make a separate drawing of the mouth of the Flea, which the spirit having opened, he was prevented from proceeding with the first sketch, till he had closed it. During the time occupied in completing the drawing, the Flea told him that all fleas were inhabited by the souls of such men, as were by nature blood-thirsty to excess.

The smaller drawing of the flea's mouth, mentioned by Varley, is also in the Tate collection.

Clearly, Varley felt that Blake was transcribing his visions directly, though we may be able to detect an array of literary and visual points of reference. A visual source for Blake's conception of this creature has been detected in Robert Hooke's *Micrographia, or some Physiological Descriptions of Minute Bodies being Made by Magnifying Glasses, with Observations and Inquiries Thereupon* (1665). The creature has a precedent in Blake's own work, with his scaly personification of pestilence as 'the destroyer' (fig.110, p.200) and may also carries memories of Fuseli's monstrous imps. Fleas feature in folklore as bothersome, sometimes vampiric and monstrous creatures. The presence in the flea's left hand of an acorn, and in the right a thorn or 'sting', fits well with traditional fairy iconography. Meanwhile, the presence of this figure on what is clearly meant as a theatrical stage, complete with curtains, conjures associations with the realm of magic and popular entertainments.

102
The Ghost of a Flea
c.1819–20
Tempera heightened with gold on mahogany
21.4 x 16.2
Tate

103
Attributed to John Linnell after William Blake
The Man who Taught Blake Painting in his Dreams
c.1825
Pencil on paper
26 x 20.6
Tate

Writings on Art

William Blake's most direct and lucid statements about visual art come largely from a relatively short period, from around 1809 to 1810. His printed *Descriptive Catalogue*, which accompanied his exhibition in Golden Square (1809), provides a disarmingly frank discussion of his imagery and techniques. The printed statements that accompanied the publication of his print of Chaucer's Canterbury pilgrims (1809–10), and his extended rant on the subject of printmaking that was intended to be presented to the Chalcographic Society (known as the 'Public Address' and written c.1809–10) express his frustration with contemporary taste vividly. Together with the annotations to his copy of Joshua Reynolds's *Discourses* in his edition of his *Works* (1798), written from around 1798 to 1809, his long manuscript descriptions of his paintings of the Last Judgement (around 1808) and the inscriptions on his prints of *Joseph of Arimathea* (around 1810) and the *Laocoön* (1826–7), these texts provide a rich sense of Blake's convictions, ambitions and fears.

Naturally, the two selections of Blake's writings presented here draw heavily on the texts produced from around 1809 to 1810. The first selection focuses on Blake's conception of the techniques of printmaking and of painting. The second encompasses the artist's comments on art, the art world, and the artist.

The intention has been to produce a readable text, based largely on the transcriptions provided by David V. Erdman in his *Complete Poetry and Prose of William Blake* (1965; revised ed. 1988), with deleted texts suppressed and some additional punctuation.

1. ON TECHNIQUE
On engraving

By the late eighteenth century, a range of printmaking techniques were in general use in Britain, each with their distinct qualities, values and associations. 'Intaglio' techniques were pre-eminent. They relied on the creation of lines and marks on to a metal plate; most usually, this would be copper. The marks would be loaded with ink that would convey the design in reverse from the plate on to a dampened paper sheet, when the two were

passed together through a press. The preparation of all these materials – copperplate, ink, papers – was precise and demanding, and the management of the printing press an exacting business. The seven-year apprenticeships that were standard in the trade of engraving would be taken up in learning these techniques and the practical preparation of materials.

As an apprentice of the engraver James Basire, Blake had a thorough grounding in the basic intaglio techniques. Line engraving was the most traditional. Here lines were cut directly into a copperplate using special tools ('gravers' or 'burin'). The weight, breadth and contour of any individual mark was all-important: the expert massing and organisation of individual marks could create effects of tone, texture, even an illusion of colour. In principle, it was not possible to correct or change a design once cut into the plate. Accordingly, a high degree of prestige was traditionally attached to this method. In practice, areas of the plates would be re-beaten (and the evidence is that Blake did this with his prints).

Etching was a major alternative method. Here, a plate would be prepared with a wax coating, and this surface smoked to darken it. Using a blunt needle, the artist would draw into the wax. Thus prepared, the plate would be dipped into acid. In those areas where the wax had been removed with the needle, the copper itself would be eaten away (etched). With the wax wiped away, the plate would be marked by the acid and could be printed as with the engraved method. The relative ease of the technique, and the chance to correct and rework designs, meant that it was seen as less demanding or precise than line engraving. There was a strong tradition of amateur activity in this area. In practice, most professionally produced line engravings included some elements of etching, with the initial design being etched rather than engraved, using a drawing or tracing as a model, and elements within a print being drawn with etched line, to give more expressive or textural effects.

The other major traditional technique was mezzotint, a method Blake is not known to have deployed. Here, the entire plate is marked with a toothed wheel (a 'rocker'), so that if printed in this condition the whole plate would be printed black; by rubbing down areas with 'scrapers', the plate was flattened out, so it would not hold ink. Thus the design emerges white out of black. This tonal technique meant that it was especially used for portraits and 'fancy' images.

Within Blake's lifetime several new techniques came into use. Stipple engraving used wheels or rockers to make dotted marks; the light tonal and textural effects meant that it came particularly into use for pastoral and light mythological scenes (decorative and 'feminine' genres). Sepia or other colours were used for the printing. Aquatint was a form of etching that was based around the application of special, partly porous resins to the plate, leading to the creation of tonal areas of fine grain when the plate is bitten. In a variant technique, 'sugar lift', a plate is prepared with stopping-out varnish, and the design drawn on using a solution of sugar, which lifts the varnish away, creating textural effects when bitten. Soft-ground etching was a method by which a plate is prepared with a special kind of wax, a sheet of paper is laid on it, and the etcher draws on to the paper. When the sheet is removed, it carries away the wax where the etcher has drawn. When the plate is etched by acid, the etcher's design (and the textures of his marks) is bitten, creating close imitations of the effects of drawn line.

The comments by Blake gathered below reflect the ongoing debates over the value and significance of these various techniques. Market forces, competition between different professionals and amateurs, the interventions of connoisseurs and tastemakers, and, increasingly, entrepreneurs, changed the way these were thought about and appreciated.

An Island in the Moon, c.1784–5
Blake's early satire on the intellectual pretensions of a group of scholars and gentlemen modelled on London's literary set contains two intriguing references to printmaking. The first follows a silly conversation between 'Aradobo' and 'Obtuse Angle', which ranks engraving as a science even greater than a long list of 'ologies' and even 'painting'. The second is an intriguing but incoherent passage that relates

grandiose plans for self-publication. The comments about the texts being engraved rather than 'printed' (set in type) have been taken as anticipating Blake's own invention of 'relief printing', but seem more likely to relate to George Cumberland's documented attempts to publish a form of engraved writing.

Mrs Gimblet lookd as if they meant her. Tilly Lally laught like a Cherry clapper. Aradobo askd who was Phebus Sir. Obtuse Angle answerd, quickly, He was the God of Physic, Painting Perspective Geometry Geography Astronomy, Cookery, Chymistry Mechanics, Tactics Pathology Phraseology Theolog[y] Mythology Astrology Osteology, Somatology in short every art & science adorn'd him as beads round his neck. here Aradobo lookd Astonishd & askd if he understood Engraving – Obtuse Angle Answerd indeed he did. – Well said the other he was as great as Chatterton.[1]

[…] them Illuminating the Manuscript – Ay said she that would be excellent. Then said he I would have all the writing Engraved instead of Printed & at every other leaf a high finishd print all in three Volumes folio, & sell them a hundred pounds a piece. they would Print off two thousand then said she whoever will not have them will be ignorant fools & will not deserve to live Dont you think I have something of the Goats face says he. Very like a Goats face – she answerd – I think your face said he is like that noble beast the Tyger –[2]

Letter to the Revd John Trusler, 23 August 1799

The Revd Trusler (1735–1820) commissioned prints and paintings from Blake in 1799, but proved to be a tricky customer. He was baffled by Blake's imagery and suspicious of his technique. Here, Blake alludes, in a disarmingly offhand way, to his dual identity as original artist and professional printmaker.

To Engrave after another Painter is infinitely more laborious than to Engrave ones own Inventions. And of the Size you require my price has been Thirty Guineas & I cannot afford to do it for less. I had Twelve for the Head I sent you as a Specimen, but after my own designs I could do at least Six times the quantity of labour in the same time which will account for the difference of price as also

that Chalk Engraving [soft-ground etching] is at least six times as laborious as Aqua tinta. I have no objection to Engraving after another Artist. Engraving is the profession I was apprenticed to, & should never have attempted to live by any thing else If orders had not come in for my Designs & Paintings, which I have the pleasure to tell you are Increasing Every Day. Thus If I am a Painter it is not to be attributed to Seeking after. But I am contented whether I live by Painting or Engraving.[3]

Annotations, c.1798–1809, written in Joshua Reynolds's *Discourses* (1769–90)

Blake's annotations in his copy of Reynolds's lectures (1798) contain his most furious statements about art. Here he lambasts the academic preference for the refined products of the seventeenth century and states the superiority of the 'Gothic' or primitive artists of an earlier age.

I was once looking over the Prints from Rafael & Michael Angelo. in the Library of the Royal Academy Moser[4] came to me & said You should not Study these old Hard Stiff & Dry Unfinishd Works of Art, Stay a little & I will shew you what you should Study. He then went & took down Le Bruns & Rubens's Galleries[5] How I did secretly Rage. I also spoke my Mind […] I said to Moser, These things that you call Finishd are not Even Begun how can they then, be Finishd? The Man who does not know The Beginning, never can know the End of Art.[6]

The 'Prospectus' for Blake's Canterbury pilgrims (1809)

During the course of his one-man exhibition at his brother's shop in 1809, Blake initiated a subscription scheme for an engraving of the Canterbury pilgrims. As well as advertising the project, Blake takes the opportunity to polemicise about the qualities of early printmakers.

BLAKE'S CHAUCER,
THE CANTERBURY PILGRIMS.
THE FRESCO PICTURE,
Representing Chaucer's Characters painted by
WILLIAM BLAKE,
As it is now submitted to the Public,

The Designer proposes to Engrave, in a correct and finished Line manner of Engraving, similar to those original Copper Plates of Albert Durer, Lucas, Hisben, Aldegrave[7] and the old original Engravers, who were great Masters in Painting and Designing, whose method, alone, can delineate Character as it is in this Picture, where all the Lineaments are distinct.

It is hoped that the Painter will be allowed by the Public (notwithstanding artfully dissemminated insinuations to the contrary) to be better able than any other to keep his own Characters and Expressions; having had sufficient evidence in the Works of our own Hogarth,[8] that no other Artist can reach the original Spirit so well as the Painter himself, especially as Mr. B. is an old well-known and acknowledged Engraver.

The size of the Engraving will be 3-feet 1-inch long, by 1-foot high. – The Artist engages to deliver it, finished, in One Year from September next. – No Work of Art, can take longer than a Year: it may be worked backwards and forwards without end, and last a Man's whole Life; but he will, at length, only be forced to bring it back to what it was, and it will be worse than it was at the end of the first Twelve Months. The Value of this Artist's Year is the Criterion of Society: and as it is valued, so does Society flourish or decay.

The Price to Subscribers – Four Guineas, Two to be paid at the time of Subscribing, the other Two, on delivery of the Print.

Subscriptions received at No. 28, Corner of Broad-street, Golden Square; where the Picture is now Exhibiting, among other Works, by the same Artist.

The Price will be considerably raised to Non-subscribers. May 15th, 1809.

Public Address (c.1809–10)

In the wake of his disastrous one-man exhibition and the miserable disappointments regarding Cromek's commissions, in around 1809–10 Blake prepared a speech for the Chalcographic Society, a professional organisation for engravers. In this lengthy and rambling text, he lamented the state of the current print market and the poor skills of the more fashionable contemporary engravers. His further comments on the unity of invention and execution, the relationship of drawing to painting and engraving, and the supreme importance of manual skill, constitute key statements of his theory of art.

I account it a Public Duty respectfully to address myself to The Chalcographic Society & to Express to them my opinion the result of the incessant Practise & Experience of Many Years[:] That Engraving as an Art is Lost in England owing to an artfully propagated opinion that Drawing spoils an Engraver[.] I request the Society to inspect my Print of which Drawing is the Foundation & indeed the Superstructure[;] it is Drawing on Copper as Painting ought to be Drawing on Canvas or any other surface & nothing Else[.] I request likewise that the Society will compare the Prints of Bartollouzzi Woolett Strange[9] &c with the old English Portraits[,] that is compare the Modern Art with the Art as it Existed Previous to the Enterance of Vandyke & Rubens into this Country since which English Engraving is Lost & I am sure the Result of this comparison will be that the Society must be of my Opinion that Engraving by Losing Drawing has Lost all Character & all Expression without which The Art is Lost. [...]

In this Plate [of the Canterbury pilgrims] Mr B has resumed the style with which he set out in life of which Heath[10] & Stothard were the awkward imitators at that time[:] it is the style of Alb Durers Histries & the old Engravers which cannot be imitated by any one who does not understand Drawing & which according to Heath & Stothard Flaxman & even Romney. Spoils an Engraver for Each of these Men have repeatedly asserted this Absurdity to me in condemnation of my Work & approbation of Heaths lame imitation[,] Stothard being such a fool as to suppose that his blundering blurs can be made out & delineated by any Engraver who knows how to cut dots & lozenges equally well with those little prints which I engraved after him five & twenty Years ago & by which he got his reputation as a Draughtsman [...]

What is Calld the English Style of Engraving such as proceeded from the Toilettes of Woolett & Strange (for theirs were Fribbles Toilettes) can never produce Character & Expression. I knew the Men intimately from

their Intimacy with Basire my Master & knew them both to be heavy lumps of Cunning & Ignorance as their works Shew to all the Continent who Laugh at the Contemptible Pretences of Englishmen to Improve Art before they even know the first Beginnings of Art[.] I hope this Print will redeem my Country from this Coxcomb situation & shew that it is only some Englishmen and not All who are thus ridiculous in their Pretences[.] Advertizements in Newspapers are no proof of Popular approbation. but often the Contrary[.] A Man who Pretends to Improve Fine Art Does not know what Fine Art is[.] Ye English Engravers must come down from your high flights ye must condescend to study Marc Antonio[11] & Albert Durer. Ye must begin before you attempt to finish or improve & when you have begun you will know better than to think of improving what cannot be improvd[.] It is very true what you have said for these thirty two Years[:] I am Mad or Else you are so both of us cannot be in our right senses[.] Posterity will judge by our Works[.] Wooletts & Stranges works are like those of Titian & Correggio[:] the Lifes Labour of Ignorant journeymen Suited to the Purposes of Commerce no doubt for Commerce Cannot endure Individual Merit[,] its insatiable Maw must be fed by What all can do Equally well at least it is so in England as I have found to my Cost these Forty Years [...] I do not Pretend to Engrave finer than Alb Durer Goltzius Sadeler or Edelinck[12] but I do pretend to Engrave finer than Strange Woolett Hall[13] or Bartolozzi & All because I understand Drawing which they understand not
[...]
Commerce is so far from being beneficial to Arts or to Empire that it is destructive of both as all their History shews[,] for the above Reason of Individual Merit being its Great hatred. Empires flourish till they become Commercial & then they are scatterd abroad to the four winds
[...]
Painting is Drawing on Canvas & Engraving is Drawing on Copper & Nothing Else & he who pretends to be either Painter or Engraver without being a Master of Drawing is an Impostor [...] I know my Execution is not like Any Body Else[.] I do not intend it should be

so[.] None but Blockheads Copy one another[.] My Conception & Invention are on all hands allowd to be Superior[;] My Execution will be found so too. To what is it that Gentlemen of the first Rank both in Genius & Fortune have subscribed their Names to My Inventions. The Executive part they never Disputed[...] the Lavish praise I have received from all Quarters for Invention & Drawing has Generally been accompanied by this[:] he can conceive but he cannot Execute[.] this Absurd assertion has done me & may still do me the greatest mischief[;] I call for Public protection against these Villains[.] I am like others only Equal in Invention & in Execution as my works shew[.] I in my own defence Challenge a Competition with the finest Engravings & defy the most critical judge to make the Comparison Honestly asserting in my own Defence that This Print is the Finest that has been done or is likely to be done in England where drawing its foundation is Contemnd and absurd Nonsense about dots & Lozenges & Clean Strokes made to occupy the attention to the Neglect of all real Art[.] I defy any Man to Cut Cleaner Strokes than I do or rougher when I please & assert that he who thinks he can Engrave or Paint either without being a Master of Drawing is a Fool[.] Painting is Drawing on Canvas & Engraving is Drawing on Copper & nothing Else[,] Drawing is Execution & nothing Else[,] & he who Draws best must be the best Artist & to this I subscribe my name as a Public Duty[14]

On Illuminated Printing

The unique method of printmaking that Blake developed at the end of the 1780s, and which he referred to as 'illuminated printing', differed fundamentally from the intaglio methods that he was trained in. Instead of cutting or etching into a copperplate to create a design, Blake etched the plates but printed primarily from the raised surfaces. Blake left no clear record of the methods used in creating these prints, and our understanding of the technique has been based on a tradition of practical experimentation, the physical evidence of the prints themselves, and documents. While the basic principles of Blake's methods have been established in

104

The Marriage of Heaven and Hell: Plate 15

1790–3
Relief etching with ink
and watercolour on paper
150 x 103
Fitzwilliam Museum,
Cambridge

a way that satisfies most scholars, there are still major questions. Did he write his poems in manuscript, and then incorporate these polished texts into the designs of his plates? Or did he write and illustrate together, composing his texts on the copperplate as he went along? Did he have an overall structure in mind for these books? And why produce his writings as prints at all? The texts quoted below provide fascinating clues and insights, but leave these fundamental questions unanswered.

The Marriage of Heaven and Hell (1790)

The Marriage of Heaven and Hell (*figs.47, 48*) *includes what seems to be an allegorical meditation on the techniques of relief etching. In Plate 14 the acid burning of the plate appears as a kind of diabolical alchemy, opening up the 'doors of perception', and a spiritual apocalypse. As Joseph Viscomi has detailed, the ensuing Plate 15, 'A Memorable Fancy' (fig.104) allegorises each stage of production, from cleaning the plate ('clearing away the rubbish') through etching with acid ('melting the metals into living fluids') and putting together the finished product.* [15]

The ancient tradition that the world will be consumed in fire at the end of six thousand years is true. as I have heard from Hell.

For the cherub with his flaming sword is hereby commanded to leave his guard at the tree of life, and when he does, the whole creation will be consumed, and appear infinite. and holy whereas it now appears finite & corrupt.

This will come to pass by an improvement of sensual enjoyment.

But first the notion that man has a body distinct from his soul, is to be expunged; this I shall do, by printing in the infernal method, by corrosives, which in Hell are salutary and medicinal, melting apparent surfaces away, and displaying the infinite which was hid.

If the doors of perception were cleansed every thing would appear to man as it is: infinite.

For man has closed himself up, till he sees all things thro' narrow chinks of his cavern.

A Memorable Fancy

I was in a Printing house in Hell & saw the method in which knowledge is transmitted from generation to generation.

In the first chamber was a Dragon-Man, clearing away the rubbish from a caves mouth; within, a number of Dragons were hollowing the cave,

In the second chamber was a Viper folding round the rock & the cave, and others adorning it with gold silver and precious stones,

In the third chamber was an Eagle with wings and feathers of air, he caused the inside of the cave to be infinite, around were numbers of Eagle like men, who built palaces in the immense cliffs.

In the fourth chamber were Lions of flaming fire raging around & melting the metals into living fluids.

In the fifth chamber were Unnam'd forms, which cast the metals into the expanse.

There they were reciev'd by Men who occupied the sixth chamber, and took the forms of books & were arranged in libraries. [16]

The 'Prospectus' (1793)

In 1793 Blake engraved an advertisement describing his stock of illuminated books, and indicating new publishing ventures. The original of this single printed sheet is lost, and is known only from the transcription that appears in Alexander Gilchrist's biography of the artist (1863). The prices that the artist provides, his important note relating to 'Subscriptions' and his use of the terms 'Illuminated Books' and 'Illuminated Printing' (which have become standard) provide vital evidence for how Blake viewed these productions.

TO THE PUBLIC *October* 10, 1793.

The Labours of the Artist, the Poet, the Musician, have been proverbially attended by poverty and obscurity; this was never the fault of the Public, but was owing to a neglect of means to propagate such works as have wholly absorbed the Man of Genius. Even Milton and Shakespeare could not publish their own works.

This difficulty has been obviated by the Author of the following productions now presented to the Public; who has invented a method of Printing both Letter-press and

Engraving in a style more ornamental, uniform, and grand, than any before discovered, while it produces works at less than one fourth of the expense.

If a method of Printing which combines the Painter and the Poet is a phenomenon worthy of public attention, provided that it exceeds in elegance all former methods, the Author is sure of his reward.

Mr. Blake's powers of invention very early engaged the attention of many persons of eminence and fortune; by whose means he has been regularly enabled to bring before the Public works (he is not afraid to say) of equal magnitude and consequence with the productions of any age or country: among which are two large highly finished engravings (and two more are nearly ready) which will commence a Series of subjects from the Bible, and another from the History of England.

The following are the Subjects of the several Works now published and on Sale at Mr. Blake's, No. 13, Hercules Buildings, Lambeth.

1. Job, a Historical Engraving. Size 1 ft. 7 ½ in. by 1 ft. 2 in.: price 12s.

2. Edward and Elinor, a Historical Engraving. Size 1 ft. 6 ½ in. by 1 ft.: price 10s. 6d.

3. America, a Prophecy, in Illuminated Printing. Folio, with 18 designs: price 10s. 6d.

4. Visions of the Daughters of Albion, in Illuminated Printing. Folio, with 8 designs, price 7s. 6d.

5. The Book of Thel, a Poem in Illuminated Printing. Quarto, with 6 designs, price 3s.

6. The Marriage of Heaven and Hell, in Illuminated Printing. Quarto, with 14 designs, price 7s. 6d.

7. Songs of Innocence, in Illuminated Printing. Octavo, with 25 designs, price 5s.

8. Songs of Experience, in Illuminated Printing. Octavo, with 25 designs, price 5s.

9. The History of England, a small book of Engravings. Price 3s.

10. The Gates of Paradise, a small book of Engravings. Price 3s.

The Illuminated Books are Printed in Colours, and on the most beautiful wove paper that could be procured.

No Subscriptions for the numerous great works now in hand are asked, for none are wanted; but the Author will produce his works, and offer them to sale at a fair price[17]

Letter to Dawson Turner, 9 June 1818

Blake's letter to the Norfolk banker Dawson Turner (1775–1858) is a key document regarding the artist's later attitude towards his illuminated books. It indicates how he could conceive of the visual elements of these as standing alone, although he seems reluctant to separate the texts and images completely. The prices he expects for the illuminated books are more comparable to unique paintings than prints; as Blake states explicitly, this form of 'publishing' was thoroughly uneconomical, compared to conventional printing methods.

I send you a List of the different Works you have done me the honour to enquire after – unprofitable enough to me tho Expensive to the Buyer

Those I Printed for Mr Humphry[18] are a selection from the different Books of such as could be Printed without the Writing tho to the Loss of some of the best things For they when Printed perfect accompany Poetical Personifications & Acts without which Poems they never could have been Executed

America	18 prints	Folio	£5.	5.	0
Europe	17 do.	folio	5.	5.	0
Visions &c	8 do.	folio	3.	3.	0
Thel	6 do.	Quarto	2.	2.	0
Songs of Innocence	28 do.	Octavo	3.	3.	0
Songs of Experience	26 do.	Octavo	3.	3.	0
Urizen	28 Prints	Quarto	5.	5.	0
Milton	50 do.	Quarto	10.	10.	10
12 Large Prints Size of Each about 2 feet by 1 & ½ Historical & Poetical Printed in Colours		Each	5.	5.	0

These last 12 Prints are unaccompanied by any writing

The few I have Printed & Sold are sufficient to have gained me great reputation as an Artist which was the chief thing Intended. But I have never been able to produce a Sufficient number for a general Sale by means of a regular Publisher[.] It is therefore necessary to me that any Person wishing to have any or all of them should send me their Order to Print them on the above terms & I will take care that they shall be done at least as well as any I have yet Produced[19]

Letter to George Cumberland, 12 April 1827

The great majority of Blake's illuminated books are thought to have been printed by him and Catherine from 1789 to 1795, but as this letter indicates he continued to print on order throughout his life, possibly even to within weeks of his death. By this date, they were even more expensive than in 1818, with the Songs of Innocence and of Experience, *which had proved to be a bestseller (in the limited sense that this applies here), priced at 10 guineas.*

You are desirous I know to dispose of some of my Works & to make them Pleasin[g], I am obliged to you & to all who do so But having none remaining of all that I had Printed I cannot Print more Except at a great loss for at the time I printed those things I had a whole House to range in now [.] I am shut up in a Corner therefore am forced to ask a Price for them that I scarce expect to get from a Stranger. I am now Printing a Set of the Songs of Innocence & Experience for a Friend at Ten Guineas which I cannot do under Six Months consistent with my other Work, so that I have little hope of doing any more of such things. the Last Work I produced is a Poem Entitled Jerusalem the Emanation of the Giant Albion, but find that to Print it will Cost my Time the amount of Twenty Guineas One I have Finishd It contains 100 Plates but it is not likely that I shall get a Customer for it

As you wish me to send you a list with the Prices of these things they are as follows

America	£6.	6.	0
Europe	6.	6.	0
Visions &c	5.	5.	0
Thel	3.	3.	0
Songs of Innocence & Experience	10.	10.	0
Urizen	6.	6.	0

The Little Card I will do as soon as Possible[20] but when you Consider that I have been reduced to a Skeleton from which I am slowly recovering you will I hope have Patience with me.[21]

On Painting

Blake's rejection of oil paint as a medium is well documented. In his writings on art, he explained his preference for watercolour and his invented tempera technique by referring to these as forms of 'fresco', the medium preferred by the greatest artists of the sixteenth century.

Advertisement for Blake's Exhibition of 1809

A Wall on Canvas or Wood, or any other portable thing, of dimensions ever so large, or ever so small, which may be removed with the same convenience as so many easel Pictures; is worthy the consideration of the Rich and those who have the direction of public Works. If the Frescos of APELLES, of PROTOGENES,[22] of RAPHAEL, or MICHAEL ANGELO could have been removed, we might, perhaps, have them now in England. I could divide Westminster Hall, or the walls of any other great Building, into compartments and ornament them with Frescos, which would be removable at pleasure.

Oil will not drink or absorb Colour enough to stand the test of very little Time and of the Air; it grows yellow, and at length brown. It was never generally used till after VANDYKE'S time. All the little old Pictures, called cabinet Pictures, are in Fresco, and not in Oil.

Fresco Painting is properly Miniature, or Enamel Painting; every thing in Fresco is as high finished as Miniature or Enamel, although in Works larger than Life. The Art

has been lost: I have recovered it. How this was done, will be told, together with the whole Process, in a Work on Art, now in the Press. The ignorant Insults of Individuals will not hinder me from doing my duty to my Art. Fresco Painting, as it is now practised, is like most other things, the contrary of what it pretends to be.

The execution of my Designs, being all in Water-colours, (that is in Fresco) are regularly refused to be exhibited by the *Royal Academy*, and the *British Institution*[23] has, this year, followed its example, and has effectually excluded me by this Resolution; I therefore invite those Noblemen and Gentlemen, who are its Subscribers, to inspect what they have excluded: and those who have been told that my Works are but an unscientific and irregular Eccentricity, a Madman's Scrawls, I demand of them to do me the justice to examine before they decide.[24]

Descriptive Catalogue (1809)

THE eye that can prefer the Colouring of Titian and Rubens to that of Michael Angelo and Rafael, ought to be modest and to doubt its own powers. Connoisseurs talk as if Rafael and Michael Angelo had never seen the colouring of Titian or Correggio: They ought to know that Correggio was born two years before Michael Angelo, and Titian but four years after. Both Rafael and Michael Angelo knew the Venetian, and contemned and rejected all he did with the utmost disdain, as that which is fabricated for the purpose to destroy art.

Mr. B. appeals to the Public, from the judgment of those narrow blinking eyes, that have too long governed art in a dark corner. The eyes of stupid cunning never will be pleased with the work any more than with the look of self-devoting genius. The quarrel of the Florentine with the Venetian is not because he does not understand Drawing, but because he does not understand Colouring. How should he? he who does not know how to draw a hand or a foot, know how to colour it.

Colouring does not depend on where the Colours are put, but on where the lights and darks are put, and all depends on Form or Outline. On where that is put; where that is wrong, the Colouring never can be right; and it is always wrong in Titian and Correggio, Rubens and Rembrandt. Till we get rid of Titian and Correggio, Rubens and Rembrandt, We never shall equal Rafael and Albert Durer, Michael Angelo, and Julio Romano.[25]

[...]

All Frescos are as high finished as miniatures or enamels, and they are known to be unchangeable; but oil being a body itself, will drink or absorb very little colour, and changing yellow, and at length brown, destroys every colour it is mixed with, especially every delicate colour. It turns every permanent white to a yellow and brown putty, and has compelled the use of that destroyer of colour, white lead; which, when its protecting oil is evaporated, will become lead again. This is an awful thing to say to oil Painters; they may call it madness, but it is true. All the genuine old little Pictures, called Cabinet Pictures, are in fresco and not in oil. Oil was not used except by blundering ignorance, till after Vandyke's time, but the art of fresco painting being lost, oil became a fetter to genius, and a dungeon to art. But one convincing proof among many others, that these assertions are true is, that real gold and silver cannot be used with oil, as they are in all the old pictures and in Mr. B.'s frescos.[26]

[...]

The distinction that is made in modern times between a Painting and a Drawing proceeds from ignorance of art. The merit of a Picture is the same as the merit of a Drawing. The dawber dawbs his Drawings; he who draws his Drawings draws his Pictures. There is no difference between Rafael's Cartoons and his Frescos, or Pictures, except that the Frescos, or Pictures, are more finished. When Mr. B. formerly painted in oil colours his Pictures were shewn to certain painters and connoisseurs, who said that they were very admirable Drawings on canvass; but not Pictures: but they said the same of Rafael's Pictures. Mr. B. thought this the greatest of compliments, though it was meant otherwise. If losing and obliterating the outline constitutes a Picture, Mr. B. will never be so foolish as to do one. Such art of losing the outlines is the art of Venice and Flanders;

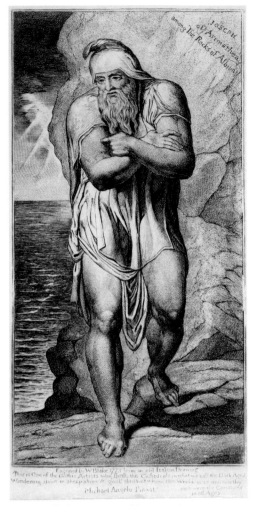

105
Joseph of Arimathea
Among the Rocks of Albion
c.1810
Engraving on paper
255 x 139
Fitzwilliam Museum,
Cambridge

knew each other by this line. Rafael and Michael Angelo, and Albert Durer, are known by this and this alone. The want of this determinate and bounding line evidences the [want of] idea in the artist's mind, and the pretence of the plagiary in all its branches. How do we distinguish the oak from the beech, the horse from the ox, but by the bounding outline? How do we distinguish one face or countenance from another, but by the bounding line and its infinite inflexions and movements? What is it that builds a house and plants a garden, but the definite and determinate? What is it that distinguishes honesty from knavery, but the hard and wiry line of rectitude and certainty in the actions and intentions. Leave out this line and you leave out life itself; all is chaos again, and the line of the almighty must be drawn out upon it before man or beast can exist. Talk no more then of Correggio, or Rembrandt, or any other of those plagiaries of Venice or Flanders. They were but the lame imitators of lines drawn by their predecessors, and their works prove themselves contemptible dis-arranged imitations and blundering misapplied copies.[27]

2. ARTISTS AND THE ART WORLD

The Nature of the True Artist

Annotations, c.1798–1809, written in Joshua Reynolds's *Discourses* (1769–90)

The Rich Men of England form themselves into a Society. to Sell & Not to Buy Pictures The Artist who does not throw his Contempt on such Trading Exhibitions. does not know either his own Interest or his Duty.
[…]
The Enquiry in England is not whether a Man has Talents. & Genius? But whether he is Passive & Polite & a Virtuous Ass: & obedient to Noblemens Opinions in Art & Science. If he is; he is a Good Man: If Not he must be Starved[28]
[…]
The difference between a bad Artist & a Good One Is the Bad Artist Seems to Copy a Great Deal: The Good one Really Does Copy a Great Deal[29]
[…]

it loses all character, and leaves what some people call, expression: but this is a false notion of expression; expression cannot exist without character as its stamina; and neither character nor expression can exist without firm and determinate outline. Fresco Painting is susceptible of higher finishing than Drawing on Paper, or than any other method of Painting. But he must have a strange organization of sight who does not prefer a Drawing on Paper to a Dawbing in Oil by the same master, supposing both to be done with equal care.

The great and golden rule of art, as well as of life, is this: That the more distinct, sharp, and wiry the bounding line, the more perfect the work of art; and the less keen and sharp, the greater is the evidence of weak imitation, plagiarism, and bungling. Great inventors, in all ages, knew this: Protogenes and Apelles

The Man who on Examining his own Mind finds nothing of Inspiration ought not to dare to be an Artist he is a Fool. & a Cunning Knave suited to the Purposes of Evil Demons[30]

Joseph of Arimathea Among the Rocks of Albion c.1810 (fig.105)

According to legend, Joseph of Arimathea had brought Christ to England as a child, and had built the first cathedral. He represented for Blake an ideal of the true artist. This print was reworked from a student exercise of around 1773 (fig.9) and exhibits a 'Gothic' primitivism in its engraved technique.

This is One of the Gothic Artists who Built the Cathedrals in what we call the Dark Ages Wandering about in sheep skins & goat skins of whom the World was not worthy such were the Christians in all Ages

Public Address (c.1809–10)

In a Commercial Nation Impostors are abroad in all Professions these are the greatest Enemies of Genius. In the Art of Painting these Impostors sedulously propagate an Opinion that Great Inventors Cannot Execute. This Opinion is as destructive of the true Artist as it is false by all Experience. Even Hogarth cannot be either Copied or Improved[32]

'A Vision of the Last Judgement' (c.1810)

Nations Flourish under Wise Rulers & are depressd under foolish Rulers[.] it is the same with Individuals as Nations[.] works of Art can only be produced in Perfection where the Man is either in Affluence or is Above the Care of it[.] Poverty is the Fools Rod which at last is turnd on his own back[.] this is A Last Judgment when Men of Real Art Govern & Pretenders Fall[...] Some People & not a few Artists have asserted that the Painter of this Picture would not have done so well if he had been properly Encouragd[.] Let those who think so reflect on the State of Nations under Poverty & their incapability of Art. tho Art is Above Either the Argument is better for Affluence than Poverty & tho he would not have been a greater Artist yet he would have produced Greater works of Art in proportion, to his means[.] A Last Judgment is not for the purpose of making Bad Men better but for the Purpose of hindering them from opressing the Good with Poverty & Pain by means of Such Vile Arguments & Insinuations[31]

Laocoön c.1826–7 (fig.106)

Blake's final 'illuminated' production was this single plate, representing the acclaimed classical sculpture of the Laocoön surrounded by dense grafitti of textual commentary. The pithy words selected below conjure a radical historical vision – in which the canonical works of ancient Greece and Rome are damned as mere impostures of the true, spiritual art of a yet more ancient era – and insist upon the absolute union of faith and creativity.

Christianity is Art & not Money

Money is its Curse

The Old & New Testaments are the Great Code of Art

Jesus & his Apostles & Disciples were all Artists

Their Works were destroyd by the Seven Angels of the Seven Churches in Asia. Antichrist Science

SCIENCE is the Tree of DEATH

ART is the Tree of LIFE GOD is JESUS

Prayer is the Study of Art

Praise is the Practise of Art

Fasting &c. all relate to Art

The outward Ceremony is Antichrist

Without Unceasing Practise nothing can be done

Practise is Art If you leave off you are Lost

A Poet a Painter a Musician an Architect: the Man

106
Laocoön
c.1826–7
Engraving on paper
274 x 227
Fitzwilliam Museum,
Cambridge

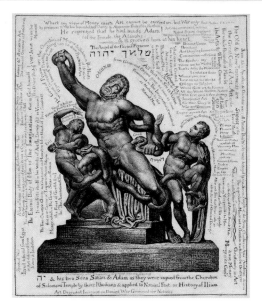

Or Woman who is not one of these is not
a Christian

You must leave Fathers & Mothers & Houses
& Lands if they stand in the way of ART

The unproductive Man is not a Christian
much less the Destroyer

The True Christian Charity not dependent
on Money (the lifes blood of Poor Families)
that is on

Caesar or Empire or Natural Religion

For every Pleasure Money Is Useless

Money, which is The Great Satan or Reason
the Root of Good & Evil In The Accusation
of Sin
 Where any view of Money exists Art cannot
be carried on, but War only (Read Matthew
CX. 9 & 10 v) [33] by pretences to the Two
Impossibilities Chastity & Abstinence Gods
of the Heathen
 Is not every Vice possible to Man described
in the Bible openly

All is not Sin that Satan calls so all the Loves
& Graces of Eternity.

If Morality was Christianity Socrates was
the Saviour

Art can never exist without Naked Beauty
displayed

No Secresy in Art

On his Symbolism and Characters

Blake's iconography and symbolic system
have fascinated and frustrated generations
of readers. Yet he did, occasionally, provide
explicit commentaries on his own images,
which involved reflections on much wider
issues of technique, vision and value.

Letter to the Revd John Trusler, 16 August 1799
*In 1799, Blake was commissioned by the Revd
Trusler to paint four watercolours on the themes
of 'Malevolence', 'Benevolence', 'Pride' and
'Humility'. Trusler was a conservative Anglican,
who had previously written a moralising (and
censorial) account of Hogarth's work. He must have
been expecting an anecdotal treatment of these
themes in the manner of that artist. What he
received [fig.107] disappointed and confused him.
Blake's explanations and justifications of this
design constitute one of his most lucid statements
about his approach.*

I find more & more that my Style of
Designing is a Species by itself. & in this
which I send you have been compelld by
my Genius or Angel to follow where he led
if I were to act otherwise it would not fulfill
the purpose for which alone I live. which
is in conjunction with such men as my friend
Cumberland to renew the lost Art of the
Greeks
 I attempted every morning for a fortnight
together to follow your Dictate. but when
I found my attempts were in vain. resolvd
to shew an independence which I know
will please an Author better than slavishly
following the track of another however
admirable that track may be At any rate
my Excuse must be: I could not do otherwise,
it was out of my power!
 I know I begged of you to give me your
Ideas & promised to build on them here
I counted without my host I now find
my mistake
 The Design I have Sent. Is
 A Father taking leave of his Wife & Child.

107

Malevolence
1799
Pen and ink and
watercolour on paper
300 x 225
Philadelphia Museum
of Art

Is watchd by Two Fiends incarnate. with intention that when his back is turned they will murder the mother & her infant – If this is not Malevolence with a vengeance I have never seen it on Earth. & if you approve of this I have no doubt of giving you Benevolence with Equal Vigor. as also Pride & Humility. but cannot previously describe in words what I mean to Design for fear I should Evaporate the Spirit of my Invention. But I hope that none of my Designs will be destitute of Infinite Particulars which will present themselves to the Contemplator. And tho I call them Mine I know that they are not Mine being of the same opinion with Milton when he says That the Muse visits his Slumbers & awakes & governs his Song when Morn purples The East. & being also in the predicament of that prophet who says I cannot go beyond the command of the Lord to speak good or bad

If you approve of my Manner & it is agreeable to you. I would rather Paint Pictures in oil of the same dimensions than make Drawings. & on the same terms. by this means you will have a number of Cabinet pictures. which I flatter myself will not be unworthy of a Scholar of Rembrant & Teniers.[34] whom I have Studied no less than Rafael & Michael angelo – Please to send me your orders respecting this & In my next Effort I promise more Expedition[35]

Letter to the Revd John Trusler, 23 August 1799
I really am sorry that you are falln out with the Spiritual World Especially if I should have to answer for it[.] I feel very sorry that your Ideas & Mine on Moral Painting differ so much as to have made you angry with my method of Study. If I am wrong I am wrong in good company. I had hoped your plan comprehended All Species of this Art & Especially that you would not reject that Species which gives Existence to Every other. namely Visions of Eternity[.] You say that I want somebody to Elucidate my Ideas. But you ought to know that What is Grand is necessarily obscure to Weak men. That which can be made Explicit to the Idiot is not worth my care. The wisest of the Ancients considerd what is not too Explicit as the fittest for Instruction because it rouzes the faculties

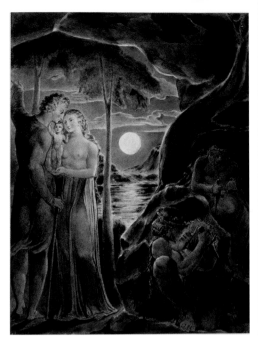

to act. I name Moses Solomon Esop Homer Plato

But as you have favord me with your remarks on my Design permit me in return to defend it against a mistaken one, which is. That I have supposed Malevolence without a Cause. – Is not Merit in one a Cause of Envy in another & Serenity & Happiness & Beauty a Cause of Malevolence. But Want of Money & the Distress of A Thief can never be alledged as the Cause of his Thievery. for many honest people endure greater hard ships with Fortitude We must therefore seek the Cause elsewhere than in want of Money for that is the Misers passion, not the Thiefs

I have therefore proved your Reasonings Ill proportiond which you can never prove my figures to be. They are those of Michael Angelo Rafael & the Antique & of the best living Models. I percieve that your Eye is perverted by Caricature Prints, which ought not to abound so much as they do. Fun I love but too much Fun is of all things the most loathsom. Mirth is better than Fun & Happiness is better than Mirth – I feel that a Man may be happy in This World. And I know that This World Is a World of Imagination & Vision I see Every thing I paint In This World, but Every body does not see alike. To the Eyes of a Miser a Guinea is more beautiful than the Sun & a bag worn with

the use of Money has more beautiful proportions than a Vine filled with Grapes.

The tree which moves some to tears of joy is in the Eyes of others only a Green thing that stands in the way. Some See Nature all Ridicule & Deformity & by these I shall not regulate my proportions, & Some Scarce see Nature at all But to the Eyes of the Man of Imagination Nature is Imagination itself. As a man is So he Sees. As the Eye is formed such are its Powers You certainly Mistake when you say that the Visions of Fancy are not be found in This World. To Me This World is all One continued Vision of Fancy or Imagination & I feel Flatterd when I am told So. What is it sets Homer Virgil & Milton in so high a rank of Art. Why is the Bible more Entertaining & Instructive than any other book. Is it not because they are addressed to the Imagination which is Spiritual Sensation & but mediately to the Understanding or Reason Such is True Painting and such was alone valued by the Greeks & the best modern Artists. Consider what Lord Bacon says 'Sense sends over to Imagination before Reason have judged & Reason sends over to Imagination before the Decree can be acted.' See Advancemt of Learning Part 2 P 47 of first Edition[36]

But I am happy to find a Great Majority of Fellow Mortals who can Elucidate My Visions & Particularly they have been Elucidated by Children who have taken a greater delight in contemplating my Pictures than I even hoped. Neither Youth nor Childhood is Folly or Incapacity Some Children are Fools & so are some Old Men. But There is a vast Majority on the side of Imagination or Spiritual Sensation[37]

Letter to George Cumberland, 26 August 1799
I ought long ago to have written to you to thank you for your kind recommendation to Dr Trusler which tho it has faild of success is not the less to be rememberd by me with Gratitude – I have made him a Drawing in my best manner he has sent it back with a Letter full of Criticisms in which he says it accords not with his Intentions which are to Reject all Fancy from his Work. How far he Expects to please I cannot tell. But as I cannot paint Dirty rags & old Shoes where

I ought to place Naked Beauty or simple ornament. I despair of Ever pleasing one Class of Men – Unfortunately our authors of books are among this Class how soon we Shall have a change for the better I cannot Prophecy. Dr Trusler says '*Your Fancy* from what I have seen of it. & I have seen variety at Mr Cumberlands seems to be in the other world or the World of Spirits. which accords not with my Intentions. which whilst living in This World Wish to follow *the Nature of it*' I could not help Smiling at the difference between the doctrines of Dr Trusler & those of Christ. But however for his own sake I am sorry that a Man should be so enamourd of Rowlandsons[38] caricatures as to call them copies from life & manners or fit Things for a Clergyman to write upon[39]

Descriptive Catalogue (1809)
The printed catalogue that accompanied Blake's one-man exhibition is the fullest and longest discussion of his own imagery. In the examples provided here, he emphasises the universal basis of his symbolism, and the interrelationship between his techniques and ideas.

NUMBER I.
The spiritual form of Nelson guiding Leviathan, in whose wreathings are infolded the Nations of the Earth (fig.83).

CLEARNESS and precision have been the chief objects in painting these Pictures. Clear colours unmudded by oil, and firm and determinate lineaments unbroken by shadows, which ought to display and not to hide form, as is the practice of the latter Schools of Italy and Flanders.

NUMBER II, ITS COMPANION
The spiritual form of Pitt, guiding Behemoth; he is that Angel who, pleased to perform the Almighty's orders, rides on the whirlwind, directing the storms of war: He is ordering the Reaper to reap the Vine of the Earth, and the Plowman to plow up the Cities and Towers (fig.84).

THIS Picture also is a proof of the power of colours unsullied with oil or with any cloggy vehicle. Oil has falsely been supposed to give strength to colours: but a little consideration

must shew the fallacy of this opinion. Oil will not drink or absorb colour enough to stand the test of very little time and of the air. It deadens every colour it is mixed with, at its first mixture, and in a little time becomes a yellow mask over all that it touches. Let the works of modern Artists since Rubens' time witness the villany of some one at that time, who first brought oil Painting into general opinion and practice: since which we have never had a Picture painted, that could shew itself by the side of an earlier production. Whether Rubens or Vandyke, or both, were guilty of this villany, is to be enquired in another work on Painting, and who first forged the silly story and known falshood, about John of Bruges[40] inventing oil colours: in the mean time let it be observed, that before Vandyke's time, and in his time all the genuine Pictures are on Plaster or Whiting grounds and none since.

The two Pictures of Nelson and Pitt are compositions of a mythological cast, similar to those Apotheoses of Persian, Hindoo, and Egyptian Antiquity, which are still preserved on rude monuments, being copies from some stupendous originals now lost or perhaps buried till some happier age. The Artist having been taken in vision into the ancient republics, monarchies, and patriarchates of Asia, has seen those wonderful originals called in the Sacred Scriptures the Cherubim, which were sculptured and painted on walls of Temples, Towers, Cities, Palaces, and erected in the highly cultivated states of Egypt, Moab, Edom, Aram, among the Rivers of Paradise, being originals from which the Greeks and Hetrurians copied Hercules, Farnese, Venus of Medicis, Apollo Belvidere, and all the grand works of ancient art. They were executed in a very superior style to those justly admired copies, being with their accompaniments terrific and grand in the highest degree. The Artist has endeavoured to emulate the grandeur of those seen in his vision, and to apply it to modern Heroes, on a smaller scale.

No man can believe that either Homer's Mythology, or Ovid's, were the production of Greece, or of Latium; neither will any one believe, that the Greek statues, as they are called, were the invention of Greek Artists;

perhaps the Torso is the only original work remaining; all the rest are evidently copies, though fine ones, from greater works of the Asiatic Patriarchs. The Greek Muses are daughters of Mnemosyne, or Memory, and not of Inspiration or Imagination, therefore not authors of such sublime conceptions. Those wonderful originals seen in my visions, were some of them one hundred feet in height; some were painted as pictures, and some carved as basso relievos, and some as groupes of statues, all containing mythological and recondite meaning, where more is meant than meets the eye. The Artist wishes it was now the fashion to make such monuments, and then he should not doubt of having a national commission to execute these two Pictures on a scale that is suitable to the grandeur of the nation, who is the parent of his heroes, in high finished fresco, where the colours would be as pure and as permanent as precious stones though the figures were one hundred feet in height.[41] [...]

NUMBER IV
The Bard, from Gray (fig.82)

The connoisseurs and artists who have made objections to Mr. B.'s mode of representing spirits with real bodies, would do well to consider that the Venus, the Minerva, the Jupiter, the Apollo, which they admire in Greek statues, are all of them representations of spiritual existences of God's immortal, to the mortal perishing organ of sight; and yet they are embodied and organized in solid marble. Mr. B. requires the same latitude and all is well. The Prophets describe what they saw in Vision as real and existing men whom they saw with their imaginative and immortal organs; the Apostles the same; the clearer the organ the more distinct the object. A Spirit and a Vision are not, as the modern philosophy supposes, a cloudy vapour or a nothing: they are organized and minutely articulated beyond all that the mortal and perishing nature can produce. He who does not imagine in stronger and better lineaments, and in stronger and better light than his perishing mortal eye can see does not imagine at all. The painter of this work

asserts that all his imaginations appear to him infinitely more perfect and more minutely organized than any thing seen by his mortal eye. Spirits are organized men: Moderns wish to draw figures without lines, and with great and heavy shadows; are not shadows more unmeaning than lines, and more heavy? O who can doubt this! [42]

[...]

NUMBER V
The Ancient Britons

In the last Battle of King Arthur only Three Britons escaped, these were the Strongest Man, the Beautifullest Man, and the Ugliest Man; these three marched through the field unsubdued, as Gods, and the Sun of Britain sat [*sic*], but shall arise again with tenfold splendor when Arthur shall awake from sleep, and resume his dominion over earth and ocean.

The three general classes of men who are represented by the most Beautiful, the most Strong, and the most Ugly, could not be represented by any historical facts but those of our own country, the Ancient Britons; without violating costume. The Britons (say historians) were naked civilized men, learned, studious, abstruse in thought and contemplation; naked, simple, plain, in their acts and manners; wiser than after-ages. They were overwhelmed by brutal arms all but a small remnant; Strength, Beauty, and Ugliness escaped the wreck, and remain for ever unsubdued, age after age.

The British Antiquities are now in the Artist's hands; all his visionary contemplations, relating to his own country and its ancient glory, when it was as it again shall be, the source of learning and inspiration. Arthur was a name for the constellation Arcturus, or Bootes, the Keeper of the North Pole. And all the fables of Arthur and his round table; of the warlike naked Britons; of Merlin; of Arthur's conquest of the whole world; of his death, or sleep, and promise to return again; of the Druid monuments, or temples; of the pavement of Watling-street; of London stone; of the caverns in Cornwall, Wales, Derbyshire, and Scotland; of the Giants of Ireland and Britain; of the elemental beings, called by us by the general name of Fairies; and of these three who escaped, namely, Beauty, Strength, and Ugliness. Mr. B. has in his hands poems of the highest antiquity. Adam was a Druid, and Noah; also Abraham was called to succeed the Druidical age, which began to turn allegoric and mental signification into corporeal command, whereby human sacrifice would have depopulated the earth. All these things are written in Eden. The artist is an inhabitant of that happy country, and if every thing goes on as it has begun, the world of vegetation and generation may expect to be opened again to Heaven, through Eden, as it was in the beginning.

The Strong man represents the human sublime. The Beautiful man represents the human pathetic, which was in the wars of Eden divided into male and female. The Ugly man represents the human reason. They were originally one man, who was fourfold; he was self-divided, and his real humanity slain on the stems of generation, and the form of the fourth was like the Son of God. How he became divided is a subject of great sublimity and pathos. The Artist has written it under inspiration, and will, if God please, publish it; it is voluminous, and contains the ancient history of Britain, and the world of Satan and of Adam. [43]

In the mean time he has painted this Picture, which supposes that in the reign of that British Prince, who lived in the fifth century, there were remains of those naked Heroes, in the Welch Mountains; they are there now, Gray saw them in the person of his bard on Snowdon; [44] there they dwell in naked simplicity; happy is he who can see and converse with them above the shadows of generation and death. The giant Albion, was Patriarch of the Atlantic, he is the Atlas of the Greeks, one of those the Greeks called Titans. The stories of Arthur are the acts of Albion, applied to a Prince of the fifth century, who conquered Europe, and held the Empire of the world in the dark age, which the Romans never again recovered. In this Picture, believing with Milton, the ancient British History, Mr. B. has done, as all the ancients did, and as all the moderns, who are worthy

of fame, given the historical fact in its poetical vigour; so as it always happens, and not in that dull way that some Historians pretend, who being weakly organized themselves, cannot see either miracle or prodigy; all is to them a dull round of probabilities and possibilities; but the history of all times and places, is nothing else but improbabilities and impossibilities; what we should say, was impossible if we did not see it always before our eyes.

The antiquities of every Nation Under Heaven, is no less sacred than that of the Jews. They are the same thing as Jacob Bryant,[45] and all antiquaries have proved. How other antiquities came to be neglected and disbelieved, while those of the Jews are collected and arranged, is an enquiry, worthy of both the Antiquarian and the Divine. All had originally one language, and one religion, this was the religion of Jesus, the everlasting Gospel. Antiquity preaches the Gospel of Jesus. The reasoning historian, turner and twister of causes and consequences, such as Hume, Gibbon and Voltaire;[46] cannot with all their artifice, turn or twist one fact or disarrange self evident action and reality. Reasons and opinions concerning acts, are not history. Acts themselves alone are history, and these are neither the exclusive property of Hume, Gibbon nor Voltaire, Echard, Rapin, Plutarch, nor Herodotus.[47] Tell me the Acts, O historian, and leave me to reason upon them as I please; away with your reasoning and your rubbish. All that is not action is not worth reading. Tell me the What; I do not want you to tell me the Why, and the How; I can find that out myself, as well as you can, and I will not be fooled by you into opinions, that you please to impose, to disbelieve what you think improbable or impossible. His opinions, who does not see spiritual agency, is not worth any man's reading; he who rejects a fact because it is improbable, must reject all History and retain doubts only.

It has been said to the Artist, take the Apollo for the model of your beautiful Man and the Hercules for your strong Man, and the Dancing Fawn for your Ugly Man.[48] Now he comes to his trial. He knows that what he does is not inferior to the grandest Antiques. Superior they cannot be, for human power cannot go beyond either what he does, or what they have done, it is the gift of God, it is inspiration and vision. He had resolved to emulate those precious remains of antiquity he has done so and the result you behold; his ideas of strength and beauty have not been greatly different. Poetry as it exists now on earth, in the various remains of ancient authors, Music as it exists in old tunes or melodies, Painting and Sculpture as it exists in the remains of Antiquity and in the works of more modern genius, is Inspiration, and cannot be surpassed; it is perfect and eternal. Milton, Shakspeare, Michael Angelo, Rafael, the finest specimens of Ancient Sculpture and Painting, and Architecture, Gothic, Grecian, Hindoo and Egyptian, are the extent of the human mind. The human mind cannot go beyond the gift of God, the Holy Ghost. To suppose that Art can go beyond the finest specimens of Art that are now in the world, is not knowing what Art is; it is being blind to the gifts of the spirit.

Letters to Ozias Humphry, describing 'A Vision of the Last Judgement', January–February 1808 [fig.108]

The text compiled by David Erdman as 'The Design of the Last Judgement' is based on three drafts of a letter written by Blake to Ozias Humphry early in 1808. He had secured for Blake the commission to paint The Last Judgement for the Earl and Countess of Egremont, of Petworth House in Sussex. Blake painted the subject of the last judgement (the last day of history when God judges all men either fit to ascend to Heaven, or damned to Hell) a number of times between 1806 and his death, including a very large version, over 2 metres (79 in) high, which is now lost. He also wrote a substantial written account of the theme, intended, it appears, as an addition to the catalogue of Blake's exhibition of 1809, if this had re-opened the following year.

The Design of The Last Judgment which I have completed by your recommendation for The Countess of Egremont it is necessary to give some account of & its various parts ought to be described for the accomodation of those who give it the honor of attention

Christ seated on the Throne of Judgment before his feet & around him the heavens in clouds are rolling like a scroll ready to be

consumed in the fires of the Angels who descend with the Four Trumpets sounding to the Four Winds

Beneath Earth is convulsed with the labours of the Resurrection – in the Caverns of the Earth is the Dragon with Seven heads & ten Horns chained by two Angels & above his Cavern on the Earths Surface is the Harlot siezed & bound by two Angels with chains while her Palaces are falling into ruins & her councellors & warriors are descending into the Abyss in wailing & despair

Hell opens beneath the Harlots seat on the left hand into which the Wicked are descending

The right hand of the Design is appropriated to the Resurrection of the Just the left hand of the Design is appropriated to the Resurrection & Fall of the Wicked

Vision of the Last Judgement c.1810
These notes were prepared by Blake for an addition to the catalogue of the 1809 exhibition of his works, in the expectation that it would re-open with extra paintings on show. They remained unpublished in his lifetime.

The Last Judgment is not Fable or Allegory but Vision Fable or Allegory are a totally distinct & inferior kind of Poetry. Vision or Imagination is a Representation of what Eternally Exists. Really & Unchangeably. Fable or Allegory is Formd by the Daughters of Memory. Imagination is Surrounded by the daughters of Inspiration who in the aggregate are calld Jerusalem[…] The Hebrew Bible & the Gospel of Jesus are not Allegory but Eternal Vision or Imagination of All that Exists[…] The Last judgment is one of these Stupendous Visions. I have represented it as I saw it to different People it appears differently as every thing else does for tho on Earth things seem Permanent they are less permanent than a Shadow as we all know too well

The Nature of Visionary Fancy or Imagination is very little Known & the Eternal nature & permanence of its ever Existent Images is considerd as less permanent than the things of Vegetative & Generative Nature[.] yet the Oak dies as well as the Lettuce but Its Eternal Image & Individuality never dies. but renews by its seed. just so the Imaginative Image returns by the seed of Contemplative Thought[.] the Writings of the Prophets illustrate these conceptions of the Visionary Fancy by their various sublime & Divine Images as seen in the Worlds of Vision[52]

On the State of the Arts in Britain

Blake was conscious that he was living through a time of material affluence, but knew, too, that as an independent engraver of little means, and an original artist with few patrons, he was unlikely to benefit much from it. His disappointments over the commissions he failed to receive from R. H. Cromek after 1805, and the disaster of his 1809 exhibition further embittered him. The statements that follow reflect his deepening pessimism after 1800.

Letter to George Cumberland, 2 July 1800
I am still Employd in making Designs & little Pictures with now & then an Engraving & find that in future to live will not be so difficult as it has been[.] It is very Extraordinary that London in so few years from a City of meer Necessaries or at l[e]ast a commerce of the lowest order of luxuries should have become a City of Elegance in some degree & that its once stupid inhabitants should enter into an Emulation of Grecian manners. There are now I believe as many Booksellers as there are Butchers & as many Printshops as of any other trade[.] We remember when a Print shop was a rare bird in London & I myself remember when I thought my pursuits of Art a kind of Criminal Dissipation & neglect of the main chance which I hid my face for not being able to abandon as a Passion which is forbidden
by Law & Religion, but now it appears to be Law & Gospel too, at least I hear so from the few friends I have dared to visit in my stupid Melancholy. Excuse this communication of sentiments which I felt necessary to my repose at this time. I feel very strongly that I neglect my Duty to my Friends, but It is not want of Gratitude or Friendship but perhaps an Excess of both.[53]

108
A Vision of the Last Judgement
1808
Pen and watercolour over pencil
51 × 395
The National Trust: Petworth House, Sussex

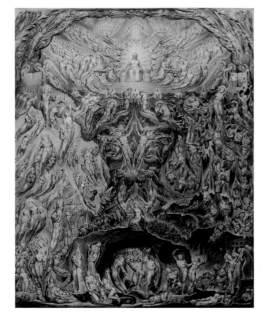

Annotations, c.1798–1809, written in Joshua Reynolds's *Discourses* (1769–90)

Having spent the Vigour of my Youth & Genius under the Opression of Sr Joshua & his Gang of Cunning Hired Knaves Without Employment & as much as could possibly be Without Bread, The Reader must Expect to Read in all my Remarks on these Books Nothing but Indignation & Resentment While Sr Joshua was rolling in Riches Barry was Poor & Unemployd except by his own Energy Mortimer was calld a Madman & only Portrait Painting applauded & rewarded by the Rich & Great. Reynolds & Gainsborough Blotted & Blurred one against the other & Divided all the English World between them Fuseli Indignant almost hid himself – I am hid [...]

The Arts & Sciences are the Destruction of Tyrannies or Bad Governments Why should A Good Government endeavour to Depress What is its Chief & only Support [...]

The Foundation of Empire is Art & Science Remove them or Degrade them & the Empire is No More – Empire follows Art & Not Vice Versa as Englishmen suppose[54]

Letter to William Hayley, 7 October 1803

Art in London flourishes. Engravers in particular are wanted. Every Engraver turns away work that he cannot Execute from his superabundant Employment. Yet no one brings work to me. I am content that it shall be so as long as God pleases I know that many works of a lucrative nature are in want of hands other Engravers are courted. I suppose that I must go a Courting which I shall do awkwardly [...]

How is it possible that a Man almost 50 Years of Age who has not lost any of his life since he was five years old without incessant labour & study. how is it possible that such a one with ordinary common sense can be inferior to a boy of twenty who scarcely has taken or deigns to take a pencil in hand but who rides about the Parks or Saunters about the Playhouses who Eats & drinks for business not for need how is it possible that such a fop can be superior to the studious lover of Art can scarcely be imagind[.] Yet such is somewhat like my fate & such it is likely to remain. Yet I laugh & sing for if on Earth neglected I am in heaven a Prince among Princes & even on Earth beloved by the Good as a Good Man[.] this I should be perfectly contented with but at certain periods a blaze of reputation arises round me in which I am considerd as one distinguishd by some mental perfection but the flame soon dies again & I am left stupified & astonishd[.] O that I could live as others do in a regular succession of Employment[.] this wish I fear is not to be accomplishd to me – Forgive this Dirge-like lamentation over a dead horse & now I have lamented over the dead horse let me laugh & be merry with my friends till Christmas for as Man liveth not by bread alone I shall live altho I should want bread[55]

On Reynolds

Annotations, c.1798–1809, written in Joshua Reynolds's *Discourses* (1769–90)

This Man was Hired to Depress Art This is the opinion of Will Blake my Proofs of this Opinion are given in the following Notes [...]

I consider Reynolds's Discourses to the Royal Academy as the Simulations of the Hypocrite who Smiles particularly where he means to Betray. His Praise of Rafael is like the Hysteric Smile of Revenge[;] His Softness & Candour. the hidden trap. & the poisoned feast,

He praises Michael Angelo for Qualities which Michael Angelo Abhorrd; & He blames Rafael for the only Qualities which Rafael Valued, Whether Reynolds. knew what he was doing. is nothing to me; the Mischief is just the same, whether a Man does it Ignorantly or Knowingly: I always consider'd True Art & True Artists to be particularly Insulted & Degraded by the Reputation of these Discourses As much as they were Degraded by the Reputation of Reynolds's Paintings. & that Such Artists as Reynolds, are at all times Hired by the Satan's. for the Depression of Art A Pretence of Art: To Destroy Art[56]

From 'Florentine Ingratitude' (c.1809)

Sir Joshua sent his own Portrait to
The birth Place of Michael Angelo
And in the hand of the simpering fool
He put a Dirty paper scroll
And on the paper to be polite
Did Sketches by Michel Angelo write

The Florentines said Tis a Dutch English
 bore
Michael Angelos Name writ on Rembrandts
 door
The Florentines call it an English Fetch
For Michael Angelo did never Sketch
Every line of his has Meaning
And needs neither Suckling nor Weaning
Tis the trading English Venetian Cant
To speak Michael Angelo & Act Rembrandt[57]

'A Pitiful Case' (c.1809)

The Villain at the Gallows tree
When he is doomd to die
To assuage his misery
In Virtues praise does cry

So Reynolds when he came to die
To assuage his bitter woe:
Thus aloud did howl & cry
Michael Angelo Michael Angelo[58]

On Fuseli and Barry

'To H –'

You think Fuseli is not a Great Painter Im Glad
This is one of the best compliments he ever had[59]

'The only Man that eer I knew'

The only Man that eer I knew
Who did not make me almost spew
Was Fuseli he was both Turk & Jew
And so dear Christian Friends how
do you do[60]

Annotations, c.1798–1809, written in Joshua Reynolds's *Discourses* (1769–90)

Who will Dare to Say that Polite Art is Encouraged, or Either Wished or Tolerated in a Nation where The Society for the Encouragement of Art. Sufferd Barry to Give them, his Labour for Nothing[61] A Society Composed of the Flower of the English Nobility & Gentry – Suffering an Artist to Starve while he Supported Really what They under pretence of Encouraging were Endeavouring to Depress – Barry told me that while he Did that Work – he Lived on Bread & Apples

O Society for Encouragement of Art – O King & Nobility of England! Where have you hid Fuseli's Milton[.][62] Is Satan troubled at his Exposure[?]

The Neglect of Fuselis Milton in a Country pretending to the Encouragement of Art is a Sufficient Apology for My Vigorous Indignation if indeed the Neglect of My own Powers had not been Ought not the Employers of Fools to be Execrated in future Ages.

Letter to the *Monthly Magazine* (1806)

Such an artist as Fuseli is invulnerable, he needs not my defence; but I should be ashamed not to set my hand and shoulder, and whole strength, against those wretches who, under pretence of criticism, use the dagger and the poison [...]

The taste of English amateurs has been too much formed upon pictures imported from Flanders and Holland; consequently our countrymen are easily brow-beat on the subject of painting; and hence it is so common to hear a man say, 'I am no judge of pictures' but, O Englishmen! know that every man ought to be a judge of pictures, and every man is so who has not been connoisseured out of his senses.

A gentleman who visited me the other day, said, 'I am very much surprised at the dislike

that some connoisseurs shew on viewing the pictures of Mr. Fuseli; but the truth is, he is a hundred years beyond the present generation.' Though I am startled at such an assertion, I hope the contemporary taste will shorten the hundred years into as many hours; for I am sure that any person consulting his own eyes must prefer what is so supereminent; and I am as sure that any person consulting his own reputation, or the reputation of his country, will refrain from disgracing either by such ill-judged criticisms in future.[63]

On Flaxman

Letter to John Flaxman, 12 September 1800

My Dearest Friend,
It is to you I owe All my present Happiness
It is to you I owe perhaps the Principal
Happiness of my life. I have presumd on
your friendship in staying so long away
& not calling to know of your welfare but
hope, now every thing is nearly completed
for our removal to Felpham, that I shall see
you on Sunday as we have appointed Sunday
afternoon to call on Mrs Flaxman at
Hempstead. I send you a few lines which
I hope you will Excuse. And As the time is
now arrivd when Men shall again converse
in Heaven & walk with Angels I know you will
be pleased with the Intention & hope you will
forgive the Poetry.

To My Dearest Friend John Flaxman these
lines

I bless thee O Father of Heaven & Earth that
 ever I saw Flaxmans face
Angels stand round my Spirit in Heaven. the
 blessed of Heaven are my friends upon
 Earth
When Flaxman was taken to Italy.[64] Fuseli
 was giv'n to me for a season
And now Flaxman hath given me Hayley his
 friend to be mine such my lot upon Earth
Now my lot in the Heavens is this; Milton lovd
 me in childhood & shewd me his face
Ezra came with Isaiah the Prophet, but
 Shakespeare in riper years gave me his
 hand
Paracelsus & Behmen[65] appeard to me. terrors

appeard in the Heavens above
And in Hell beneath & a mighty & awful
 change threatend the Earth
The American War began All its dark horrors
 passed before my face
Across the Atlantic to France. Then the French
 Revolution commencd in thick clouds
And My Angels have told me. that seeing such
 visions I could not subsist on the Earth
But by my conjunction with Flaxman who
 knows to forgive Nervous Fear[66]

Public Address (c.1809–10)

Secret Calumny & open Professions of Friendship are common enough all the world over but have never been so good an occasion of Poetic Imagery. When a Base Man means to be your Enemy he always begins with being your Friend[.] Flaxman cannot deny that one of the very first Monuments he did I gratuitously designd for him at the same time he was blasting my character as all Artist to Macklin my Employer as Macklin told me at the time how much of his Homer & Dante he will allow to be mine I do not know as he went far enough off to Publish them even to Italy. but the Public will know & Posterity will know[67]

Encountering Blake: An Anthology of Responses from Creative Artists

The literature on Blake is vast and various. He may be the most written-about British artist, by some stretch. There are already a number of important and thorough collections bringing together essays, commentaries and documentary records of Blake's life, and several studies reflecting on Blake's reputation over the centuries (see Bibliography). This present selection is both narrower and more impressionistic. It brings together quotes only from writers, painters and musicians responding to Blake's works. While some of these constitute important critical statements (A.C. Swinburne and T.S. Eliot, notably), the intention has been to offer a more informal and personal sense of Blake's reputation among artists. For even in this limited selection, it is possible to detect something of the recurring shifts in Blake's reputation and status among creative writers and artists, a group who have, repeatedly, proved to be most significant in maintaining Blake's reputation. What H. Dumaresq told George Cumberland regarding Blake's *Job* designs, that they 'will be valued only by artists', proved to be true of the artist's work more generally. Here, we can see how the ambivalent respect afforded him by his contemporaries gave way, among the Ancients (including John Linnell and Samuel Palmer), to a passionate admiration for their elder's spiritual wisdom. There is evidence, too, for the successive rediscovery of Blake among artists; the Pre-Raphaelites and decadents of the later nineteenth century (D.G. Rossetti, Swinburne) viewed Blake as a mystic and suffering artist, an image much helped by the bogus (but still-enduring) belief that Blake had immediate Irish ancestry, and could thus enjoy a still more dubious aura of Celtic mysticism. For the mid-twentieth-century artists associated with Surrealism and its British variant, labelled Neo-Romanticism (here represented by Ruthven Todd, John Piper and David Jones), Blake was a visionary whose unique and lasting influence on British art was his intense focus on nature. Here, he is the contrarily national and strangely modern Blake, both anticipating Modernism's radicalism and also resistant to it. Then there is Blake the proto-hippie, recovered by the Beat poets (Allen Ginsberg

and Jack Kerouac): sexy, sexual, wild, a tripped-out guru and bohemian. And in our own day, we encounter Blake the psychogeographer and 'cockney Visionary', a paradoxically unearthly, urban outsider.

John Flaxman (1755–1826), artist, writing to William Hayley, 26 April 1784

I have left a *Pamphlet of Poems* with Mr Long which he will transmit to Eartham; they are the writings of a Mr BLAKE you have heard me mention, his education will plead sufficient excuse to your Liberal mind for the defects of his work & there are few so able to distinguish & set a right value of the beauties as yourself, I have beforementioned that Mr Romney thinks his historical drawings rank with those of Ml. Angelo; he is at present employed as an engraver, in which his encouragement is not extraordinary.[1]

Henry Fuseli (1741–1825), artist and writer, recorded in the diary of Joseph Farington, 24 June 1796

Fuseli called on me last night & sat till 12 oClock. He mentioned Blake, the Engraver, whose genius & invention have been much spoken of. Fuseli has known him several years, and thinks He has a great deal of invention, but that 'fancy is the end, and not a means in his designs'. He does not employ it to give novelty and decoration to regular conceptions; but the whole of his aim is to produce singular shapes & odd combinations […] Fuseli says, Blake has something of madness abt. Him. He acknowledges the superiority of Fuseli: but thinks himself more able than Stothard.[2]

Thomas Stothard (1755–1834) and John Hoppner (1758–1810), artists, recorded in the diary of Joseph Farington, 12 January 1797

We supped together and had laughable conversation. Blakes eccentric designs were mentioned. Stothard supported his claims to Genius, but allowed He had been misled to extravagance in his art, & He knew by whom. – Hoppner ridiculed the absurdity of his designs, and said nothing could be more easy than to produce such. – They were like the conceits of a drunken man or a madman. 'Represent a man sitting on the moon, and

Pissing the Sun out – that would be a whim of as much merit.' – Stothard was angry mistaking the laughter caused by Hoppners description. –[3]

Robert Hartley Cromek (1770–1812), printmaker and publisher, writing to James Montgomery, 17 April 1807

That 'wild & wonderful genius' is still in Fairy Land; still believing that what has been called *Delusion* is the only *Reality*! What has been called Fancy & Imagination the Eternal World! & that this World is the only Cheat, Imagination the *only Truth*! […] Blake's Drawings for 'The Grave' have been presented to the Queen & Princes at Windsor – I received a Letter from Miss Planta stating Her Majesty's wish that Mr Blake would dedicate the Work to Her – This circumstance has so much pleased Blake that he has already produced a *Design* for the Dedication & a poetic Address to the Queen marked with his usual Characteristics – Sublimity, Simplicity, Elegance and Pathosm his wildness *of course*.[4]

Samuel Taylor Coleridge (1772–1834), poet and critic, writing to Charles Augustus Tulk, 12 February 1812

I return to you Blake's poesies, metrical and graphic, with thanks. With this and the Book I have sent a rude scrawl as to the order in which I was pleased by the several poems […]

Blake's Poems
I begin with my Dyspathies that I may forget them: and have uninterrupted space for Loves and Sympathies. Title page and the following emblem contain all the faults of the Drawings with as few beauties, as could be in the compositions of a man who was capable of such faults + such beauties. – The faults – despotism in symbols, amounting in the Title page to the μισητέου, and occasionally, irregular unmodified Lines of the Inanimate, sometimes as the effect of rigidity and sometimes of exossation – like a wet tendon. So likewise the ambiguity of the Drapery. Is it a garment – or the body incised and scored out? The *Limpness* (= the effect of Vinegar on an egg) in the upper one of the two prostate figures in the Title page, and the *eye*-likeness of the twig posteriorly on the second,

– and the strait line down the waist-coat of pinky goldbeater's skin in the next drawing, with the I don't know whatness of the countenance, as if the mouth had been formed by the habit of placing the tongue, not contemptuously, but stupidly, between the lower gums and the lower jaw – these are the only *repulsive* faults I have noticed. The figure, however, of the second leaf (abstracted from the *expression* of the countenance given it by something about the mouth and the interspace from the lower lip to the chin) is such as only a Master learned in his art could produce.[5]

Samuel Taylor Coleridge writing to Henry Francis Cary, 6 February 1818

I have been this morning reading a strange publication – viz. Poems with very wild and interesting pictures, as the swathing, etched (I suppose) but it is said – printed and painted by the Author, W. Blake. He is a man of Genius – and I apprehend, a Swedenborgian – certainly, a mystic *emphatically*. You perhaps smile at *my* calling another Poet, a *Mystic*; but verily I am in the very mire of commonplace common-sense compared with Mr Blake, apo- or rather ana-calyptic Poet, and Painter![6]

John Linnell (1792–1882), artist, recalls meeting Blake in 1818, from his 'Autobiography' (c.1863–4)

Everything in Art was at a low ebb then. Even Turner could not sell his pictures for as many hundreds as they have since fetched thousands. I soon encountered Blakes peculiarities and was somewhat taken aback by the boldness of some of his assertions. I never saw anything the least like madness for I never opposed him spitefully as many did but being really anxious to fathom if possible the amount of truth which might be in his most startling assertions I generally met with a sufficiently rational explanation in the most really friendly & conciliatory tone. Even when John Varley to whom I had introduced Blake & who readily devoured all the marvellous in Blake's most extravagant utterances, even to Varley Blake would ocasionally explain unasked how he beleived that both Varley & I could see the same visions as he saw making it evident to me that Blake claimed the possession of some powers only in a greater degree that all men possessed and which they undervalued in themselves & lost through love of sordid pursuits – pride, vanity, & the unrighteous mammon.[7]

Thomas Griffiths Wainewright (1794–1852), artist and critic, writing to John Linnell, February 1827

How is that excellent artist & man Mr Blake? The admirers & true lovers of noble art owe you much for your care of him. May it be repaid to you *here* as well as hereafter! His Dante is the most wonderful emanation of imagination that I have ever heard of. His fate is a national disgrace; while his pious content is a national example.[8]

George Cumberland (1754–1848), amateur artist, undated note (after 1827?)

They say Blake was mad: If so Shakespeare & Milton were so too. Blake was a man of imagination Consequently a decided original – he could not be brought to place learning above inspiration.[9]

Samuel Palmer (1805–81), artist, undated note (after 1827)

Those artists who are so base that they do not attempt grandeur of form and yet lyingly pretend to grand effect are now called modest; but those who, as William Blake, do attempt and achieve both will with him, by blind cunning and stupid wilfuness be set down impudent madmen: for our taste is Dutch; Rembrandt is our Da Vinci, and Rubens our Michelangiolo![10]

John Ruskin (1819–1900), critic and artist, from a rejected passage from *The Seven Lamps of Architecture* (1849)

We have had two in the present century, two magnificent and mighty – William Blake and JMW Turner. I do not speak of the average genius of the higher ranks of the human mind, of that glitter and play of dominant capacity which in all ages is the adornment and light of each living department of literature and of art. We have seen many of those light waves on the wide

human sea, and we shall have their like again in the renewed swelling of its tides. I speak not of them, but of the Great Pharoses of the moving wilderness, those towering and solitary beacons whose tops are seen from above, and beyond the morning cloud and the evening horizon. We have had only two of these built for us; two men who if they had been given to us in a time of law, and of recognised discipline, if they had either teaching in their youth, or reverence in their manhood, might have placed our age on a level with the proudest periods of creative art. But what have they done for us? The influence of the one is felt as much as the weight of last winter's snow: and that of the other has been so shortened by our dulness, and distorted by our misapprehension, that it may be doubted whether it has wrought among us more of good or of evil.[11]

Samuel Palmer (1805–81), artist, writing to Alexander Gilchrist, 23 August 1855

His knowledge was various and extensive, and his conversation so nervous and brilliant, that, if recorded at the time, it would now have thrown much light upon his character, and in no way lessened him in the estimation of those who know him only by his works.

In him you saw at once the Maker, the Inventor; one of the few in any age: a fitting companion for Dante. He was energy itself, and shed around him a kindling influence; an atmosphere of life, full of the ideal. To walk with him in the country was to perceive the soul of beauty through the forms of matter; and the high, gloomy buildings between which, from his study window, a glimpse was caught of the Thames and the Surrey shore, assumed a kind of grandeur from the man dwelling near them. Those may laught at this who never knew such a one as Blake, but of him it is the simple truth.

He was a man without a mask; his aim single, his path straightforward, and his wants few; so he was free, noble, and happy.[12]

Algernon Charles Swinburne (1837–1909), poet and critic, writing to M.D. Conway, 7 November 1866

In many points both of matter and manner – gospel and style – [Walt Whitman's] *Leaves of Grass*[13] have been anticipated or rivalled by the unpublished semi-metrical 'Prophetic Books' of William Blake (which I presume you have never read?). This I have proved in my forthcoming book on the suppressed works of that great artist and thinker,[14] whose philosophy, to my mind far deeper and subtler than his rival Swedenborg's, has never yet been published because of the abject and faithless and blasphemous timidity of our wretched English literary society; a drunken clerical club dominated by the spurious spawn of the press.

However, I have printed (with comments of my own) a good deal of these books. Written in the same semi-metrical verse (or prose) as the *Leaves of Grass*, they preach almost exactly the same gospel; and I think might interest Walt Whitman and his admirers in America, where I suppose these books of Blake's (who regarded them as the real grave work of his life) are as little known as here – less known they cannot be. In the original 'Prophecies' there are passages quite as broad (and perhaps more offensive) as any in the *Leaves of Grass*. These I have not quoted in my critical essay; but the gist of them is precisely that of Walt Whitman's book – on other words, healthy, natural, and anti-natural. But I abstain, (for once) in print, because I want to see what I hope may yet be achieved by subscription – a complete or quasi-complete edition of Blake's works; photographs thoroughly well done of his chief drawings; artistic engravings of his chief pictures or 'frescos,' to use his own term; and a full though critical edition of his writings. Then only one of the greatest of Englishmen – a poet when there was no poet – an artist when there was hardly an artist – a republican under the very shadow of the gibbet which George III (who flung Blake's drawings away when they were laid before his miserable blind eyes) had prepared for all such men – a lover of America, of freedom, and of France from the first to the last – the one single man in London who dared to go out with the red cap on his head (not through bravado, but simply as a matter of principle) – then only, I say, will this great man be understood.[15]

Algernon Charles Swinburne, from *William Blake: A Critical Essay* (1868; revised ed. 1906)

The genius of William Blake – and his genius is one with his character: at one with it on all points and in every way – has so peculiar a charm that no one not incapable of feeling its fascination can ever outlive his delight in it. While we were able to regard this Londoner born and bred as not only a fellow-countryman of Milton's but a fellow-countryman of Shakespeare's, it did seem an almost insoluble problem to explain or to conjecture how so admirable and adorable a genius is vitiated by such unutterable and unimaginative defects. But if we regarded him as a Celt rather than an Englishman, we shall find it no longer so difficult to understand from whence he derived his amazing capacity for such illimitable emptiness of mock-mystical babble as we find in his bad imitations of so bad a model as the Apocalypse: his English capacity for occasionally superb and serious workmanship we may rationally attribute to his English birth and breeding. Some Hibernian commentator on Blake, if I rightly remember a fact so insignificant, has somewhere said something to some such effect as that I, when writing about some fitfully audacious and fancifully delirious deliverance of the poet he claimed as a countryman, and trying to read into it some coherent and imaginative significance, was innocent of any knowledge of Blake's meaning. It is possible, if the spiritual fact of his Hibernian heredity has been established or can be established, that I was: for the excellent reason that, being a Celt, he now and then too probably had none worth the labour of deciphering – or at least worth the serious attention of any student belonging to a race in which reason and imagination are the possibly preferable substitutes for fever and fancy. But in that case it must be gladly and gratefully admitted that the Celtic tenuity of his sensitive and prehensile intelligence throws into curious relief the occasional flashes of inspiration, the casual fits of insight, which raise him to the momentary level of a deep and a free thinker as well as a true and immortal poet.[16]

Dante Gabriel Rossetti (1828–82), poet and artist, 'William Blake' (1880)

(To Frederick Shields,[17] on his sketch of Blake's work-room and death-room, 3 Fountain Court, Strand)

This is the place. Even here the dauntless soul,
The unflinching hand, wrought on; till in that
 nook,
As on that very bed, his life partook
New birth, and passed. Yon river's dusky shoal,
Whereto the close-built coiling lanes unroll,
Faced his work-window, whence his eyes would
 stare,
Thought-wandering, unto nought that met them
 there,
But to the unfettered irreversible goal.

This cupboard, Holy of Holies, held the cloud
Of his soul writ and limned; this other one,
His true wife's charge, full oft in their abode
Yielded for daily bread the martyr's stone,
Ere yet their food might be that Bread alone,
The words now home-speech of the mouth of God.

[Note by William Michael Rossetti] I need hardly dwell on my brother's early love and study of Blake's work in poetry and design, and on the part he took in connexion with Gilchrist's 'Life of Blake'. The design of Mr Shields, referred to in the heading of the sonnet, was reproduced in *The Art-Journal* in 1903. The sonnet refers to two several cupboards, but I can only see one in the design.[18]

William Butler Yeats (1865–1939), poet, from his essay 'William Blake and the Imagination' (1897)

There have been men who loved the future like a mistress, and the future mixed her breath into their breath and shook her hair about them, and hid them from the understanding of their times. William Blake was one of these men, and if he spoke confusedly and obscurely it was because he spoke of things for whose speaking he could find no models in the world he knew. He announced the religion of art, of which no man dreamed in the world he knew; and he understood it more perfectly than the thousands of subtle spirits who have received its baptism in the world we know, because in the beginnings of important things – in the

beginning of love, in the beginning of the day, in the beginning of any work – there is a moment when we understand more perfectly than we understand again until all is finished. In this time educated people believed that they amused themselves with books of imagination, but that they 'made their souls' by listening to sermons and by doing or not doing certain things. When they had to explain why serious people like themselves honoured the great poets greatly they were hard put to it for lack of good reasons. In our time we are agreed that we 'make our souls' out of some one of the great poets of ancient times, or out of Shelley or Wordsworth, or Goethe or Balzac, or Flaubert, or Count Tolstoy,[19] in the books he wrote before he became a prophet and fell into a lesser order, or out of Mr Whistler's[20] pictures, while we amuse ourselves, or, at best, make a poorer sort of soul, by listening to sermons or by doing or by not doing certain things. We write of great writers, even of writers whose beauty would once have seemed an unholy beauty, with rapt sentences like those our fathers kept for the beatitudes and mysteries of the Church; and no matter what we believe with our lips, we believe with our hearts that beautiful things, as Browning[21] said in his one prose essay that was not in verse, have 'lain burningly on the Divine' and, that when time has begun to wither, the Divine hand will fall heavily on bad taste and vulgarity. When no man believed these things William Blake believed them, and began that preaching against the Philistines which is as the preaching of the Middle Ages against the Saracen.[22]

Lafcadio Hearn (1850–1904), writer and translator, from his lecture 'Blake – The First English Mystic' (c.1899–1902)
Altogether he was one of the most extraordinary persons in the whole history of English letters. He was not only a poet, but a very great painter. And he was a wonderful prose writer. And finally he must be remembered as the first great English mystic [...] What little of Blake's work is left to-day chiefly belongs to the British Museum, and is considered beyond price.

You must go to the British Museum to see it. As an artist Blake has had a great deal of influence upon the modern painters; and almost every modern painter of note goes to the British Museum to study the work of Blake [...] In our day every poet of importance makes a serious study of Blake; there is perhaps no poet of the Victorian age that has not learned a great deal from him. That is his chief glory.[23]

James Joyce (1882–1941), writer, from a lecture on 'William Blake' (1912)
Armed with this two-edged sword, the art of Michelangelo and the revelations of Swedenborg, Blake killed the dragon of experience and natural wisdom, and, by minimizing space and time and denying the existence of memory and the senses, he tried to paint his works on the void of the divine bosom. To him, each moment shorter than a pulse-beat was equivalent in its duration to six thousand years, because in such an infinitely short instant the work of the poet is conceived and born. To him, all space larger than a red globule of human blood was visionary, created by the hammer of Los, while in a space smaller than a globule of blood we approach eternity, of which our vegetable world is but a shadow. Not *with* the eye, then, but *beyond* the eye, the soul and the supreme love must look, because the eye, which was born in the night while the soul was sleeping in rays of light, will also die in the night. Dionysius the psuedo-Areopagite,[24] in his book *De Divinis Nominibus*, arrives at the throne of God by denying and overcoming every moral and metaphysical attribute, and falling into ecstasy and prostrating himself before the divine obscurity, before that unutterable immensity which precedes and encompasses the supreme knowledge in the divine order. The mental process by which Blake arrives at the threshold of the infinite is a similar process. Flying from the infinitely small to the infinitely large, from a drop of blood to the universe of stars, his soul is consumed by the rapidity of light, and finds itslf renewed and winged and immortal on the edge of the dark ocean of God.[25]

Stanley Spencer (1891–1959), artist, writing to Florence Spencer, 17 July 1917

I am doing something very interesting. I am reading Keats[26] & Blake at the same time. Can anything be more scathing than Blake's epigrams on the artists of his time? I wish he had been alive today.

Fuseli is the only man he speaks well of, & I am quite ignorant of this man.

'The only man ever I knew
Who did not make me almost spue
Was Fuseli: he was both Turk and Jew
And so, dear Christian friends, how do you do?'[27]

Don't you think Blake's lyrics such as 'silks and fine array' & 'How sweet I roamed from field to field' are comparable with Shakespeare's?[28]

Yet the man who wrote
'When the voices of children are heard in the green'[29]
was according to such men as Flaxman, a mad man.

I love Keats more than Blake, but I think Blake is an infinitely greater man than Keats. Blake is free. Everything comes from Blake, with apparently no effort, clear & pure as the Light of God. But Keats is only at times inspired. As Jacques Raverat[30] said of me, so I say of Keats: he 'interfered with the Holy Ghost'. Blake had perfect faith, which accounts for the ease one feels in reading Blake. There is not this ease with Keats [...] Keats was a perfectly good man, but he did not realise the importance of knowing always the time of his visitation. His faith was shaky & that is why I do not feel as happy when I read Keats as I do when I read Blake. But I cannot read Blake for long. He is like Bach – rather overpowering.[31]

Stanley Spencer, note of c.1952

The verity of God: the sense of His presence becomes an urgently wished for thing through the looking at Blake's drawings, reading his writings. His (God's presence) becomes the only thing one wishes to express, or think about at all. The one attractive thing in Blake is that God is found everywhere all the time.[32]

T.S. Eliot (1888–1965), poet and critic, from his essay 'Blake' (1920)

If one follow Blake's mind through the several stages of his poetic development it is impossible to regard him as a naïf, a wild man, a wild pet for the supercultivated. The strangeness is evaporated, the peculiarity is seen to be the peculiarity of all great poetry: something which is found (not everywhere) in Homer and Æschylus and Dante and Villon,[33] and profound and concealed in the work of Shakespeare – and also in another form in Montaigne and in Spinoza.[34] It is merely a peculiar honesty, which, in a world too frightened to be honest, is peculiarly terrifying. It is an honesty against which the whole world conspires, because it is unpleasant. Blake's poetry has the unpleasantness of great poetry. Nothing that can be called morbid or abnormal or perverse, none of the things which exemplify the sickness of an epoch or a fashion, have this quality; only those things which, by some extraordinary labour of simplification, exhibit the essential sickness or strength of the human soul. And this honesty never exists without great technical accomplishment. The question about Blake the man is the question of the circumstances that concurred to permit this honesty in his work, and what circumstances define its limitations. The favouring conditions probably include these two: that, being early apprenticed to a manual occupation, he was not compelled to acquire any other education in literature than he wanted, or to acquire it for any other reason than that he wanted it; and that, being a humble engraver, he had no journalistic-social career open to him.[35]

Paul Nash (1889–1946), artist, from his autobiography *Outline* (1949)

In those days I knew nothing of the sea or the magical implications of aerial perspective across miles of shore where waves alternately devour and restore the land. But among the poems of Blake I found one which arrested my thought. Its message for me seemed in accord with that call to the heath, an exhortation to open my eyes and look about me, above all, to look up, to search the skies.

'To my friend Butts I write
My first vision of light
On the yellow sands sitting.
The sun was emitting
His glorious beams
From Heaven's high streams.
Over sea, over land,
My eyes did expand
Into regions of air
Away from all care;
Into regions of fire,
Remote from desire;
The light of the morning
Heaven's mountains adorning;
In particles bright
The jewels of light
Distinct shone and clear.
Amazed and in fear
I each particle gazèd
Astonished, amazèd;
For each was a man
Human-formed. Swift I ran,
For they beckoned to me,
Remote by the sea,
Saying: "Each grain of sand,
Every stone on the land,
Each rock and each hill,
Each fountain and rill,
Each herb and each tree,
Mountain, hill, earth, and sea,
Clouds, meteor, and star,
Are men seen afar."'[36]

The strange import of this poem, which
has even more meaning for me to-day,
penetrated my consciousness insidiously,
I began to form a habit of visual expansion,
'into regions of air'. I believed that by
a process of what I can only describe as
inward dilation of the eyes I could increase
my actual vision. I seemed to develop a
power of interpenetration which disclosed
strange phenomena. I persuaded myself
I was seeing visions.[37]

Herbert Read (1893–1968), critic and poet, from his autobiographical essay 'The Discovery of Poetry'

The compositions which came to me
so easily in these adolescent days were
destroyed long ago, and I have no very
precise recollection of their nature. They
were, I think, mostly short lyrics about
flowers, birds, atmospheric moods; the
more realistic of them may have attempted
to catch something of the poetry of foggy,
gas-lit streets, the glow of furnaces by night,
the clatter of clogs on the stone pavements.
There were no love poems, for my heart was
not yet engaged.

It was then that the poetry of William
Blake descended on me like an apocalypse.
Tennyson[38] had chimed in with my moods,
and shown me felicity. Blake shook me to
the depths of my awakening mind, scattered
the world of my objective vision, and left me
floundering in subjective fantasy. I did not,
at that time, venture far into the Prophetic
Books; but the Songs of Innocence and
Experience, and the poems from the Rossetti
and Pickering manuscripts,[39] pierced me like
gleaming steel, and their meaning was
annealed to my mind. Their meaning? –
I should rather say their mystery, for many
of these poems were not easy to understand,
and indeed I did not seek to understand
them. From the beginning I was content
with the incantation of a poem, and I still
maintain that this is the only *necessary*
approach to poetry.[40]

George Orwell (1903–50), writer, from his essay 'Charles Dickens' (1940)

It is not at all certain that a merely moral
criticism of society may not be just as
'revolutionary' – and revolution, after all,
means turning things upside down – as the
political-economic criticism which is
fashionable at this moment. Blake was not
a politician, but there is more understanding
of the nature of capitalist society in a poem
like 'I wander through each charter'd street'
[41] than in three-quarters of Socialist
literature. [42]

David Jones (1895–1974), poet and artist, writing to H.S. Ede, 3 July 1943

I went to a lecture with my old friend and
master Mr Hartrick the other night, given
by the artist Hennell, on Blake, with lantern
slides and then I saw what you have
so often said about the enhancement
(and enchantment) given to some pictures
by the size on the screen.

109
The Body of Abel found by Adam and Eve
c.1826
Pen and tempera with gold, on wood
325 × 433
Tate

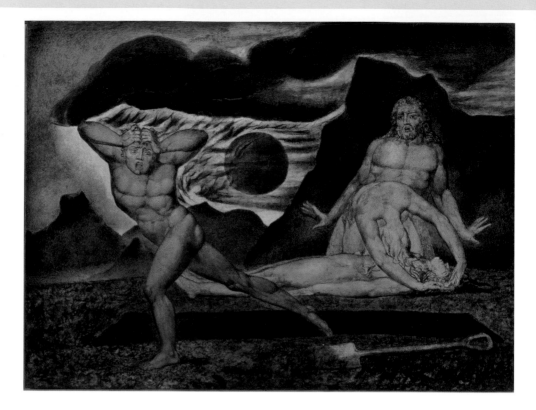

I've always reckoned I 'liked' Blake, but my God! – that size and with that luminosity they fair bowl you over – absolutely terrific. A certain tightness which, sometimes, to me, mars Blake all disappears and the freedom of them becomes really overwhelming. I was very glad I went. The lecturer was good and informative also – but it was those enormous great shapes that really startled me. That one called *Cain* with the distraught Eve and Adam and the dead Abel etc. really looked unbelievable in its power[43] [fig.109].

Philip Larkin (1922–85), poet, writing to Norman Iles, 29 January 1945

When I stole a Nonesuch[44] Blake from Blackwells[45] (looking back on those days it's a miracle I didn't end up in the police court) I read the Songs of Innocence & Experience & the additional poems from the Rossetti MSS,[46] but I never ventured on the prophetic books. I thought them very great at the time, but my opinions have been clouded by neglect, also by Blake's technical roughness […] also by the way Blake has been taken up by poets I don't care for. These are poor excuses & I will read him again.[47]

Michael Ayrton (1921–75), artist, from his essay 'British Drawings' (1946)

In my own personal and probably superstitious opinion, William Blake was one of the greatest beings ever to inhabit the planet, and had the Gods granted him a pictorial ability equal to his vision we should simply not know what he was about. The Gods did not, they made of him a competent engraver and a passable draughtsman. With these inadequate tools, by the sheer power of his imagination and some gift for designing within the picture, Blake contrived to make a unique contribution to European art. It is however important to correct the very general and mistaken impression that Blake was unique in the form his work took. Imaginative or visionary art was a going concern with a number of able practitioners involved, in the latter half of the eighteenth century. No one of them was Blake's imaginative equal; no one of them had anything approaching Blake's genius, but several of them drew better than Blake, from a technical point of view. All of them, both his seniors and his juniors, now seem to

radiate from Blake. They knew him and their work achieved life; before they knew him they were comparatively empty; after his presence faded they dried up.[48]

John Piper (1903–92), artist, from his essay 'British Romantic Artists' (1946)

Blake never obeyed rules made by anyone else. He broke ordinary rules all his life, with profit to his art. He was rare simply in his capacity to live fully. In its general cast his art was very much of the period, related to that of Fuseli, Flaxman, Barry, and Romney, in Romney's much less public moods. Blake picked up the rags and tags of the Gothic Revival and the Italian Decadence and without fluency, but with infinite patience transfigured them into works that were vital and necessary. His few small woodcuts for the school text of Philip's *Imitation of Virgil's first Ecologue* burst with life. His hand-coloured prints that illustrate his own poems are tender and exuberant. No word-description of Blake's art is adequate; no approach to it reasonable but the approach of acceptance. His own marginalia, letters, poems and epigrams are the best footnotes to his pictures.[49]

Ruthven Todd (1914–78), poet and Blake scholar, from his 'Introduction' to *William Blake: Poems* (1949)

Those who wish to believe that Blake was a mad dreamer, living in a world where his ghosts spoke more clearly than his friends, are at liberty to go on believing it. They are wrong. Blake told the young George Richmond that he could look at a knot in a piece of wood until it frightened him; if he could do that, it is easy to see how real the figures he called up with all the intensity of his burning and unusually vivid imagination must have appeared.[50]

Jack Kerouac (1922–69) poet, writing to Allen Ginsberg, 10 June 1949

Do you know what about Blake? He talks affably and cheerfully about those things in the Bible that we never could understand. 'They wandered long till they sat down upon the margined sea, conversing in the visions of Beulah . . . Nine years they viewed the living spheres, feeding the visions of Beulah?'[51] Who is Beulah? Beulah is the mystery of the Bible, huh?[52]

Allen Ginsberg (1926–97), poet, from his essay 'Prose Contribution to Cuban Revolution' (1961)

Then as I've said but never fully described nor in context of development, came a time when college days were o'er and I had to depend on myself, and Jack and Bill went their ways in the world – though I felt bound to them by sacramental mellow lifelong-to-be ties – and the one idealistic love affair I had with Neal came to an end because it was impractical and he was married and not really the same thing I was after – which was a lifelong sex-soul union – he was willing but not to the extreme all out homo desire I had – anyway I realized I was alone and not ever to be loved as I wanted to be loved – though I'd had with him some great pathos love-bed scenes which surpassed in tenderness anything I'd ever be handed on earth – so that the loss was even more utterly felt, as a kind of permanent doom of my desires as I knew them since childhood – I want somebody to love me, want somebody to carry me

Hoagy tenderness – and at that point living alone eating vegetables, taking care of Huncke[53] who was too beat to live elsewhere – I opened my book of Blake (as I've said before it's like the Ancient Mariner repeating his obsessional futile tale to every guest he can lay his hand on)[54] and had a classical hallucinatory-mystical experience, i.e. heard his voice commanding and prophesying to me from eternity, felt my soul open completely all its doors and windows and the cosmos flowed thru me, and *experienced* a state of altered apparently total consciousness so fantastic and science-fictional I even got scared later, at having stumbled on a secret door in the universe all alone.[55]

Mervyn Peake (1911–68), writer and artist, 'Blake' (c.1950)

When I remember how his spirits throve
Amid dark city streets he did not see
Because his eyes were veiled with poetry

And at his heart the Prophets wings were
 wove,

When I recall the squalor of his days
And then remember what rare fire was
spent
When amid quenchless words he died,
I praise
Whatever Gods were in his wonderment.[56]

Aldous Huxley (1894–1963), writer, from *The Doors of Perception* (1954)

From what I had read of the mescalin
experience I was convinced in advance that
the drug would admit me, at least for a few
hours, into the kind of inner world
described by Blake and Æ.[57] But what I had
expected did not happen. I had expected
to lie with my eyes shut, looking at visions
of many-coloured geometries, of animated
architectures, rich with gems and
fabulously lovely, of landscapes with heroic
figures, of symbolic dramas trembling
perpetually on the verge of ultimate
revelation.[58]

Aldous Huxley writing to Dr Humphry Osmond, 19 February 1958

One of the things that should be read
to a person under LSD is Blake's *Marriage of
Heaven and Hell*, including the extraordinary
'Memorable Fancies' that precede and
follow the 'Proverbs of Hell'. Read the thing
through and see if you don't agree. I'm sure
if this were put on tape it would be found
extremely enlightening by the subject.[59]

Georges Bataille (1897–1962), critic and writer, 'William Blake' (1957)

If I had to name those English writers who
moved me most, they would be John Ford,
Emily Brontë[60] and William Blake. I agree
that such classifications are pretty
meaningless, yet these names have certain
powers in common. They have just emerged
from obscurity and in the excessive violence
of their work, Evil attains a form of purity.

 Ford left an incomparable image
of criminal love. Emily Brontë saw the
wickedness of a foundling as the only clear
answer to the demands which consumed
her. Blake managed, in phrases of

peremptory simplicity, to reduce humanity
to poetry and poetry to Evil. […] William
Blake's life seems almost banal: it was
regular and unadventurous. And yet it had
one striking peculiarity: it escaped, to a large
extent, from the common limitations of life.
His contemporaries were not unaware of his
existence. In his lifetime he enjoyed a certain
notoriety, but he was always alone – he never
formed part of a group. If Wordsworth and
Coleridge appreciated him, it was not
without reservations. Coleridge, at least,
complained of the indecency of his writings.
He had, on the whole, to be kept aside, to be
kept in the background. 'He is a lunatic,' they
said of him, and continued to repeat it even
after his death. His works (his writings and
his paintings) have a maladjusted quality.
They astonish us with their indifference to
common rules. Something exhorbitant, deaf
to the reproaches of others, raise these poems
and these violently coloured figures to a
sublime level. Though Blake was a visionary
he never gave a real value to his visions.
He was not mad: he simply saw them as
humans, the creations of the human mind.[61]

Kathleen Raine (1908–2003), poet and Blake scholar, from her autobiography *The Land Unknown* (1975)

Presently, by another of those seeming
miracles by which a change of inner
disposition is followed by a corresponding
change in the outward course of events, my
course became calmer. Blake now became
my Virgil and my guide;[62] I took the end
of his golden string, and began, with an
exhilarating sense of return to duty, to wind
it into a ball. Others before and since have
found that string longer than they had
supposed. As I entered the British Museum
each morning, to begin my day's work where
Yeats had worked on Blake before me, my
heart would give a little leap of pleasure,
a sure sign that the work I was doing was
the work I was then meant to be doing.
I persisted in the winding in of the golden
string a great deal more whole-heartedly
than I had ever practised the Catholic
religion; and felt myself now once again
engaged in a serious imaginative task, and
no longer play-acting.[63]

Peter Ackroyd (b.1949), novelist and biographer of *Blake* (1995)

He called himself 'English Blake', and appropriately so, but he might also be known as 'London Blake'. He left the city only once, and most of his life was spent in the same small area banded by the Strand, Holborn and Oxford Street. He did not need to travel any further because he saw, literally *saw*, Eternity there. But these conditions helped to shape the kind of artist he became: he was a Cockney visionary, and takes his place with Turner and Dickens as one of the great artists of London.[64]

Alex James (b.1968), musician, quoted in *The Scotsman*, 7 November 2000

The range of Blake's canon is bewildering – from two-minute pop moments ('Tyger Tyger, burning bright') to abstruse heavy-duty versions of deity. Polymath, nutter. The original Soho nutcase.

Patti Smith (b.1946), musician and poet, interviewed by Louisa Buck, *London Evening Standard*, 30 November 2000

I have grown up with Blake. He has permeated so many of the things that I do – my aesthetics, the idea of merging different forms and also the idea that one person can do so many things. For me, the great thing about Blake is that he created his own universe. But it's not a cosmology that you can set a skeleton key to and lay it all out; it's imperfect, and I think this is what gives it its most enduring beauty. Blake's work is always in flux – it always seems to me in a state of disarray, which is what keeps it alive.

Iain Sinclair (b.1943), writer and filmmaker, interviewed in the *Daily Telegraph*, 7 May 2005

William Blake haunts my vision of London: he created a cosmology from the particulars of the city's geography and life. His epic poem *Jerusalem* has a mythical system all of its own. It's beyond emulation.

A Guide to Collections

All of Blake's works, whether printed, painted in watercolour or tempera, or in manuscript, are extremely vulnerable. While the great majority of Blake's works are now in public collections, these instutitions are not able to keep these works on permanent show and are obliged to control access to them. A selection of works may be on public display at any given time, but it would be wise to check before you visit. Most public collections have study rooms where these works can be viewed under supervision, generally only by appointment. Even then, there are works that are too fragile ever to be handled. Loan exhibitions provide an exceptional opportunity to see large groups of works together, and the accompanying catalogues are an important source of illustrations and commentary. However, these are expensive and complex events, and full-scale retrospectives appear only many years apart.

As some form of compensation, many of Blake's works are available in facsimile – that is, reproduced on the same scale and as far as possible with the same colour properties as the original. Early facsimile editions were works of art in their own right, even including colouring applied by hand. As technology has advanced, facsimiles have become still more accurate and yet also more economical. All of Blake's illuminated works are available in this form, along with selected manuscripts and some drawings and paintings. Furthermore, digital access to Blake's works is always increasing, both on the William Blake Archive's website (www.blakearchive.org/blake), and on the web pages of individual collections (see below).

The following is intended as a guide to seeing Blake's works both in person and in reproduction. It supplies details of the major public collections of Blake's works and specialist catalogues of these collections, a listing of notable exhibitions since 1975, notes on the whereabouts of Blake's illuminated books and major series of prints, paintings and drawings, and details of the main facsimiles.

Major Collections

United Kingdom
Cambridge

FITZWILLIAM MUSEUM
(www.fitzmuseum.cam.ac.uk)
An outstanding collection of watercolours,
illuminated books and prints, enhanced by
the exceptional bequest of the Blake scholar
Geoffrey Keynes (1887–1982).

David Bindman, *William Blake: Catalogue
of the Collection in the Fitzwilliam Museum,
Cambridge*, Cambridge 1970

London

THE BRITISH MUSEUM, LONDON
(www.british-museum.ac.uk)
The Department of Prints and Drawing
holds the largest and most comprehensive
collection of Blake's drawings,
watercolours, prints and illuminated
books, together with original copperplates
and woodblocks, commercial engravings
and fascimile editions.

Richard Morgan with G.E. Bentley,
'A Handlist of Works by William Blake in
the Department of Prints and Drawings
of the British Museum', *Blake Newsletter*,
20, spring 1972

TATE BRITAIN (www.tate.org.uk)
An exceptional collection of Blake's
watercolours, tempera paintings and
drawings, including major selections of
illustrations to the Bible, designs for Dante
and eleven of the twelve 'large colour
prints'. Blake's works feature in the
changing programme of displays, and
the gallery organised the major loan
exhibitions in 1978 and 2000.

Martin Butlin, *William Blake 1757–1827*,
Tate Gallery Collections. vol .5, London
1990

Martin Butlin, *William Blake: A Complete
Catalogue of the Works in the Tate Gallery*,
introduction by Anthony Blunt, London
1971

VICTORIA AND ALBERT MUSEUM
(www.vam.ac.uk)
A significant collection of watercolours,
drawing and tempera paintings, together with
engravings and some relief-printed plates.

Australia
Melbourne

NATIONAL GALLERY OF VICTORIA
(www.ngv.vic.gov.au)
A major collection of watercolours, prints
and drawings, particularly notable for the
exceptional selection of Blake's illustrations
to Dante.

Martin Butlin and Ted Gott, *William Blake
in the Collection of the National Gallery of Victoria*,
Melbourne 1989

United States
California: San Marino

HUNTINGTON LIBRARY, ART COLLECTIONS
AND BOTANICAL GARDENS
(www.huntington.org)
The library collections and art gallery have
comprehensive holdings of drawings, paintings,
prints and illuminated books, and the unique
proof copy of *The French Revolution* (1791).

Robert N. Essick, *The Works of William Blake in
the Huntington Collections: A Complete Catalogue*,
San Marino 1985

Robert N. Essick, *William Blake at the
Huntington: An Introduction to the William Blake
Collection in the Henry E. Huntington Library and
Art Gallery, San Marino, California*, New York
1994

Connecticut: New Haven

YALE CENTER FOR BRITISH ART
(www.ycb.yale.edu/index.asp)
The largest collection of British art outside the
United Kingdom has major holdings of Blake's
paintings, drawings and illuminated books,
based around the collection of its benefactor,
Paul Mellon (1907–99).

Patrick Noon, *The Human Form Divine: William
Blake from the Paul Mellon Collection*, New Haven
1997

Massachussetts: Boston
MUSEUM OF FINE ARTS
(www.mfa.org)
A significant collection of watercolours,
including illustrations to Milton and the Bible.

Massachussetts: Cambridge
FOGG ART MUSEUM
(www.artmuseums.harvard.edu/fogg)
An exceptional collection of watercolours and
paintings, including most of the second series
of *Job* watercolours (1821).

New York State: New York
THE MORGAN LIBRARY & MUSEUM
(www.morganlibrary.org)
This library holds a large collection
of illuminated books and watercolours.

New York State: New York
NEW YORK PUBLIC LIBRARY (www.nypl.org)
Holds a large collection of illuminated books.

Pennsylvania: Philadelphia
ROSENBACH MUSEUM & GALLERY
(www.rosenbach.org/home/home.html)
A notable collection of watercolours, drawings
and illuminated books.

Washington DC
LIBRARY OF CONGRESS
(www.loc.gov/rr/rarebook)
A comprehensive collection of illuminated
books, together with watercolours and other
prints.

Washington DC
NATIONAL GALLERY OF ART
(www.nga.gov)
The Lessing J. Rosenwald Collection at the
National Gallery includes a large number of
watercolours and temperas, some prints, and
the sole surviving fragment of an original
copperplate for a relief-printed page.

Selected exhibition history

Kunsthalle, Hamburg, 1975, *William Blake,
1757–1827*, exh. cat. by David Bindman

Tate Gallery, London, 1978, *William Blake*,
exh. cat. by Martin Butlin

Yale Center for British Art, New Haven, 1979,
*The Fuseli Circle in Rome: Early Romantic Art of the
1770s*, exh. cat. by Nancy Pressly

Yale Center for British Art, New Haven, and Art
Gallery of Ontario, Toronto, 1982, *William Blake:
His Art and Times*, exh. cat. by David Bindman

Torre de' Passeri, Casa Dante in Abruzzo,
Pescara, 1983, *Blake e Dante*, exh. cat. by Corradi
Gizzi *et al.*, Milan 1983

Henry E. Huntington Library and Art Gallery,
San Marino, CA, 1987, *William Blake and his
Contemporaries and Followers: Selected Works from
the Collection of Robert N. Essick*

National Museum of Western Art, Tokyo 1990,
William Blake (1757–1827)

Israel Museum, Jerusalem,1992, *There Was a Man
in the Land of Uz: William Blake's Illustrations to the
Book of Job*, exh. cat., ed. Meira Perry-Lehmann

Fundació la Caixa, Barcelona, 1996, *William
Blake: Visiones de Mundos Eternos*

Virginia Museum of Arts, Richmond, 1997,
William Blake: Illustrations of the Book of Job,
exh. cat. by Malcolm Cormack

Tate Britain, London, and The Metropolitan
Museum of Art, New York, 2000–1, *William
Blake*, exh. cat. by Robin Hamlyn, Michael
Phillips *et al.*

Wordsworth Trust, Grasmere, 2004, *Paradise
Lost: The Poem and its Illustrators*, exh. cat. by
Robert Woof, Howard J. M. Hanley and Stephen
Hebron

Tate Britain, London, 2006, *Gothic Nightmares:
Fuseli, Blake and the Romantic Imagination*,
exh. cat. by Martin Myrone

Paintings, Drawings and Engraved Illustrations

Blake's paintings and drawings have been
catalogued by Martin Butlin (1981); single plates
and commercial engravings by Robert N. Essick
(1983 and 1991; see p.217 under 'Standard Works
of Reference'). The following list is intended for

quick reference, indicating the main locations of Blake's major series of works and of the most significant individual productions.

Early Drawings and Watercolours (c.1772–90)
The largest groups of early works are at Tate and the British Museum. The drawings of monuments in Westminster Abbey associated with Blake's apprenticeship are at the Society of Antiquaries, London, and the Bodleian Library, Oxford. The three watercolours of *Joseph* (exh.1785) are at the Fitzwilliam Museum, Cambridge. The series of designs of plague, war and fire (c.1780–c.1805) are widely spread; examples are at the Bristol City Art Gallery, Huntington Library and Art Gallery, San Marino, and the Museum of Fine Arts, Boston. The 'Tiriel' designs are also widely dispersed; there are examples at the Fitzwilliam Museum, Cambridge, the Yale Center for British Art, New Haven, and the Victoria and Albert Museum, London.

Commercial Engravings
Blake's extensive employment for commercial publishers, including Joseph Johnson and Longman & Co., means that his conventional reproductive engravings and designs are to be found in many rare book collections with strong holdings of late eighteenth- and early nineteenth-century London publications, and as loose plates in many of the more significant historical print collections.

Erasmus Darwin, *The Botanic Garden* (1791), facsimile reprint Menston 1973

Robert N. Essick and Morton D. Paley, *Robert Blair's The Grave Illustrated by William Blake: A Study with Facsimile*, London 1982

J.C. Lavater, *Aphorisms on Man* (1788), facsimile reprint New York 1980

Mary Wollstonecraft, *Original Stories from Real Life* (1791), facsimile reprint Otley 2001

The twelve 'large colour prints' (1795/1805)
Impressions of eleven of the prints are held by Tate; the twelfth (*Naomi Entreating Ruth and Oprah*) is in the Victoria and Albert Museum, London. Collections holding impressions of individual plates include the National Gallery of Scotland, Edinburgh, The Metropolitan Museum of Art, New York, the Museum of Fine Arts, Boston, Yale Center for British Art, New Haven, and the National Gallery of Art, Washington. *The House of Death* and a version of *Pity* with two pencil sketches are in the British Museum. The watercolour of *The Good and Evil Angels* is in the Cecil Higgins Museum, Bedford, and an early study of *The House of Death* at Tate.

Illustrations to Young's 'Night Thoughts' (c.1795–7)
The 537 watercolour designs are held by the British Museum, London.

John E. Grant, Edward J. Rose and Michael J. Tolley (eds), *William Blake's Designs for Edward Young's 'Night Thoughts'*, 2 vols., Oxford 1980

Robert Essick and Jenijoy la Belle, *Night Thoughts, or, The Complaint and The Consolation*, New York and London 1976

Illustrations to Thomas Gray's 'Poems' (c.1797–8)
The 116 watercolour designs are in the Yale Center for British Art, New Haven.

Geoffrey Keynes (ed.), *William Blake's Water-colour Designs for the Poems of Thomas Gray*, Paris 1972

Illustrations to the Bible (c.1799–1809)
The surviving watercolours and temperas on biblical themes produced for Thomas Butts mainly between 1799 and 1809 are now widely dispersed. The most important collection of both watercolours and temperas is at Tate. Further groups of temperas are at the Fitzwilliam Museum, Cambridge, the Victoria and Albert Museum, London, and the Yale Center for British Art, New Haven. The watercolour series is also represented well at these collections, with notable groups of designs at the Museum of Fine Arts, Boston, the National Gallery of Art, Washington, the Fogg Art Museum, Cambridge, MA, The Metropolitan Museum of Art, New York, and the Philadelphia Museum of Art.

Geoffrey Keynes (ed.), *William Blake's Illustrations to the Bible: A Catalogue*, Clairvaux 1957

Illustrations to Milton (c.1801–20)

Twelve designs from *Paradise Lost* (1807) are at the Huntington Library and Art Gallery, San Marino; nine of the second set (1808) are at the Museum of Fine Arts, Boston, with further designs at the Victoria and Albert Museum, London, and the Huntington. Eight watercolours for *Comus* (c.1801) are in the collection of the Huntington; the second set (c.1815) is in the Museum of Fine Arts, Boston. The first series of illustrations to *On the Morning of Christ's Nativity* (1809) is at the Whitworth Art Gallery, Manchester; the second series (c.1815) is at the Huntington. Twelve illustrations to *L'Allegro* and *Il Penseroso* (c.1816–20) are at the Morgan Library and Museum, New York, and the twelve illustrations to *Paradise Regained* of the same period are at the Fitzwilliam Museum, Cambridge.

Illustrations to Robert Blair's 'The Grave' (1808)

The original watercolours (c.1805–7) are widely spread, with examples at the Yale Center for British Art, New Haven, CT, the British Museum, London, and the National Gallery of Art, Washington. A further group of nineteen original designs came to light in 2001, and were sold at Sotheby's New York and dispersed in May 2006.

Robert N. Essick and Morton D. Paley, *Robert Blair's 'The Grave', Illustrated by William Blake: A Study with Facsimile*, London 1982

Illustrations to 'The Book of Job' (c.1805–23)

The first series of twenty-one designs for Thomas Butts (mainly 1805–6) are in the Morgan Library and Museum, New York. The set produced for John Linnell (1821) is held in almost complete form at the Fogg Art Museum, Cambridge, MA. The sketchbook of drawings done in preparation for the engraved version (c.1823) is dismembered and held by the Fitzwilliam Museum, Cambridge. The original engravings and later reprints are widely dispersed; the twenty-two copperplates engraved by Blake are held by the British Museum.

Laurence Binyon and Geoffrey Keynes, *Illustrations of the Book of Job … Being All the Water-colour Designs, Pencil Drawings and Engravings, Reproduced in Facsimile*, New York 1935

David Bindman (ed.), *William Blake's Illustrations of the Book of Job: The Engravings and Related Material*, 6 vols., London 1987

Visionary Heads (c.1819–25)

These drawings are widely disseminated, with groups at the Huntington Library and Art Gallery, San Marino, Tate, London, Stanford University Museum of Art, CA, and the Fitzwilliam Museum, Cambridge. The tempera *Ghost of a Flea* (c.1819) is at Tate.

Martin Butlin (ed.), *The Blake-Varley Sketchbook of 1819*, London 1969

Illustrations to Thornton's 'Virgil' (c.1820)

The original drawings are widely dispersed. The seventeen original woodblocks are held by the British Museum, London, and have been reprinted.

Laurence Binyon, *William Blake: Being All his Woodcuts Photographically Reproduced in Facsimile*, London and New York 1902

The Wood Engravings of William Blake: Seventeen Subjects Commissioned by Dr. Robert Thornton for his Virgil of 1821, Newly Printed from the Original Blocks in the British Museum, with an introduction by Andrew Wilton, London 1977

Illustrations to Dante (c.1824–7)

The 102 drawings and watercolours are distributed around a number of collections in Britain, America and Australia. The largest collections are at Tate, London, the National Gallery of Victoria, Melbourne, and the Fogg Art Museum, Cambridge, MA. Examples are also found in the collections of Birmingham City Art Gallery and Museum, the British Museum, London, the Royal Institution of Cornwall, Truro, and the Ashmolean Museum, Oxford.

Blake's Illustrations of Dante, London 1978

Bunyan's 'The Pilgrim's Progress' (c.1824–7)

Out of the series of twenty-nine illustrations to John Bunyan's *The Pilgrim's Progress* (1678–84), all but one are in the collection of The Frick Museum, New York.

Other Paintings in Tempera and Watercolour

The most significant collection is at Tate, London, including *The Spiritual Form of Nelson*, *The Spiritual Form of Pitt*, and *The Bard, from Gray*. Other temperas are at the Victoria and Albert Museum, London, the Yale Center for British Art, New Haven, and the National Gallery of Art, Washington. A series of eighteen 'Heads of Poets' done in tempera for William Hayley in c.1800–5 is at Manchester City Art Gallery. The collection at Pollok House, Glasgow (part of Glasgow Museums), includes the picture of the Canterbury pilgrims, a version of *The Last Judgement* (1806), *Adam Naming the Beasts* and *Eve Naming the Birds* (both c.1810). Petworth House, Sussex (National Trust) has a version of *The Vision of the Last Judgement*, *Satan Calling up his Legions* (c.1800–5) and *The Characters in Spenser's 'Fairie Queene'* (c.1825), painted as a pendant to the picture of the Canterbury pilgrims. The largest surviving tempera painting by Blake, *An Allegory of the Spiritual Condition of Man* (1811) is held by the Fitzwilliam Museum, Cambridge. The Fitzwilliam also holds a unique surviving tempera painting by Catherine Blake, *Agnes* (c.1800).

The Illuminated Books

There are more than 160 copies of the various illuminated books distributed around public and private collections in Britain, America, Germany, Austria, Canada and Australia. The most extensive collections include the British Museum, London, the Huntington Library and Art Gallery, San Marino, the Morgan Library and Museum, New York, the Fitzwilliam Museum, Cambridge, the Yale Center for British Art, New Haven, and the Library of Congress, Washington. Although printed works, they are extremely scarce, vary considerably from copy to copy (with plates missing or rearranged), and are in some cases completely unique. There are single surviving copies of *All Religions are One* (1788; Huntington), *The Book of Los* (1795; British Museum) and *The Book of Ahania* (1795; Library of Congress), only four copies of *Milton: A Poem* (c.1804–10) and only five complete copies of *Jerusalem* (c.1804–20). There are seventeen

copies of *The Book of Thel* (1789) and of *Visions of the Daughters of Albion* (1793), twelve of *The Marriage of Heaven and Hell* (1790), fourteen copies of *America a Prophecy* (1793), nine known copies of *Europe a Prophecy* (1794) and six of *The Song of Los* (1795). The most marketable of Blake's illuminated books, *The Songs of Innocence* (1789) and *The Songs of Innocence and of Experience* (1789–94) exist in a total of about sixty copies. At least one copy of all of the illuminated books is available in facsimile, with the most recent William Blake Trust editions (David Bindman [ed.], *Blake's Illuminated Books*, 6 vols., London 1991–6) also providing detailed discussions of the historical record and of the interpretation of the text and images. Multiple copies of the illuminated books can be viewed and compared at the online William Blake Archive (www.blakearchive.org/blake).

Early Illuminated Books (1788–93)

Morris Eaves, Robert N. Essick and Joseph Viscomi (eds), *William Blake: The Early Illuminated Books, Blake's Illuminated Books*, vol. 3, London 1993

Geoffrey Keynes (ed.), *The Book of Thel*, London 1965

Geoffrey Keynes (ed.), *All Religions are One*, London 1970

Geoffrey Keynes (ed.), *There is No Natural Religion*, London 1971

Geoffrey Keynes (ed.), *'The Marriage of Heaven and Hell' by William Blake*, London 1975

Geoffrey Keynes (ed.), *The Gates of Paradise: For Children, For the Sexes*, London 1968

Nancy Bogen (ed.), *The Book of Thel: A Facsimile and a Critical Text*, Providence, RI, 1971

The Songs of Innocence and of Experience (1789–94)

Stanley Gardner, *The Tyger, the Lamb, and the Terrible Desart: 'Songs of Innocence and of Experience' in its Times and Circumstance Including Facsimiles and Two Copies*, London and Madison 1998

Andrew Lincoln (ed.), *William Blake: 'Songs of*

Innocence and of Experience.' Blake's Illuminated Books, vol.2, London 1991

Geoffrey Keynes (ed.), *Songs of Innocence and of Experience*, London 1970

The 'Continental Prophecies' (1793–5)
G. E. Bentley (ed.), *America: A Prophecy*, Normal, IL, 1974

Blake's 'America: A Prophecy' and 'Europe: A Prophecy': Facsimile Reproductions of Two Illuminated Books, New York 1983

Dörrbecker, D.W. (ed.), *William Blake: The Continental Prophecies*, Blake's Illuminated Books, vol. 4, London 1995

Geoffrey Keynes (ed.), *William Blake: 'America: A Prophecy'*, London 1963

Geoffrey Keynes (ed.), *William Blake: 'Europe: A Prophecy'*, London 1969

Geoffrey Keynes (ed.), *William Blake: 'The Song of Los'*, London 1975

The 'Urizen Books' (1794–5)
David Worrall (ed.), *William Blake: The Urizen Books*. Blake's Illuminated Books, vol. 6, London 1995

Geoffrey Keynes (ed.), *The Book of Urizen*, London 1958

Geoffrey Keynes (ed.), *The Book of Ahania*, 1973

Geoffrey Keynes (ed.), *The Book of Los*, London 1976

Milton: A Poem (c.1804–10)
Robert N. Essick and Joseph Viscomi (eds), *William Blake: 'Milton a Poem' and the Final Illuminated Works*, Blake's Illuminated Books, vol. 5, London 1993

Geoffrey Keynes (ed.), *Milton: A Poem*, London 1967

Jerusalem (c.1804–20)
Geoffrey Keynes (ed.), *Jerusalem: The Emanation of the Giant Albion*, London 1974

Morton D. Paley (ed.), *William Blake: 'Jerusalem: The Emanation of the Giant Albion'*, Blake's Illuminated Books, vol. 1, London 1991

Andrew Solomon, *William Blake's Great Task: The Purpose of 'Jerusalem'*, London 2000

Joseph H. Wicksteed, *William Blake's 'Jerusalem'*, London 1955

Other relief etchings
Blake printed several series of illustrations from the illuminated books without text in around 1794–6. The majority of these are now in the British Museum, London; further examples are at Tate, the Fitzwilliam Museum, Cambridge, Beinecke Library, New Haven, Princeton University Library and elsewhere. The famous separate impression of *The Ancient of Days* is in the Whitworth Art Gallery, Manchester. Coloured impressions of *Glad Day* or *Albion Rose* are at the British Museum and the Huntington, San Marino. Only two copies of the late relief etching of *Laocoön* exist (c.1826–7; Fitzwilliam Museum, Cambridge, and the collection of Robert N. Essick) together with five copies of *On Homer's Poetry [and] on Virgil* and of *The Ghost of Abel* (both c.1822).

Geoffrey Keynes (ed.), *William Blake's Laocoön: A Last Testament, with Related Works: On Homer's Poetry, and On Virgil: The Ghost of Abel*, London 1976

Robert N. Essick and Joseph Viscomi (eds), *William Blake: 'Milton a Poem' and the Final Illuminated Works*, Blake's Illuminated Books, vol.5, London 1993

Works in Conventional Typography

Only two poetic works by Blake were printed using conventional typography during his lifetime: the scarce *Poetical Sketches* (1783) and *The French Revolution* (1791), of which only a single proof copy is known (Huntington Library and Art Gallery, San Marino). There are a number of copies of the printed catalogue of his 1809 exhibition and materials relating to his version of the Canterbury pilgrims, and he also made written contributions to B. H. Malkin's *A Father's Memoirs* (1806) and to R. H.

Cromek's edition of Robert Blair's *The Grave* (1808). Full details of locations are given in Bentley, *Blake Books*, and his *Blake Books Supplement* (see 'Standard Works of Reference', p.217).

G.E. Bentley (ed.), *William Blake's works in conventional typography. Facsimile reproductions of Poetical sketches (1783) Copy F, The French Revolution (1791) Copy A, Appreciation of Master Malkin, in B.H. Malkin, A father's memoirs of his child (1806), 'To the Queen' (April 1807), from Robert Blair, The grave (1808), 'Exhibition of paintings in fresco' (1809) Copy A, 'Blake's Chaucer: The Canterbury pilgrims' (1809) Copy A, A descriptive catalogue (1809) Copy O, 'Blake's Chaucer: an original engraving' (1810) Copy C*, Delmar, NY, 1984

A Descriptive Catalogue (1809), with an introduction by Jonathan Wordsworth, Poole 2001

Manuscripts

The British Library, London, holds an important group of Blake's manuscript writings and letters. Other significant holdings are found at the Fitzwilliam Museum, Cambridge, the New York Public Library, the Morgan Library and Museum, New York, and the Huntington Library and Art Gallery, San Marino. These may be occasionally displayed as part of special exhibitions; however, the major literary manuscripts are all available in fascimile.

'An Island in the Moon' (c.1784–5)
Original manuscript in the Fitzwilliam Museum, Cambridge.

Michael Phillips (ed.), *An Island in the Moon*, Cambridge 1987

'Tiriel' (c.1785–9)
The manuscript is in the British Library, London; for the watercolour designs, see above under 'Early Drawings and Watercolours'.

G.E. Bentley (ed.), *William Blake: 'Tiriel'*, Oxford 1967

'Vala', or the 'Four Zoas' (c.1796–1807)
The illustrated manuscript is in the British Library, London.

G.E. Bentley (ed.), *Vala; Or, The Four Zoas: A Facsimile of the Manuscript, a Typescript of the Poem, and a Study of its Growth and Significance*, Oxford 1963

David V. Erdman and Cettina Tramontano Magno (eds), *'The Four Zoas': A Photographic Facsimile of the Manuscript with Commentary on the Illuminations*, Lewisburg, PA, and London 1987

The Notebook (c.1785–1805)
This important collection of drawings, notes and poems previously named after its former owner, D.G. Rossetti, is in the British Library, London; an on-line 'turning the pages' version of the notebook is now available (www.bl.uk).

Geoffrey Keynes (ed.), *The Note-book of William Blake Called the Rossetti Manuscript*, London 1935

David V. Erdman (ed.), with the assistance of Donald K. Moore, *The Notebook of William Blake: A Photographic and Typographic Facsimile*, Oxford 1977

The Pickering Manuscript (c.1800–4)
A collection of ten poems, named after its previous owner, B.M. Pickering, and now in the New York Public Library.

The Pickering Manuscript, with an introduction by Charles Ryskamp, New York 1972

Letters

The original letters are widely dispersed, with significant groups at the British Library, London, the Huntington Library and Art Gallery, San Marino, and the Morgan Library and Museum, New York. Many are known only from printed versions.

Geoffrey Keynes (ed.), *Letters from William Blake to Thomas Butts, 1800–1803: Printed in Facsimile*, Oxford 1926

110
Pestilence: Death of the First Born c.1805
Pen and ink and watercolour over pencil on paper
30.4 x 34.2
Museum of Fine Arts, Boston

Chronology

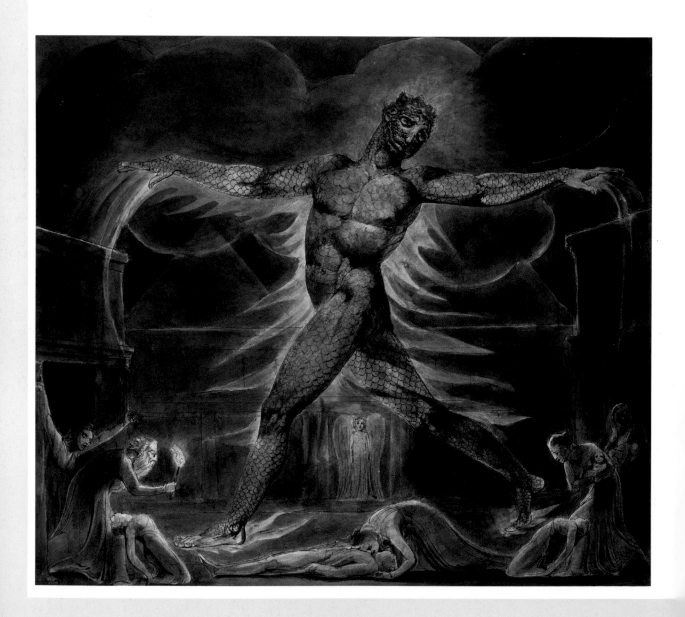

DATE	BLAKE'S LIFE	CULTURAL EVENTS	POLITICAL EVENTS
1757	William Blake born on 28 November, to James and Catherine Blake of 28 Broad Street, Golden Square, London. He is baptised on 11 December at St James's Church, Piccadilly.	Edmund Burke's influential *A Philosophical Enquiry into the Origins of Our Ideas of the Sublime and Beautiful* published	
1759			The 'Year of Victories': naval victories over the French transform Britain's fortunes; death of General James Wolfe at Quebec (13 September) makes him a popular hero
1760		Society of Artists hold their first annual exhibition. Society for Encouragement of Arts, Manufacture and Commerce (Society of Arts) begins holding competitions for artists	Accession of George III
1763			Treaty of Paris ends the Seven Years War: Britain is victorious over France, and secures power in North American and Caribbean colonies
1765		James Macpherson's hugely popular *Works of Ossian*, purporting to be the productions of an ancient Gaelic bard, is published	
1767	Blake enrols at the drawing school run by Henry and William Pars in the Strand		
1768		Founding of the Royal Academy of Arts, with Joshua Reynolds as President	
1769		Reynolds begins delivering his *Discourses*, a series of lectures on art at the Royal Academy, which continue until 1790	

1770		'The Boston Massacre': British troops fire on a crowd in Boston	
1772	Blake apprenticed to the engraver James Basire on 4 August; presumably moves in with his master at his home at 31 Great Queen Street, Lincoln's Inn Fields		
1773	Produces engraving of *Joseph of Arimathea* (fig.9), based on a figure by Michelangelo		
1774	Starts drawing from monuments in Westminster Abbey for Basire (fig.3)		
1775		1775–1783: War of American Independence	
1777		James Barry begins work on his massive decorative scheme for the Great Room of the Royal Society of Arts at the Adelphi	
1779	Enrols as an 'engraver' at the drawing schools of the Royal Academy of Arts on 8 October. Starts producing a series of watercolours of scenes from British history and legend	Death of John Hamilton Mortimer	
1780	Shows a drawing, *The Death of Earl Goodwin*, at the Royal Academy's annual exhibition in May; this is noted in the press by George Cumberland		Gordon Riots from 2–7 June, massive anti-Catholic protests in London and around the country
1781	Blake first works as an independent engraver. Employed by the publisher Joseph Johnson for the first time		

1782	Marries Catherine Boucher, daughter of a market gardener, at St Mary's Church, Battersea, on 18 August. They move to 23 Green Street, Leicester Fields	
1783	Comes to the attention of John Flaxman and the Revd A. S. Mathew; they finance the printing of a collection of youthful writings, *Poetical Sketches*. Probably meets Henry Fuseli for the first time around this date. Produces a number of prints after Thomas Stothard around this time, including the stipple engraving of Thomas Stothard's *Fall of Rosamond*, published by Thomas Macklin (fig.10)	
1784	Exhibits two watercolours at the Royal Academy, *A Breach in a City* and *War Unchained by an Angel*; these are compared to the work of Fuseli in a review. James Blake, William's father, is buried on 4 July. Sets up a print shop with James Parker at 27 Broad Street (next door to the family home). Begins writing his unfinished play 'An Island in the Moon'	
1785	Exhibits four works at the Royal Academy in May, including watercolours of the biblical figure Joseph and *The Bard, from Gray*. Moves to 28 Poland Street until 1790	
1787	William Blake's much-loved brother Robert dies suddenly and is buried on 11 February	John Flaxman travels to Italy, where he remains until 1794

1788	Supposed date of Blake's first experiments with relief etching, with the creation of the plates for *There is no Natural Religion* and *All Religions are One*, and the separate plate *The Approach of Doom* (fig.33). Engraves Hogarth's *The Beggar's Opera* for John Boydell (fig.24)	Formation of the London Committee for the Abolition of the Slave Trade
1789	William and Catherine Blake attend the first meeting of the Swedenborgian New Jerusalem Church. The date on the title pages of *The Songs of Innocence* and *The Book of Thel* (figs.34–5)	1789–93: The French Revolution
1790	Moves to 13 Hercules Building, Lambeth. Produces *The Marriage of Heaven and Hell* satirising Swedenborg (figs.47–8)	Parliamentary act for abolishing the slave trade fails
1791	The first book of *The French Revolution* printed by Joseph Johnson, who employs Blake extensively over the following years on book illustrations	Edmund Burke's *Reflections on the Revolution in France* published, an impassioned warning of the dangers of political revolution
1793	The date appearing on *Visions of the Daughters of Albion, America a Prophecy* (figs.37–9) and *For Children: The Gates of Paradise*. The engraved 'Prospectus' published on 10 October, which lists works by Blake for sale, with prices ranging from 3s. to 12s. and announces his invention of 'illuminated printing'	'The Terror' begins, a period of terrifying state violence in France, which turns public opinion in Britain against the Revolution. Prime Minister William Pitt starts to introduce new laws aimed at wiping out radical political activity in Britain 1793–1815: War with France. Execution of Louis XVI of France on 21 January 1793; Britain and France declare war

		
1794	Date appearing on *The Songs of Experience* and on a new title page for the collected *Songs of Innocence and of Experience*. Date appearing on *Europe a Prophecy* (figs.1, 40) and *The First Book of Urizen* (figs.49–50) Around 1794–6: Blake prints impressions of images from the illuminated books without the texts for Ozias Humphry	
1795	The date on the title pages of *The Song of Los*, *The Book of Ahania* and *The Book of Los* (fig.51). Date appearing on some of the 'large colour prints', including *Newton* and *Nebuchadnezzar* (figs.54, 55). Commissioned by Richard Edwards to provide illustrations for a new edition of Edward Young's *Night Thoughts* (1742)	
1796	Starts writing 'Vala', later retitled the 'Four Zoas'. Publication of J.G. Stedman's *Narrative of a Five Years Expedition Against the Revolted Negroes of Surinam*, with illustrations by Blake	
1797	Commissioned by John Flaxman to create watercolour illustrations for Thomas Gray's *Poems*	
1798	Edmund Malone (ed.), *The Works of Sir Joshua Reynolds*, published in three volumes; Blake will later annotate his copy with his abrasive opinions on the state of the arts	Bloody rebellion in Ireland

1799	Exhibits *The Last Supper*, a tempera painting, at the Royal Academy. Starts painting tempera paintings on biblical themes for Thomas Butts. Commissioned to paint four moral subjects for the Revd John Trusler	James Barry expelled from the Royal Academy; Henry Fuseli takes over as Professor of Painting	
1800	Exhibits *The Loaves and Fishes*, a tempera painting at the Royal Academy. William and Catherine Blake leave London on 18 September to stay as a guest of the poet William Hayley at Felpham, Sussex until 1802. During this time Blake paints literary portraits to decorate Hayley's library, produces illustrations for his poems, and takes up miniature painting at his behest. Begins watercolour illustrations of the Bible for Thomas Butts; the series is taken up again in 1803		Act of Union dissolves independent Irish parliament and creates a United Kingdom of Great Britain and Ireland
1801	Paints eight watercolour illustrations for Milton's *Comus* (1634) for the Revd Joseph Thomas		
1802			Treaty of Amiens brings a temporary halt to Britain's war with France
1803	Blake violently ejects a soldier, John Scolfield, from his garden at Felpham on 12 August. William and Catherine return to London on 19 September. They move to 17 South Molton Street on 26 October		

1804	Blake is tried for sedition in Chichester in January, following charges from Scholfield that he had cursed the king during the incident in August 1803; with the help of William Hayley's lawyer, Blake is acquitted. Date on title page of *Milton* and *Jerusalem*. Visits Truchsessian Gallery, London, and is impressed by early Northern European paintings	
1805	Commissioned by R. H. Cromek to create illustrations for a new edition of Robert Blair's *The Grave* (1743). Printing of the 'large colour prints'; sells eight to Thomas Butts. Paints a series of watercolours illustrating the *Book of Job* for Butts	Death of Nelson at the Battle of Trafalgar on 21 October makes him a national hero
1806	Commissioned by the Revd Joseph Thomas to paint six watercolours to extra-illustrate a copy of Shakespeare's plays. After this date, Owen Pughe commissions the massive painting of 'The Ancient Britons' (exh. 1809). Benjamin Heath Malkin's *A Father's Memoirs of his Child* includes an account of Blake and examples of his poetry	Death of James Barry
1807	Commissioned to paint twelve watercolour illustrations for Milton's *Paradise Lost* for the Revd Joseph Thomas. Commissioned to paint *The Vision of the Last Judgement* by the Countess of Egremont	Parliamentary act abolishing the slave trade in the British empire passed; slavery itself is allowed to continue on the Caribbean plantations

1808	Exhibits two watercolours at the Royal Academy, *Jacob's Dream* and *Christ in the Sepulchre*.	
	Publication of Blair's *The Grave*, with engravings by Luigi Schiavonetti after Blake. Paints a set of twelve watercolour illustrations to Milton's *Paradise Lost* for Thomas Butts	
1809	Opening of one-man exhibition of Blake's works in May at 28 Broad Street, now the house of his brother, James; publishes *A Descriptive Catalogue* to accompany the show. The exhibition is damned in a lengthy review in *The Examiner*. Prepares an angry lecture on engraving ('The Public Address')	Death of publisher Joseph Johnson
1810	Blake's exhibition remains open until the early summer. Prepares his engraving of the Canterbury pilgrims and reworks *Joseph of Arimathea*. Completes *Milton: A Poem* around this date. Henry Crabb Robinson publishes an essay on Blake in the German magazine, *Vaterländisches Museum*	
1812	Exhibits works with the Associated Society of Painters in Water Colours, including the painting of the Canterbury pilgrims, *The Spiritual Form of Pitt* (fig.84) and *The Spiritual Form of Nelson* (fig.83), and plates from *Jerusalem*	1812–15: War with the United States of America
1815	Produces engravings for the Wedgwood pottery catalogue	Vienna Settlement ends Britain's war with France

1816	Paints (c.1816–20) series of illustrations to Milton's 'L'Allegro' and 'Il Penseroso' for Thomas Butts	
1817	Blake's stipple engravings of Flaxman's illustrations to *Hesiod* published	
1818	Writes to Dawson Turner on 9 June offering illuminated books and the 'large colour prints' for sale at prices ranging from £2.2s. to £10.10s. Meets John Linnell for the first time; he will provide Blake with much employment in the coming years	
1819	Starts producing 'Visionary Heads' for John Varley	Peterloo Massacre in Manchester, a protest for radical political reform, is violently put down
1820	Completes *Jerusalem*; Thomas Griffiths Wainewright publishes a comical announcement in *The London Magazine* (September)	Accession of Prince Regent as George IV
1821	Moves with Catherine to 3 Fountain Court, the Strand. Publication of Dr Robert John Thornton's Latin primer *Pastorals of Virgil* (fig.93), featuring wood engravings by Blake. Paints a set of twenty-one illustrations for the *Book of Job* for John Linnell	
1822	In its capacity as a charity for needful artists, the Royal Academy agrees to pay Blake the sum of £25 on 28 June	
1823	Contract drawn up by John Linnell on 25 March for the designing and engraving of a set of illustrations for the *Book of Job*	

1824	Linnell commissions Blake to create illustrations for Dante's *Divine Comedy*	
1825	Visits Shoreham in Kent in September with the painters Samuel Palmer and Edward Calvert	Death of Henry Fuseli
1826	Publication of *Illustrations to the Biblical Book of Job* (figs.94, 95) in March. Starts creating an illustrated manuscript of the *Book of Genesis* (fig.100). Produces *Laocoön*	Death of John Flaxman
1827	Writes to George Cumberland on 12 April offering illuminated books for sale at prices ranging from £3.3s. to £10.10s.10d. Dies at home in Fountain Court on 12 August	

The Whirlwind: Ezekiel's Vision of the Cherubim and Eyed Wheels c.1803–5 (fig.62 detail)

Notes

Introduction

1 Anthony Blunt, *The Art of William Blake*, London 1959, pp.vii–viii.
2 David Bindman, *Blake as an Artist*, Oxford 1977, p.9.
3 Cited in G.E. Bentley, *Blake Records*, 2nd ed., London and New Haven 2004, pp.69, 104.
4 Thomas Carlyle to Edward Chapman, 28 Nov. 1859, quoted in Joseph Viscomi, 'Blake after Blake: A Nation Discovers Genius', in Steve Clark and David Worrall (eds), *Blake, Nation and Empire*, Basingstoke and New York 2006, pp.214–50 (quoted p.214).
5 On the William Blake Trust publications, see G.E. Bentley, *Blake Books Supplement*, Oxford 1995, p.13, and David Bindman, General Editor's Preface in Morton D. Paley (ed.), *William Blake: Jerusalem*, London 1991.
6 David V. Erdman, *Blake: Prophet Against Empire* (1954), revised ed., Princeton 1977.
7 E.P. Thompson, *Witness against the Beast: William Blake and the Moral Law*, Cambridge 1993.
8 William Blake to William Hayley, 28 Sept. 1805, in David V. Erdman (ed.), *The Complete Poetry and Prose of William Blake* (1965), revised ed., New York 1988, p.755.
9 On the idea of the amateur in this period, see the major studies by Ann Bermingham, *Learning to Draw: Studies in the Cultural History of a Polite and Useful Art*, New Haven and London 2000; Kim Sloan, *A Noble Art: Amateur Artists and their Drawing Masters, c.1600–1800*, London 2000; and Greg Smith, *The Emergence of the Professional Watercolourist: Contentions and Alliances in the Artistic Domain, 1760–1824*, Aldershot 2002.

1. The Engraver's World

1 *Public Advertiser*, 20 May 1762, quoted in D.G.C. Allan, *William Shipley: Founder of the Royal Society of Arts*, London 1979, p.87, in which the Shipley and Pars' drawing schools are discussed in some detail.
2 See John Sunderland, 'Mortimer, Pine and Some Political Aspects of English History Painting', in *Burlington Magazine*, 116, 1974, pp.217–26.
3 See David V. Erdman, *The Complete Poetry and Prose of William Blake* (1965), revised ed. New York 1988, pp.423–38; for the interpretation offered here, see G.A. Rosso, 'Empire of the Sea: "King Edward the Third" and English Imperial Policy', in Jackie DiSalvo, G.A. Rosso and Christopher Z. Hobson (eds), *Blake, Politics, and History*, New York and London 1998, pp.251–72.
4 Joseph Collyer, *The Parents' and Guardians' Directory*, London 1761, pp.221–2.
5 See Robert N. Essick, *William Blake's Commercial Book Illustrations*, Oxford 1991, cat.XVI.
6 See David Bindman, 'Blake's "Gothicised Imagination" and the History of England' in Morton D. Paley and Michael Phillips (eds), *William Blake: Essays in Honour of Sir Geoffrey Keynes*, Oxford 1973, pp.29–49.
7 G.E. Bentley, *Blake Records*, 2nd ed., London and New Haven 2004, p.563.
8 'Dunciad of Painting' cited in Martin Bircher and Karl S. Guthke (eds), *Johann Heinrich Füssli: Sämtliche Gedichte*, Zurich 1973, p.80.
9 John Flaxman to William Hayley, 14 Nov. 1805, in Bentley, *Blake Records*, p.208.
10 William Blake to Maria Denman, 18 [14] March 1827, in Erdman, *Complete Poetry & Prose*, p.783.
11 William Blake to George Cumberland, 26 Aug. 1799, in ibid. p.704.

2. The Royal Academy and High Art

1 The standard history of the Academy is Sidney Hutchinson, *The History of the Royal Academy, 1768–1986*, London 1986. See also Holger Hoock, *The King's Artists: The Royal Academy of Arts and the Politics of British Culture*, Oxford 2003; Matthew Hargraves, *Candidates for Fame: The Society of Artists of Great Britain, 1760–1791*, New Haven and London 2006 for the circumstances around the Academy's foundation.
2 The standard edition of Reynolds's lectures is Robert R. Wark (ed.), *Discourses on Art*, New Haven and London 1975.
3 See David H. Solkin (ed.), *Art on the Line: The Royal Academy at Somerset House, 1780–1836*, New Haven and London 2001.
4 G.E. Bentley, *Blake Records*, 2nd ed., London and New Haven 2004, pp.29–30.
5 Ibid. p.31.
6 *A Descriptive Catalogue*, 1809, in David V. Erdman, *The Complete Poetry and Prose of William Blake* (1965), revised ed. New York 1988, p.550.
7 See William L. Pressly, *The Life and Art of James Barry*, New Haven and London 1981; and Tom Dunne (ed.), *James Barry: The Great Historical Painter*, Cork 2005.
8 On Fuseli see Martin Myrone, *Henry Fuseli*, London 2000, and Myrone, *Bodybuilding: Reforming Masculinities in British Art, 1750–1810*, New Haven and London 2005, especially chapters 7, 9, 10, and Franziska Lentzsch *et al.*, *Fuseli: The Wild Swiss*, Zurich 2005. On Blake and Fuseli see Carol Louise Hall, *Blake and Fuseli: A Study in the Transmission of Ideas*, New York and London 1985; Christopher Heppner, *Reading Blake's Designs*, Cambridge 1995; and Martin Myrone, *Gothic Nightmares: Fuseli, Blake and the Romantic Imagination*, exh. cat., Tate Britain, London, 2006.
9 Bentley, *Blake Records*, pp.54–5.
10 Ibid. p.336.
11 Letter of 22 Oct. 1791, in David H. Weinglass, *The Collected English Letters of Henry Fuseli*, Millwood, New York, 1982, p.74.
12 Heppner, *Reading Blake's Designs*, p.81.
13 Robert N. Essick, *William Blake and the Langauge of Adam*, Oxford 1989, pp.224–5.

14 On the literary galleries see T.S.R. Boase, 'Macklin and Bowyer', *Journal of the Warburg and Courtauld Institutes*, 26, 1963, pp.148–77; Richard Altick, *The Shows of London*, Cambridge, MA, 1978; Rosie Dias, '"A World of Pictures": Pall Mall and the Topography of Display 1780–1799', in Miles Ogborn and C. Withers (eds), *Georgian Geographies: Essays on Space, Place and Landscape in the Eighteenth Century*, Manchester 2004, pp.92–113; Luisa Calè, *Fuseli's Milton Gallery: Turning Readers into Spectators*, Oxford 2006.

15 The partnership may have lasted a little longer than traditionally assumed, perhaps through 1785. See Angus Whitehead, 'A Reference to William Blake and James Parker, Printsellers, in Baily's British Dictionary (1785)', *Notes and Queries*, 52 (1), March 2005, pp.32–5.

16 See Howard Gaskill, *The Poems of Ossian and Related Works*, Edinburgh 1996.

17 Erdman, *Complete Poetry & Prose*, p.665. On Chatterton see Nick Groom (ed.), *Thomas Chatterton and Romantic Culture*, Basingstoke 1999.

18 Mary S. Hall, 'Blake's *Tiriel*: A Visionary Form Pedantic', *Bulletin of the New York Public Library*, 74, 1970, pp.166–76 (p.166). On '*Tiriel*' see also Peter Sorenson, 'Freemasonry and "Greek Mysteries" in William Blake's *Tiriel*', in *Classical and Modern Literature*, 15, 1995, pp.153–75, and Martha Keith Schuchard, 'Blake's *Tiriel* and the Regency Crisis: Lifting the Veil on a Royal Masonic Scandal', in Jackie DiSalvo, G.A. Rosso and Christopher Z. Hobson (eds), *Blake, Politics, and History*, New York 1998, pp.115–35.

19 Erdman, *Complete Poetry & Prose*, pp.276–7.

3. Blake's Revolution

1 See Thompson, *Witness Against the Beast: William Blake and the Moral Law*, Cambridge 1993.

2 John Mee, *Dangerous Enthusiasm: William Blake and the Culture of Radicalism in the 1790s*, Oxford 1992.

3 Erdman, *Complete Poetry & Prose*, p.342.

4 Ibid. p.427.

5 Knowles, *Life and Writings of Henry Fuseli*, vol.3, p.135.

6 Edward Larrissy, *William Blake*, Oxford 1985, esp. p.36. On Johnson and his circle see Helen Braithwaite, *Romanticism, Publishing and Dissent: Joseph Johnson and the Cause of Liberty*, Basingstoke 2003; also Brian Rigby, 'Radical Spectators of the Revolution: The Case of the *Analytical Review*', in Ceri Crossley and Ian Small (eds), *The French Revolution and British Culture*, Oxford and New York 1989, pp.63–83.

7 Anne K. Mellor, 'Sex, Violence, and Slavery: Blake and Wollstonecraft', in *William Blake: Images and Texts*, San Marino 1997, pp.69–94.

8 On Stedman and his text, see Richard Price and Sally Price (eds), *John Gabriel Stedman: Narrative of the Five Years Expedition Against the Revolted Negroes of Surinam*, Baltimore and London 1988.

9 David V. Erdman, 'Blake's Vision of Slavery', *Journal of the Warburg and Courtauld Institutes*, 15, 1952, pp.242–52.

10 David Bindman, 'Blake's Vision of Slavery Revisited' and Anne K. Mellor, 'Sex, Violence, and Slavery', both in *William Blake: Images and Texts*, San Marino 1997, pp.69–106 .

11 Marcus Wood, *Blind Memory: Visual Representation of Slavery in England and America 1760-1865*, Manchester and New York 2000; and his *Slavery, Empathy and Pornography*, Oxford 2002. See also Debbie Lee, *Slavery and the Romantic Imagination*, Philadelphia 2002, pp.66–119; Anne Rubinstein and Camilla Townsend, 'Revolted Negroes and the Devilish Principle: William Blake and the Conflicting Visions of Boni's War in Surinam, 1772–1796', in Jackie DiSalvo, G.A. Rosso and Christopher Hobson (eds), *Blake, Politics and History*, New York 1998; Mario Klarer, 'Humanitarian Pornography: John Gabriel Stedman's *Narrative of a Five Years Expedition Against the Revolted Negroes of Surinam* (1796)', *New Literary History*, 36, 2005, pp.559–82.

12 See the materials quoted in Martin Myrone (ed.), *The Gothic Reader: A Critical Anthology*, London 2006, pp.295–7.

13 See Bindman, 'Blake's Vision of Slavery Revisited'. See also Alan Richardson, 'Colonialism, Race and Lyric Irony in Blake's "The Little Black Boy"', *Papers in Language and Literature*, 26, 1990, pp.233–48; Laurent Henry, '"Sunshine and Shady Groves": What Blake's "Little Black Boy" Learned from African Writers', in Tim Fulford and Peter J. Kitson (eds), *Romanticism and Colonialism: Writing and Empire, 1780–1830*, Cambridge 1998, pp.67–86; Sybille Erle, 'Representing Race: The Meaning of Colour and Line in William Blake's 1790s Bodies', in Steve Clark and Masahi Suzuki (eds), *The Reception of Blake in the Orient*, London and New York 2006, pp.87–103.

14 J.T. Smith, *Nollekens and his Times* (1828), in G.E. Bentley, *Blake Records*, 2nd ed., London and New Haven 2004, p.609.

15 See Joseph Viscomi, *Blake and the Idea of the Book*, Princeton 1993; Michael Phillips, *William Blake: The Creation of the ' Songs' : From Manuscript to Illuminated Printing*, London 2000; Michael Phillips, 'Color-Printing Songs of Experience and Blake's Method of Registration: A Correction', in *Blake: An Illustrated Quarterly*, 36, 2002, pp.44–5; Martin Butlin, '"Is This a Private War or Can Anyone Join In?" A Plea for a Broader Look at Blake's Color-Printing Techniques', in *Blake: An Illustrated Quarterly*, 36, 2002, pp.45–9; Robert N. Essick and Joseph Viscomi, 'Blake's Method of Color Printing: Some Responses and Further Observations', in *Blake: An Illustrated Quarterly*, 36, 2002, pp.49–64. (http://www.rochester.edu/college/eng/blake/response/text.html) and 'An Inquiry into Blake's Illuminated Printing' (http://www.rochester.edu/college/eng/blake/inquiry/enhanced/index.html); Mei-Ying Sung, 'Technical and Material Studies of William Blake's Engraved *Illustrations of the Book of Job* (1826)', Ph.D. Thesis, Nottingham Trent University 2005.

16 A.H. Palmer, *The Life and Letters of Samuel Palmer*, London 1892, p.243.

17 Keri Davies, 'Mrs Bliss: A Blake Collector of 1794', in Steve Clark and David Worrall (eds), *Blake in the Nineties*, Basingstoke 1999, pp.212–30 and 'Rebekah Bliss: Collector of William Blake and Oriental Books' in Steve Clark and Masashi Suzuki (eds), *The Reception of Blake in the Orient*, London and New York 2006, pp.38–62. On the 'Prospectus' see Morris Eaves, 'National Arts and Descriptive Technologies in Blake's Prospectus of 1793', in Steve Clark and David Worrall (eds), *Blake, Nation and Empire*, Basingstoke 2006, pp.119–35.

4. Blake and the Bible

1 G.E. Bentley, *Blake Records*, 2nd ed., London and New Haven 2004, pp.606–7.

2 Ibid. pp. 625–6.

3 See Keri Davies, 'William Blake's Mother: A New Identification', in *Blake: An Illustrated Quarterly*, 33, 1999, pp.36–50; Keri Davies and Marsha Keith Schuchard, 'Recovering the Lost Moravan History of William Blake's Family' in *Blake: An Illustrated Quarterly*, 38 (2004), pp.36–43; and Marsha Keith Schuchard, *Why Mrs Blake Cried: William Blake and the Sexual Basis of Spiritual Vision*, London 2006.

4 E.P. Thompson, *Witness Against the Beast: William Blake and the Moral Law*, Cambridge 1993 See also John Mee, 'Is there an Antinomian in the House? William Blake and the After-Life of a Heresy', in Steve Clark and David Worrall (eds), *Historicizing Blake*, Basingstoke 1994, pp.43–58.

5 David V. Erdman (ed.), *The Complete Poetry and Prose of William Blake* (1965), revised ed., New York 1988, p.618.

6 For scholarly and speculative influences on Blake's interpretation of the Bible, see Stephen Prickett, 'Jacob's Dream: A Blakean Interpretation of the Bible', in Michael Gassenmeier *et al.* (eds), *British Romantics as Readers: Intertextualities, Maps of Misreading, Reintrepretations*, Heidelberg 1998, pp.99–105; Stephen Prickett, *Origins of Narrative: The Romantic Appropriation of the Bible*, Cambridge 1996, pp.216–20. See also Thompson, *Witness Against the Beast*, Robert N. Essick, *William Blake and the Langauge of Adam*, Oxford 1989, and John Mee, *Dangerous Enthusiasm: William Blake and the Culture of Radicalism in the 1790s*, Oxford 1992. The major study of esoteric sources in

Blake's work is Kathleen Raine, *Blake and Tradition*,
2 vols, Princeton 1968 (republished in abridged form as *Blake and Antiquity*, London 1979).

7 Erdman, *Complete Poetry & Prose*, p.39.

8 From 'The Laocoön', c.1810; in ibid. p.275.

9 Stephen C. Behrendt, 'Blake's Bible of Hell: Prophecy as Political Program', in Jackie DiSalvo, G.A. Rosso and Christopher Z. Hobson (eds), *Blake, Politics, and History*, New York and London 1998, pp.37–52

10 Noa Cahaner McManus and Joyce H. Townsend, 'The Large Colour Prints: Methods and Materials', in Townsend (ed.), *William Blake: The Painter at Work*, London 2003, pp.82–99. On the prints see also Martin Butlin, 'The Physicality of William Blake: The Large Color Prints of "1795"', *Huntington Library Quarterly*, 52, 1989, pp.1–17, and the full catalogue entries in his *William Blake 1757–1827*, Tate Gallery Collections, vol.5, London 1990.

11 Bentley, *Blake Records*, p.48.

12 See Gert Schiff, 'The Night of Enitharmon's Joy: Catalogue Entry' in *Blake: An Illustrated Quarterly*, 36, 2002, pp.38–9; Christopher Heppner, *Reading Blake's Designs*, Cambridge 1995, pp.120–31; Martin Myrone, *Gothic Nightmares: Fuseli, Blake and the Romantic Imagination*, exh. cat., Tate Britain, London 2006, cat. no.86; Mei-Ying Sung, 'Technical and Material Studies of William Blake's Engraved *Illustrations of the Book of Job* (1826)', Ph.D. Thesis, Nottingham Trent University 2005, pp.215–22.

13 David Bindman in Malcolm Cormack, *William Blake: Illustrations to the Book of Job*, exh. cat., Virginia Museum of Fine Arts, Richmond 1997, pp.76–7. The major study of Blake's biblical designs remains David Bindman, *Blake as an Artist*, Oxford 1977. See also David Sten Herrstrom, 'Blake's Transformation of Ezekiel's Cherubim Vision in Jerusalem', *Blake: An Illustrated Quarterly*, 15:2, 1981, pp.64–77; Mary Lynn Johnson, 'Blake's Judgment on the Book of Judges: The Watercolor Designs as Biblical Commentary' in Mary Lynn Johnson and Seaphia D. Leyda (eds), *Reconciliations: Studies in Honor of Richard Harter Fogle*, Salzburg 1983, pp.41–71; Mary Lynn Johnson, 'David's Recognition of the Human Face of God in Blake's Designs for the Book of Psalms', in David V. Erdman (ed.), *Blake and His Bibles*, West Cornwall, CT, 1990, pp.117–56; Heppner, *Reading Blake's Designs*.

14 See Myrone, *Gothic Nightmares*, pp.53–71.

15 David Bindman, 'Blake as a Painter' in Morris Eaves (ed.), *The Cambridge Companion to William Blake*, Cambridge 2003, pp.85–109 (p.98).

16 Christopher Burdon, *The Apocalypse in England: Revelation Unravelling, 1700–1834*, Basingstoke 1997, p.93.

17 On Blake's treatment of the Book of Job, see Bo Lindberg, *William Blake's Illustrations to the Book of Job* (Acta Academiae Aboensis 46), Abo, Finland, 1973; Kathleen Raine, *The Human Face of God: William Blake and the Book of Job*, London 1982; David Bindman (ed.), *William Blake's Illustrations of the Book of Job: The Engravings and Related Material*, 6 vols, London 1987; Meira Perry-Lehmann (ed.), *There Was a Man in the Land of Uz: William Blake's Illustrations to the Book of Job*, exh. cat., Israel Museum, Jerusalem, 1992; Malcolm Cormack, *William Blake: Illustrations to the Book of Job*, exh. cat., Virginia Museum of Fine Arts, Richmond, 1997.

18 On Blake and Milton see Pamela Dunbar, *William Blake's Illustrations to the Poetry of Milton*, Oxford 1980; Stephen C. Behrendt, *The Moment of Explosion: Blake and the Illustration of Milton*, Lincoln, Nebraska, and London 1983.

19 Erdman, *Complete Poetry & Prose*, pp.728–9.

20 Ibid. p.109.

21 Ibid. p.110.

22 Behrendt, *The Moment of Explosion*.

23 Erdman, *Complete Poetry & Prose*, p.685.

24 Ibid. p.393.

5. Blake and the Public

1 David V. Erdman (ed.), *The Complete Poetry and Prose of William Blake* (1965), revised ed., New York 1988 p.724.

2 Ibid. p.727.

3 See David H. Solkin, *Painting for Money: The Visual Arts and the Public Sphere in Eighteenth-Century England*, New Haven and London 1993; John Barrell, *The Political Theory of Painting from Reynolds to Hazlitt: ' The Body of the Public'* , New Haven and London 1986; Morris Eaves, *The Counter-Arts Conspiracy: Art and Industry in the Age of Blake*, Ithaca and London 1992.

4 G.E. Bentley, *Blake Records*, 2nd ed., London and New Haven 2004, p.74.

5 Ibid. p.617.

6 Diary entry of 24 June 1796, in ibid. p.71.

7 *New Monthly Magazine*, Dec. 1830, in ibid. p.536.

8 William Blake to William Hayley, 17 Nov. 1805, in Erdman, *Complete Poetry & Prose*, p.766. On the commission see Martin Butlin, 'New Risen from the Grave: Nineteen Unknown Watercolors by William Blake', in *Blake: An Illustrated Quarterly*, 35, 2002, pp.68–73, and the sale catalogue *William Blake: Designs for Blair's Grave*, Sotheby's New York, 2 May 2006.

9 John Flaxman to William Hayley, 18 Oct. 1805, in Bentley, *Blake Records*, p.207.

10 Ibid. p.219.

11 Geoffrey Keynes (ed.), *The Letters of William Blake with Related Documents*, Oxford 1980, p.128.

12 Bentley, *Blake Records*, p.211.

13 Ibid. p.260.

14 Ibid. p.283.

15 Ibid. p.274.

16 John Flaxman to William Hayley, 1 Dec. 1805, in ibid. p.220.

17 For documentation and a highly speculative recreation of the installation, see Troy Patenaude, '"The glory of a Nation": Recovering William Blake's 1809 Exhibition', in *The British Art Journal*, 4:1, 2003, pp.52–63.

18 Seymour Kirkup to A.C. Swinburne, 25 Jan. 1866, in Bentley, *Blake Records*, p.289.

19 Ibid. pp.307–9.

20 Ibid. p.287.

21 Ibid. p.299.

22 Ibid. p.282.

23 Greg Smith, *The Emergence of the Professional Watercolourist*, Aldershot 2002.

24 Bentley, *Blake Records*, p.312. See Robert N. Essick, 'Blake Exhibition of 1812', in *Blake: An Illustrated Quarterly*, 27:2, 1993, p.36–42.

25 Bentley, *Blake Records*, p.314.

26 Ibid. p.305.

27 Ibid. p.246.

28 Ibid. p.310.

29 Ibid. pp.370–1.

30 Erdman, *Complete Poetry & Prose*, p.543.

31 Ibid. p.171.

32 See Susan Matthews, 'Jerusalem and Nationalism' (1992), in John Lucas (ed.), *William Blake*, London and New York 1998, pp.80–100, and the essays by Steve Clark and Robert Essick in Steve Clark and David Worrall (eds), *Blake, Nation and Empire*, Basingstoke 2006. On the history and politics of the hymn 'Jerusalem', adapted from the 'Preface' to *Milton*, see also: Nancy M. Goslee, '"In England's Green and Pleasant Land": The Building of Vision in Blake's Stanzas from Milton', *Studies in Romanticism*, 13:4 (1974), pp.105–25; Michael Ferber, 'Blake's "Jerusalem" as a Hymn', *Blake: An Illustrated Quarterly*, 34:3 (Winter 2000–1, pp.82–9; Shirley Dent and Jason Whittaker, *Radical Blake: Influence and Afterlife from 1827*, Basingstoke 2002, pp.88–95.

6. Blake Among the Ancients

1 David V. Erdman (ed.), *The Complete Poetry and Prose of William Blake* (1965), revised ed., New York 1988, p.756.

2 See Morton D. Paley, 'The Truchsessian Gallery Revisited', in *Studies in Romanticism*, 16, 1977, pp.165–76.

3 Heather MacLennan, 'Antiquarianism, Master Prints and Aesthetics in the New Collecting Culture of the Early Nineteenth Century', Ph.D. Thesis, University of London 2000, p.11; see also MacLennan, 'Antiquarianism, Connoisseurship and the Northern Renaissance Print: New Collecting Cultures in the Early Nineteenth Century', in Martin Myrone and Lucy Peltz (eds), *Producing the Past: Aspects of Antiquarian Culture and Practice 1500–1850*, Aldershot 1999.

4 Robert R. Wark (ed.), *Discourses on Art*, New Haven and London 1975, p.81.

5 John Knowles, *The Life and Writings of*

Henry Fuseli, 3 vols, London 1831, vol.2, pp.345–6.
6 Ibid. vol.2, p.355.
7 Ibid. vol.2, p.359.
8 Erdman, *Complete Poetry & Prose*, p.595.
9 Ibid. p.549.
10 William Young Ottley, 'On the Character of Fuseli as an Artist', (c.1824–1825) in Knowles, *The Life and Writings of Henry Fuseli*, vol.1, pp.425–6.
11 G.E. Bentley, *Blake Records*, 2nd ed., London and New Haven 2004, p.669.
12 Bronwyn Ormsby with Brian Singer and John Dean, 'The Appearance of the Temperas Today', in Townsend (ed.), *William Blake: The Painter at Work*, London 2003, pp.150–9.
13 Noa Cahaner McManus and Joyce H. Townsend, 'Watercolour Methods, and Materials Use in Context', in Townsend (ed.), *William Blake: The Painter at Work*, pp.61–79.
14 Erdman, *Complete Poetry & Prose*, p.536. See Aileen Ward, 'Canterbury Pilgrims Revisited: The Blake-Cromek Controversy', *Blake: An Illustrated Quarterly*, 22, 1988–9, pp.80–92, and Andrew Moore and Robin Hamlyn, *William Blake: Chaucer's Canterbury Pilgrims*, Norwich Museums Service 1993.
15 See William Rendle and Philip Norman, *The Inns of Old Southwark and their Associations*, London 1888, pp.169–201; London County Council, *Survey of London: XXII: Bankside (The Parishes of St Saviour and Christchurch Southwark)*, London 1950, p.21n.
16 R.H. Cromek to James Montgomery, 17 April 1807, in Geoffrey Keynes (ed.), *The Letters of William Blake with Related Documents*, Oxford 1980, p.124.
17 Alexander S. Gourlay, '"Idolatry or Politics": Blake's Chaucer, the Gods of Priam, and the Powers of 1809', in Alexander S. Gourlay (ed.), *Prophetic Character: Essays on William Blake in Honor of John E. Grant*, West Cornwall, CT, 2002, pp.97–147.
18 Bentley, *Blake Records*, pp.313–14.
19 John Flaxman to Rev. William Gunn, 1 Oct. 1814, British Library, Add.MSS 39,790, f.30.
20 Gerald E. Bentley, 'Blake and the Ancients: A Prophet with Honour among the Sons of God', in *Essays on the Blake Followers*, San Marino 1983, pp.1–17.
21 See Laura Morowitz and William Vaughan (eds), *Artistic Brotherhoods in the Nineteenth Century*, Aldershot 2000.
22 Bentley, *Blake Records*, p.377.
23 For the literature on Blake and the Book of Job, see above, chapter 4, n.17.
24 George Cumberland to Catherine Blake, 25 Nov. 1827, in Keynes, *Letters of William Blake*, p.172.
25 Bentley, *Blake Records*, p.484.
26 Ibid. p.391.
27 Geoffrey Keynes, *The Gates of Memory*, Oxford 1981, p.81.
28 Quoted in David Bindman (ed.), *William Blake's Illustrations of the Book of Job: The Engravings and Related Material*, 6 vols, London 1987, pp.125, 129.

29 Ibid. p.130.
30 Robert N. Essick, 'John Linnell, William Blake, and the Printmaker's Craft', in *Essays on the Blake Followers*, San Marino 1983, pp.18–32.
31 Mei-Ying Sung, 'Technical and Material Studies of William Blake's Engraved *Illustrations of the Book of Job* (1826)', Ph.D. Thesis, Nottingham Trent University 2005, chap. 7.
32 On the Dante illustrations, see Albert S. Roe, *Blake's Illustrations to the Divine Comedy*, Princeton 1953; Milton Klonsky, *Blake's Dante: The Complete Illustrations to the Divine Comedy*, New York 1980; Corradi Gizzi et al., *Blake e Dante*, Milan 1983; David Fuller, 'Blake and Dante', *Art History*, 11, 1988, pp.349–73; Jeanne Moskal, 'Blake, Dante and "Whatever Book is for Vengeance"', *Philological Quarterly*, 70, 1991, pp.317–37.
33 Keynes, *Letters of William Blake*, p.164.
34 Bentley, *Blake Records*, p.400–1.

Writings on Art

1 David V. Erdman (ed.), *The Complete Poetry and Prose of William Blake* (1965), revised ed., New York 1988, p.451. It refers to the short-lived poet Thomas Chatterton (1752–70), who famously fabricated medieval poems.
2 Ibid. p.465.
3 Ibid. p.703.
4 George Michael Moser (1704–83), Swiss-born enamellist and painter and Keeper of the Royal Academy.
5 That is, portfolios of prints reproducing their works.
6 Erdman, *Complete Poetry & Prose*, p.639
7 Albrecht Dürer (1471–1528), German painter and engraver; Lucas van Leyden (1494–1533); 'Hisben' refers to the putative seventeenth-century German printmaker Hisbens, whose assumed works are now more firmly associated with Hans Sebald Beham (1500–50), engraver; Heinrich Aldegrever (1502–55/61), German engraver.
8 William Hogarth (1697–1764), painter of moral narratives and, importantly, engraver and publisher of his own prints.
9 Francesco Bartolozzi (1727–1815), William Woollett (1735–85), Robert Strange (1721–92), engravers.
10 James Heath (1757–1834), engraver.
11 Marcantonio Raimondi (1480–1534), Italian engraver of Raphael's works.
12 Hendrik Goltzius (1558–1617), Dutch painter and printmaker. Sadeler is the name of a family of Flemish engravers active in the late sixteenth and early seventeenth centuries; Gerard Edelinck (1640–1707), Flemish engraver.
13 John Hall (1723–97), engraver.
14 Erdman, *Complete Poetry & Prose*, pp.571–82. Compare with G.E. Bentley (ed.), *William Blake's Writings* (2 vols), Oxford 1978, vol.2, pp.1030–53, and David V. Erdman (ed.), with the assistance of Donald K. Moore, *The Notebook of William Blake: A Photographic and Typographic*

Facsimile, Oxford 1977, N.11, 51–2, 55–7, 24–5.
15 Joseph Viscomi, 'Illuminated Printing', in Morris Eaves (ed.), *The Cambridge Companion to William Blake*, Cambridge 2003, pp.37–62.
16 Erdman, *Complete Poetry & Prose*, pp.39–40.
17 Ibid. pp.692–3.
18 Ozias Humphry (1742–1810), portrait painter. The 'Books of Designs' were printed from plates for the illuminated books, with the textual elements masked out, in around 1794–6.
19 Erdman, *Complete Poetry & Prose*, p.771.
20 Cumberland's visiting card, designed and engraved by Blake.
21 Erdman, *Complete Poetry & Prose*, pp.783–4.
22 Apelles and Protogenes, ancient Greek artists.
23 An exhibition society set up by a group of connoisseurs in 1805 with the aim of promoting British history painting.
24 Erdman, *Complete Poetry & Prose*, pp.527–8.
25 Giulio Romano (1492/99–1546), Italian painter and architect.
26 Erdman, *Complete Poetry & Prose*, pp.529–30.
27 Ibid. pp.549–50.
28 Ibid. p.642.
29 Ibid. p.645.
30 Ibid. p.647.
31 Ibid. p.561.
32 Ibid. p.582.
33 'Provide neither gold, nor silver, nor brass in your purses. Nor scrip for your journey, neither two coats, neither shoes, nor yet staves: for the workman is worthy of his meat' (Matthew 10:9–10).
34 David Teniers the Elder (1582–1649), Dutch painter of genre scenes, much admired and collected in the eighteenth century.
35 Erdman, *Complete Poetry & Prose*, p.701.
36 i.e. Francis Bacon, *The Advancement of Learning* (1605).
37 Erdman, *Complete Poetry & Prose*, pp.702–3.
38 Thomas Rowlandson (1756–1827), leading caricaturist and watercolour painter.
39 Erdman, *Complete Poetry & Prose*, p.703.
40 Jan van Eyck (d.1441).
41 Erdman, *Complete Poetry & Prose*, pp.530–1.
42 Ibid. p.541.
43 A reference to the illuminated book, *Jerusalem* (c.1804–20).
44 A reference to the poet Thomas Gray's *The Bard*, the subject of a further painting by Blake included in the 1809 exhibition (fig.82).
45 The antiquarian Jacob Bryant (1715–1804). Blake had worked on the engravings for his *A New System, an Analysis of Ancient Mythologies* (1774–6) while in Basire's workshop. Bryant's exploration of the universal basis of the myths and symbols of ancient Greek, Egyptian, Jewish and

Oriental cultures has been considered a key influence on Blake.

46 David Hume (1711–76); Edward Gibbon (1737–94); Voltaire (1694–1778), all philosophers and historians of a self-consciously rationalist bent.

47 Laurence Echard (c.1670–1730), historian; Paul de Rapin-Thoyras (1661–1725), author of a much-read *History of England* that was used as a source-book by many painters in the period, including Pine and Mortimer. Plutarch and Herodotus are the ancient Greek historians.

48 The Hercules is the Farnese Hercules, which, together with the *Dancing Faun,* was among the most famous of classical sculptures. Casts of these figures would have been available to students of Pars' school, and at the drawing schools of the Academy.

49 Isaiah 17:13.

50 Erdman, *Complete Poetry & Prose*, pp.542–5.

51 Ibid. pp.552–4.

52 Ibid. pp.554–5. Compare with Bentley, *William Blake's Writings*, vol.2, pp.1007–9, and Erdman, *The Notebook*, N.68, 69.

53 Erdman, *Complete Poetry & Prose*, p.706.

54 Ibid. p.636.

55 Ibid. pp.736–7.

56 Ibid. pp.635, 642.

57 Ibid. p.511–12. Compare with Bentley, *William Blake's Writings*, vol.2, pp.943–4, and Erdman, *The Notebook*, N.32.

58 Erdman, *Complete Poetry & Prose*, p.512. After the reservations expressed in the earlier *Discourses* Reynolds had, famously, proclaimed Michelangelo's supremacy in Discourse XV (1790).

59 'H' is assumed to be Robert Hunt, who famously attacked Fuseli and Blake in his reviews in *The Examiner* (see p.150).

60 Erdman, *Complete Poetry & Prose*, p.507.

61 In 1777–83 Barry painted the decorations for the Great Room of the new Society of Arts' offices in the Adelphi on the basis that they only paid for his materials.

62 Fuseli's Milton Gallery, featuring forty paintings on themes from Milton, opened in 1799 and 1800, but attracted few visitors and was a commercial failure.

63 Erdman, *Complete Poetry & Prose*, pp.768–9. Blake was writing in response to criticisms on Fuseli's paintings that he had seen in Bell's *Weekly Messenger*, 25 May 1806.

64 Flaxman travelled to Italy in 1787, and remained there until 1794.

65 Paracelsus (1493–1541) and Jacob Boehme or Behmen, 1575–1624), mystical writers.

66 Erdman, *Complete Poetry & Prose*, p.707-8.

67 Ibid. p.572. Further accusations of plagiarism appear in short poems in Blake's notebook of the time. The source of this complaint is not clear, and Flaxman went on to provide Blake with considerable employment in the coming years.

Encountering Blake: An Anthology of Responses from Creative Artists

1 G.E. Bentley, *Blake Records*, 2nd ed., London and New Haven 2004, p.31.

2 Ibid. pp.70–1.

3 Ibid., p.77.

4 Geoffrey Keynes (ed.), *The Letters of William Blake with Related Documents*, Oxford 1980, pp.124–6.

5 Bentley, *Blake Records*, pp.336–7.

6 Ibid. p.336.

7 Ibid. p.341.

8 Ibid. p.454.

9 Ibid. p.286.

10 Ibid. p.487.

11 E.T. Cook and Alexander Wedderburn (eds), *The Works of John Ruskin*, vol.8, London 1903, p.256n.

12 From G.E. Bentley (ed.), *William Blake: The Critical Heritage*, London and Boston 1975, p.31.

13 Walt Whitman (1919–92), American poet, whose frankly sensualist *Leaves of Grass* (1855 with later revisions) caused considerable controversy.

14 *William Blake: A Critical Essay*, London 1868.

15 Cecil Y. Lang (ed.), *The Swinburne Letters*, 6 vols, New Haven 1959, vol.1, pp.208–9.

16 *William Blake: A Critical Essay*, new edition, London 1906, pp.v–vii.

17 Frederick Shields (1833–1911), artist.

18 William Michael Rossetti (ed.), *The Works of Dante Gabriel Rossetti*, London 1911, pp.230, 671.

19 The writers Percy Bysshe Shelley (1792–1822); William Wordworth (1770–1850); Johann Wolfgang Geothe (1749–1832); Honoré de Balzac (1799–1850); Gustave Flaubert (1821–80) and Leo Tolstoy (1828–1910).

20 James McNeill Whistler (1834–1903).

21 Robert Browning (1812–89), poet.

22 In W.B. Yeats, *Essays and Introductions*, London and Basingstoke 1961, pp.111–12.

23 In John Erskine (ed.), *Interpretations of Literature*, 2 vols, New Delhi 1999, vol.1, pp.51–71.

24 Mystical writer, active in the fifth century.

25 In Ellesworth Mason and Richard Ellmann (eds), *The Critical Writings of James Joyce*, London 1959, p.222.

26 John Keats (1795–1821), poet.

27 Cf. David V. Erdman (ed.), *The Complete Poetry and Prose of William Blake* (1965), revised ed., New York 1988, p.507

28 From *Poetical Sketches* (1783); cf. Erdman, *Complete Poetry & Prose*, pp.412–13.

29 The opening line of 'The Nurses Song', from *Songs of Innocence* (1789)

30 Jacques Raverat (1885–1925), French artist.

31 In Adrian Glew (ed.), *Stanley Spencer: Letters and Writings*, London 2001, pp.87–8.

32 In Glew (ed.), *Stanley Spencer*, p.238.

33 François Villon (1431–c.1474), poet.

34 The philosophers Montaigne (1533–92) and Spinoza (1632–77).

35 From *The Sacred Wood: Essays on Poetry and Criticism* (1920), London 1969, pp.151–2.

36 Cf. Erdman, *Complete Poetry & Prose*, pp.712–13.

37 Paul Nash, *Outline: An Autobiography* (1949), London 1988, pp.79–80.

38 Alfred, Lord Tennyson (1809–92), poet.

39 i.e. the 'Notebook' of poems, notes and drawings, previously owned by D.G. Rossetti (and now in the British Library), and the collection of ballads named after its nineteenth-century owner, B.M. Pickering (now Pierpont Morgan Library, New York).

40 From Herbert Read, *Annals of Innocence and Experience*, London 1940, p.80.

41 From 'London' in *Songs of Innocence* (1789).

42 In Sonia Orwell and Ian Angus (eds), *The Collected Essays, Journalism and Letters*, vol.1, London 1968, p.427.

43 In René Hague (ed.), *Dai Greatcoat: A Self-Portrait of David Jones in his Letters*, London and Boston 1980, p.123.

44 The London publisher of *The Notebook of William Blake* (1935) and editions of Blake's complete poetry and prose (from 1927).

45 The chain of booksellers.

46 i.e. the 'Notebook' (see n.39 above).

47 Anthony Twaite (ed.), *Selected Letters of Philip Larkin*, London 1992, p.96.

48 In W.J. Turner (ed.), *Aspects of British Art*, London 1947, pp.36–7.

49 Ibid. p.186.

50 In *William Blake: Poems*, London 1949.

51 Cf. Erdman, *Complete Poetry & Prose*, p.305.

52 In Ann Charters (ed.) *Jack Kerouac: Selected Letters 1940–1956*, New York 1995.

53 The writer Herbert Huncke (1915–96).

54 An allusion to the supernatural tale told by the Mariner in Coleridge's poem *The Rime of the Ancient Mariner* (1797).

55 In Allen Ginsberg, *Deliberate Prose: Selected Essays 1952–1995*, ed. Bill Morgan, New York 2000, p.138.

56 From Maeve Gilmore (ed.), *Peake's Progress: Selected Writings and Drawings of Mervyn Peake*, London 1979, p.248.

57 George William Russell (1867–1935), Irish mystical poet.

58 From Aldous Huxley, *The Doors of Perception and Heaven and Hell*, London 1994.

59 In Grover Smith (ed.), *Letters of Aldous Huxley*, London 1969, p.848.

60 John Ford (1586–c.1640), playwright; Emily Brontë (1818–48), novelist.

61 From *Literature and Evil* (1957), trans. Alistair Hamilton, London and New York 1973.

62 An allusion to Dante's *Divine Comedy*, in which the narrator is led by the Roman poet Virgil.

63 Kathleen Raine, *The Land Unknown*, London 1975, pp.203–4.

64 Ackroyd, *Blake*, London 1995, p.92.

Reading About Blake: A Bibliography

The following is a highly selective bibliography of published works on Blake, providing a basic guide to the enormous literature on his life and art. The first section lists the standard works of reference, including G.E. Bentley's indispensible works of bibliographic record and biographical documentation, David V. Erdman's edition of Blake's writings which has become the text most usually referred to in academic literature, and Martin Butlin's catalogue raisonné of watercolours, temperas, drawings and coloured prints. The section of 'Classic Studies' includes the major works of scholarship around which the study of Blake's art and thought have been orientated in modern times. Although some of these have been superceded in strict matters of fact and methodology, all remain major points of reference for the interpretation of Blake. 'Contemporary Studies' highlights some of the scholarly work produced since about 1980, with an emphasis on works approaching Blake from historical and art-historical perspectives. 'Blake's Reputation' lists works which put the artist in a longer-term critical view, and 'Cultural Contexts' includes a few works on the wider art historical and social context.

Standard Works of Reference

Bentley, G.E. *Blake Books: Annotated Catalogues of William Blake's Writings in Illuminated Printing, in Conventional Typography and in Manuscript, and Reprints Thereof, Reproductions of his Designs, Books with his Engravings, Catalogues, Books he Owned and Scholarly and Critical Works About Him*, Oxford 1977

Bentley, G.E. (ed.), *William Blake's Writings*, 2 vols, Oxford 1978

Bentley, G.E. *The Stranger from Paradise: A Biography of William Blake*, New Haven and London 2001

Bentley, G.E. *Blake Books Supplement: A Bibliography of Publications and Discoveries about William Blake, 1971–1992, Being a Continuation of 'Blake Books'*, Oxford 1995

Bentley, G.E. *Blake Records: Documents (1714–1841) Concerning the Life of William Blake (1757–1827) and his Family: Incorporating 'Blake Records' (1969), 'Blake Records Supplement' (1988) and Extensive Discoveries Since 1988*, London and New Haven 2004

Bindman, David, assisted by Deirdre Toomey, *The Complete Graphic Works of William Blake*, London 1978

Bindman, David (ed.), *The Complete Illuminated Books*, London 2000

Butlin, Martin, *The Paintings and Drawings of William Blake*, 2 vols, New Haven and London, 1981

Damon, S. Foster, *A Blake Dictionary: The Ideas and Symbols of William Blake* (1965), with a new index by Morris Eaves, London 1979

Erdman, David V. *The Illuminated Blake: William Blake's Complete Illuminated Works with a Plate-by-late Commentary*, New York 1974

Erdman, David V. (ed.), *The Complete Poetry and Prose of William Blake* (1965), revised edition, New York 1988

Essick, Robert N. *The Separate Plates of William Blake: A Catalogue*, Princeton 1983

Essick, Robert N. *William Blake's Commercial Book Illustrations: A Catalogue and Study of the Plates Engraved by Blake after Designs by Other Artists*, Oxford 1991

Gilchrist, Alexander, *Life of William Blake, Pictor Ignotus*, 2 vols, London 1863; 2nd edn London 1880. The first volume of biography has been republished a number of times, with new introductions by W. Graham Robertson (1907), Ruthven Todd (1942) and by Richard Holmes (2005); there have also been several facsimile editions.

Keynes, Geoffrey, *The Complete Portraiture of William and Catherine Blake*, London 1977

Keynes, Geoffrey (ed.), *Blake: Complete Writings with Variant Readings* (1957), Oxford 1979

Keynes, Geoffrey (ed.), *The Letters of William Blake with Related Documents*, 3rd ed., Oxford 1980

Classic Studies

Bindman, David, *Blake as an Artist*, Oxford 1977

Bloom, Harold, *Blake's Apocalypse: A Study in Poetic Argument*, New York 1963

Blunt, Anthony, *The Art of William Blake*, London 1959

Bronowski, Jacob, *William Blake and the Age of Revolution*, London 1972 (first published as *William Blake 1757-1827: A Man Without a Mask*, 1943)

Damon, S. Foster, *William Blake: His Philosophy and Symbols*, London 1924

Erdman, David V. *Blake: Prophet Against Empire: A Poet's Interpretation of the History of His Own Times* (1954), rev. edn., Princeton 1977

Frye, Northrop, *Fearful Symmetry: A Study of William Blake* (1947), Princeton 1969

Grigson, Geoffrey, 'Painters of the Abyss', *Architectural Review*, 108 (1950), pp.215-20

Keynes, Geoffrey, *Blake Studies* (1949), 2nd edn, Oxford 1971

Raine, Kathleen, *Blake and Tradition*, 2 vols, Princeton 1968 (republished in abridged form as *Blake and Antiquity*, London 1979)

Thompson, E.P. *Witness Against the Beast: William Blake and the Moral Law*, Cambridge 1993

Todd, Ruthven, *Tracks in the Snow*, London, 1946

Contemporary Studies

Blake: An Illustrated Quarterly, periodical publication, 1967– to date (an index and some articles are available online, http://www.rochester.edu/college/eng/blake/)

Clark, Steve, and David Worrall (eds), *Historicizing Blake*, Basingstoke 1994

Clark, Steve, and David Worrall (eds), *Blake in the Nineties*, Basingstoke 1999

Clark, Steve, and David Worrall (eds), *Blake, Nation and Empire*, Basingstoke and New York 2006

Clark, Steve and Masashi Suzuki (eds), *The Reception of Blake in the Orient*, London and New York 2006

Connolly, Tristanne J. *William Blake and the Body*, Basingstoke 2002

DiSalvo, Jackie, G.A. Rosso, and Christopher Z. Hobson (eds), *Blake, Politics, and History*, New York and London 1998

Eaves, Morris, *William Blake's Theory of Art*, Princeton 1982

Eaves, Morris, *The Counter-Arts Conspiracy: Art and Industry in the Age of Blake*, Ithaca 1992

Eaves, Morris (ed.), *The Cambridge Companion to William Blake*, Cambridge 2003

Essick, Robert N., *William Blake, Printmaker*, Princeton 1980

Essick, Robert N., *William Blake and the Language of Adam*, Oxford 1989

Ferber, Michael, *The Social Vision of William Blake*, Princeton 1985

Gourlay, Alexander S. (ed.), *Prophetic Character: Essays on William Blake in Honor of John E. Grant*, West Cornwall, CT, 2002

Heppner, Christopher, *Reading Blake's Designs*, Cambridge 1995

Hilton, Nelson, *Literal Imagination: Blake's Vision of Words*, Berkeley 1983

Hobson, Christopher Z., *Blake and Homosexuality*, Basingstoke 2000

Larrissy, Edward, *William Blake*, Oxford 1985

Makdisi, Saree, *William Blake and the Impossible History of the 1790s*, Chicago and London 2003

Mee, Jon, *Dangerous Enthusiasm: William Blake and the Culture of Radicalism in the 1790s*, Oxford 1992

Mitchell, W.J.T., *Blake's Composite Art*, Princeton 1978

Paley, Morton D. *The Traveller in the Evening: The Last Works of William Blake*, Oxford 2004

Phillips, Michael, *William Blake: The Creation of the 'Songs': From Manuscript to Illuminated Printing*, London 2000

Schuchard, Marsha Keith, *Why Mrs Blake Cried: William Blake and the Sexual Basis of Spiritual Vision*, London 2006

Townsend, Joyce H. (ed.), *William Blake: The Painter at Work*, London 2003

Viscomi, Joseph, *Blake and the Idea of the Book*, Princeton 1993

Viscomi, Joseph (ed.), *William Blake: Images and Texts*, San Marino 1997

Williams, Nicholas M. (ed.), *Palgrave Advances in William Blake Studies*, Basingstoke and New York 2006

Blake's reputation

Bentley, G.E. (ed.), *William Blake: The Critical Heritage*, London and Boston 1975

Berthof, Robert J. and Anette S. Levitt (eds), *William Blake and the Moderns*, Albany, NY, 1982

Dent, Shirley and Jason Whittaker, *Radical Blake: Influence and Afterlife from 1827*, Basingstoke 2002

Dorfman, Deborah, *Blake in the Nineteenth Century: His Reputation as a Poet from Gilchrist to Yeats*, New Haven 1969

Larrissy, Edward, *Blake and Modern Literature*, Basingstoke 2006

Lucas, John (ed.), *William Blake*, Oxford and New York 1998

O'Neill, Judith (ed.), *Critics on Blake*, Coral Gables 1970

Wittreich, Joseph Anthony (ed.), *Nineteenth Century Accounts of William Blake*, Gainesville 1970

Cultural contexts

Barrell, John, *The Political Theory of Painting from Reynolds to Hazlitt: 'The Body of the Public'*, New Haven and London 1986

Bindman, David, *Shadow of the Guillotine: Britain and the French Revolution*, exh. cat., British Museum, London, 1989

Brewer, John, *The Pleasures of the Imagination: English Culture in the Eighteenth Century*, London 1997

Clayton, Tim, *The English Print, 1688-1802*, New Haven and London 1997

Craske, Matthew, *Art in Europe 1700-1830: A History of the Visual Arts in an Era of Unprecedented Urban Economic Growth*, Oxford and New York 1997

Kriz, Kay Dian, *The Idea of the English Landscape Painter: Genius as Alibi in the Early Nineteenth Century*, New Haven and London 1997

Myrone, Martin, *Bodybuilding: Reforming Masculinities in British Art, 1750-1810*, New Haven and London 2005

Paulson, Ronald, *Representations of Revolution (1789-1820)*, New Haven 1983

Simpson, David, *Romanticism, Nationalism and the Revolt Against Theory*, Chicago and London 1993

Smith, Greg, *The Emergence of the Professional Watercolourist: Contentions and Alliances in the Artistic Domain, 1760-1824*, Aldershot 2002

Solkin, David (ed), *Art on the Line: The Royal Academy Exhibitions at Somerset House, 1780-1836*, New Haven and London 2001

Wahrman, Dror, *The Making of the Modern Self: Identity and Culture in Eighteenth-Century England*, New Haven and London 2004

Photographic Credits

Index